THE BEATLES

ALL YOU KNIT IS L♥VE
THE OFFICIAL BEATLES KNITTING BOOK

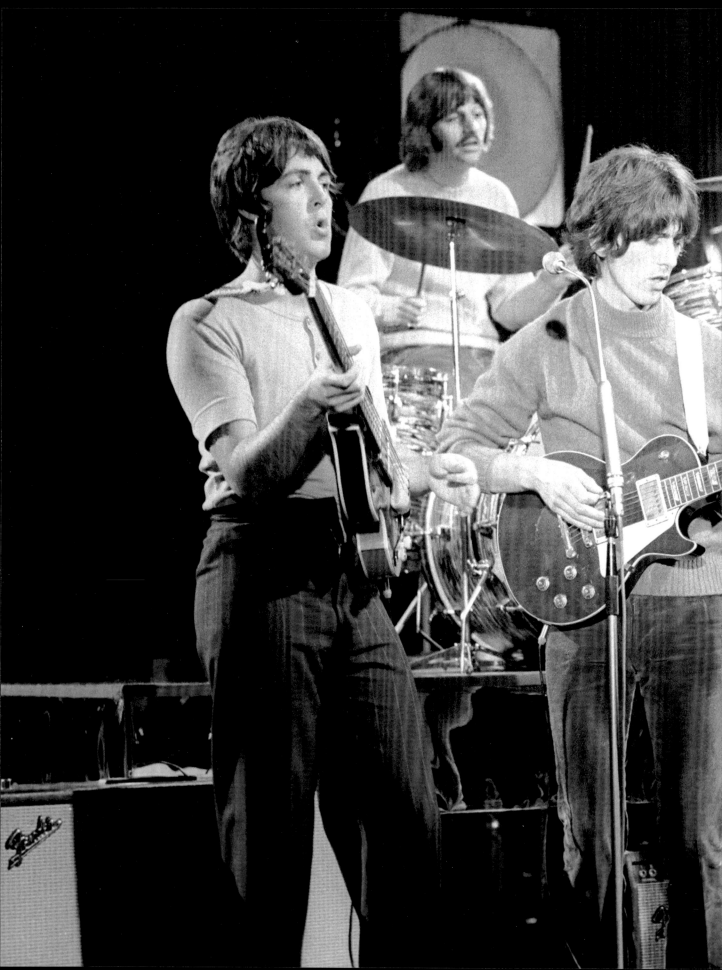

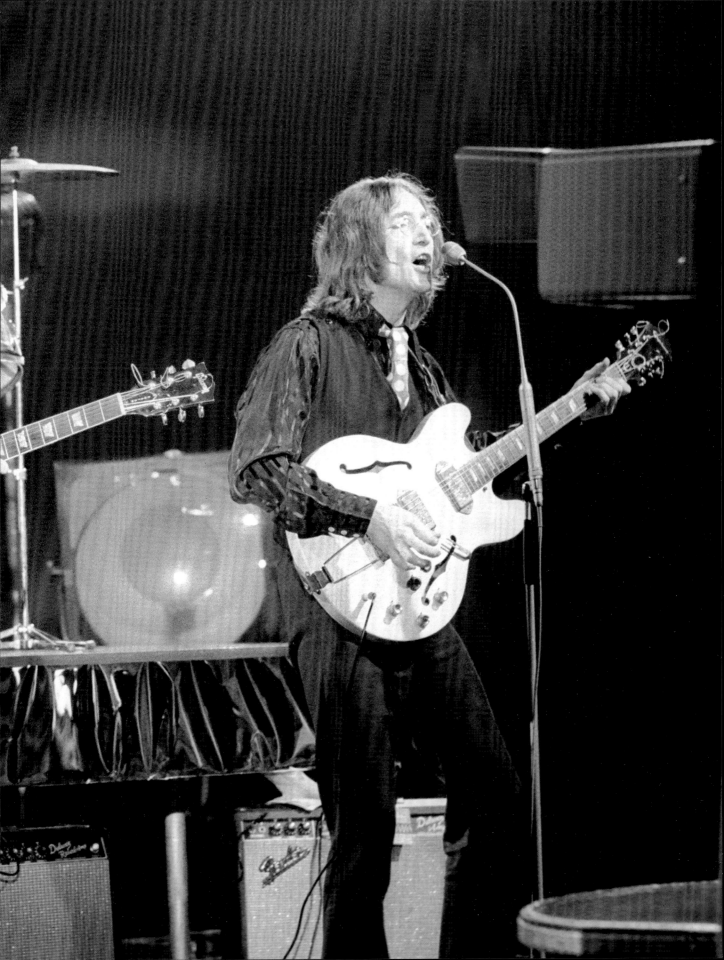

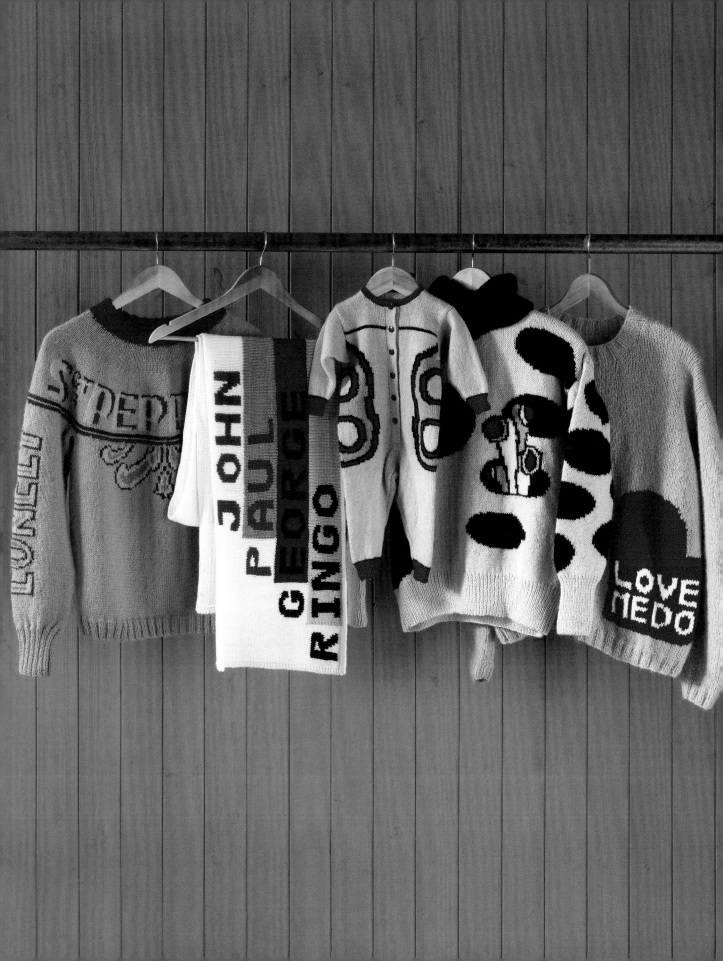

THE BEATLES

ALL YOU KNIT IS L♥VE

Caroline Smith

Photography by Jess Esposito and David Burton at Studio 68b

With patterns by Anna Alway, Julie Brooke,
Sian Brown, Jane Burns, Cécile Jeffrey,
Susie Johns, and Lynne Watterson

INSIGHT
EDITIONS

SAN RAFAEL · LOS ANGELES · LONDON

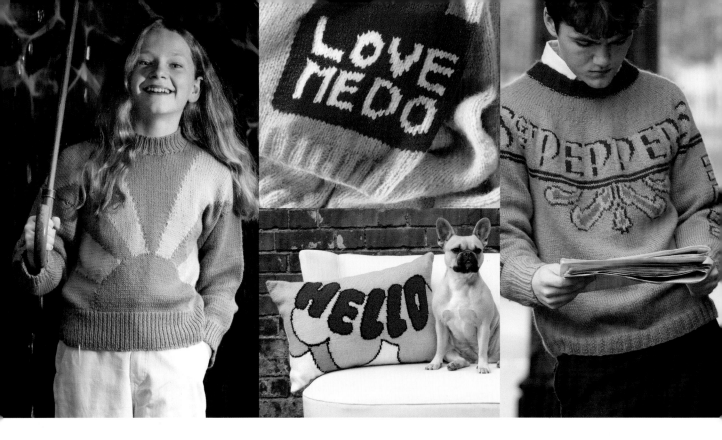

10 PLEASE PLEASE ME

Keep chills at bay with cozy and comforting unisex apparel.

12	Yellow Submarine Sweater	●●●
22	Love Me Do Sweater	●●
32	Sgt. Pepper's Band Sweater	●●●
40	Greatest Hits Sweater	●
46	Sea of Holes Sweater	●●●
56	Sergeant's Stripe Hoodie	●●●
64	Paul's Fair Isle Sweater Vest	●●●
70	Revolution Ruana Wrap	●●
76	Old Fred's Jacket	●●●
82	Apple Sweater Vest	●●
88	A Hard Day's Night Cardigan	●●●

100 FROM ME TO YOU

Stylish accessories with timeless appeal make the perfect gifts for friends, family, and of course, yourself.

102	Ob-La-Di, Ob-La-Da Wrap	●●
106	Abbey Road Throw	●
114	Fab Four Scarf	●●
118	Dreadful Flying Glove Socks	●●
122	Yellow Submarine Beanie Hat	●●
126	Hey Jude Shawl	●●
134	Rubber Soul Pillow	●●
140	Love Love Love Mittens	●●
144	Day Tripper Bag	●●
150	Magical Mystery Tour Hat and Mittens	●●
156	Hello, Goodbye Pillow	●●

CONTENTS

●	EASY
●●	INTERMEDIATE
●●●	ADVANCED

162 OH, DARLING!

The sweetest Beatles-themed garments and accessories for babies and children.

164 All You Need Is Love Baby Blanket 🍎

168 Yellow Submarine Onesie 🍎🍎🍎

176 Blue Meanie Socks 🍎🍎

180 Octopus's Garden Sweater 🍎🍎

186 Here Comes the Sun Sweater 🍎🍎

192 WE CAN WORK IT OUT

Tips, tricks, and essential information.

194 Glossary

201 Abbreviations

202 Yarn Information

203 Size Information and Chart

204 INDEX

206 MEET THE DESIGNERS

208 ACKNOWLEDGMENTS

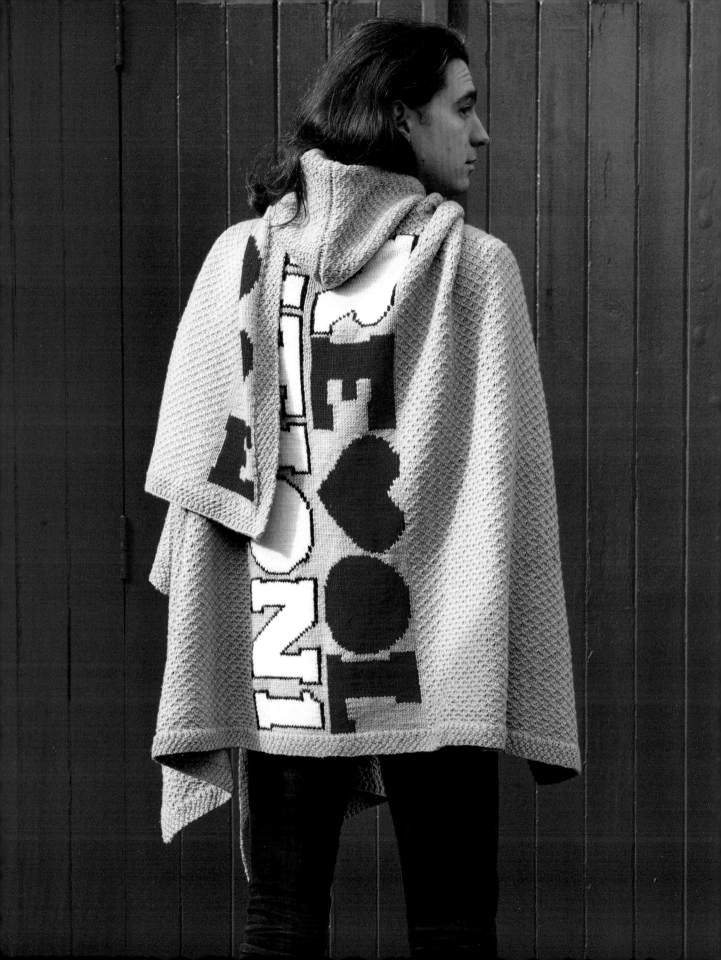

INTRODUCTION

The Beatles have been at the heart of popular culture for more than sixty years. The band's role as trendsetters is unparalleled: as their music and style changed with the times, the times changed with them. Right from the get-go, their image had the power to influence music, art, movies, and fashion.

Whether you remember the '60s or you're new to the Fab Four, there's something in this book for you. From newborn to age sixty-four—and beyond—there's a perfect project waiting in these pages, including cozy sweaters, original accessories, quirky kids' wear, and textiles for your home. Every project is accompanied by full pattern instructions and detailed charts, and features a timeless song title or a cool graphic from the band's extensive archive. And if there's a technique that's new to you, you'll find more information in the book's glossary.

As we know, "All You Need Is Love," so why not share some with your friends and family by creating one—or more—of the beautiful Beatles knits in this book?

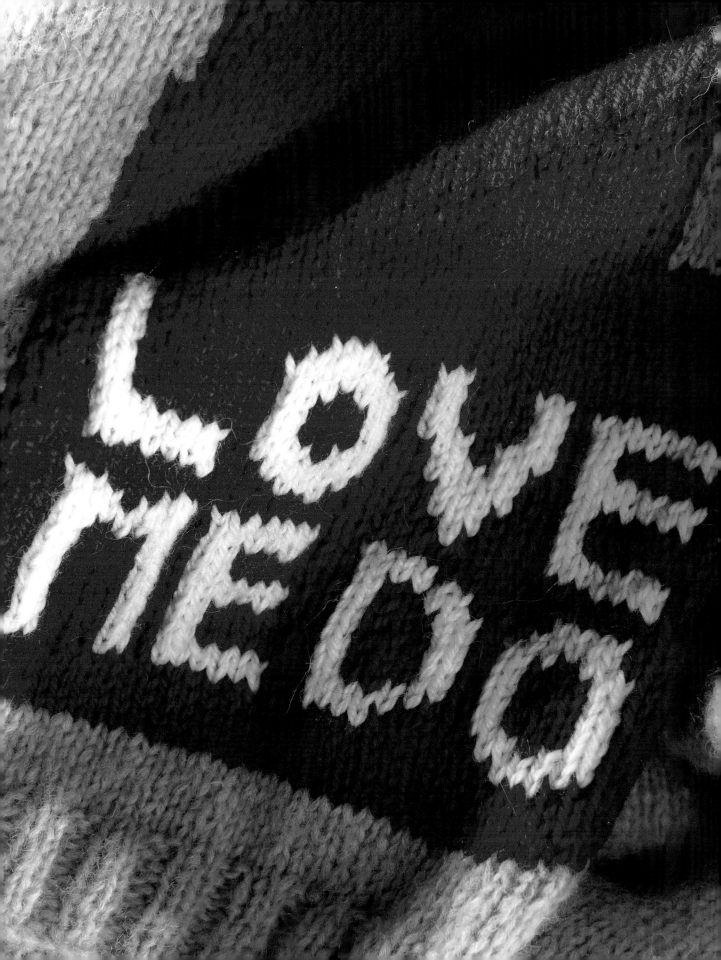

PLEASE PLEASE ME

Keep chills at bay with cozy
and comforting unisex apparel.

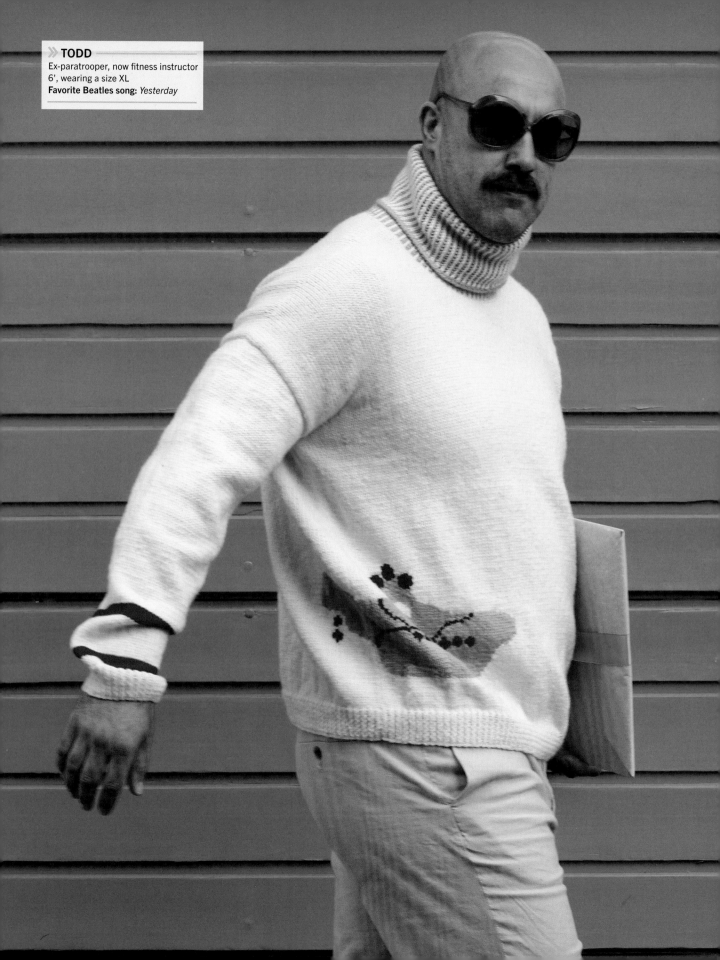

YELLOW SUBMARINE SWEATER

The Yellow Submarine *movie was released in 1968 in both the UK and the United States. The Beatles attended the film's world premiere on July 17 at the London Pavilion, which was at Piccadilly Circus in the center of the city. The film came out in the United States in November.*

Designed by Sian Brown
Skill level ●●●

I n the film of the same name, the Yellow Submarine's home is in Pepperland, where it sits atop a pyramid. The submarine carries the Beatles from their home in Liverpool to the distant Pepperland, with many adventures on the way. This cozy sweater is ideal for keeping you warm on outdoor adventures, or if you're simply snuggled on the sofa, watching a movie.

Knitted from the bottom up, it features drop-shoulder sleeves, so there's no armhole shaping. The sleeves feature stripes, but in different colors and in different positions on each one.

A Yellow Submarine design swims around the bottom of the sweater, from front to back. Created using the intarsia technique, you will need to work from the relevant chart for your size, so check the information in the pattern instructions.

SIZES
Child sizes
4–6yrs:6–8yrs:**8–10yrs**:10–12yrs
Adult sizes
XS:S:**M**:L:**XL**:2XL:**3XL**:4XL

FINISHED MEASUREMENTS
Child sizes
Chest:
29¼:30¾:**32¼**:33½ in. / **74**:78:**82**:85 cm
Length to shoulder:
13½:15:**16½**:18 in. / **34**:38:**42**:46 cm
Sleeve length to underarm:
12:13:**14¼**:15¼ in. / **30**:33:**36**:39 cm
Adult sizes
Chest:
39½:43¾:**48**:52:**56¼**:60⅝:**65**:69¼ in. /
100:111:**122**:132:**143**:154:**165**:176 cm
Length to shoulder:
24½:24¾:**25¼**:25½:**26**:26½:**26¾**:27¼ in. /
62:63:**64**:65:**66**:67:**68**:69 cm
Sleeve length to underarm:
18 in. / 46 cm (all adult sizes)

continued on the next page >>

YARN

DK weight (medium #4), shown in Cascade Yarns, 220 Superwash® (100% wool; 220 yd. / 200 m per 3½ oz. / 100 g ball)

Child sizes
MC: Ecru (817), **4**:5:**5**:5 balls
CC1: Gold Fusion (263), 1 ball for each size
CC2: Ridge Rock (874), 1 ball for each size
CC3: Really Red (809), 1 ball for each size

Adult sizes
MC: Ecru (817), **6**:7:**7**:8:**8**:9:**9**:10 balls
CC1: Gold Fusion (263), 1 ball for each size
CC2: Ridge Rock (874), 1 ball for each size
CC3: Really Red (809), 1 ball for each size

NEEDLES

US 3 / 3.25 mm, US 5 / 3.75 mm, and US 6 / 4 mm needles (see Pattern Notes), or size needed to obtain gauge
Set of five US 3 / 3.25 mm, US 5 / 3.75 mm, US 6 / 4 mm, and US 7 / 4.5 mm dpn, or size needed to obtain gauge

NOTIONS

Stitch holders
Tapestry needle

GAUGE

22 sts and 28 rows = 4 in. / 10 cm square over St st using US 6 / 4 mm needles
Be sure to check your gauge.

ABBREVIATIONS

See page 201.

PATTERN NOTES

- For larger sizes it may be easier to use circular needles and work back and forth.
- This sweater uses the intarsia technique (see page 196), following the charts on pages 18–20. Wind separate balls of the different colors and twist them together where they join to avoid holes in the finished work.
- The ribbing used around the bottom of the body and cuffs is 1x1: *k1, p1, rep from * to end.
- For the child sizes there are two options for the neckline—crew neck or roll neck.
- For more on reading charts, see page 196.

CHILD-SIZE SWEATER

BACK

With US 5 / 3.75 mm needles and MC, cast on **82**(86:**90**:94) sts.
Work **8**(8:**10**:10) rows in 1x1 rib.
Change to US 6 / 4 mm needles.
Beg with a k row, work in St st for **4**(6:**10**:12) rows.**
Foll Back Chart 1, work as foll:
Row 1: K12 sts from Row 1 of chart, k**70**(74:**78**:82) in MC.
Row 2: P**70**(74:**78**:82) in MC, p12 sts from Row 2 of chart.
These 2 rows set the position of the charted design.
Cont to work to end of chart, then cont in MC only until Back measures **13½**(15:**16½**:18) in. / **34**(38:**42**:46) cm from cast-on edge, ending with a p row.
Shape shoulders
Bind off 8 sts at beg of next 4 rows and **8**(9:**10**:11) sts at beg of foll 2 rows.
Leave rem **34**(36:**38**:40) sts on a holder.

FRONT

Work as for Back to **.
Beg with a k row, work in St st for **4**(6:**10**:12) rows.
Foll Front Chart 1, work as foll:
Row 1: K**48**(52:**56**:60) in MC, then k34 sts from Row 1 of chart.
Row 2: P34 sts from Row 2 of chart, then p**48**(52:**56**:60) in MC.
These 2 rows set the position of the charted design.
Cont to work to end of chart, then cont in MC only until 16 rows fewer have been worked than on the Back to shoulder shaping.
Shape left front neck
Next row: K**28**(29:**30**:31), skpo, turn and work on these **29**(30:**31**:32) sts for left side of neck.
Next row: P to end.
Next row: K to last 2 sts, skpo. (**28**(29:**30**:31) sts)

Rep the prev 2 rows 4 more times. (**24**(25:**26**:27) sts)
Beg with a p row, work in St st for 5 rows, ending at armhole edge.
Shape left shoulder
Bind off 8 sts at beg of next row and foll RS row. (**8**(9:**10**:11) sts)
P 1 row.
Bind off.
Shape right front neck
With RS facing, place center **22**(24:**26**:28) sts on a holder, rejoin yarn to rem sts, k2tog, k to end. (**29**(30:**31**:32) sts)
Next row: P to end.
Next row: K2tog, k to end. (**28**(29:**30**:31) sts)
Rep the prev 2 rows 4 more times. (**24**(25:**26**:27) sts)
Beg with a p row, work in St st for 6 rows, ending at armhole edge.
Shape right shoulder
Bind off 8 sts at beg of next row and foll WS row. (**8**(9:**10**:11) sts)
K 1 row.
Bind off.

RIGHT SLEEVE

With US 3 / 3.25 mm needles and MC, cast on **48**(50:**52**:54) sts.
Work **8**(8:**10**:10) rows in 1x1 rib.
Change to US 6 / 4 mm needles.
Beg with a k row, work in St st in foll stripe sequence: 2 rows MC, 6 rows CC3, **14**(14:**16**:16) rows MC, 6 rows CC3, then cont in MC, AND AT THE SAME TIME inc as foll:
Inc row: K3, m1, k to last 3 sts, m1, k3.
Work 7 rows in St st.
Rep the last 8 rows **7**(8:**9**:10) more times, then the inc row once. (**66**(70:**74**:78) sts)
Work straight until Sleeve measures **12**(13:**14¼**:15¼) in. / **30**(33:**36**:39) cm from cast-on edge, ending with a p row.
Shape top
Next row: Bind off 4 sts, k to last 2 sts, skpo. (**61**(65:**69**:73) sts)

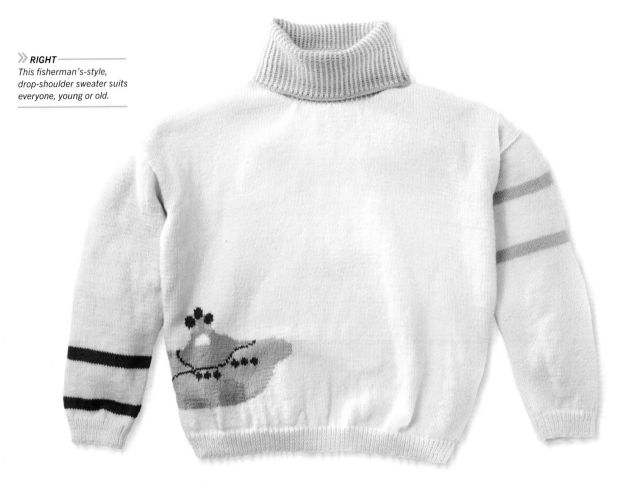

» RIGHT
This fisherman's-style, drop-shoulder sweater suits everyone, young or old.

Next row: Bind off 4 sts, p to last 2 sts, p2tog. (**56**(60:**64**:68) sts)
Rep the last 2 rows once more. (**46**(50:**54**:58) sts)
Next row: Bind off 4(5:6:7) sts, k to last 2 sts, skpo. (**41**(44:**47**:50) sts)
Next row: Bind off 4(5:6:7) sts, p to last 2 sts, p2tog. (**36**(38:**40**:42) sts)
Rep the last 2 rows once more. (26 sts)
Bind off.

LEFT SLEEVE

Work as for Right Sleeve but with foll stripe sequence: 40(44:48:52) rows MC, 6 rows CC1, **14**(14:**16**:16) rows MC, 6 rows CC1, then cont in MC.

CREW-NECK OPTION

Join shoulder seams.
With RS facing and using set of US 3 / 3.25 mm dpn and MC, pick up and k 16 sts down left side of front

neck, k**22**(24:**26**:28) sts from front neck holder, pick up and k 16 sts up right side of front neck, k**34**(36:**38**:40) sts from back neck holder. (**88**(92:**96**:100) sts)
Divide sts evenly bet four needles and join to work in the round.
Rib round 1: Using MC, *k1, sl 1, rep from * to end.
Rib round 2: Using CC1, *sl 1, k1, rep from * to end.
Rib round 3: Using MC, *k1, sl 1, rep from * to end.
Rib round 4: Using CC1, *sl 1, ytf, p1, ytb, rep from * to end.
Rounds 3 and 4 form the rib patt **.
Work in patt for 11 rounds, ending with Rib round 3.
Cut off MC.
Next round: Using CC1, *k1, p1, rep from * to end.
Bind off rib-wise.

ROLL-NECK OPTION

Work as given for crew neck to **.
Work in patt for 6 rounds.
Change to US 5 / 3.75 mm dpn.
Work in patt for **10**(12:**14**:16) rounds.
Rib round 21(23:**25**:27): Using MC, *p1, sl 1, rep from * to end.
Rib round 22(24:**26**:28): Using CC1, *ytf, sl 1, ytb, k1, rep from * to end.
These 2 rounds reverse the rib patt.
Work in patt for 8 rounds.
Change to US 6 / 4 mm dpn.
Work in patt for **10**(12:**14**:16) rounds.
Change to US 7 / 4.5 mm dpn.
Work in patt for 5 rounds, ending with a Rib round **21**(23:**25**:27).
Cut off MC.
Next round: Using CC1, *p1, k1, rep from * to end.
Bind off rib-wise.

FINISHING

See Adult size.

ADULT-SIZE SWEATER

BACK

With US 5 / 3.75 mm needles and MC, cast on **110**(122:**134**:146:**158**:170:**182**:194) sts.

Work 12 rows in 1x1 rib, inc 1 st at center of last row. (**111**(123:**135**:147:**159**:171:**183**:195) sts)

Change to US 6 / 4 mm needles.

Beg with a k row, work in St st for **12**(12:**12**:12:**14**:14:**14**:14) rows.**

Foll Back Chart **2**(2:**2**:3:**3**:4:**4**:4), work as foll:

Row 1: K**15**(15:**15**:19:**19**:23:**23**:23) sts from Row 1 of chart, then k**96**(108:**120**:128:**140**:148:**160**:172) in MC.

Row 2: P**96**(108:**120**:128:**140**:148:**160**:172) in MC, then p**15**(15:**15**:19:**19**:23:**23**:23) sts from Row 2 of chart.

These 2 rows set the position of the charted design.

Cont to work to end of chart, then cont in St st in MC only until Back measures **24½** (24¾:**25¼**:25½:**26**:26½:**26¾**:27¼) in. / **62**(63:**64**:65:**66**:67:**68**:69) cm from cast-on edge, ending with a p row.

Shape shoulders and back neck

Next row: Bind off **7**(8:**9**:10:**11**:12:**13**:14) sts, k next **31**(35:**39**:43:**47**:51:**55**:59) sts, skpo, turn and work on these **33**(37:**41**:45:**49**:53:**57**:61) sts for right side of neck.

Next row: P2tog tbl, p to end. (**32**(36:**40**:44:**48**:52:**56**:60) sts)

Next row: Bind off **7**(8:**9**:10:**11**:12:**13**:14) sts, k to last 2 sts, skpo. (**24**(27:**30**:33:**36**:39:**42**:45) sts)

Rep the last 2 rows once more. (**15**(17:**19**:21:**23**:25:**27**:29) sts)

P 1 row.

Next row: Bind off **7**(8:**9**:10:**11**:12:**13**:14) sts, k to end. (**8**(9:**10**:11:**12**:13:**14**:15) sts)

P 1 row.

Bind off.

With RS facing, place center **29**(31:**33**:35:**37**:39:**41**:43) sts on a holder, rejoin yarn to rem sts, k2tog, k to end. (**40**(45:**50**:55:**60**:65:**70**:75) sts)

Next row: Bind off **7**(8:**9**:10:**11**:12:**13**:14) sts, p to last 2 sts, p2tog. (**32**(36:**40**:44:**48**:52:**56**:60) sts)

Next row: K2tog, k to end. (**31**(35:**39**:43:**47**:51:**55**:59) sts)

Rep the last 2 rows once more. (**22**(25:**28**:31:**34**:37:**40**:43) sts)

Next row: Bind off **7**(8:**9**:10:**11**:12:**13**:14) sts, p to end. (**15**(17:**19**:21:**23**:25:**27**:29) sts)

K 1 row.

Rep the last 2 rows once more. (**8**(9:**10**:11:**12**:13:**14**:15) sts)

Bind off.

FRONT

Work as for Back to **.

Foll Front Chart **2**(2:**2**:3:**3**:4:**4**:4), work as foll:

Row 1: K**69**(81:**93**:94:**106**:104:**116**:128) in MC, then k**42**(42:**42**:53:**53**:67:**67**:67) sts from Row 1 of chart.

Row 2: P**42**(42:**42**:53:**53**:67:**67**:67) sts from Row 2 of chart, then p**69**(81:**93**:94:**106**:104:**116**:128) in MC.

These 2 rows set the position of the charted design.

Cont to work to end of chart, then cont in MC only until 20 rows fewer have been worked than on Back to shoulder and neck shaping.

Shape left front neck

Next row: K**44**(49:**54**:59:**64**:69:**74**:79), skpo, turn and work on these **45**(50:**55**:60:**65**:70:**75**:80) sts for left side of neck shaping.

Next row: P to end.

Next row: K to last 2 sts, skpo. (**44**(49:**54**:59:**64**:69:**74**:79) sts)

Rep the last 2 rows 8 more times. (**36**(41:**46**:51:**56**:61:**66**:71) sts)

P 1 row.

Shape left shoulder

Bind off **7**(8:**9**:10:**11**:12:**13**:14) sts at beg of next and 3 foll RS rows. (**8**(9:**10**:11:**12**:13:**14**:15) sts)

P 1 row.

Bind off.

Shape right front neck

With RS facing, place center **19**(21:**23**:25:**27**:29:**31**:33) sts on a holder, rejoin yarn to rem sts, k2tog, k to end. (**45**(50:**55**:60:**65**:70:**75**:80) sts)

Next row: P to end.

Next row: K2tog, k to end. (**44**(49:**54**:59:**64**:69:**74**:79) sts)

Rep the last 2 rows 8 more times. (**36**(41:**46**:51:**56**:61:**66**:71) sts)

Work 2 rows in St st.

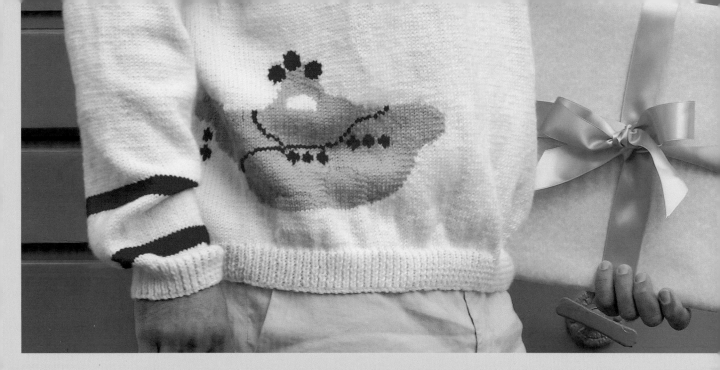

Shape right shoulder
Bind off **7**(8:**9**:10:**11**:12:**13**:14) sts
 at beg of next and 3 foll WS rows.
 (**8**(9:**10**:11:**12**:13:**14**:15) sts)
K 1 row.
Bind off.

RIGHT SLEEVE

With US 3 / 3.25 mm needles and MC,
 cast on **48**(54:**60**:66:**72**:78:**84**:90)
 sts. Work 12 rows in 1x1 rib.
Change to US 6 / 4 mm needles.
Beg with a k row, work in St st in foll
 stripe sequence: 4 rows MC, 6 rows
 CC3, 18 rows MC, 6 rows CC3, then
 cont in MC only.
Work 6 rows in St st.
Cont in St st and foll stripe sequence
 AND AT THE SAME TIME inc as foll:
Inc row: K4, m1, k to last 4 sts, m1, k4.
Work 7 rows in St st.
Rep the last 8 rows 11 more times
 and the inc row once more.
 (**74**(80:**86**:92:**98**:104:**110**:116) sts)
Work straight until Sleeve measures
 18 in. (46 cm) from cast-on edge,
 ending with a p row.
Shape top
Next row: Bind off 3 sts, k to last 2 sts,
 skpo.
Next row: Bind off 3 sts, p to last 2 sts,
 p2tog.

Rep the last 2 rows
 7(7:**8**:8:**9**:9:**10**:10) more times.
 (**10**(16:**14**:20:**18**:24:**22**:28) sts)
Bind off.

LEFT SLEEVE

Work as for Right Sleeve but with foll
 stripe sequence: 74 rows MC, 6 rows
 CC1, 22 rows MC, 6 rows CC1, then
 cont in MC.

ROLL NECK

Join shoulder seams.
With RS facing and using set of US 3 /
 3.25 mm dpn and MC, pick up and
 k 24 sts down left side of front neck,
 k**19**(21:**23**:25:**27**:29:**31**:33) sts from
 front neck holder, pick up and k 24
 sts up right side of front neck and
 10 sts down right side of back neck,
 k**29**(31:**33**:35:**37**:39:**41**:43) sts from
 back neck holder, pick up and k 10
 sts up left side of back neck. (**116**
 (120:**124**:128:**132**:136:**140**:144) sts)
Divide sts evenly bet four needles and
 join to work in the round.
Rib round 1: Using MC, *k1, sl 1, rep
 from * to end.
Rib round 2: Using CC1, *sl 1, k1, rep
 from * to end.
Rib round 3: Using MC, *k1, sl 1, rep
 from * to end.

Rib round 4: Using CC1, *sl 1, ytf, p1,
 ytb, rep from * to end.
Rounds 3 and 4 form the rib patt.
Work in patt for 6 rounds.
Change to set of US 5 / 3.75 mm dpn.
Work in patt for 26 rounds.
Rib round 37: Using MC, *p1, sl 1, rep
 from * to end.
Rib round 38: Using CC1, *ytf, sl 1, ytb,
 k1, rep from * to end.
These 2 rounds reverse the rib patt.
Work in patt for 26 rounds.
Change to set of US 6 / 4 mm dpn.
Work in patt for 36 rounds.
Change to set of US 7 / 4.5 mm dpn.
Work in patt for 11 rounds, ending with
 a Rib round 37.
Cut off MC.
Next round: Using CC1, *p1, k1, rep
 from * to end.
Bind off rib-wise.

FINISHING

Weave in yarn ends.
Block the joined Front and Back; block
 the Sleeves (see page 199 for more
 on blocking).
Sew the sleeves in place, matching
 centers of sleeve tops to shoulder
 seams.
Join the side and sleeve seams. Weave
 in remaining yarn ends.

CHARTS

KEY

- ☐ MC
- ▨ CC1
- ▨ CC2
- ▨ CC3

FRONT CHART 1

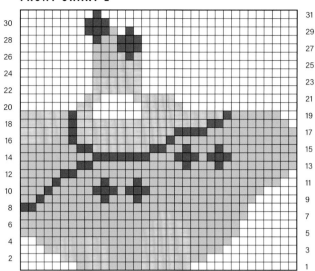

BACK CHART 1

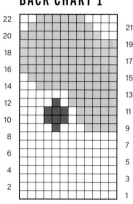

FRONT CHART 3

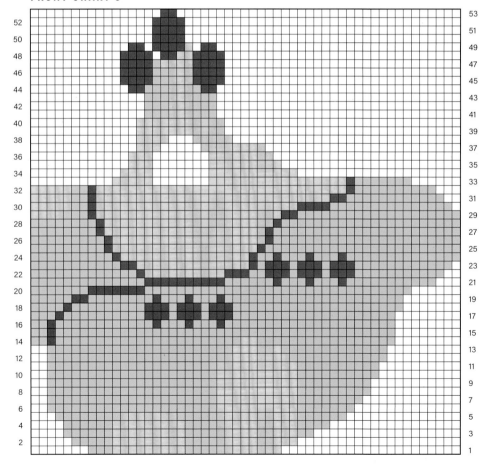

BACK CHART 3

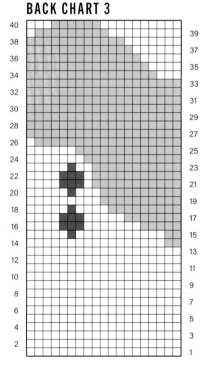

FRONT CHART 2

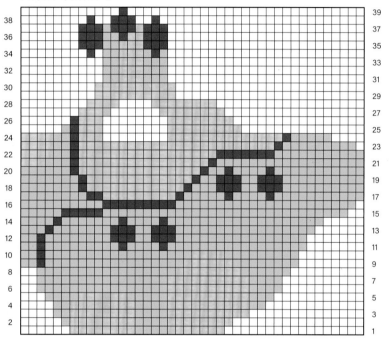

BACK CHART 4

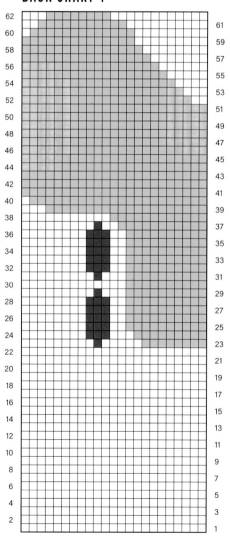

BACK CHART 2

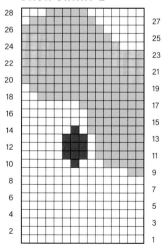

KEY

- ☐ MC
- ▨ CC1
- ▨ CC2
- ■ CC3

FRONT CHART 4

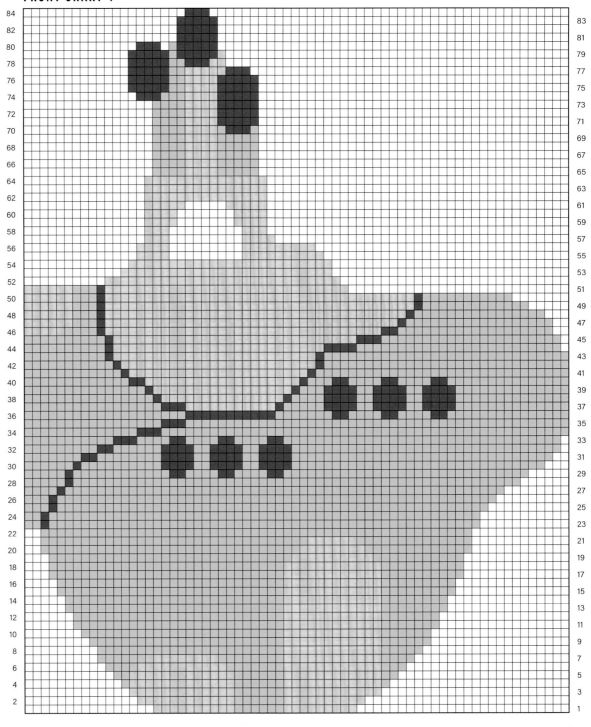

CHILD SIZES

Shoulder width:
4⅛:4¼:**4½**:4¾ in. /
10.5:11:**11.5**:12 cm

Sleeve width at widest part:
12:12½:**13¼**:14 in. /
30:32:**33.5**:35.5 cm

Sleeve width at top:
4¾ in. / 12 cm

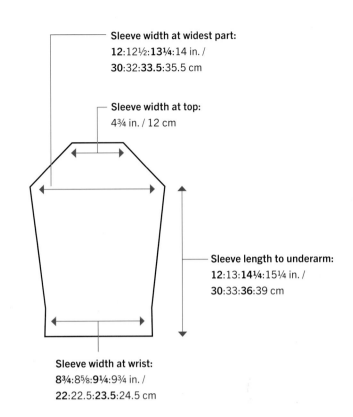

Front & Back width:
14½:15¼:**16**:16¾ in. /
37:39:**41**:42.5 cm

Length to shoulder:
13½:15:**16½**:18 in. /
34:38:**42**:46 cm

Sleeve length to underarm:
12:13:**14¼**:15¼ in. /
30:33:**36**:39 cm

Sleeve width at wrist:
8¾:8⅝:**9¼**:9¾ in. /
22:22.5:**23.5**:24.5 cm

ADULT SIZES

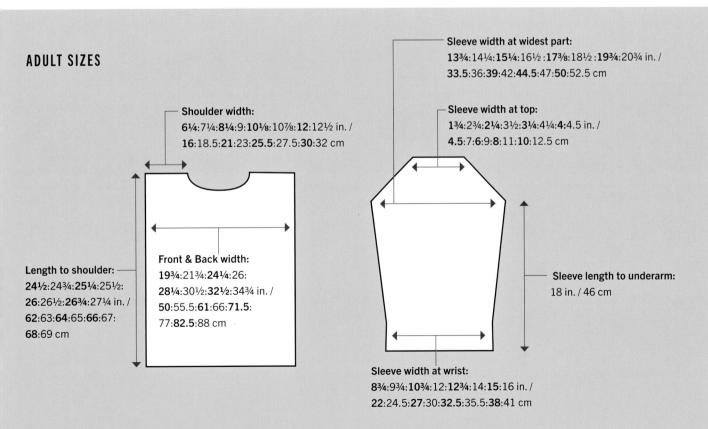

Shoulder width:
6¼:7¼:**8¼**:9:**10⅛**:10⅞:**12**:12½ in. /
16:18.5:**21**:23:**25.5**:27.5:**30**:32 cm

Sleeve width at widest part:
13¾:14¼:**15¼**:16½ :**17⅜**:18½ :**19¾**:20¾ in. /
33.5:36:**39**:42:**44.5**:47:**50**:52.5 cm

Sleeve width at top:
1¾:2¾:**2¼**:3½:**3¼**:4¼:**4**:4.5 in. /
4.5:7:**6**:9:**8**:11:**10**:12.5 cm

Front & Back width:
19¾:21¾:**24¼**:26:
28¼:30½:**32½**:34¾ in. /
50:55.5:**61**:66:**71.5**:
77:**82.5**:88 cm

Length to shoulder:
24½:24¾:**25¼**:25½:
26:26½:**26¾**:27¼ in. /
62:63:**64**:65:**66**:67:
68:69 cm

Sleeve length to underarm:
18 in. / 46 cm

Sleeve width at wrist:
8¾:9¾:**10¾**:12:**12¾**:14:**15**:16 in. /
22:24.5:**27**:30:**32.5**:35.5:**38**:41 cm

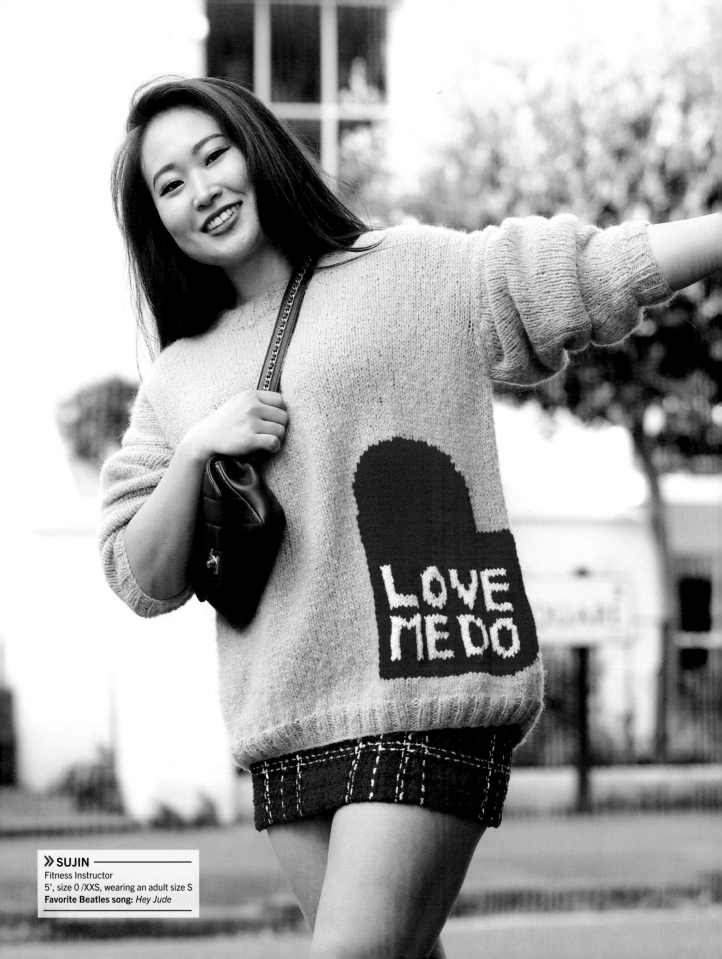

≫ SUJIN
Fitness Instructor
5', size 0 /XXS, wearing an adult size S
Favorite Beatles song: *Hey Jude*

LOVE ME DO
SWEATER

Designed by Sian Brown
Skill level ●●

" ove Me Do," featuring "P.S. I Love You" on the flip side, was The Beatles' official debut single. In the more than sixty years since the song's release, it has remained a memorable Beatles classic, thanks to its catchy melody and simple lyrics.

Make love the message you send out and wear your heart on your side—rather than your sleeve—with this pink and red sweater. The "Love Me Do" song title is set within a red heart that wraps around the side of your body. Most of the sweater is knitted in a slightly fluffy pink yarn, while the heart is worked in a smoother yarn for a contrast in texture.

Released on October 5, 1962, "Love Me Do" reached number seventeen on the UK charts, but wasn't released in the United States until 1964.

Ringo Starr joined the band in 1962, and so the famous lineup of John Lennon, Paul McCartney, George Harrison, and Ringo Starr was complete.

SIZES
Child sizes
4—**6yrs**:6—8yrs:**8**—**10yrs**:10—12yrs
Adult sizes
XS:S:**M**:L:**XL**:2XL:**3XL**:4XL

FINISHED MEASUREMENTS
Child sizes
Chest:
28½:30½:**32¼**:34¼ in. / **72**:77:**82**:87 cm
Length to shoulder:
13¾:15¼:**17**:18½ in. / **35**:39:**43**:47 cm
Sleeve length to underarm:
12:13:**14¼**:15¼ in. / **30**:33:**36**:39 cm
Adult sizes
Chest:
40⅛:44:**48½**:52¾:**56⅝**:60¼:**65⅜**:69¼ in. /
102:112:**123**:134:**144**:153:**166**:176 cm
Length to shoulder:
24¼:24½:**24¾**:25¼:**25½**:26:**26½**:26¾ in. /
61:62:**63**:64:**65**:66:**67**:68 cm
Sleeve length to underarm:
18 in. / 46 cm (all adult sizes)

YARN
• Aran weight (medium #4), shown in DROPS Air (65% alpaca, 28% polyamide, 7% wool; 164 yd. / 150 m per 2 oz. / 50 g ball)

continued on the next page >>

Child sizes
MC: Pink (24), **3**:**4**:**4**:5 balls
Adult sizes
MC: Pink (24), **7**:**7**:**8**:**8**:**8**:**9**:**9**:10 balls
• Aran weight (medium #4), shown in DROPS
Nepal (65% wool, 35% alpaca; 82 yd. / 75 m
per 2 oz. / 50 g ball)
Child sizes
CC1: Red (3620), 1 ball for each size
CC2: Off-White (100), 1 ball for each size
Adult sizes
CC1: Red (3620), **1**:**1**:**1**:**1**:**2**:**2**:**2**:2 ball(s)
CC2: Off-White (100), 1 ball for each size

NEEDLES

US 6 / 4 mm, US 7 / 4.5 mm, and
US 8 / 5 mm needles, or size needed
to obtain gauge

NOTIONS

Tapestry needle

GAUGE

17 sts and 24 rows = 4 in. / 10 cm square
over St st in MC using US 8 / 5 mm needles
Be sure to check your gauge.

ABBREVIATIONS

See page 201

PATTERN NOTES

- The heart motif wraps around the body: try
 to create a neat seam between the front
 and back to keep it intact.
- Use the intarsia technique (see page 196)
 to work the heart and lettering, following
 the charts on pages 29–30. Wind balls of
 the different colors and twist them together
 where they join to avoid holes.
- For more on reading charts, see page 196.

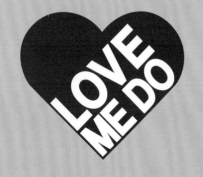

CHILD-SIZE SWEATER

BACK

Using US 7 / 4.5 mm needles and MC,
cast on **62**(66:**70**:74) sts.
Rib row 1: K2, *p2, k2, rep from * to
end.
Rib row 2: P2, *k2, p2, rep from * to
end.
Rep these 2 rows 3 more times.
Change to US 8 / 5 mm needles.
Beg with a k row, work **2**(4:**6**:8) rows in
St st.**
Foll Back Chart 1, work as foll:
Row 1 (RS): K**53**(57:**61**:65) in MC, then
k9 sts from Row 1 of chart.
Row 2: P9 sts from Row 2 of chart, then
p**53**(57:**61**:65) in MC.
These 2 rows set the position of the
charted design.
Cont to work to end of chart, then
cont in St st in MC only until Back
measures 9½(10¾:**12**:13) in. /
24(27:**30**:33) cm from cast-on edge,
ending with a p row.
Shape armholes
Next row: K2, skpo, k to last 4 sts,
k2tog, k2. (**60**(64:**68**:72) sts)
Next row: P to end.
Rep the prev 2 rows 3 more times.
(**54**(58:**62**:66) sts)
Work straight until Back measures
13¾(15¼:**17**:18½) in. / **35**(39:**43**:
47) cm from cast-on edge, ending
with a p row.
Shape shoulders
Bind off **8**(8:**9**:9) sts at beg of next
2 rows and **8**(9:**9**:10) sts at beg
of foll 2 rows. (**22**(24:**26**:28) sts)
Place rem sts on a holder.

FRONT

Work as for Back to **.
Foll Front Chart 1, work as foll:
Row 1 (RS): K30 sts from Row 1
of chart, then k**32**(36:**40**:44)
in MC.
Row 2: P**32**(36:**40**:44) in MC, then
p30 sts from Row 2 of chart.

These 2 rows set the position of the
charted design.
Cont to work to end of chart, then
cont in St st in MC only until Front
measures 9½(10¾:**12**:13) in. /
24(27:**30**:33) cm from cast-on edge,
ending with a p row.
Shape armholes
Next row: K2, skpo, k to last 4 sts,
k2tog, k2. (**60**(64:**68**:72) sts)
Next row: P to end.
Rep the prev 2 rows 3 more times.
(**54**(58:**62**:66) sts)
Work straight until 18 rows fewer
have been worked than on Back
to shoulder shaping.
Shape left front neck
Next row: K**20**(21:**22**:23), skpo,
turn and work on these **21**(22:**23**:
24) sts only for left side of neck
shaping.
Next row: P to end.
Next row: K to last 2 sts, skpo.
(**20**(21:**22**:23) sts)
Rep the last 2 rows 4 more times.
(**16**(17:**18**:19) sts)
Work 7 more rows in St st.
Shape left shoulder
Bind off **8**(8:**9**:9) sts at beg of next row.
(**8**(9:**9**:10) sts)
P 1 row.
Bind off.
Shape right front neck
Next row: With RS facing, place center
10(12:**14**:16) sts on a holder, rejoin
yarn to rem sts, k2tog, k to end.
(**21**(22:**23**:24) sts)
Next row: P to end.
Next row: K2tog, k to end.
(**20**(21:**22**:23) sts)
Rep the prev 2 rows 4 more times.
(**16**(17:**18**:19) sts)
Work 8 more rows in St st.
Shape right shoulder
Bind off **8**(8:**9**:9) sts at beg of next row.
(**8**(9:**9**:10) sts)
K 1 row.
Bind off.

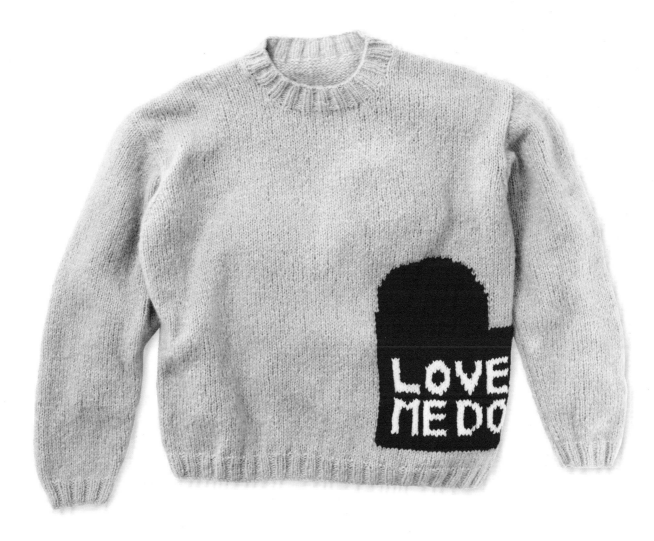

SLEEVES (MAKE 2)

Using US 6 / 4 mm needles and MC, cast on **26**(26:**30**:30) sts.

Rib row 1: K2, *p2, k2, rep from * to end.

Rib row 2: P2, *k2, p2, rep from * to end.

Rep these 2 rows 3 more times, inc **0**(2:**0**:2) st(s) evenly across last row. (**26**(28:**30**:32) sts)

Change to US 8 / 5 mm needles.

Beg with a k row, work 6 rows in St st.

Inc row: K4, m1, k to last 4 sts, m1, k4. (**28**(30:**32**:34) sts)

Work 5 more rows in St st.

Rep the prev 6 rows **8**(9:**10**:11) more times and the inc row again. (**44**(48:**52**:56) sts)

Work straight until Sleeve measures **12**(13:**14¼**:15¼) in. / **30**(33:**36**: 39) cm from cast-on edge, ending with a p row.

Shape sleeve top

Next row: K2, skpo, k to last 4 sts, k2tog, k2. (**42**(46:**50**:54) sts)

Next row: P to end.

Rep the prev 2 rows 3 more times. (**36**(40:**44**:48) sts)

Next row: Bind off 2 sts, k to last 2 sts, skpo. (**33**(37:**41**:45) sts)

Next row: Bind off 2 sts, p to last 2 sts, p2tog. (**30**(34:**38**:42) sts)

Rep the prev 2 rows 3 more times. (**12**(16:**20**:24) sts)

Bind off.

NECKBAND

Weave in yarn ends on Back and Front and block.

Join right shoulder seam.

With RS facing and using US 7 / 4.5 mm needles and MC, pick up and k 19 sts down left side of front neck, **10**(12:**14**:16) sts from center front holder, 19 sts up right side of front neck, and **22**(24:**26**:28) sts from back neck holder. (**70**(74:**78**: 82) sts)

Rib row 1: K2, *p2, k2, rep from * to end.

Rib row 2: P2, *k2, p2, rep from * to end.

Rep these 2 rows 2 more times.

Change to US 6 / 4 mm needles and work 3 Rib rows.

Bind off rib-wise.

FINISHING

See Adult size.

ADULT-SIZE SWEATER

BACK

Using US 7 / 4.5 mm needles and MC, cast on **86**(94:**102**:114:**122**:130:**138**:150) sts.

Rib row 1: K2, *p2, k2, rep from * to end.

Rib row 2: P2, *k2, p2, rep from * to end.

Rep these 2 rows 4 more times, inc **1**(2:**3**:0:**1**:2:**3**:0) st(s) evenly across the last row. (**87**(96:**105**:114:**123**:132:**141**:150) sts)

Change to US 8 / 5 mm needles.

Beg with a k row, work 6 rows in St st.**

Foll Back Chart **2**(2:**2**:2:**3**:3:**3**:3), work as foll:

Row 1 (RS): K75(84:**93**:102:**108**:117:**126**:135) in MC, then k**12**(12:**12**:12:**15**:15:**15**:15) sts from Row 1 of chart.

Row 2: P**12**(12:**12**:12:**15**:15:**15**:15) sts from Row 2 of chart, then p**75**(84:**93**:102:**108**:117:**126**:135) in MC.

These 2 rows set the position of the charted design.

Cont to work to end of chart, then cont in St st in MC only until Back measures 16½ in. / 42 cm from cast-on edge, ending with a p row.

Shape armholes

Next row: K2, skpo, k to last 4 sts, k2tog, k2. (**85**(94:**103**:112:**121**:130:**139**:148) sts)

Next row: P to end.

Rep the prev 2 rows **3**(4:**5**:6:**7**:8:**9**:10) more times. (**79**(86:**93**:100:**107**:114:**121**:128) sts)

Work straight until Back measures 24¼(24½:**24¾**:25¼:**25½**:26:**26½**:26¾) in. / **61**(62:**63**:64:**65**:66:**67**:68) cm from cast-on edge, ending with a p row.

Shape shoulders

Bind off **8**(9:**10**:11:**12**:13:**14**:15) sts at beg of next 6 rows. (**31**(32:**33**:

34:**35**:36:**37**:38) sts)

Place rem sts on a holder.

FRONT

Work as for Back to **.

Foll Front Chart **2**(2:**2**:2:**3**:3:**3**:3), work as foll:

Row 1 (RS): K38(38:**38**:38:**48**:48:**48**:48) sts from Row 1 of chart, then k49(58:**67**:76:**75**:84:**93**:102) in MC.

Row 2: P49(58:**67**:76:**75**:84:**93**:102) in MC, then p**38**(38:**38**:38:**48**:48:**48**:48) sts from Row 2 of chart.

These 2 rows set the position of the charted design.

Cont to work to end of chart, then cont in St st in MC only until Front measures 16½ in. / 42 cm from cast-on edge, ending with a p row.

Shape armholes

Next row: K2, skpo, k to last 4 sts, k2tog, k2. (**85**(94:**103**:112:**121**:130:**139**:148) sts)

Next row: P to end.

Rep the prev 2 rows **3**(4:**5**:6:**7**:8:**9**:10) more times. (**79**(86:**93**:100:**107**:114:**121**:128) sts)

Work straight until 16(16:**18**:18:**18**:20:**20**:20) rows fewer have been worked than on Back to shoulder shaping.

Shape left front neck

Next row: K30(33:**36**:39:**42**:45:**48**:51), skpo, turn and work on these **31**(34:**37**:40:**43**:46:**49**:52) sts only for left side of neck shaping.

Next row: P2tog, p to end. (**30**(33:**36**:39:**42**:45:**48**:51) sts)

Next row: K to last 2 sts, skpo. (**29**(32:**35**:38:**41**:44:**47**:50) sts)

Rep the prev 2 rows 2 more times. (**25**(28:**31**:34:**37**:40:**43**:46) sts)

Next row: P2tog, p to end. (**24**(27:**30**:33:**36**:39:**42**:45) sts)

Work 8(8:**10**:10:**10**:12:**12**:12) more rows in St st.

Shape left shoulder

Bind off **8**(9:**10**:11:**12**:13:**14**:15)

sts at beg of next and foll RS row. (**8**(9:**10**:11:**12**:13:**14**:15) sts)

P 1 row. Bind off.

Shape right front neck

Next row: With RS facing, place center **15**(16:**17**:18:**19**:20:**21**:22) sts on a holder, rejoin yarn to rem **32**(35:**38**:41:**44**:47:**50**:53) sts, k2tog, k to end. (**31**(34:**37**:40:**43**:46:**49**:52) sts)

Next row: P to last 2 sts, p2tog. (**30**(33:**36**:39:**42**:45:**48**:51) sts)

Next row: K2tog, k to end. (**29**(32:**35**:38:**41**:44:**47**:50) sts)

Rep the prev 2 rows 2 more times. (**25**(28:**31**:34:**37**:40:**43**:46) sts)

Next row: P to last 2 sts, p2tog. (**24**(27:**30**:33:**36**:39:**42**:45) sts)

Work 9(9:**11**:11:**11**:13:**13**:13) more rows in St st.

Shape right shoulder

Bind off **8**(9:**10**:11:**12**:13:**14**:15) sts at beg of next and foll WS row. (**8**(9:**10**:11:**12**:13:**14**:15) sts)

K 1 row.

Bind off.

SLEEVES (MAKE 2)

Using US 6 / 4 mm needles and MC, cast on **38**(42:**46**:54:**58**:62:**70**:74) sts.

Rib row 1: K2, *p2, k2 rep from * to end.

Rib row 2: P2, *k2, p2 rep from * to end.

Rep these 2 rows 4 more times, inc **2**(4:**6**:4:**6**:8:**6**:8) sts evenly across the last row. (**40**(46:**52**:58:**64**:70:**76**:82) sts)

Change to US 8 / 5 mm needles.

Beg with a k row, work 6 rows in St st.

Inc row: K4, m1, k to last 4 sts, m1, k4. (**42**(48:**54**:60:**66**:72:**78**:84) sts)

Work 5 more rows in St st.

Rep the prev 6 rows 11 more times, then rep the Inc row once more. (**66**(72:**78**:84:**90**:96:**102**:108) sts)

Work straight until Sleeve measures 18 in. / 46 cm from cast-on edge, ending with a p row.

Shape sleeve top

Next row: K2, skpo, k

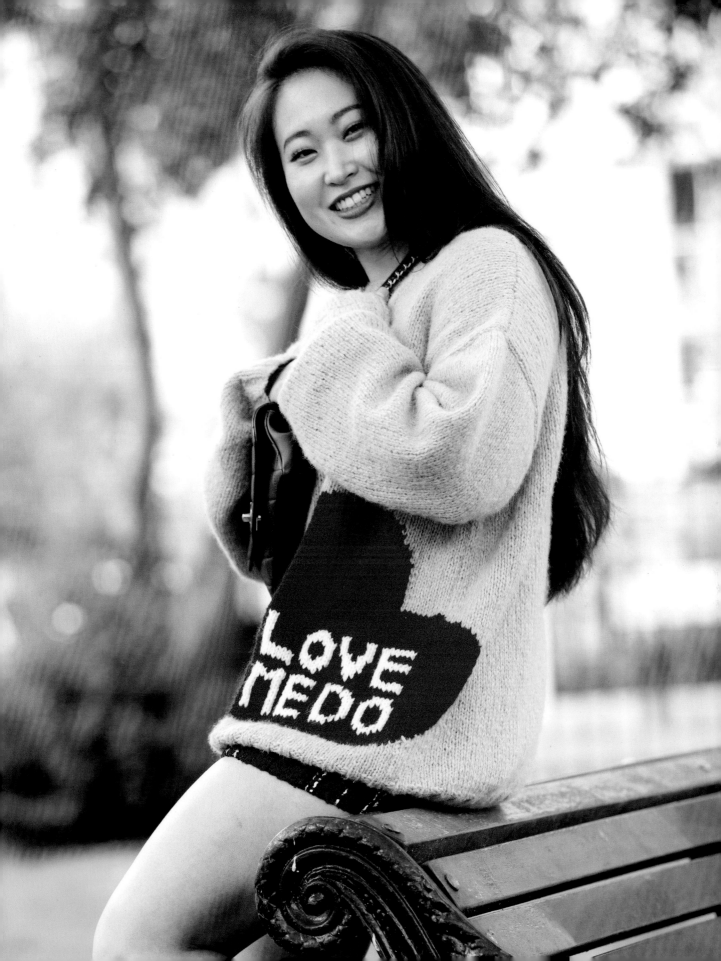

to last 4 sts, k2tog, k2.
(**64**(70:**76**:82:**88**:94:**100**:106) sts)
Next row: P to end.
Rep the prev 2 rows **3**(4:**5**:6:**7**:8:**9**:10)
 more times. (**58**(62:**66**:70:**74**:78:**82**:
 86) sts)
Next row: Bind off 2 sts, k to last 2 sts,
 skpo. (**55**(59:**63**:67:**71**:75:**79**:83) sts)
Next row: Bind off 2 sts, p to last 2 sts,
 p2tog. (**52**(56:**60**:64:**68**:72:**76**:80) sts)
Rep the prev 2 rows 7 more times.
 (**10**(14:**18**:22:**26**:30:**34**:38) sts)
Bind off.

NECKBAND
Weave in yarn ends on Back and Front
and block both pieces.
Join right shoulder seam.
With RS facing and using US 7 /
 4.5 mm needles and MC, pick up
 and k **16**(17:**18**:19:**20**:21:**22**:23)
 sts down left side of front neck,
 15(16:**17**:18:**19**:20:**21**:22)
 sts from center front holder,
 16(17:**18**:19:**20**:21:**22**:23) sts
 up right side of front neck, and
 31(32:**33**:34:**35**:36:**37**:38)
 sts from back neck holder.
 (**78**(82:**86**:90:**94**:98:**102**:106) sts)
Rib row 1: K2, *p2, k2, rep from * to end.
Rib row 2: P2, *k2, p2, rep from * to end.
Rep these 2 rows 2 more times.

Change to US 6 / 4 mm needles and work
 5 Rib rows.
Bind off rib-wise.

FINISHING
Weave in remaining yarn ends and block
 the Sleeves (see page 199 for more on
 blocking).
Join the left shoulder and neckband
 seams.
Sew the sleeves in place, matching
 centers of sleeve tops to shoulder
 seams.
Join the side and sleeve seams.

CHARTS

KEY

- ◻ MC
- ◼ CC1
- ☐ CC2

BACK CHART 1

FRONT CHART 1

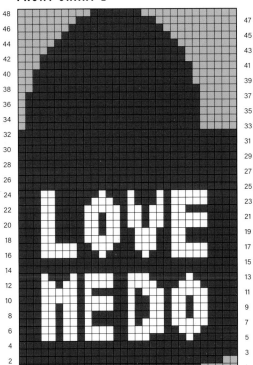

FRONT CHART 2

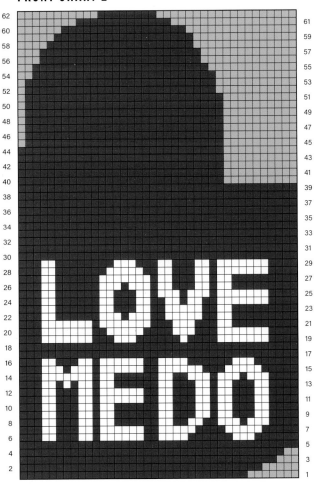

BACK CHART 2

KEY

FRONT CHART 3

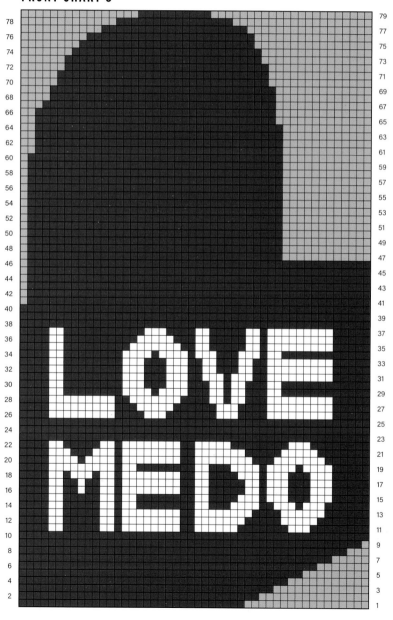

BACK CHART 3

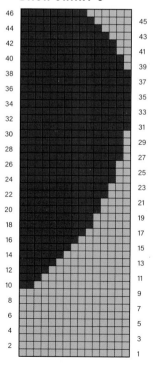

CHILD SIZES

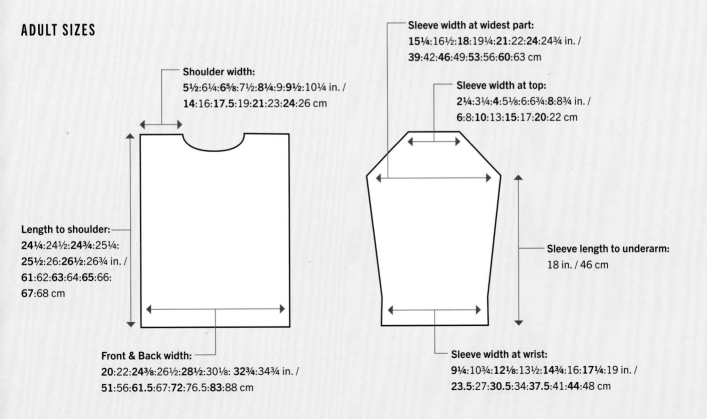

Shoulder width:
3½:4:**4⅛**:4¼ in. /
9:10:**10.5**:11 cm

Sleeve width at widest part:
10¼:11:**12**:13 in. /
26:28:**30**:33 cm

Sleeve width at top:
2¾:3½:**4¾**:5½ in. /
7:9:**12**:14 cm

Length to shoulder:
13¾:15¼:**17**:18½ in. /
35:39:**43**:47 cm

Sleeve length to underarm:
12:13:**14¼**:15¼ in. /
30:33:**36**:39 cm

Front & Back width:
14¼:15⅛:**16**:17⅛ in. /
36:38.5:**41**:43.5 cm

Sleeve width at wrist:
6:6¼:**6⅝**:7½ in. /
15:16:**17.5**:19 cm

ADULT SIZES

Shoulder width:
5½:6¼:**6⅝**:7½:**8¼**:9:**9½**:10¼ in. /
14:16:**17.5**:19:**21**:23:**24**:26 cm

Sleeve width at widest part:
15¼:16½:**18**:19¼:**21**:22:**24**:24¾ in. /
39:42:**46**:49:**53**:56:**60**:63 cm

Sleeve width at top:
2¼:3¼:**4**:5⅛:**6**:6¾:**8**:8¾ in. /
6:8:**10**:13:**15**:17:**20**:22 cm

Length to shoulder:
24¼:24½:**24¾**:25¼:
25½:26:**26½**:26¾ in. /
61:62:**63**:64:**65**:66:
67:68 cm

Sleeve length to underarm:
18 in. / 46 cm

Front & Back width:
20:22:**24⅜**:26½:**28½**:30⅛: **32¾**:34¾ in. /
51:56:**61.5**:67:**72**:76.5:**83**:88 cm

Sleeve width at wrist:
9¼:10¾:**12⅛**:13½:**14¾**:16:**17¼**:19 in. /
23.5:27:**30.5**:34:**37.5**:41:**44**:48 cm

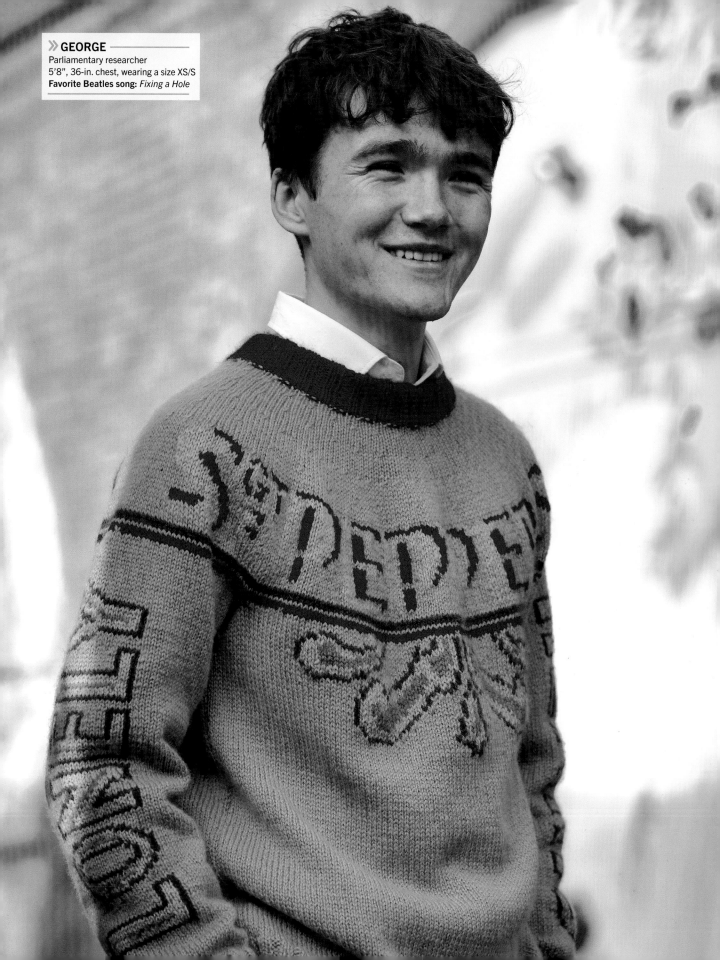

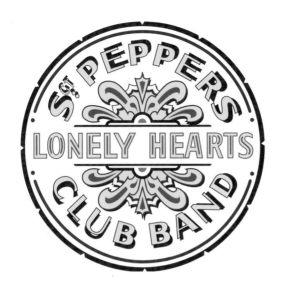

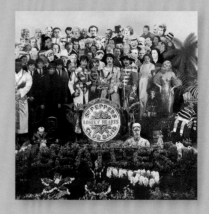

SGT. PEPPER'S BAND SWEATER

Designed by Cécile Jeffrey
Skill level ●●●

Possibly as famous for the design of its cover as for its songs, the *Sgt. Pepper's Lonely Hearts Club Band* album jacket features The Beatles dressed in '60s versions of early-twentieth-century marching band uniforms, standing behind a bass drum painted with the album title in fairground-style lettering.

This sweater takes that graphic style and the wording from the album title and sets it around the yoke and down each sleeve. The design is worked using the intarsia technique; to be able to do this, the yoke is split into back and front sections that are worked back and forth before being combined for working in the round.

SIZES
XS/**S**:M:**L**:XL:**2/3XL**:4/**5XL**:**6XL**

FINISHED MEASUREMENTS
Chest: **38**:41:**44**:48½:**52**:58:**65** in. /
96:104:**112**:122:**132**:147:**165** cm
Length to neck:
22:23½:**24½**:25¾:**26⅛**:27¼:**27** in. /
56:60:**62.5**:65.5:**66.5**:69:**68.5** cm
Length of sleeve to beginning of yoke:
19:21:**21**:21:**21**:20¼:**19¼** in. /
48.5:53:**53**:53:**53**:51.5:**49** cm

YARN
DK weight (light #3), shown in Rowan
Norwegian Wool (100% wool; 137 yd. /
125 m per 2 oz. / 50 g ball)
MC: Mountain (022), **7**:8:**9**:10:**10**:12:**12** balls
CC1: Golden Nugget (012), 1 ball for each size
CC2: Emerald (017), 1 ball for each size
CC3: Ribbon Red (018), 1 ball for each size
CC4: Coastal Fjord (013), 1 ball for each size

NEEDLES
US 4 / 3.5 mm and US 6 / 4 mm straight
needles and US 4 / 3.5 mm and US 6 / 4 mm
circular needles, 48 in. / 120 cm long, or size
needed to obtain gauge

continued on the next page >>

NOTIONS
14 stitch holders
Stitch marker
Tapestry needle

GAUGE
22 sts and 28 rows = 4 in. / 10 cm over St st
on US 6 / 4 mm needles
Be sure to check your gauge.

ABBREVIATIONS
See page 201.

PATTERN NOTES
- The cast on used here is the backward loop technique (see page 194).
- The Front, Back, and Sleeves are partially worked before being combined to work the yoke. The yoke is worked in two sections at first, knitting back and forth on each one, to make it simpler to work the intarsia technique (see page 196), following the charts on pages 37–39. The two sections are then combined and knitted in the round before working the neckband. It is therefore necessary to join the Front and Back Yoke sections at the shoulders. Wind separate balls of the different colors and twist them together where they join to avoid holes in the finished work.
- You will need to graft together some of the sleeve stitches at the underarms using Kitchener stitch (see page 198).
- For more on reading charts, see page 196.

THE SWEATER

FRONT
Using US 4 / 3.5 mm needles and MC, cast on **106**(114:**124**:134:**146**:162:**182**) sts using the backward loop technique.
Size L only:
Rib row 1 (RS): K1, *p2, k2, rep from * to last 3 sts, p2, k1.
Rib row 2: P1, *k2, p2, rep from * to last 3 sts, k2, p1.
All other sizes:
Rib row 1 (RS): K2, *p2, k2, rep from * to end.
Rib row 2: P2, *k2, p2, rep from * to end.
All sizes:
Rep these 2 Rib rows until work measures 1½ in. / 4 cm, ending with a WS row.
Change to US 6 / 4 mm needles.
Beg with a k row, work 64(72:**74**:78:**82**:80:**76**) rows in St st.
Foll Swirl Chart, work as foll:
Next row: Using MC, k16(20:**25**:30:**36**:44:**54**), k73 sts from Row 1 of chart, k in MC to end.
Next row: Using MC, p**17**(21:**26**:31:**37**:45:**55**), p73 sts from Row 2 of chart, p in MC to end.
These 2 rows set the position of the charted design.
Cont to work to end of chart.
Place the first **9**(9:**9**:10:**11**:12:**14**)

sts on a stitch holder, the next **88**(96:**106**:114:**124**:138:**154**) sts on another holder, and the rem **9**(9:**9**:10:**11**:12:**14**) sts on a third holder.

BACK
Work as for Front.

RIGHT SLEEVE
Using US 4 / 3.5 mm needles and MC, cast on **58**(58:**58**:62:**66**:70:**78**) sts.
Rib row 1 (RS): K2, *p2, k2, rep from * to end.
Rib row 2: P2, *k2, p2, rep from * to end.
Rep these 2 rows until work measures 4 in. / 10 cm, ending with a WS row.
Change to US 6 / 4 mm needles.
K 1 row, inc 8 sts evenly across the row. (**66**(66:**66**:70:**74**:78:**86**) sts)
To shape Sleeve, inc as foll:
Beg with a p row, work 8(10:**10**:10:**10**:6:**9**) rows in St st.
Cont in St st, inc 1 st at each end of next and every foll 10th row until there are **82**(84:**84**:88:**90**:98:**106**) sts.
Cont straight until Lonely Chart is complete (see below).
AT SAME TIME as inc, work the intarsia design, foll Lonely Chart.
Size XS/S only:
After working 6 rows in St st, cont as foll:
Next row: Using MC, k23, k19 sts from Row 1 of chart, k in MC to end.

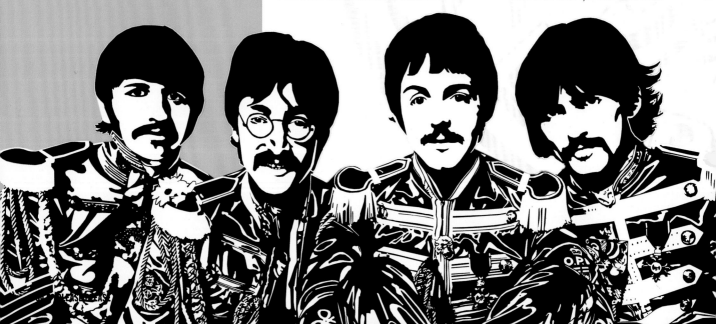

Next row: Using MC, p24, p19 sts from Row 2 of chart, p in MC to end.

Cont to work in St st, inc as given and maintaining the position of the charted design as set until the chart is complete.

Sizes M:L:XL:2XL–3XL only:

After working 18 rows in St st, cont as foll:

Next row: Using MC, k**24**(24:**26**:28), k19 sts from Row 1 of chart, k in MC to end.

Next row: Using MC, p**25**(25:**27**:29), p19 sts from Row 2 of chart, p in MC to end.

Cont to work in St st, inc as given and maintaining the position of the charted design as set until the chart is complete.

Size 4XL–5XL only:

After working 14 rows in St st, cont as foll:

Next row: Using MC, k30, k19 sts from Row 1 of chart, k in MC to end.

Next row: Using MC, p31, p19 sts from Row 2 of chart, p in MC to end.

Cont to work in St st, inc as given and maintaining the position of the charted design as set until the chart is complete.

Size 6XL only:

After working 8 rows in St st, cont as foll:

Next row: Using MC, k33, k19 sts from Row 1 of chart, k in MC to end.

Next row: Using MC, p34, p19 sts from Row 2 of chart, p in MC to end.

Cont to work in St st, inc as given and maintaining the position of the charted design as set until the chart is complete.

Working straight, cont in MC only for 8 more rows.

All sizes:

Place the first **9**(9:**9**:10:**11**:12:**14**) sts on a stitch holder, the next **32**(33:**33**:34:**34**:37:**39**) sts on another holder, the next **32**(33:**33**:34:**34**:37:**39**) on a third holder, and the rem **9**(9:**9**:10:**11**:12:**14**) sts on a fourth.

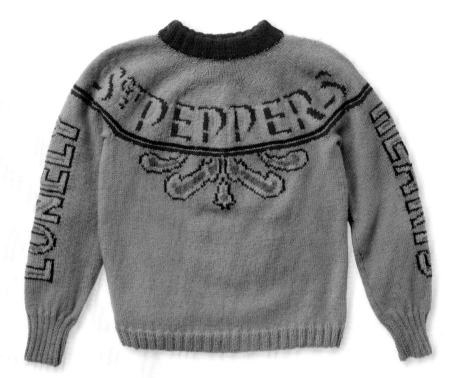

LEFT SLEEVE

Work as for Right Sleeve but use the Hearts Chart and work 7 rows in St st in MC when chart is completed.

YOKE

Front yoke

With WS of the Right Sleeve facing you, transfer the left-hand set of **32**(33:**33**:34:**34**:37:**39**) sts from the holder onto a US 6 / 4 mm circular needle. With WS of Front facing you, transfer the center **88**(96:**106**:114:**124**:138:**154**) sts onto the needle, then with the WS of Left Sleeve facing you, transfer the right-hand set of **32**(33:**33**:34:**34**:37:**39**) sts onto the needle.
(**152**(162:**172**:182:**192**:212:**232**) sts)

**With RS facing, join on MC and, working back and forth in rows, k to last st, working tog last st of each piece with the first st of next one, kfb.
(**151**(161:**171**:181:**191**:211:**231**) sts)

Beg with a p row, cont in St st, foll Front Yoke chart.

For first size, work area inside pink line; for second size, work area inside blue line; for third size, work area inside

orange line; for fourth size, work area inside yellow line; for fifth size, work area inside purple line; for sixth size, work area inside red line; for seventh size, work area inside black line.**

Cut off yarns and transfer sts to a holder.

Back yoke

With WS of the Left Sleeve facing you, transfer the left-hand set of **32**(33:**33**:34:**34**:37:**39**) sts from the holder onto a US 4 / 3.5 mm circular needle. With WS of Back facing you, transfer the center **88**(96:**106**:114:**124**:138:**154**) sts onto the needle, then with the WS of Right Sleeve facing you, transfer the right-hand set of **32**(33:**33**:34:**34**:37:**39**) sts onto the needle.
(**152**(162:**172**:182:**192**:212:**232**) sts)

Work as for Front Yoke from ** to **, foll Back Yoke chart.

Leave sts on the needle, cut off all yarns except MC.

Finishing the yoke

With RS facing, transfer Front Yoke sts onto the needle, then the Back Yoke sts, so the Back Yoke sts are worked first.
(**302**(322:**342**:362:**382**:422:**462**) sts)

Join to work in the round; PM to indicate beg of round, moving it up with each round.

Round 1: K to end, working tog last st of Back Yoke with first st of Front Yoke and last st of Front Yoke with first st of Back Yoke. (**300**(320:**340**:360:**380**:420:**460**) sts)

Round 2: K2, k2tog, *k3, k2tog, rep from * to last st, k1. (**240**(256:**272**:288:**304**:336:**368**) sts)

Rounds 3 to 5: K to end.

Round 6: *K2tog, k6, rep from *, to last st. (**210**(224:**238**:252:**266**:294:**322**) sts)

Rounds 7 to 10: K to end.

Round 11: *K2tog, k5, rep from * to end. (**180**(192:**204**:216:**228**:252:**276**) sts)

Rounds 12 to 15: K to end.

Round 16: *K2tog, k4, rep from * to end. (**150**(160:**170**:180:**190**:210:**230**) sts)

Rounds 17 to 21: K to end.

Round 22: *K2 tog, k3, rep from * to end. (**120**(128:**136**:144:**152**:168:**184**) sts)

Rounds 23 to 27: K to end.

Round 28: *K2 tog, k2, rep from * to end. (**90**(96:**102**:108:**114**:126:**138**) sts)

Work straight for **1**(1:**8**:12:**14**:18:**24**) rounds, dec **2**(0:**2**:0:**2**:2:**2**) sts evenly around the last of these rounds. (**88**(96:**100**:108:**112**:124:**136**)) sts

Neckband

Change to US 4 / 3.5 mm circular needle and join on CC3.

Rib round: *K2, p2, rep from * to end of round.

Rep this Rib round until neckband measures 4 in. / 10 cm.

Bind off rib-wise.

FINISHING

Weave in yarn ends and block the garment (see page 199 for more on blocking).

Using Kitchener stitch (see page 198), graft together the stitches on the holders at each underarm.

Using ladder stitch (see page 198), join the seams between the Front and Back Yoke pieces, and the Sleeve and side seams.

Turn the neckband under to the wrong side and sew loosely in place.

CHARTS

KEY

▢	MC
▢	CC1
▢	CC3
▢	CC4

—	XS
—	S
—	M
—	L
—	2/3XL
—	4/5XL
—	6XL

Copy the charts on these pages (enlarging them if you wish). Join the two parts of the Front Yoke chart together; do the same with the Back Yoke chart sections.

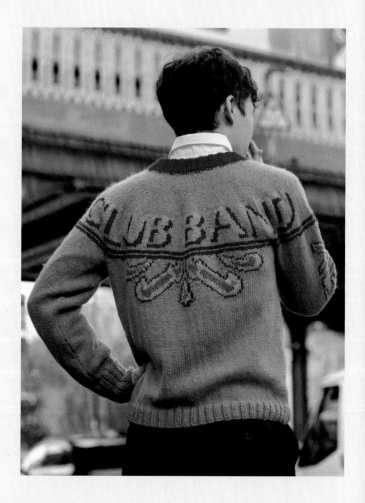

FRONT YOKE—LEFT

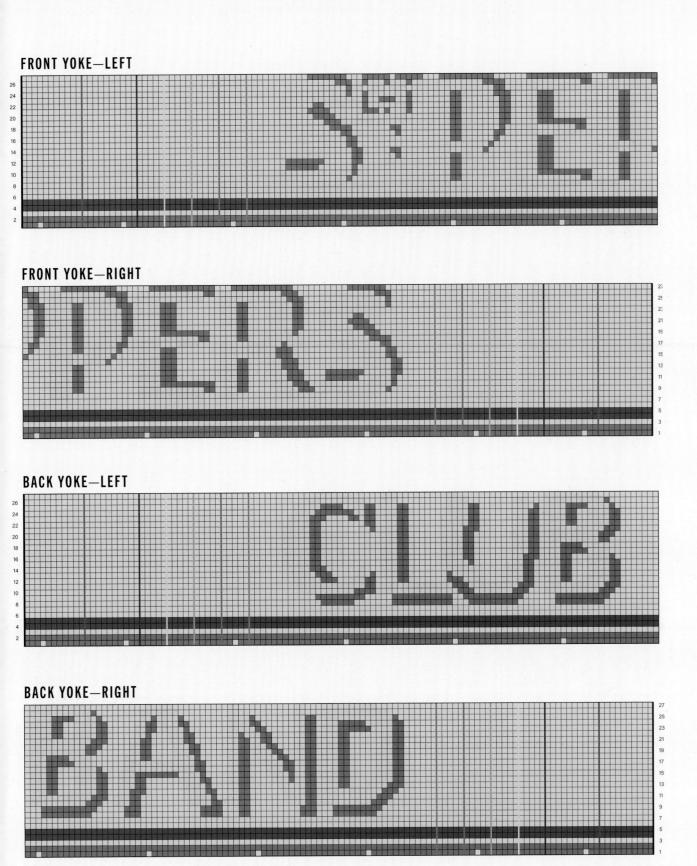

FRONT YOKE—RIGHT

BACK YOKE—LEFT

BACK YOKE—RIGHT

KEY

- ☐ MC
- ☐ CC1
- ☐ CC2
- ☐ CC4

LONELY CHART

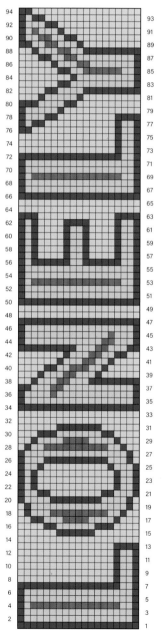

HEARTS CHART

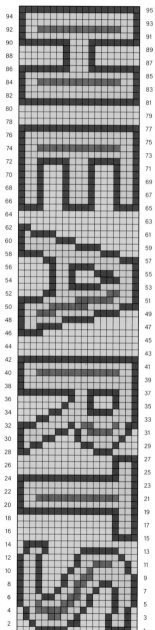

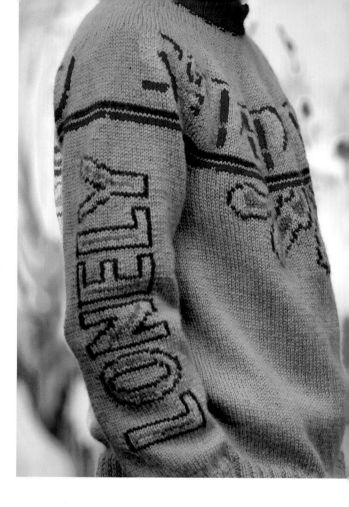

SWIRL CHART

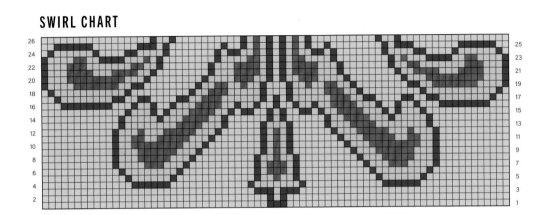

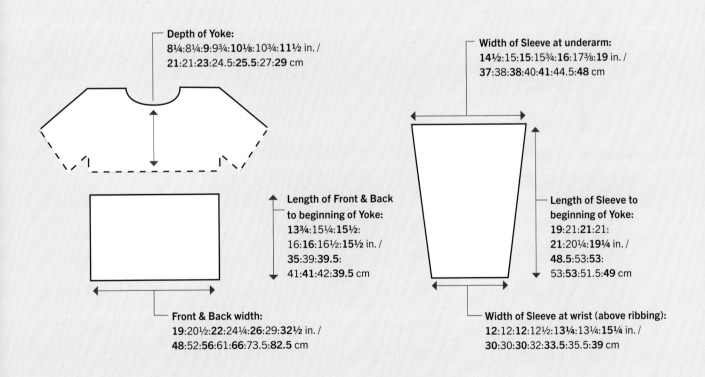

Depth of Yoke:
8¼:8¼:9:9¾:10⅛:10¾:11½ in. /
21:21:23:24.5:25.5:27:29 cm

Width of Sleeve at underarm:
14½:15:15:15¾:16:17⅜:19 in. /
37:38:38:40:41:44.5:48 cm

Length of Front & Back
to beginning of Yoke:
13¾:15¼:15½:
16:16:16½:15½ in. /
35:39:39.5:
41:41:42:39.5 cm

Length of Sleeve to
beginning of Yoke:
19:21:21:21:
21:20¼:19¼ in. /
48.5:53:53:
53:53:51.5:49 cm

Front & Back width:
19:20½:22:24¼:26:29:32½ in. /
48:52:56:61:66:73.5:82.5 cm

Width of Sleeve at wrist (above ribbing):
12:12:12:12½:13¼:13¼:15¼ in. /
30:30:30:32:33.5:35.5:39 cm

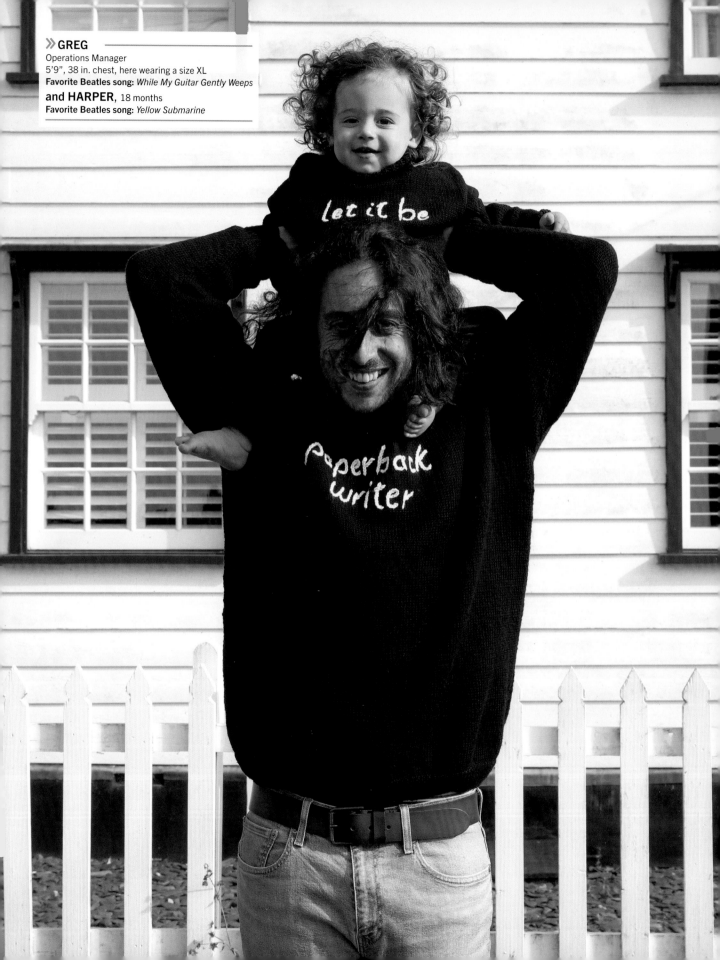

» GREG
Operations Manager
5'9", 38 in. chest, here wearing a size XL
Favorite Beatles song: *While My Guitar Gently Weeps*
and HARPER, 18 months
Favorite Beatles song: *Yellow Submarine*

GREATEST HITS SWEATER

Designed by **Caroline Smith**
Skill level 🍎

From their first hit, "Love Me Do," in 1962, through to "The Long and Winding Road," in 1970, The Beatles have produced an impressive catalog of song titles that are perfect for adding to these slogan-style sweaters. Choose your favorite Beatles hit—or maybe one that sends a special message—to add to the front of this polo-neck pattern.

The sweater draws its style inspiration from the beatnik fashions of the early-to-mid-'60s, and it can be made in both children's and adult sizes—perfect for a whole family of Beatles fans, whatever their age! With drop-shoulder sleeves and a ribbed neck, it's easy to make. The lettering is added using embroidery—chain stitch—and an alphabet template is given on page 44 so you can compose any title you wish.

During their career, The Beatles released more than thirty singles, twelve albums, and more than fifteen EPs. "Paperback Writer" (shown here) was released in 1966, in May in the United States and in June in the UK. "Let It Be" came out in May 1970.

SIZES
Child sizes
4–6yrs:6–8yrs:**8–10yrs**:10–12yrs
Adult sizes
XS:S:**M**:L:**XL**:2XL:**3XL**:4XL:**5XL**:6XL

FINISHED MEASUREMENTS
Child sizes
Chest: **24¼**:26½:**27½**:30 in. / **61**:67:**70**: 76 cm
Length to shoulder: **14**:16:**18**:20 in. / **35.5**:41:**46**:51 cm
Sleeve length to underarm:
10¾:11¾:**12¾**:13¾ in. / **27**:29.5:**32.5**:35 cm
Adult sizes
Chest: **32¼**:35:**37½**:41:**44⅞**:48⅞:**52⅜**: 56¼:**60**:63 in. / **82**:89:**95**:104:**114**:124: **133**:143:**152**:162 cm
Length to shoulder: **21¾**:22¾:**23½**:24⅜: **25**:25¾:**26⅝**:27⅜:**28¼**:29 in. / **55.5**:57.5: **59.5**:61.5:**63.5**:65.5:**67.5**:69.5:**71.5**:73.5 cm
Sleeve length to underarm: **16½**:17:**17**:17¾: **17¾**:18¼:**18¼**:18¾:**18¾**:18¾ in. / **42**:43: **43**:45:**45**:46.5:**46.5**:47.5:**47.5**:47.5 cm

YARN
DK weight (medium #4), shown in DROPS Merino Extra Fine (100% wool; 114 yd. / 105 m per 2 oz. / 50 g ball)
Child sizes
MC: Black (02), **6**:7:**8**:9 balls
CC: Off-White (01), 1 ball for each size

continued on the next page >>

Adult sizes

MC: Black (02), **10**:11:**12**:14:**15**:17:**18**:20:
22:23 balls
CC: Off-White (01), 1 ball for each size

NEEDLES

US 4 / 3.5 mm and US 6 / 4 mm needles (see
Pattern Notes), or size needed to obtain gauge
US 6 / 4 mm and US 8 / 5 mm circular
needles, 16 in. / 40 cm long, or size needed to
obtain gauge

NOTIONS

4 locking stitch markers
Tapestry needle
Tissue paper
Felt-tip pen
Sewing needle and thread (for tacking)

GAUGE

21 sts and 28 rows = 4 in. / 10 cm square over
St st using US 6 / 4 mm needles
Be sure to check your gauge.

ABBREVIATIONS

See page 201.

PATTERN NOTES

- For larger sizes it may be easier to use
 circular needles and work back and forth.
- The ribbing used is 1x1: *k1, p1, rep from
 * to end.

CHILD-SIZE SWEATER

BACK

Using US 4 / 3.5 mm needles and MC,
cast on **64**(70:**74**:80) sts.
Work in 1x1 ribbing for 1 in. / 2.5 cm.
Change to US 6 / 4 mm needles and beg
with a k row, work in St st until piece
measures **14**(16:**18**:20) in. /
35.5(41:**46**:51) cm from cast-on
edge.
Shape shoulders and back neck
Bind off **20**(21:**22**:25) sts at beg of next
2 rows. (**24**(28:**30**:30) sts)
Bind off.

FRONT

Using US 4 / 3.5 mm needles and MC,
cast on **64**(70:**74**:80) sts.
Work in 1x1 ribbing for 1 in. / 2.5 cm.
Change to US 6 / 4 mm needles and beg
with a k row, work in St st until piece
measures **12⅛**(14¼:**16**:17¾) in. /
30.5(36:**41**:45) cm, ending with a
p row.
Shape neck
Next row (RS): K**27**(28:**29**:32), bind
off **10**(14:**16**:16) sts, k to end.
(**54**(56:**58**:64) sts)
Next row: Working on first **27**(28:**29**:
32) sts, p to neck edge, turn.

Next row: Bind off 3 sts, k to end.
(**24**(25:**26**:29) sts)
Next row: P to end.
Next row: Bind off 2 sts, k to end.
(**22**(23:**24**:27) sts)
Next row: P to end.
Next row: K1, k2tog, k to end.
(**21**(22:**23**:26) sts)
Rep prev 2 rows once. (**20**(21:**22**:
25) sts)
Cont in St st until right-hand side
measures same as back from
cast-on edge to shoulder, ending with
a RS row.
Bind off.
With WS facing, rejoin yarn at neck edge
and p to end.
Next row: K to end.
Next row: Bind off 3 sts, p to end.
(**24**(25:**26**:29) sts)
Next row: K to end.
Next row: Bind off 2 sts, p to end.
(**22**(23:**24**:27) sts)
Next row: K to end.
Next row: P1, p2tog, p to end.
(**21**(22:**23**:26) sts)
Rep prev 2 rows once. (**20**(21:**22**:
25) sts)
Cont in St st until left-hand side
measures same as Back from cast-on
edge to shoulder, ending with a WS
row.
Bind off.

SLEEVES (MAKE 2)

Using US 4 / 3.5 mm needles and MC,
cast on **30**(32:**36**:38) sts.
Work in 1x1 ribbing for 1 in. /
2.5 cm.
Change to US 6 / 4 mm needles
and beg with a k row, work 4 rows
in St st.
Inc 1 st at each end of next and
every foll 4th row until there are
62(68:**76**:82) sts.
Cont in St st until Sleeve measures
10¾(11¾:**12¾**:13¾) in. /
27(29.5:**32.5**:35) cm from cast-on
edge.
Bind off.

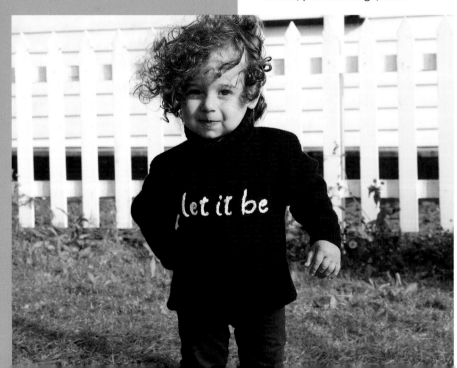

NECKBAND

Block Front and Back and join at right-hand shoulder seam.

Using US 6 / 4 mm circular needle and MC, start at left-hand shoulder and with RS facing, pick up and knit **14**(14:**15**:15) sts along left front neck edge, pick up and knit **10**(14:**16**:16) sts across bound-off sts, pick up and knit **14**(14:**15**:15) sts along right front neck edge, pick up and knit **24**(28:**30**:30) sts across bound-off sts at back neck. (**62**(70:**76**:76) sts)

Work in 1x1 rib until neck is desired length.

Change to US 8 / 5 mm circular needle and cont in 1x1 rib until neck is twice desired length.

Bind off rib-wise.

FINISHING

See Adult size.

ADULT-SIZE SWEATER

BACK

Using US 4 / 3.5 mm needles and MC, cast on **86**(94:**100**:110:**120**:130:**140**:150:**160**:170) sts.

Work in 1x1 ribbing for 2 in. / 5 cm.

Change to US 6 / 4 mm needles and beg with a k row, work in St st until piece measures **21¾**(22¾:**23½**:24¾:**25**:25⅜:**26⅝**:27⅜:**28¼**:29) in. / **55.5**(57.5:**59.5**:61.5:**63.5**:65.5:**67.5**:69.5:**71.5**:73.5) cm from cast-on edge.

Shape shoulders and back neck

Bind off **27**(31:**34**:37:**40**:44:**48**:52:**54**:58) sts at beg of next 2 rows. (**32**(32:**32**:36:**40**:42:**44**:46:**52**:54) sts)

Bind off.

FRONT

Using US 4 / 3.5 mm needles and MC, cast on **86**(94:**100**:110:**120**:130:**140**:150:**160**:170) sts.

Work in 1x1 ribbing for 2 in. / 5 cm.

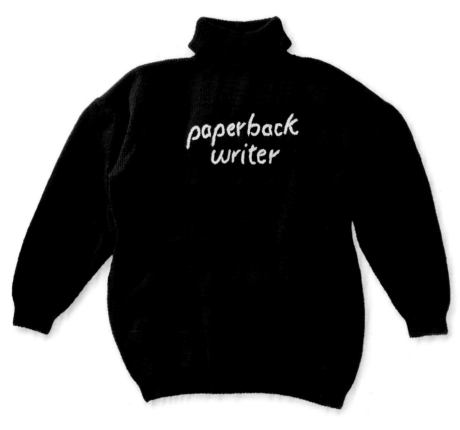

Change to US 6 / 4 mm needles and beg with a k row, work in St st until piece measures **19⅞**(20¾:**21⅜**:22¼:**23⅛**:24⅛:**24⅝**:25⅜:**26¼**:27) in. / **50.5**(52.5:**54.5**:56.5:**58.5**:60.5:**62.5**:64.5:**66.5**:68.5) cm from cast-on edge.

Shape neck

Next row (RS): K**35**(39:**42**:45:**50**:54:**58**:62:**66**:70), bind off **16**(16:**16**:20:**20**:22:**24**:26:**28**:30) sts, k to end. (**70**(78:**84**:90:**100**:108:**116**:124:**132**:140) sts)

Next row: Working on first **35**(39:**42**:45:**50**:54:**58**:62:**66**:70) sts, p to neck edge, turn.

Next row: Bind off 3 sts, k to end. (**32**(36:**39**:42:**47**:51:**55**:59:**63**:67) sts)

Next row: P to end.

Next row: Bind off 2 sts, k to end. (**30**(34:**37**:40:**45**:49:**53**:57:**61**:65) sts)

Rep prev 2 rows **0**(0:**0**:0:**1**:1:**1**:1:**2**:2) more time(s). (**30**(34:**37**:40:**43**:47:**51**:55:**57**:61) sts)

Next row: P to end.

Next row: K1, k2tog, k to end. (**29**(33:**36**:39:**42**:46:**50**:54:**56**:60) sts)

Rep prev 2 rows twice. (**27**(31:**34**:37:**40**:44:**48**:52:**54**:58) sts)

Cont in St st until right-hand side measures same as Back from armhole to shoulder, ending with a RS row.

Bind off.

With WS facing, rejoin yarn at neck edge and p to end.

Next row: K to end.

Next row: Bind off 3 sts, p to end. (**32**(36:**39**:42:**47**:51:**55**:59:**63**:67) sts)

Next row: K to end.

Next row: Bind off 2 sts, p to end. (**30**(34:**37**:40:**45**:49:**53**:57:**61**:65) sts)

Rep prev 2 rows **0**(0:**0**:0:**1**:1:**1**:1:**2**:2) more time(s). (**30**(34:**37**:40:**43**:47:**51**:55:**57**:61) sts)

Next row: K to end.

Next row: P1, p2tog, p to end. (**29**(33:**36**:39:**42**:46:**50**:54:**56**:60) sts)

Rep prev 2 rows twice. (**27**(31:**34**:37:**40**:44:**48**:52:**54**:58) sts)

Cont in St st until left-hand side measures same as Back from armhole to shoulder, ending on a WS row.

Bind off.

abcdefghij
klmnopqrs
tuvwxyz

SLEEVES (MAKE 2)

Using US 4 / 3.5 mm needles and MC, cast on **40**(44:**46**:50:**50**:54:58:62:**68**:68) sts.

Work in 1x1 ribbing for 2 in. / 5 cm.

Change to US 6 / 4 mm needles and beg with a k row, work 4 rows in St st.

Inc 1 st at each end of next and every foll 4th row until there are **90**(94:**98**:104:**104**:110:**114**:120:**126**:126) sts.

Cont in St st until Sleeve measures **16½**:17:**17**:17¾:**17¾**:18¼:**18¼**:18¾:**18¾**:18¾ in. / **42**:43:**43**:45:**45**:46.5:**46.5**:47.5:**47.5**:47.5 cm from cast-on edge.

Bind off.

NECKBAND

Block both the Front and Back and join at right-hand shoulder seam.

Using US 6 / 4 mm circular needle and MC, start at left-hand shoulder and with RS facing, pick up and knit 16 sts along left front neck edge, pick up and knit **16**(16:**16**:20:**20**:22:**24**:26:**28**:30) sts across bound-off sts, pick up and knit 16 sts along right front neck edge, pick up and knit **32**(32:**32**:36:**40**:42:**44**:46:**52**:54) sts across bound-off sts of back neck. (**78**(78:**78**:86:**90**:94:**100**:104:**112**:116) sts)

Work in 1x1 rib until neck is desired length.

Change to US 8 / 5 mm circular needle and cont in 1x1 rib until neck is twice desired length.

Bind off rib-wise.

FINISHING

Embroidery

Decide on The Beatles song title you would like to use and how large the writing will be on the front of the sweater. Photocopy the alphabet template (above), reducing or enlarging it to the size required.

Place some tissue paper over the top of the photocopied letters and, using a felt-tip pen, trace over the ones you need to make up your chosen song title. Cut around the words, leaving a margin of about 2 in. / 5 cm, then place this on the front of the sweater in the desired position, making sure that the lettering is straight. Using a sewing needle and thread, tack the tissue paper onto the sweater.

Cut a long strand of CC and, using a tapestry needle, work chain stitch (see page 198) over the traced text, sewing through the tissue paper and the knitting underneath it. Work one chain stitch for a dot over the i or j.

When you have embroidered over all the letters, remove the tacking thread and gently pull away the tissue paper: use the tip of a needle to ease out any pieces caught under the stitches.

Joining the Sleeves

Block the Sleeves (see page 199 for more on blocking). Join the remaining shoulder seam and the neck edges. Sew the sleeves in place, matching centers of Sleeve tops to shoulder seams. Join the side and sleeve seams.

CHILD SIZES

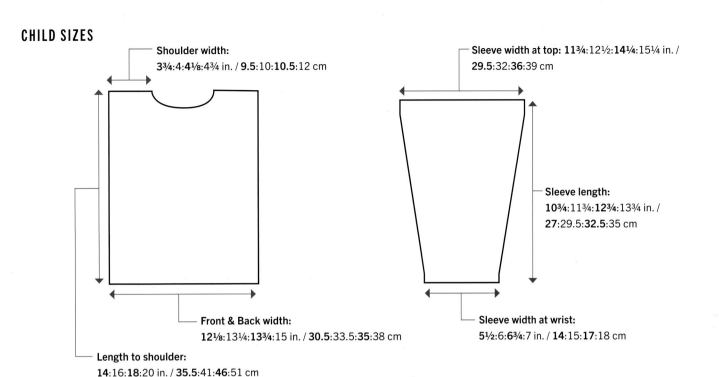

Shoulder width:
3¾:4:4⅛:4¾ in. / **9.5**:10:**10.5**:12 cm

Sleeve width at top: 11¾:12½:**14¼**:15¼ in. /
29.5:32:**36**:39 cm

Sleeve length:
10¾:11¾:**12¾**:13¾ in. /
27:29.5:**32.5**:35 cm

Front & Back width:
12⅛:13¼:**13¾**:15 in. / **30.5**:33.5:**35**:38 cm

Sleeve width at wrist:
5½:6:6¾:7 in. / **14**:15:**17**:18 cm

Length to shoulder:
14:16:**18**:20 in. / **35.5**:41:**46**:51 cm

ADULT SIZES

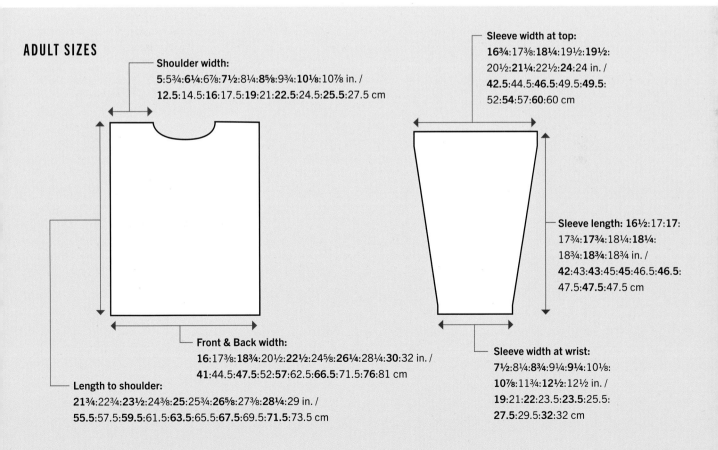

Shoulder width:
5:5¾:**6¼**:6⅞:**7½**:8¼:**8⅝**:9¾:**10⅛**:10⅞ in. /
12.5:14.5:**16**:17.5:**19**:21:**22.5**:24.5:**25.5**:27.5 cm

Sleeve width at top:
16¾:17⅜:**18¼**:19½:**19½**:
20½:**21¼**:22½:**24**:24 in. /
42.5:44.5:**46.5**:49.5:**49.5**:
52:**54**:57:**60**:60 cm

Sleeve length: 16½:17:**17**:
17¾:**17¾**:18¼:**18¼**:
18¾:**18¾**:18¾ in. /
42:43:**43**:45:**45**:46.5:**46.5**:
47.5:**47.5**:47.5 cm

Front & Back width:
16:17⅜:**18¾**:20½:**22½**:24⅝:**26¼**:28¼:**30**:32 in. /
41:44.5:**47.5**:52:**57**:62.5:**66.5**:71.5:**76**:81 cm

Sleeve width at wrist:
7½:8¼:**8¾**:9¼:**9¼**:10⅛:
10⅞:11¾:**12½**:12½ in. /
19:21:**22**:23.5:**23.5**:25.5:
27.5:29.5:**32**:32 cm

Length to shoulder:
21¾:22¾:**23½**:24⅜:**25**:25¾:**26⅝**:27⅜:**28¼**:29 in. /
55.5:57.5:**59.5**:61.5:**63.5**:65.5:**67.5**:69.5:**71.5**:73.5 cm

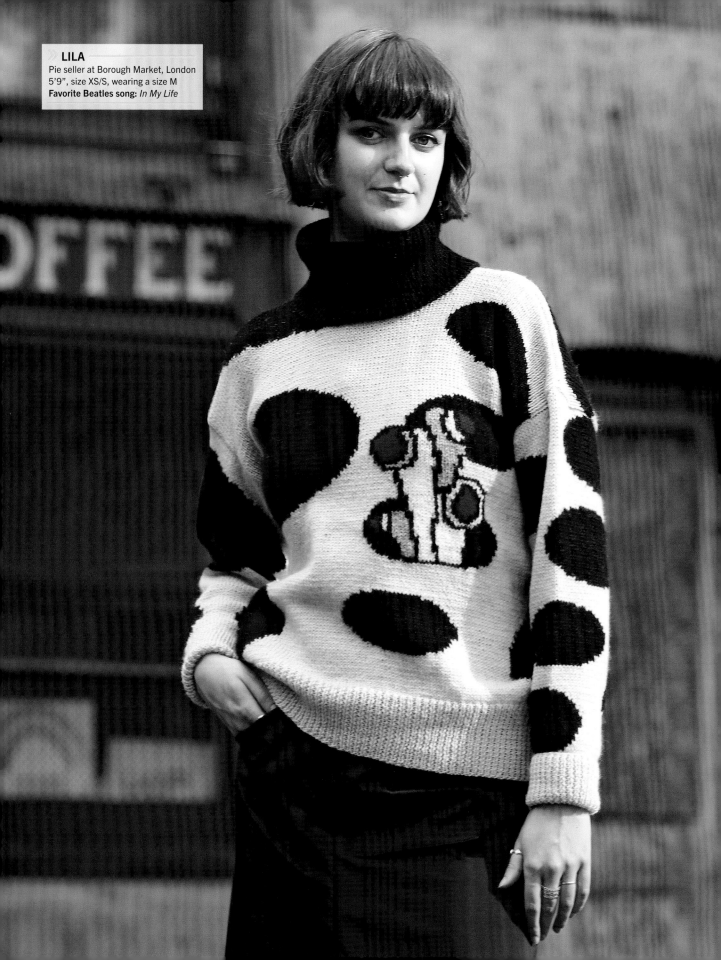

SEA OF HOLES
SWEATER

Designed by Cécile Jeffrey
Skill level ●●●

As the Yellow Submarine travels through the mysterious seas, The Beatles have some strange adventures. Time runs both backward and forward in the Sea of Time; Ringo has to be rescued from terrifying creatures in the Sea of Monsters; and they meet Jeremy, the Nowhere Man, who joins them on their voyage in the Sea of Nothing. When they reach the perilous Sea of Holes, they finally find the way through to Pepperland.

Dotted with holes of different sizes, this sweater features the Yellow Submarine's periscope emerging from one of them. As you'll be using intarsia to create the design, twist the yarns neatly together to avoid too many gaps between your color joins.

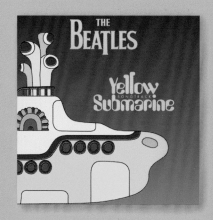

In the Yellow Submarine film, as The Beatles travel to Pepperland with Old Fred, they pass through several different seas, including the Sea of Time, the Sea of Monsters, the Sea of Nothing, and, finally, the Sea of Holes. The movie's animation style has been hugely influential over the more than fifty years since its release.

SIZES
S:M:**L**:XL:**2XL**:3XL

FINISHED MEASUREMENTS
Chest: **40⅛**:42½:**44½**:46⅞:**48⅞**:51 in. /
102:108:**113**:119:**124**:130 cm
Length: **24⅝**:25¼:**26**:26¾:**27¾**:28⅝ in. /
62.5:64:**66**:68:**70.5**:72.5 cm
Sleeve length: **20**:20¼:**20½**:21⅛:**21⅜**:
22 in. / **51**:51.5:**52**:53.5:**54.5**:56 cm

YARN
DK weight (light #3), shown in Rowan
Norwegian Wool (100% wool; 137 yd. /
125 m per 2 oz. / 50 g ball)
MC: Wind Chime (010), 7(7:8:8:9:9) balls
CC1: Peat (019), 5(5:6:6:7:7) balls
CC2: Golden Nugget (012), 1 ball for
each size
CC3: Vanilla Custard (021), 1 ball for
each size
CC4: Ribbon Red (018), 1 ball for each size

NEEDLES
US 2½ / 3 mm and US 6 / 4 mm needles, or
size needed to obtain gauge

continued on the next page >>

NOTIONS

Stitch holder
Tapestry needle

GAUGE

22 sts and 28 rows = 4 in. / 10 cm over St st
on US 6 / 4 mm needles
Be sure to check your gauge.

ABBREVIATIONS

See page 201.

PATTERN NOTES

- The cast on used here is the backward loop technique (see page 194).
- Follow the charts on pages 51–55 for each section of the sweater, using the intarsia technique (see page 196). Remember to wind small, separate balls of yarn and twist the yarns together where they join to avoid unintentional holes in the finished work.
- For more on reading charts, see page 196.

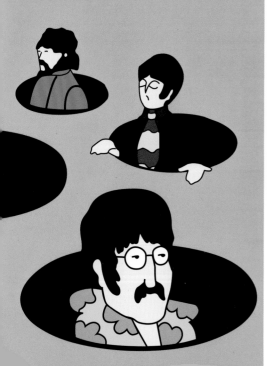

THE SWEATER

FRONT

Using US 2½ / 3 mm needles and MC, cast on **113**(119:**125**:131:**137**:143) sts using the backward loop technique.

Rib row 1: *K1, p1, rep from * to last st, k1.

Rib row 2: *P1, k1, rep from * to last st, p1.

Rep these 2 rows until ribbing measures 3½ in. / 9 cm.

Change to US 6 / 4 mm needles.

Beg with a k row, cont in St st, working from relevant chart as foll: for first size, work area inside pink line; for second size, work area inside blue line; for third size, work area inside orange line; for fourth size, work area inside yellow line; for fifth size, work area inside purple line; for sixth size, work area inside red line.**

Foll chart until Row **130**(134:**140**:146:**150**:156) has been worked.

Shape neck

Next row: Cont to foll chart, k**49**(52:**55**:58:**61**:64) sts, turn; leaving rem sts on a holder, cont on these sts only for left side of neck.

***Bind off 4 sts at beg of next row, 3 sts at beg of foll alt row, and 2 sts at beg of next alt row. (**40**(43:**46**:49:**52**:55) sts)

Dec 1 st at neck edge on foll 4 alt rows. (**36**(39:**42**:45:**48**:51) sts)

Work straight to end of chart.

Bind off.***

Transfer sts on holder to a US 6 / 4 mm needle so as to beg with a k row.

Next row: Place first 15 sts on a stitch holder, rejoin yarn, k to end. (**49**(52:**55**:58:**61**:64) sts)

P 1 row.

Work as first side of neck from *** to ***.

BACK

Work as given for Front to **.

Cont to foll relevant chart until Row **150**(154:**160**:166:**172**:178) has been worked.

Bind off **36**(39:**42**:45:**48**:51) sts, place 41 sts on a holder, bind off rem sts.

RIGHT SLEEVE

Using US 2½ / 3 mm needles and MC, cast on **51**(55:**60**:65:**70**:75) sts.

Rib row 1: *K1, p1, rep from * to last st, k1.

Rib row 2: *P1, k1, rep from * to last st, p1.

Rep these 2 rows until ribbing measures 4¾ in. / 12 cm.

Change to US 6 / 4 mm needles.

Beg with a k row, cont in St st, foll relevant chart AND AT SAME TIME inc 1 st at each end of first and every foll 6th row until there are **83**(87:**92**:97:**102**:107) sts, then work straight to end of chart.

Work from chart as foll:

For first size, work area inside pink line; for second size, work area inside blue line; for third size, work area inside orange line; for fourth size, work area inside yellow line; for fifth size, work area inside purple line; for sixth size, work area inside red line.

Bind off.

LEFT SLEEVE

Work as for Right Sleeve, inc as given and foll relevant chart.

NECK

Block both the Front and Back pieces and join right-hand shoulder seam.

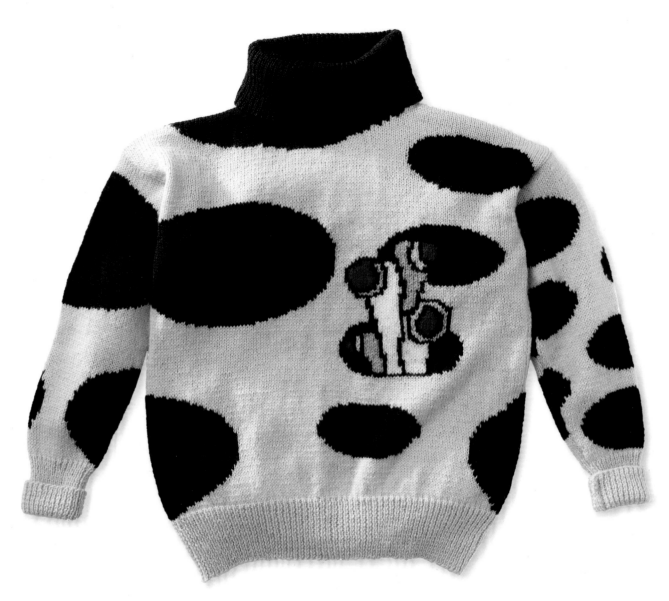

Using US 21/2 / 3mm needles and CC1, with RS of work facing, pick up and k **32**(32:**32**:32:**36**:36) sts down left front, k 15 sts from st holder at front neck, pick up and k **32**(32:**32**:32:**36**:36) sts up right front, and k 41 sts from st holder at back neck. **120**(120:**120**:120:**128**:128) sts
Rib row 1: *K1, p1, rep from * to end.
Rib row 2: *P1, k1, rep from * to end.

Rep these 2 rows until ribbing measures 2¼ in. / 6 cm.

Next row: [Rib 4, k into next st 3 times, rib 3] **15**(15:**15**:15:**16**:16) times. (**150**(150:**150**:150:**160**:160) sts)
Cont in rib until neck measures 8¼ in. / 21 cm.
Bind off rib-wise.

FINISHING

Weave in yarn ends.
Block the Sleeves (see page 199) and sew in place, matching centers of sleeve tops to shoulder seams.
Join neck, sleeve, and side seams.

⌃ *ABOVE*
Blocking the pieces of your sweater before you join them will ensure a neat finish.

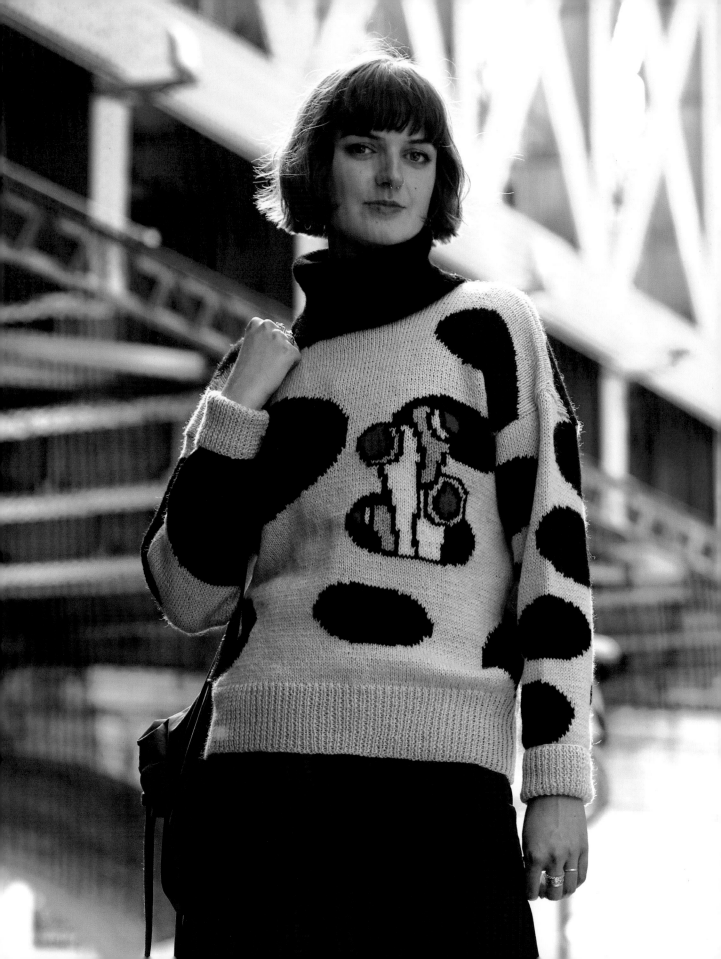

CHARTS

KEY

- ⬜ MC
- ⬛ CC1
- ⬛ CC2
- ⬜ CC3
- ⬛ CC4

- — S
- — M
- — L
- — XL
- — 2XL
- — 3XL

Copy the charts on the following pages, enlarging them if desired. Join the two Front Charts together along the long, unnumbered edges, so chart A is to the right of chart B; do the same with the two Back Charts. Join the two Right Sleeve Charts together along the long, unnumbered edges so chart A is to the right of chart B; do the same with the two Left Sleeve Charts.

FRONT CHART—A

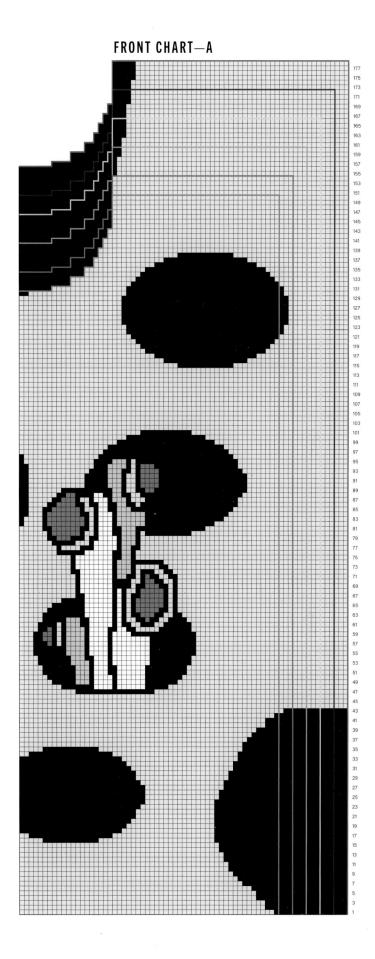

FRONT CHART—B

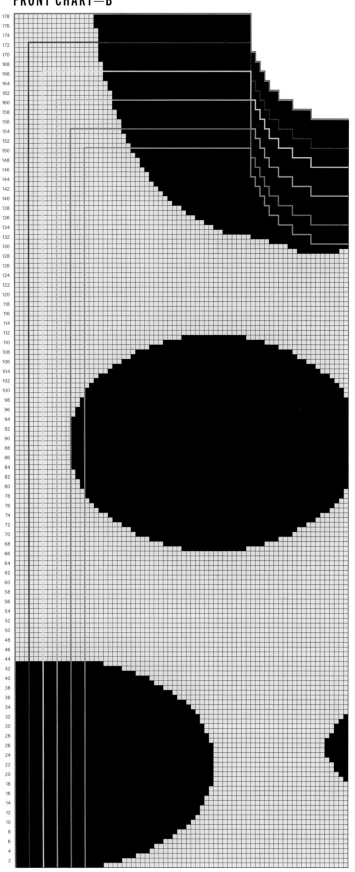

KEY

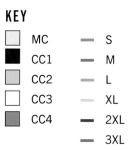

MC		S	
CC1		M	
CC2		L	
CC3		XL	
CC4		2XL	
		3XL	

RIGHT SLEEVE CHART—B

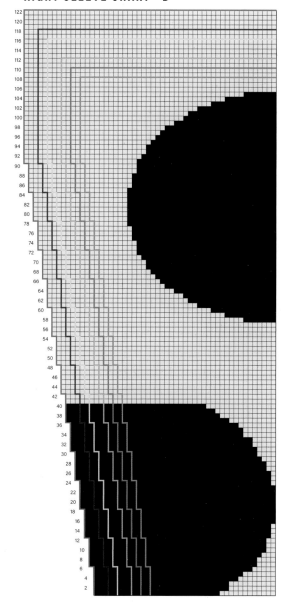

RIGHT SLEEVE CHART—A

BACK CHART—A

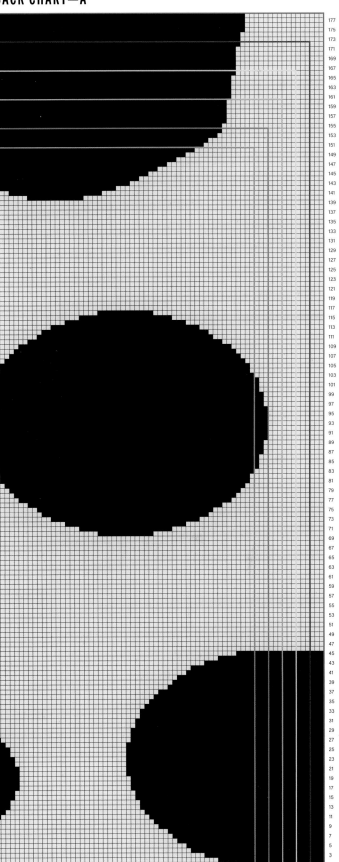

BACK CHART—B

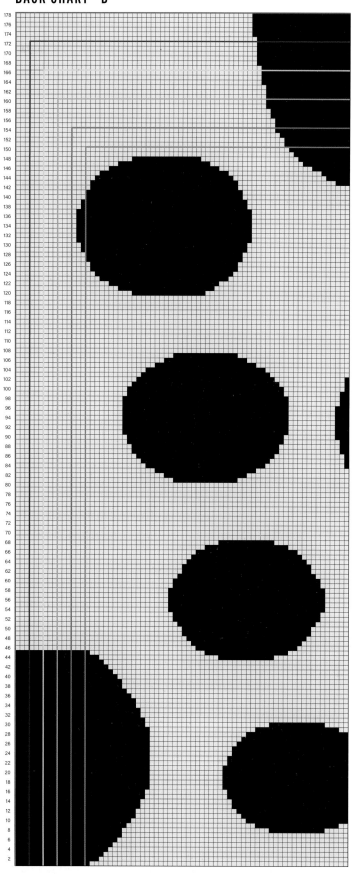

KEY

▢	MC	▬	S
■	CC1	▬	M
▨	CC2	▬	L
▢	CC3	▬	XL
▨	CC4	▬	2XL
		▬	3XL

LEFT SLEEVE CHART—B

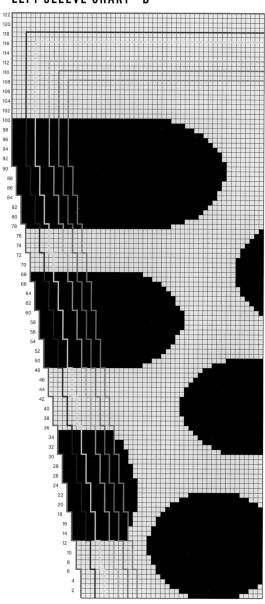

LEFT SLEEVE CHART—A

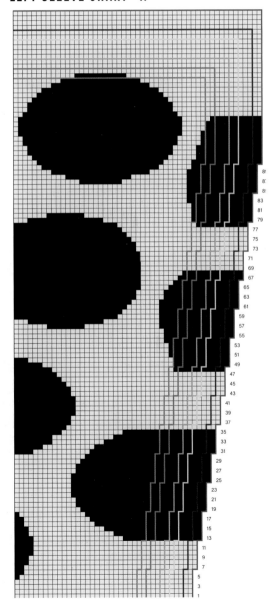

89
87
85
83
81
79
77
75
73
71
69
67
65
63
61
59
57
55
53
51
49
47
45
43
41
39
37
35
33
31
29
27
25
23
21
19
17
15
13
11
9
7
5
3
1

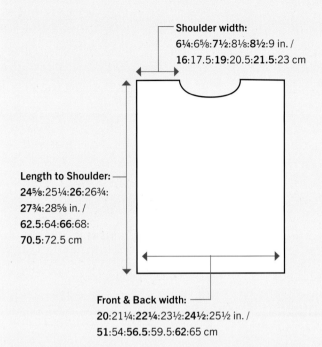

Shoulder width:
6¼:6⅝:**7½**:8⅛:**8½**:9 in. /
16:17.5:**19**:20.5:**21.5**:23 cm

Length to Shoulder:
24⅝:25¼:**26**:26¾:
27¾:28⅝ in. /
62.5:64:**66**:68:
70.5:72.5 cm

Front & Back width:
20:21¼:**22¼**:23½:**24½**:25½ in. /
51:54:**56.5**:59.5:**62**:65 cm

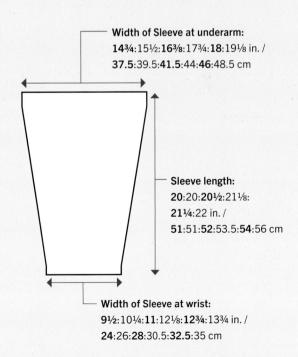

Width of Sleeve at underarm:
14¾:15½:**16⅜**:17¾:**18**:19⅛ in. /
37.5:39.5:**41.5**:44:**46**:48.5 cm

Sleeve length:
20:20:**20½**:21⅛:
21¼:22 in. /
51:51:**52**:53.5:**54**:56 cm

Width of Sleeve at wrist:
9½:10¼:**11**:12⅛:**12¾**:13¾ in. /
24:26:**28**:30.5:**32.5**:35 cm

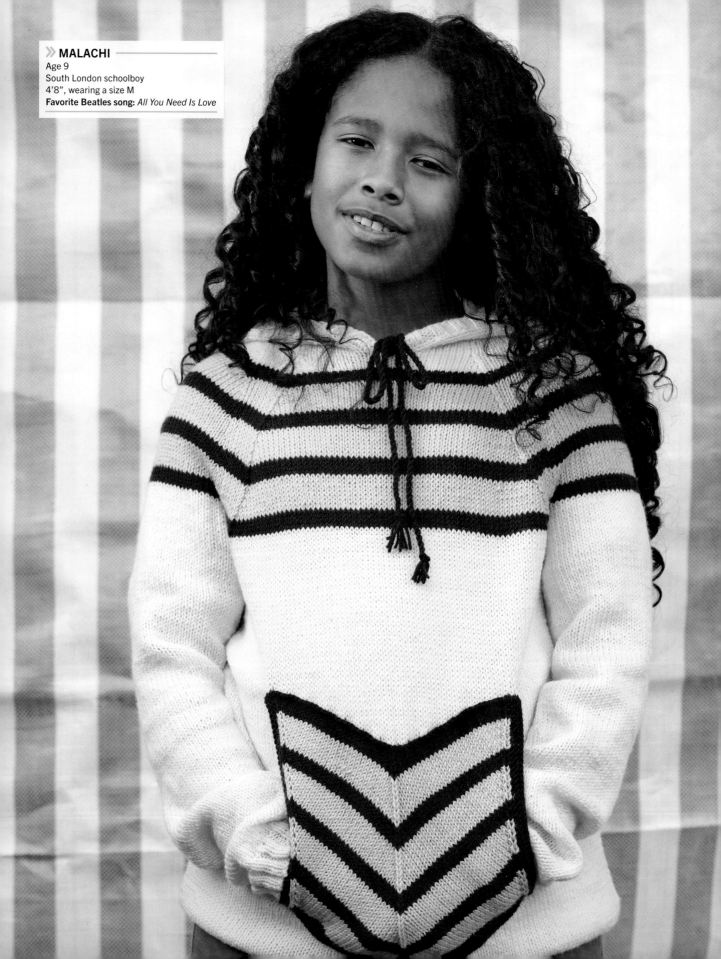

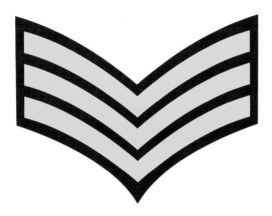

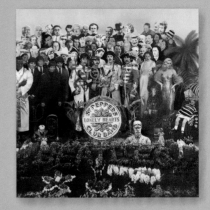

SERGEANT'S STRIPE HOODIE

Designed by **Sian Brown**

Skill level ●●●

Sgt. Pepper and his band not only became the title for a Beatles album, but they also became important characters in the *Yellow Submarine* movie. When they are captured by the Blue Meanies, Pepperland is doomed without their music, and the plot of the movie revolves around the rescue of the band's members by The Beatles.

The iconic stripes of a sergeant's uniform have been used to decorate this hoodie—the stripes wrap around the yoke and a sergeant's chevron has been used to create the front pocket. It's made with raglan sleeves, and the hood of the sweater is finished with a twisted cord detail, made from the red yarn.

SIZES
Child sizes
4–6yrs:6–8yrs:**8–10yrs**:10–12yrs
Adult sizes
XS:S:M:**L**:XL:2XL:**3XL**:4XL

FINISHED MEASUREMENTS
Child sizes
Chest: **30½**:31½:**34**:35½ in. / **77**:80:**86**: 90 cm
Length to back neck: **12¾**:13¾:**15¾**: 17⅛ in. / **32.5**:35:**40**:43.5 cm
Sleeve length to underarm: **10¼**:12:**13½**: 15 in. / **26**:30:**34**:38 cm
Adult sizes
Chest: **38¼**:42½:**46⅞**:51:**55½**:59⅞:**63**: 68⅛ in. / **97**:108:**119**:130:**141**:152:**162**: 173 cm
Length to back neck:
23½:24:**24¼**:24½:**24⅝**:24¾:**25¼**:25⅜ in. / **59.5**:60:**61**:62:**62.5**:63:**64**:64.5 cm
Sleeve length to underarm: 18 in. / 46 cm (all adult sizes)

continued on the next page >>

YARN

DK weight (light #3), shown in Rico Essentials DK (100% wool; 131 yd. / 120 m per 2 oz. / 50 g ball)

Child sizes
MC: Natural (60), **5**:6:**6**:7 balls
CC1: Brick Red (79), 1 ball for each size
CC2: Yellow (65), 1 ball for each size

Adult sizes
MC: Natural (60), **9**:10:**11**:12:**13**:14:**15**:16 balls
CC1: Brick Red (79), **1**:2:**2**:2:**2**:2:**3**:3 ball(s)
CC2: Yellow (65), **2**:2:**2**:2:**2**:3:**3**:3 balls

NEEDLES

US 3 / 3.25 mm, US 5 / 3.75 mm, and US 6 / 4 mm needles (see Pattern Notes), or size needed to obtain gauge
US 3 / 3.25 mm and US 6 / 4 mm circular needles, or size needed to obtain gauge

NOTIONS

Tapestry needle
Stitch holders

GAUGE

22 sts and 28 rows = 4 in. / 10 cm square over St st using US 6 / 4 mm needles
Be sure to check your gauge.

ABBREVIATIONS

See page 201.

PATTERN NOTES

- On the larger adult sizes, it may be easier to use long circular needles and work back and forth.
- Short-row shaping is used when knitting the hood (see page 196).
- In the example shown in the photograph, a single yarn color has been used to make the twisted cord at the neck, but you could combine all three colors if you desire.

CHILD-SIZE SWEATER

BACK

Using US 5 / 3.75 mm needles and MC, cast on **82**(86:**94**:98) sts.
Rib row 1: K2, *p2, k2, rep from * to end.
Rib row 2: P2, *k2, p2, rep from * to end.
Rep these 2 rows 4 more times, inc **3**(3:**1**:1) st(s) evenly across the last row. (**85**(89:**95**:99) sts)
Change to US 6 / 4 mm needles.
Beg with a k row, work in St st until Back measures 6¼(7½:8¾:10) in. / **16**(19:**22**:25) cm from cast-on edge, ending with a p row.
Shape raglan armholes
Bind off **5**(6:**7**:8) sts at beg of next 2 rows. (**75**(77:**81**:83) sts)**
Foll the stripe sequence of **8**(8:**10**:10) rows MC, 4 rows CC1, [8 rows CC2, 4 rows CC1] twice, **8**(10:**10**:12) rows MC, cont as foll:
Next row: K to end.
Next row: P to end.
Next row: K2, skpo, k to last 4 sts, k2tog, k2. (**73**(75:**79**:81) sts)
Next row: P to end.
Rep the prev 4 rows twice more. (**69**(71:**75**:77) sts)
Next row: K2, skpo, k to last 4 sts, k2tog, k2. (**67**(69:**73**:75) sts)
Next row: P to end.
Rep the prev 2 rows **15**(16:**17**:18) more times. (**37**(37:**39**:39) sts)
Bind off.

FRONT

Work as for Back to **.
Foll the stripe sequence of **8**(8:**10**:10) rows MC, 4 rows CC1, [8 rows CC2, 4 rows CC1] twice, **8**(10:**10**:12) rows MC, cont as foll:
Next row: K to end.
Next row: P to end.
Next row: K**6**(7:**8**:9), skpo, k to last **8**(9:**10**:11) sts, k2tog, k**6**(7:**8**:9). (**73**(75:**79**:81) sts)

Next row: P to end.
Rep the prev 4 rows 2 more times. (**69**(71:**75**:77) sts)
Next row: K**6**(7:**8**:9), skpo, k to last **8**(9:**10**:11) sts, k2tog, k**6**(7:**8**:9). (**67**(69:**73**:75) sts)
Next row: P to end.
Rep the prev 2 rows **14**(15:**16**:17) more times, then the first of these 2 rows one more time. (**37**(37:**39**:39) sts)
Next row: P**16**(16:**17**:17), bind off 5 sts, p to end.
Place the 2 sets of sts on stitch holders.

SLEEVES (MAKE 2)

Using US 3 / 3.25 mm needles and MC, cast on **42**(42:**46**:46) sts.
Rib row 1: K2, *p2, k2, rep from * to end.
Rib row 2: P2, *k2, p2, rep from * to end.
Rep these 2 rows 5 more times, inc **2**(2:**0**:0) st(s) evenly across the last row. (**44**(44:**46**:46) sts)
Change to US 6 / 4 mm needles. Beg with a k row, work **2**(4:**4**:6) rows St st.
Inc row: K3, m1, k to last 3 sts, m1, k3.
Work 7 more rows in St st.
Rep the prev 8 rows **6**(7:**8**:9) more times, then rep the inc row once. (**60**(62:**66**:68) sts)
Cont in St st until Sleeve measures 10¼(12:13½:15) in. / **26**(30:**34**:38) cm from cast-on edge, ending with a p row.
Shape sleeve top
Bind off **5**(6:**7**:8) sts at beg of next 2 rows. (**50**(50:**52**:52) sts)
Foll the stripe sequence of **8**(8:**10**:10) rows MC, 4 rows CC1, [8 rows CC2, 4 rows CC1] twice, **8**(10:**10**:12) rows MC, cont as foll:
Next row: K to end.
Next row: P to end.
Next row: K2, skpo, k to last 4 sts, k2tog, k2. (**48**(48:**50**:50) sts)
Next row: P to end.
Rep the prev 4 rows **4**(5:**6**:8) more times. (**40**(38:**38**:34) sts)
Next row: K2, skpo, k to last 4 sts, k2tog, k2. (**38**(36:**36**:32) sts)
Next row: P to end.

Rep the prev 2 rows **11**(10:**9**:6) more times. (**16**(16:**18**:20) sts)
Bind off.

POCKET

Using US 6 / 4 mm needles and CC1, cast on **47**(47:**51**:51) sts.
Beg with a k row, work 2 rows in St st.
Foll the stripe sequence of [4 rows CC1, 8 rows CC2] 3 times, 5 rows CC1, cont as foll:
Next row: K2, m1, k**20**(20:**22**:22), s2kpo, k**20**(20:**22**:22), m1, k2.
Next row: P to end.
Maintaining stripe sequence, rep the prev 2 rows 19 more times.
Next row: K to end.
Bind off k-wise in CC1.

POCKET EDGINGS

With RS facing, using US 3 / 3.25 mm needles and CC1, pick up and k 32 sts along row ends on one side of Pocket.
K 4 rows then bind off.
Rep at other side of Pocket.

HOOD

With RS facing, using US 6 / 4 mm circular needle and MC, k**16**(16:**17**:17) sts from Right Front holder, turn, cast on **80**(80:**86**:86) sts, k**16**(16:**17**:17) from Left Front holder. (**112**(112:**120**:120) sts)
Next row: P to end.
Next 2 rows: K5, wrap 1, turn, p to end.
Next 2 rows: K10, wrap 1, turn, p to end.
Next 2 rows: K15, wrap 1, turn, p to end.
Next 2 rows: K20, wrap 1, turn, p to end.
Next row: K across all sts.
Next 2 rows: P5, wrap 1, turn, k to end.
Next 2 rows: P10, wrap 1, turn, k to end.
Next 2 rows: P15, wrap 1, turn, k to end.
Next 2 rows: P20, wrap 1, turn, k to end.
Next row: P across all sts.
Beg with a k row, work in St st until hood measures 8 in. / 20 cm.
Shape top
Dec row 1: K**53**(53:**57**:57), k2tog, k2, ssk, k**53**(53:**57**:57). (**110**(110:**118**:118) sts)

Next row: P to end.
Dec row 2: K**52**(52:**56**:56), k2tog, k2, ssk, k**52**(52:**56**:56). (**108**(108:**116**:116) sts)
Next row: P to end.
Cont in St st, dec as set, until **88**(88:**96**:96) sts rem.
P 1 row.
Next row: K**44**(44:**48**:48), turn and work on these sts only for first side of hood.
Next row: Bind off 8 sts, p to end.
Next row: K to end.
Rep prev 2 rows 3 more times. (**12**(12:**16**:16) sts)
Bind off.
With RS facing, rejoin yarn to rem sts.
Next row: Bind off 8 sts, k to end.
Next row: P to end.

Rep prev 2 rows 3 more times. (**12**(12:**16**:16) sts)
Bind off.

HOOD EDGING

Fold hood in half and join top seam.
With RS facing, using US 3 / 3.25 mm circular needle and MC, pick up and k 146 sts evenly around row ends at edge of hood.
Rib row 1: K2, *p2, k2, rep from * to end.
Rib row 2: K4, *p2, k2, rep from * to last 6 sts, p2, k4.
Work 3 more Rib rows.
Bind off rib-wise.

FINISHING

See Adult size.

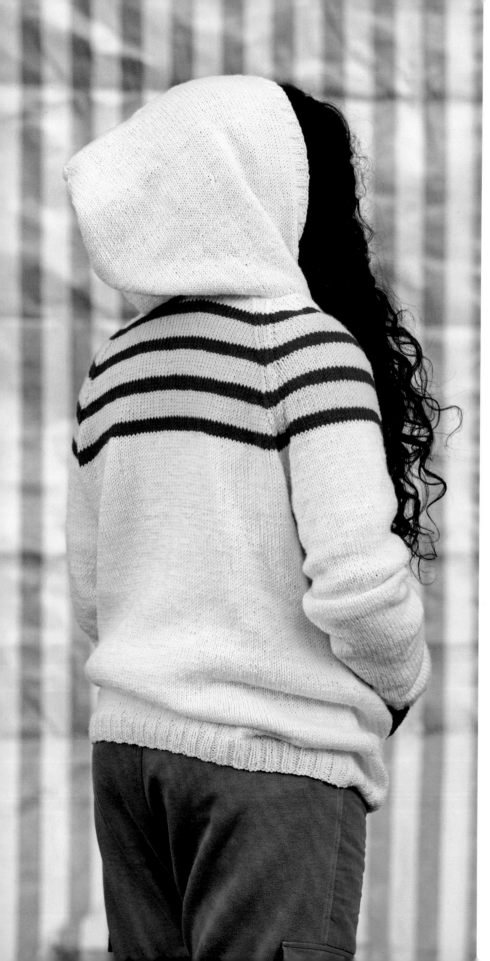

ADULT-SIZE SWEATER

BACK

Using US 5 / 3.75 mm needles and MC, cast on **106**(118:**130**:142:**154**:166: **178**:190) sts.

Rib row 1: K2, *p2, k2, rep from * to end.

Rib row 2: P2, *k2, p2, rep from * to end.

Rep these 2 rows 4 more times, inc 1 st at center of last row. (**107**(119:**131**: 143:**155**:167:**179**:191) sts)

Change to US 6 / 4 mm needles.

Beg with a k row, work in St st until Back measures 15¼ in. / 39 cm from cast-on edge, ending with a p row.

Shape raglan armholes

Bind off **4**(6:**8**:10:**12**:14:**16**:18) sts at beg of next 2 rows. (**99**(107:**115**:123: **131**:139:**147**:155) sts)

Foll the stripe sequence of **8**(8:**10**:10:**12**:12:**14**:14) rows MC, 4 rows CC1, [8 rows CC2, 4 rows CC1] 3 times, **8**(10:**10**:12:**12**:14:**14**:16) rows MC, cont as foll:

Next row: Bind off 2 sts, k to last 2 sts, skpo. (**96**(104:**112**:120:**128**:136: **144**:152) sts)

Next row: Bind off 2 sts, p to last 2 sts, p2tog. (**93**(101:**109**:117:**125**:133: **141**:149) sts)

Rep prev 2 rows **0**(1:**2**:3:**4**:5:**6**:7) more time(s). (**93**(95:**97**:99:**101**:103: **105**:107) sts)**

Next row: K2, skpo, k to last 4 sts, k2tog, k2. (**91**(93:**95**:97:**99**:101:**103**:105) sts)

Next row: P to end.

Rep prev 2 rows 26 more times. (**39**(41:**43**:45:**47**:49:**51**:53) sts)

Bind off.

FRONT

Work as for Back to **.

Next row: K**6**(7:**8**:9:**10**:11:**12**:13), skpo, k to last **8**(9:**10**:11:**12**:13:**14**:15) sts, k2tog, k**6**(7:**8**:9:**10**:11:**12**:13). (**91**(93:**95**:97:**99**:101:**103**:105) sts)

Next row: P to end.

Rep prev 2 rows 25 more times,
then rep the first row once.
(**39**(41:**43**:45:**47**:49:**51**:53) sts)

Next row: P17(18:**19**:20:**21**:22:**23**:24),
bind off 5 sts, p to end.

Place these 2 sets of sts on stitch holders
for the Right and Left Fronts.

SLEEVES (MAKE 2)

Using US 3 / 3.25 mm needles and MC,
cast on 42(46:**54**:58:**66**:70:**78**:82) sts.

Rib row 1: K2, *p2, k2, rep from * to end.
Rib row 2: P2, *k2, p2, rep from * to end.

Rep these 2 rows 4 more times, inc 3 sts
evenly across last row. (**45**(49:**57**:61:
69:73:**81**:85) sts)

Change to US 6 / 4 mm needles.

Beg with a k row, work 6 rows in St st.

Inc row: K4, m1, k to last 4 sts, m1, k4.
(**47**(51:**59**:63:**71**:75:**83**:87) sts)

Work 9 more rows in St st.

Rep the prev 10 rows 9 more times, then
rep the inc row once. (**67**(71:**79**:83:**91**:
95:**103**:107) sts)

Cont in St st until Sleeve measures
18 in. / 46 cm from cast-on edge,
ending with a p row.

Shape sleeve top

Bind off **4**(6:**8**:10:**12**:14:**16**:18)
sts at beg of next 2 rows.
(**59**(59:**63**:63:**67**:67:**71**:71) sts)

Foll the stripe sequence of
12(14:**18**:20:**24**:26:**28**:32) rows MC,
4 rows CC1, [8 rows CC2, 4 rows CC1]
3 times, **8**(10:**10**:12:**12**:14:**14**:16)
rows MC, cont as foll:

Next row: K2, skpo, k to last 4 sts,
k2tog, k2. (**57**(57:**61**:61:**65**:65:**69**:
69) sts)

Next row: P to end.

Next row: K to end.

Next row: P to end.

Rep the prev 4 rows **10**(12:**13**:15:**16**:
18:**19**:21) more times. (**37**(33:**35**:31:
33:29:**31**:27) sts)

Sizes XS:S:M:L:XL:2XL:3XL only:

Next row: K2, skpo, k to last 4 sts, k2tog,
k2. (**35**(31:**33**:29:**31**:27:**29**:0) sts)

Next row: P to end.

Rep the prev 2 rows **7**(5:**5**:3:**3**:1:**1**:0)
more times. (**21**(21:**23**:23:**25**:25:**27**:
0) sts)

All sizes:
Bind off.

POCKET

Using US 6 / 4 mm needles and CC1,
cast on **55**(59:**63**:67:**71**:75:**79**:83) sts.

Beg with a k row, work 2 rows in St st.

Foll the stripe sequence of [4 rows CC1,
8 rows CC2] 4 times, 5 rows CC1, cont
as foll:

Next row: K2, m1, k24(26:**28**:30:**32**:
34:**36**:38), s2kpo, k24(26:**28**:30:**32**:
34:**36**:38), m1, k2.

Next row: P to end.

Maintaining stripe sequence, rep the
prev 2 rows 25 more times.

Next row: K to end.

Bind off k-wise in CC1.

POCKET EDGINGS

With RS facing, using US 3 / 3.25 mm
needles and CC1, pick up and k 42 sts
along row ends on one side of Pocket.

K 4 rows.

Bind off.

Rep at other side of Pocket.

HOOD

With RS facing, using US 6 / 4
mm circular needle and MC,
k**17**(18:**19**:20:**21**:22:**23**:24) sts from
Right Front holder, turn, cast on
92(94:**98**:100:**104**:106:**110**:112) sts,
k**17**(18:**19**:20:**21**:22:**23**:24) from Left
Front holder. (**126**(130:**136**:140:**146**:
150:**156**:160) sts)

Next row: P to end.

Next 2 rows: K5, wrap 1, turn, p to end.
Next 2 rows: K10, wrap 1, turn, p to end.
Next 2 rows: K15, wrap 1, turn, p to end.
Next 2 rows: K20, wrap 1, turn, p to end.
Next 2 rows: K25, wrap 1, turn, p to end.
Next 2 rows: K across all sts.
Next 2 rows: P5, wrap 1, turn, k to end.
Next 2 rows: P10, wrap 1, turn, k to end.
Next 2 rows: P15, wrap 1, turn, k to end.
Next 2 rows: P20, wrap 1, turn, k to end.
Next 2 rows: P25, wrap 1, turn, k to end.
Next row: P across all sts.

Beg with a k row, work in St st until hood
measures 9 in. / 23 cm from cast-on
edge.

Shape top

Dec row 1: K60(62:**65**:67:**70**:72:**75**:77),
k2tog, k2, ssk, k60(62:**65**:67:**70**:72:
75:77). (**124**(128:**134**:138:**144**:148:
154:158) sts)

Next row: P to end.

Dec row 2: K59(61:**64**:66:**69**:71:**74**:76),
k2tog, k2, ssk, k59(61:**64**:66:**69**:71:
74:76). (**122**(126:**132**:136:**142**:146:
152:156) sts)

Next row: P to end.

Cont in St st, dec as set, until **106**(110:
116:120:**126**:130:**136**:140) sts rem.

P 1 row.

Next row: K53(55:**58**:60:**63**:65:**68**:70),
turn and work on these sts only for first
side of hood.

Next row: Bind off 10 sts, p to end.

Next row: K to end.

Rep prev 2 rows 3 more times. (**13**(15:
18:20:**23**:25:**28**:30) sts)

Bind off.

With RS facing, rejoin yarn to rem sts.

Next row: Bind off 10 sts, k to end.

Next row: P to end.

Rep prev 2 rows 3 more times.
(**13**(15:**18**:20:**23**:25:**28**:30) sts)

Bind off.

HOOD EDGING

Fold hood in half and join top seam.

With RS facing, using US 3 / 3.25 mm
circular needle and MC, pick up and
k 162 sts evenly around row ends at
edge of hood.

Rib row 1: K2, *p2, k2, rep from * to end.
Rib row 2: K4, *p2, k2, rep from * to last
6 sts, p2, k4.

Work 3 more Rib rows.

Bind off rib-wise.

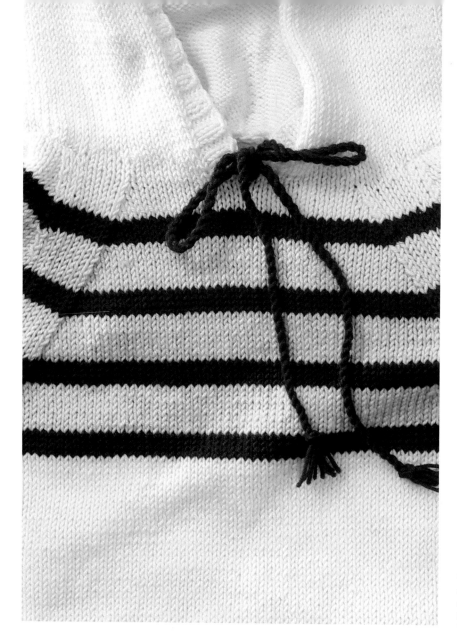

« *LEFT*
Make a twisted cord in red or yellow and attach it at the center neck.

FINISHING

Weave in yarn ends and block (see page 199 for more on blocking).

Beginning at neck edge, join the raglan seams as far as the bound-off edges on Front and Back, then join the remainder of Sleeve row ends to the bound-off edges on Back and Front.

Sew the cast-on edge of the Hood to the bound-off edges of the Back and Sleeves. Join the side and Sleeve seams. Sew the row ends of the Hood edging to the bound-off sts at the center front.

Sew the Pocket onto the Front, with the point at the base just above the center of the ribbing; leave the sides open.

Making a twisted cord

Cut 3 lengths of CC1, each 94½ in. / 240 cm long, and knot them together at one end. Loop the knotted end over a sturdy hook or door handle. Tie the unknotted end of the lengths of yarn to a spare knitting needle, then turn it in one direction until the lengths of yarn are twisted, keeping the yarn taut as you do so. Using your finger and thumb, take hold of the center of the twisted yarns and fold at this point so that the yarns come together and twist around each other. Run your fingers down the twisted cord to smooth it out. Unloop the knotted end from the hook or door handle and knot together the opposite ends.

Find the center of the twisted cord and sew this securely to the center of the neck on the Front. Tie the cord into a bow. (Note: If making the hoodie for a very young child, it may be advisable to omit the cord.)

CHILD SIZES

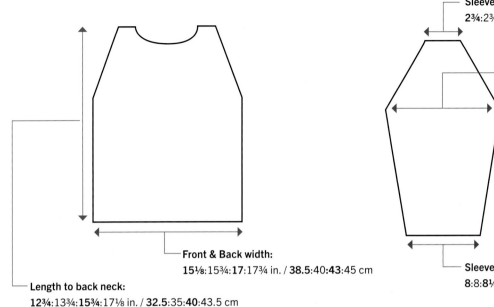

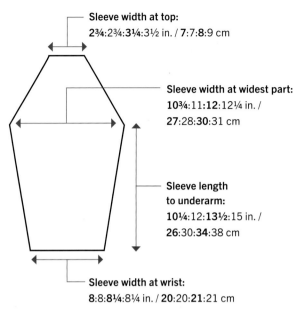

Sleeve width at top:
2¾:2¾:3¼:3½ in. / 7:7:8:9 cm

Sleeve width at widest part:
10¾:11:12:12¼ in. /
27:28:30:31 cm

Sleeve length
to underarm:
10¼:12:13½:15 in. /
26:30:34:38 cm

Front & Back width:
15⅛:15¾:17:17¾ in. / 38.5:40:43:45 cm

Length to back neck:
12¾:13¾:15¾:17⅛ in. / 32.5:35:40:43.5 cm

Sleeve width at wrist:
8:8:8¼:8¼ in. / 20:20:21:21 cm

ADULT SIZES

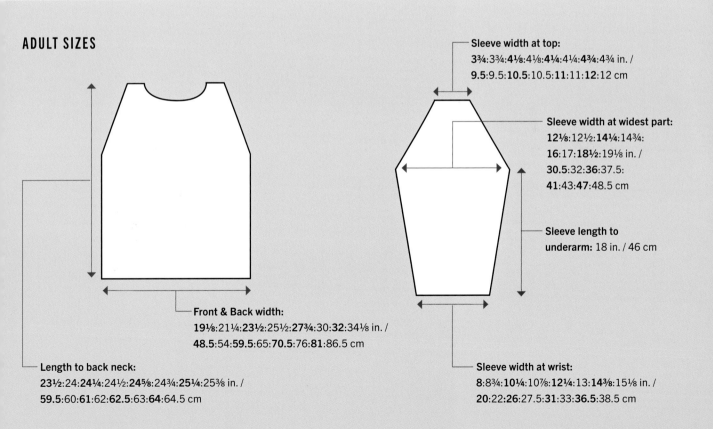

Sleeve width at top:
3¾:3¾:4⅛:4⅛:4¼:4¼:4¾:4¾ in. /
9.5:9.5:10.5:10.5:11:11:12:12 cm

Sleeve width at widest part:
12⅛:12½:14¼:14¾:
16:17:18½:19⅛ in. /
30.5:32:36:37.5:
41:43:47:48.5 cm

Sleeve length to
underarm: 18 in. / 46 cm

Front & Back width:
19⅛:21¼:23½:25½:27¾:30:32:34⅛ in. /
48.5:54:59.5:65:70.5:76:81:86.5 cm

Length to back neck:
23½:24:24¼:24½:24⅝:24¾:25¼:25⅜ in. /
59.5:60:61:62:62.5:63:64:64.5 cm

Sleeve width at wrist:
8:8¾:10¼:10⅞:12¼:13:14⅜:15⅛ in. /
20:22:26:27.5:31:33:36.5:38.5 cm

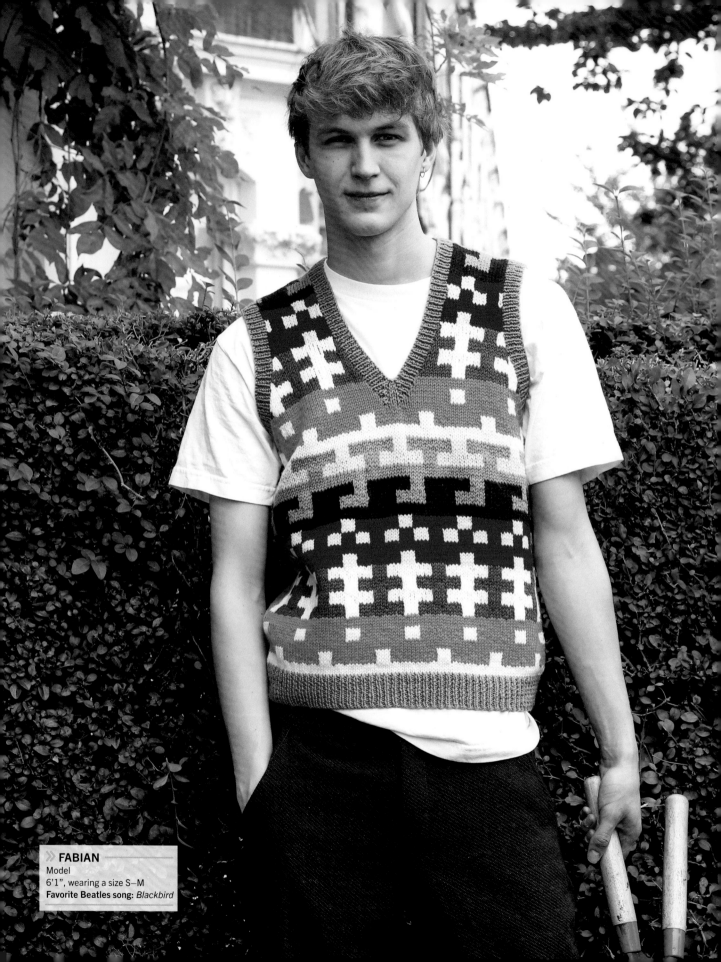

⟫ FABIAN
Model
6'1", wearing a size S—M
Favorite Beatles song: *Blackbird*

PAUL'S FAIR ISLE SWEATER VEST

Designed by **Caroline Smith**
Skill level ●●●

In the *Magical Mystery Tour* movie, Paul McCartney can be seen wearing a colorful knitted sweater vest that drew on traditional Fair Isle garments. It followed a popular trend of the '60s, when fashions were often heavily influenced by heritage clothing and textiles.

Paul's sweater vest is made up of many rows of different color and pattern combinations. This version is inspired by that sweater vest, but it takes some of the motifs and enlarges them to create a traditional design with a twist. Although made up of several colors, no more than two shades are used in every row. It's made using the Fair Isle technique (see page 195), so the color that's not being knitted is carried across the back of the work.

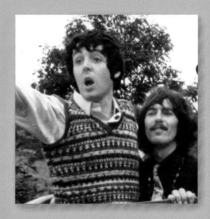

Released on December 26, 1967, the Magical Mystery Tour *features The Beatles traveling aboard a brightly decorated, blue-and-yellow, sixty-seater bus, along with a motley group of strangers.*

The coach was a British Bedford VAL with a license plate reading URO 913E. Much of the movie was shot in England—at a disused airfield in the county of Kent and locations in the West Country.

SIZES

Child 4—6yrs:Child 8yrs—XS:S—M:
L—XL:2XL—3XL

FINISHED MEASUREMENTS

Chest: 26:32:**38**:44:**50** in. / 66:82:**97**:112:
127 cm
Length to shoulder: 12⅛:20¼:**23⅛**:25⅜:
27⅜ in. / **30.5**:51.5:**58.5**:64.5:**69.5** cm

YARN

DK weight (medium #4), shown in Cascade Yarns, 220 Superwash® (100% wool; 220 yd. / 200 m per 3½ oz. / 100 g ball)
MC: Desert Sun (253), **1**:2:**3**:3:**3** ball(s)
CC1: Yellow (824), 1 ball for each size
CC2: Verdant Green (352), 1 ball for each size
CC3: Cobalt Heather (1925), 1 ball for each size
CC4: White (871), 1 ball for each size
CC5: Really Red (809), 1 ball for each size
CC6: Mint (1942), 1 ball for each size
CC7: Black (815), 1 ball for each size

continued on the next page >>

NEEDLES

US 5 / 3.75 mm and US 6 / 4 mm needles,
or size needed to obtain gauge
US 5 / 3.75 mm circular needle, or size
needed to obtain gauge

NOTIONS

Safety pin (see Pattern Notes)
Stitch holder (see Pattern Notes)
Stitch markers
Tapestry needle

GAUGE

21 sts and 28 rows = 4 in. / 10 cm over
Fair Isle pattern using US 6 / 4 mm needles
Be sure to check your gauge.

ABBREVIATIONS

See page 201.

PATTERN NOTES

- Because this vest starts with a ribbed
 edge, the alternating cable cast on has
 been used. If preferred, you can use a
 simple knitted cast on or cable cast on.
 (See page 194 for information about
 different cast ons.)
- For larger sizes, you might find it easier
 to use a circular needle; for the sample
 shown here, a circular needle was used
 for the neckband stitches.
- The ribbing used is 1x1: *k1, p1, rep
 from * to end.
- The pattern is worked using the Fair Isle
 technique (see page 195).
- As the back and front are blocked before
 being joined to complete the neckband
 and armbands, use a rustproof safety pin
 and stitch holder or a length of spare yarn
 to hold the back and front neck stitches.

THE SWEATER VEST

BACK

Using US 5 / 3.75 mm needles and MC,
cast on **70**(86:**102**:118:**134**) sts using
the alternating cable cast on (see
page 194).
Work **10**(12:**16**:18:**20**) rows in 1x1 rib.
Change to US 6 / 4 mm needles and
work in St st for **7**(12:**13¾**:15:
15¾) in. / **18**(30:**35**:38:**40**) cm,
ending with a WS row.**
Shape armholes
Bind off **6**(8:**9**:11:**13**) sts at beg of next
2 rows. (**58**(70:**84**:96:**108**) sts)
Cont in St st, dec 1 st at each end of
next and foll **4**(6:**7**:8:**9**) alt rows.
(**48**(56:**68**:78:**88**) sts)
Cont until work measures
12⅛(20¼:**23⅛**:25⅜:**27⅜**) in. /
30.5(51.5:**58.5**:64.5:**69.5**) cm from
cast-on edge, ending with a WS row.
Shape shoulders
Bind off **6**(7:**9**:11:**12**) sts at beg of next
2 rows, then **8**(9:**10**:11:**14**) sts at beg
of next 2 rows.
Leave rem **20**(24:**30**:34:**36**) sts on a
stitch holder or length of spare yarn.

FRONT

Work as for Back to **, foll chart (see
page 68) to work patt over St st.
Shape left armhole and neck edge
Maintaining patt, dec as foll:
Bind off **6**(8:**9**:11:**13**) sts at beg of next
2 rows. (**58**(70:**84**:96:**108**) sts)
Next row: K1, k2tog, k**23**(29:**36**:42:**48**),
k2tog, turn, and leave rem
30(36:**43**:49:**55**) sts on a stitch
holder. (**26**(32:**39**:45:**51**) sts)
Next row: P to end.
Next row: K1, k2tog, k to end.
Next row: P to end.
Maintaining patt and St st, cont to dec
as foll:
Dec 1 st at armhole edge on next and
foll **3**(4:**5**:5:**5**) alt rows, then keep
armhole straight; AT SAME TIME, dec
1 st at neck edge on next and every

foll 4th row until **14**(16:**19**:22:**26**) sts
rem, ending with a WS row.
Cont in patt until Left Front measures
same as Back, ending on a WS row.
Shape left shoulder
Bind off **6**(7:**9**:11:**12**) sts at beg of next
row.
P 1 row.
Bind off.
Shape right armhole and neck edge
With RS facing, sl center 2 sts onto
a safety pin; rejoin yarn and,
maintaining patt, dec as foll:
Next row: K2tog, k to last 3 sts, k2tog,
k1. (**26**(32:**39**:45:**51**) sts)
Cont as for Left Front, reversing
shaping.

NECKBAND

Weave in yarn ends on Back and Front
and block both pieces.
Join the left shoulder seam.
With RS facing, transfer back neck sts
to a US 5 / 3.75 mm circular needle.
Join on MC and pick up and k 1 st
for each row down left neck edge,
ensuring you have an even number;
PM; sl 2 sts from safety pin onto the
other tip of the needle and k them;
PM; pick up and k 1 st for each row
up right neck edge, ensuring you
have same number of sts as left
neck edge, turn.
Row 1: Beg with a k st, work in 1x1 rib to
2 sts before first SM, ssk, sl SM, p2, sl
SM, k2tog, cont in 1x1 rib
to end.
Row 2: Work in rib to 2 sts before
SM, ssk, sl SM, k2, sl SM, k2tog,
rib to end.
Rep these 2 rows **1**(2:**2**:2:**2**) more
time(s).
Bind off rib-wise as far as SM, remove
SM, p2tog, cont to bind off rib-wise,
removing second SM.

ARMBANDS

Join right shoulder seam and neckband.
Using US 5 / 3.75 mm needles and MC,
with RS facing, pick up and k 1 st for

each st at base of armhole shaping on Back, 1 st for each row around armhole edge and 1 st for each st at base of armhole shaping on Front, ensuring you have an even number.
Work **5**(6:**6**:6:**6**) rows in 1x1 rib.
Bind off rib-wise.
Rep for other armhole, ensuring you have same number of sts as first armhole.

FINISHING
Lightly block the neckband and armbands.
Join the side seams and edges of neckband, then weave in any remaining loose ends.

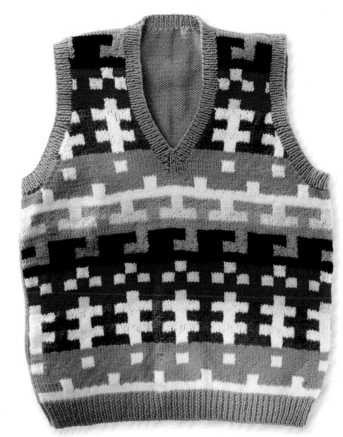

BELOW
Paul sports his iconic Fair Isle sweater vest in the Magical Mystery Tour *movie.*

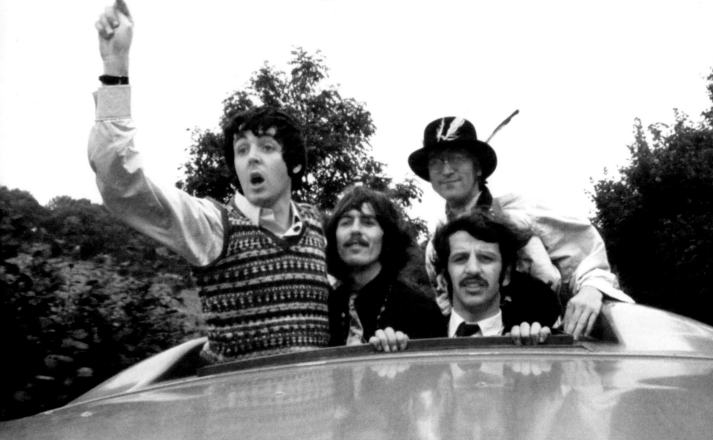

CHART

KEY

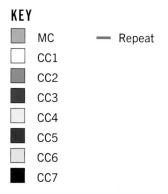

▨	MC	— Repeat
☐	CC1	
▨	CC2	
▓	CC3	
☐	CC4	
▓	CC5	
▨	CC6	
■	CC7	

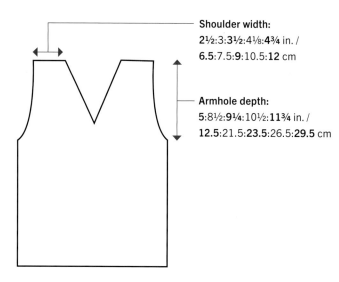

Shoulder width:
2½:3:3½:4⅛:4¾ in. /
6.5:7.5:**9**:10.5:**12** cm

Armhole depth:
5:8½:**9¼**:10½:**11¾** in. /
12.5:21.5:**23.5**:26.5:**29.5** cm

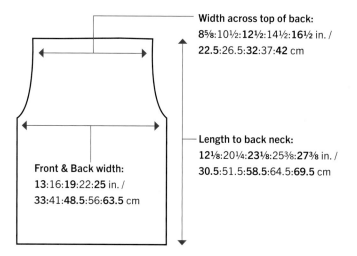

Width across top of back:
8⅝:10½:**12½**:14½:**16½** in. /
22.5:26.5:**32**:37:**42** cm

Front & Back width:
13:16:**19**:22:**25** in. /
33:41:**48.5**:56:**63.5** cm

Length to back neck:
12⅛:20¼:**23⅛**:25⅜:**27⅜** in. /
30.5:51.5:**58.5**:64.5:**69.5** cm

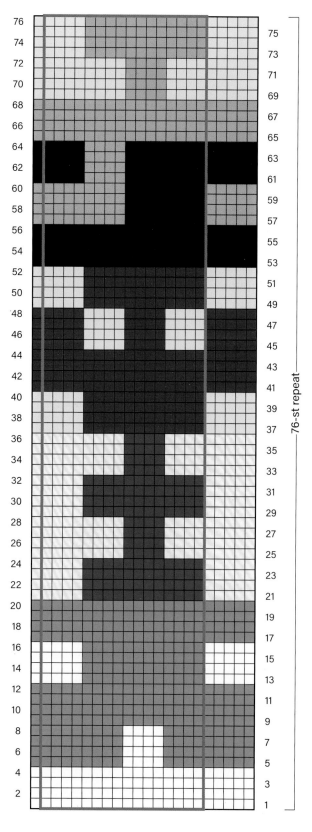

16-st repeat

76-st repeat

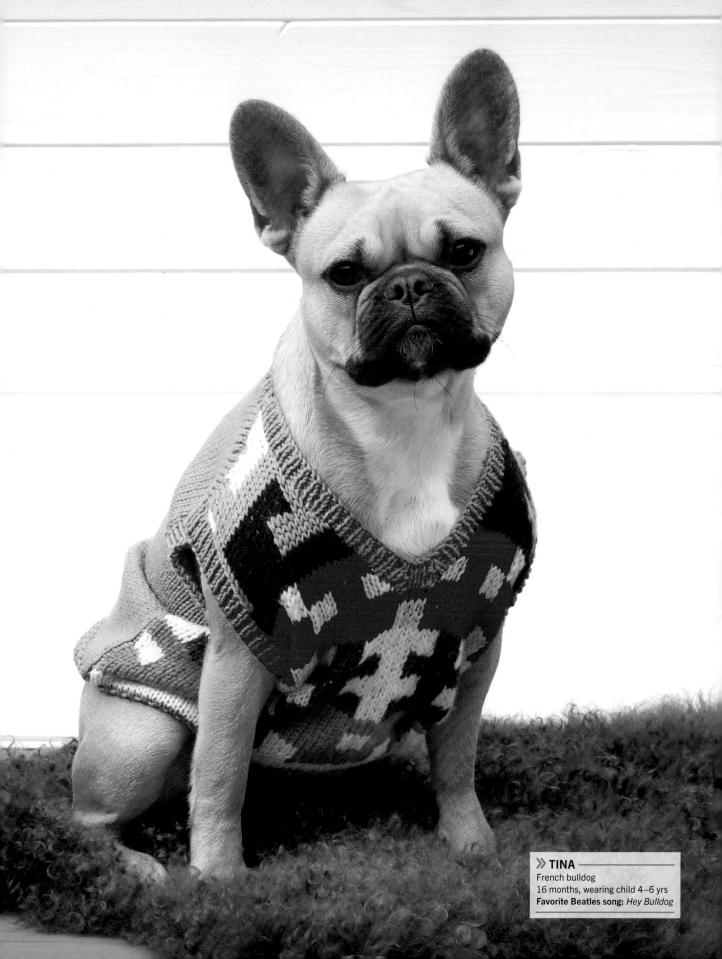

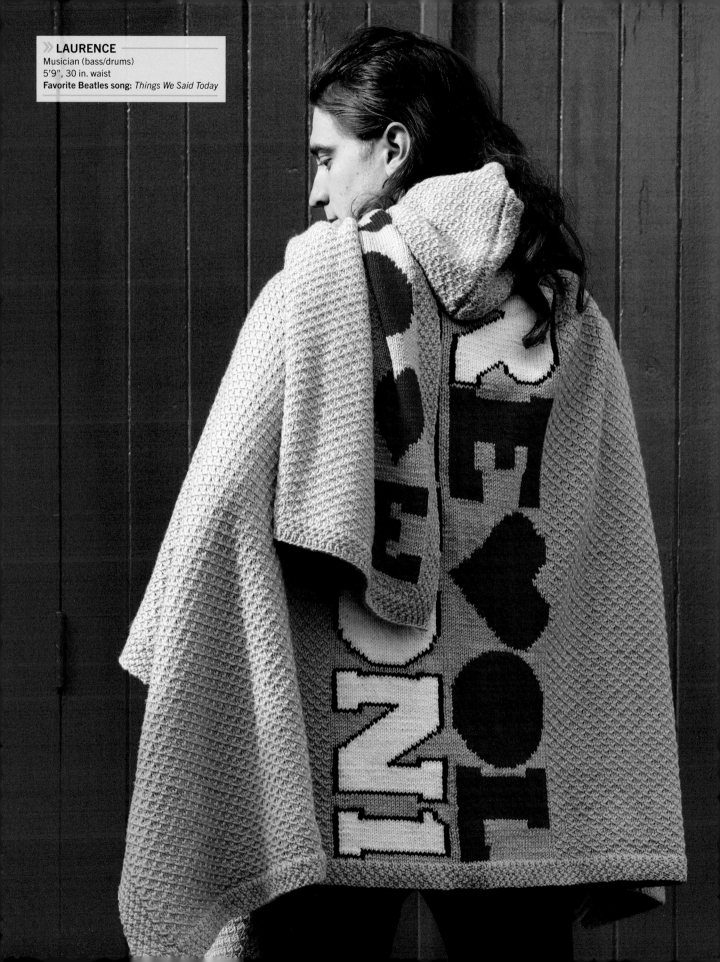

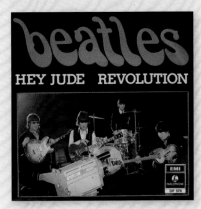

"Revolution" was released as the B-side to "Hey Jude"—the single came out in August 1968.

A version of the track appeared later the same year on The Beatles (a.k.a. The White Album*).*

SIZE
One size

FINISHED MEASUREMENTS
Width: 51 in. / 130 cm
Back Length: 29½ in. / 75 cm

YARN
DK weight (medium #4), shown in Cascade Yarns, 220 Superwash® (100% wool; 220 yd. / 200 m per 3. oz. / 100 g ball)
MC: Irish Cream (349), 11 balls
CC1: Really Red (809), 1 ball
CC2: Ecru (817), 1 ball
CC3: Black (815), 1 ball

NEEDLES
US 6 / 4 mm circular needle, 48 in. / 120 cm long, or size needed to obtain gauge

NOTIONS
Tapestry needle
Stitch markers
Stitch holder(s) (see Pattern Notes)
Row counter (see Pattern Notes)

GAUGE
22 sts and 30 rows = 4 in. / 10 cm over twisted-st patt using US 6 / 4 mm needles

ABBREVIATIONS
See page 201.

REVOLUTION RUANA WRAP

Designed by **Cécile Jeffrey**
Skill level 🍎🍎

As well as being issued as the flip side of "Hey Jude," "Revolution" came out on the LP that would come to be known as *The White Album*—the first album released by the band on the Apple label. The lettering design that runs down the back of this wrap uses the "Revolution" graphic; the word *love*—which can be seen running backward within the word *revolution*—appears on the front. Hearts replace the letter *V* in both words.

A ruana is similar to a poncho; it drapes over the shoulders but has an opening at the front and often has a hood. Worked in a warm, pure wool yarn, this one-size garment makes a cozy cover-up to wear from fall through spring.

continued on the next page >>

PATTERN NOTES

- The cast on used here is the backward loop technique (see page 194).
- The ruana is knitted in one piece, beginning at the bottom edge of the back. The right-hand shoulder is shaped before working the right front; the yarn is rejoined to the left shoulder to shape that, and then the left front is worked. The hood is created in two sections, with stitches picked up around the neckline, and then seamed together.
- The panels of lettering on both front and back are worked in intarsia (see page 196) over stockinette stitch, following the charts on pages 74–75. Placing a stitch marker on either side of the panel will help you keep track of its position. On the back, the intarsia design begins on a wrong-side row, so remember to read that chart row of the chart from left to right. Wind separate balls of the different colors and twist them together where they join to avoid holes in the finished work.
- For more on reading charts, see page 196.
- As this is a large piece of knitting, it is a good idea to use a row counter.
- When you begin shaping the right shoulder, the remaining stitches are transferred to a stitch holder. Because there are a large number of stitches, you may find you need more than one holder. Stitch markers can also help you keep track of the position of your turns as you work the short rows that shape the shoulders (see page 196).

THE RUANA

THE BODY

Using US 6 / 4 mm needles and MC, cast on 286 sts using the backward loop technique (see page 194).

Row 1: *K1, p1, rep from * to end.

Row 2: Rep Row 1.

Row 3: *P1, k1, rep from * to end.

Row 4: Rep Row 3.

Rep these 4 rows once more.

Row 9: [K1, p1] 4 times, k106, PM, k58, PM, k to last 8 sts, [k1, p1] 4 times.

Back intarsia panel

Foll Back chart, work as foll, sl SM as you go:

Row 10 (WS): Using MC, [k1, p1] 4 times, p106; p58 sts from Row 1 of Back Chart; using MC, p106, [k1, p1] 4 times.

Row 11: Using MC, [p1, k1] 4 times, [TW2, k2] 26 times, TW2; k58 sts from Row 2 of Back Chart; using MC, [TW2, k2] 26 times, TW2, [p1, k1] 4 times.

Row 12: Using MC, [p1, k1] 4 times, p106; p58 sts from Row 3 of Back Chart; using MC, p106, [p1, k1] 4 times.

Row 13: Using MC, [k1, p1] 4 times, [k2, TW2] 26 times, k2; k58 sts from Row 4 of Back Chart; using MC, [k2, TW2] 26 times, k2, [k1, p1] 4 times.

These 4 rows set the position of the charted design, with moss st borders and twisted-st patt on either side.

Cont to work as set until Row 202 has been worked.

Shape back shoulders

Row 203 (RS): Work as set to last 6 sts, turn.

Row 204: Rep row 203.

Rows 205 to 209: Work as set to 6 sts before the turn on prev row, turn.

NOTE: Charted design for the Back is complete, discard SM and cont in MC only, working twisted-st patt as set.

Row 210: P to 6 sts before the turn on prev row, turn.

Row 211: Work in twisted-st patt to 6 sts before the turn on prev row, turn.

Rep prev 2 rows 6 times more, then rep Row 210 once.

Shape right back neck

Row 225: Work in twisted-st patt for 59 sts, leave rem sts on a holder(s), turn and work on these 59 sts only.

Row 226: P2tog, p to 6 sts before the turn on prev row, turn.

Row 227: Work in twisted-st patt patt to end.

Rep these 2 rows 3 times more.

Shape right neck and shoulders

Row 234: P to turn on prev row, then p 3 of the next unworked sts, turn and work on these 34 sts.

Row 235: Work in twisted-st patt to end.

Row 236: P34, then p 6 of the next unworked sts, turn and work on these 40 sts.

Row 237: Rep Row 235.

Row 238: P40, then p 6 of the next unworked sts, turn and work on these 46 sts.

Cont to work in the same way, working into 6 of the unworked sts on the left-hand needle on even-numbered rows until Row 262 is worked AND AT SAME TIME, beg at Row 256, inc 1 st at neck edge on every foll row.

Row 263: Work in moss st for 2 sts, k1, work in twisted-st patt to last 2 sts, kfb, k1.

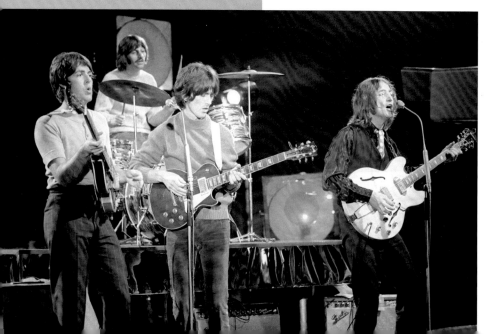

RE♥OL UTION1

Row 264: P1, pfb, p119, work in moss st for 5 sts, then work in moss st across last 3 unworked sts. (130 sts)

Row 265: Work in moss st for 8 sts, work in twisted-st patt to last 2 sts, kfb, k1. (131 sts)

Row 266: P1, pfb, p to last 8 sts, work in moss st to end. (132 sts)

Cont in twisted-st patt on RS with p rows on WS, with border of 8 moss sts at right-hand side AND AT SAME TIME inc 1 st at neck edge on every row until there are 141 sts.

Right front

Row 276: Work in moss st for 8 sts, p to last 8 sts, work in moss st to end.

Row 277: Work in moss st for 8 sts, work in twisted-st patt to last 9 sts, k1, work in moss st to end.

Rep prev 2 rows 10 times more, then rep Row 276 once.

Front intarsia panel

Foll Front Chart, work as foll:

Row 299: Using MC, work in moss st for 8 sts, work in twisted-st patt for 104 sts; k21 sts from Row 1 of Front Chart; using MC, work in moss st to end.

Row 300: Using MC, work in moss st for 8 sts; p21 sts from Row 2 of Front Chart; using MC, work in twisted-st patt for 104 sts, work in moss st to end.

These 2 rows set the position of the charted design, with a moss st border on one side and a twisted-st patt and moss st border on the other side.

Cont to work as set until Row 449 has been worked and the charted design has been completed.

Row 450: Work in moss st for 8 sts, p to last 8 sts, work in moss st to end.

Row 451: Work in moss st for 8 sts, work in twisted-st patt to last 9 sts, k1, work in moss st to end.

Rep prev 2 rows twice more, then rep Row 450 once.

Rows 457 to 464: Rep Rows 1 to 8. Bind off in patt.

Shape back left shoulder and neck

Return to sts on holder. Leave 36 sts on holder for back neck and with RS facing place rem sts back onto the circular needle, rejoin MC.

Row 225: K2tog, work in twisted-st patt for 51 sts, turn and work on these 52 sts only.

Row 226: P to end.

Row 227: K2tog, work in twisted-st patt to 6 sts before the turn on prev row, turn.

Rep these 2 rows twice more, then rep Row 226 once.

Shape left front neck and shoulders

Row 233: Work in twisted-st patt to turn on prev row, then work over 3 of the next unworked sts, turn and work on these 34 sts.

Row 234: P to end.

Row 235: Work in twisted-st patt for 34 sts, then work over 6 of the next unworked sts.

Row 236: Rep Row 234.

Row 237: Work in twisted-st patt for 40 sts, then work over 6 of the next unworked sts.

Cont to work in the same way, working into 6 of the unworked sts on left-hand needle on odd-numbered rows until Row 260 is worked AND AT

SPECIAL NOTES

- Two stitch patterns are used over the body of the ruana—moss stitch and a twisted-stitch pattern.
- For the moss stitch, work a repeat of k1, p1 for two rows, then a repeat of p1, k1 for the next two rows.
- To work the twisted stitch (TW2), slip the next stitch on the left-hand needle onto the right-hand needle, then knit the next stitch on the left-hand needle. Use the tip of the left-hand needle to lift the slipped stitch over the stitch just knitted, then knit into the back of the slipped stitch. To work the pattern, work a repeat of [k2, TW2] on one row, followed by a repeat of [TW2, k2] on the next knit row. When you work the twisted-stitch pattern over an odd number of stitches, work one knit stitch at either the beginning or the end of the row, depending on where the "twist" falls on the previous right-side row.

SAME TIME, beg at Row 255, inc 1 st at neck edge of every foll row.

Row 261: Kfb, work in twisted-st patt to turn on prev row, then work in twisted-st patt over the next unworked st, then work moss st over 5 of next unworked sts, turn.

Row 262: Work in moss st for 5 sts, then p to last st, pfb.

Row: 263: Kfb, work in twisted-st patt to 5 sts before turn on prev row, work 5 sts in moss st, then cont in moss st over 3 rem unworked sts. (130 sts)

Row 264: Work in moss st for 8 sts, then p to last st, pfb. (131 sts)

Row 265: Kfb, work in twisted-st patt to last 8 sts, work in moss st to end. (132 sts).

Cont in twisted-st patt on RS with p rows on WS and with border of 8 moss sts at left-hand side AND AT SAME TIME inc 1 st at neck edge on every row until there are 141 sts.

Left front

Row 275: Work in moss st for 8 sts, work in twisted-st patt to last 8 sts, work in moss st to end.

Row 276: Work in moss st for 8 sts, p to last 8 sts, work in moss st to end.

Rep prev 2 rows until Row 456 has been worked.

Rows 457 to 464: Rep Rows 1 to 8.

Bind off in patt.

RIGHT HOOD

Using US 6 / 4 mm needles and with RS facing, pick up and k 48 sts around right side of neck and 18 sts from holder across back neck.

Row 1 (WS): P to last 8 sts, work in moss st to end.

Row 2: Work in moss st for 8 sts, work in twisted-st patt to end.

Work in twisted-st patt with moss st border for 84 rows, dec 1 st at beg of next row and at same edge of every foll row to row 96.

Bind off in patt.

LEFT HOOD

Using US 6 / 4 mm needles and with RS facing, k 18 sts from holder across back neck and pick up and k 48 sts around left side of neck.

Row 1: Work in moss st for 8 sts, p to end.

Row 2: Work in twisted-st patt to last 8 sts, work in moss st to end.

Work in twisted-st patt with moss st border for 84 rows, dec 1 st at end of next row and at same edge of every foll row to row 96.

Bind off in patt.

FINISHING

Weave in the yarn ends and block the garment (see page 199 for more on blocking).

Seam together the Right and Left Hood pieces from the back neck to the moss-stitch edging.

CHART

KEY

- ▨ MC
- ◼ CC1
- ☐ CC2
- ◼ CC3

Copy the charts on these pages (enlarging them if you wish). Join the two parts of the Back chart together (see sample, right); do the same with the Front chart sections so they say the word "LOVE."

BACK CHART—A

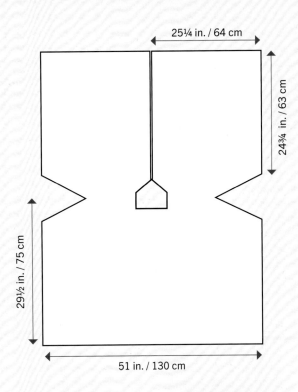

25¼ in. / 64 cm

24¾ in. / 63 cm

29½ in. / 75 cm

51 in. / 130 cm

BACK CHART—B

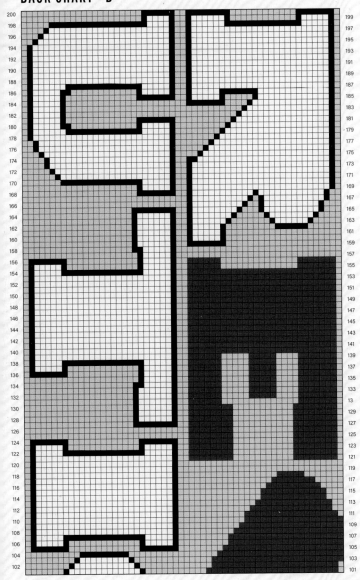

FRONT CHART—A

FRONT CHART—B

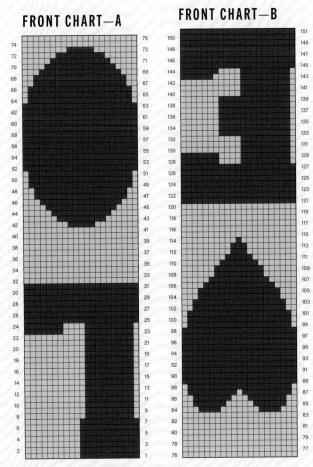

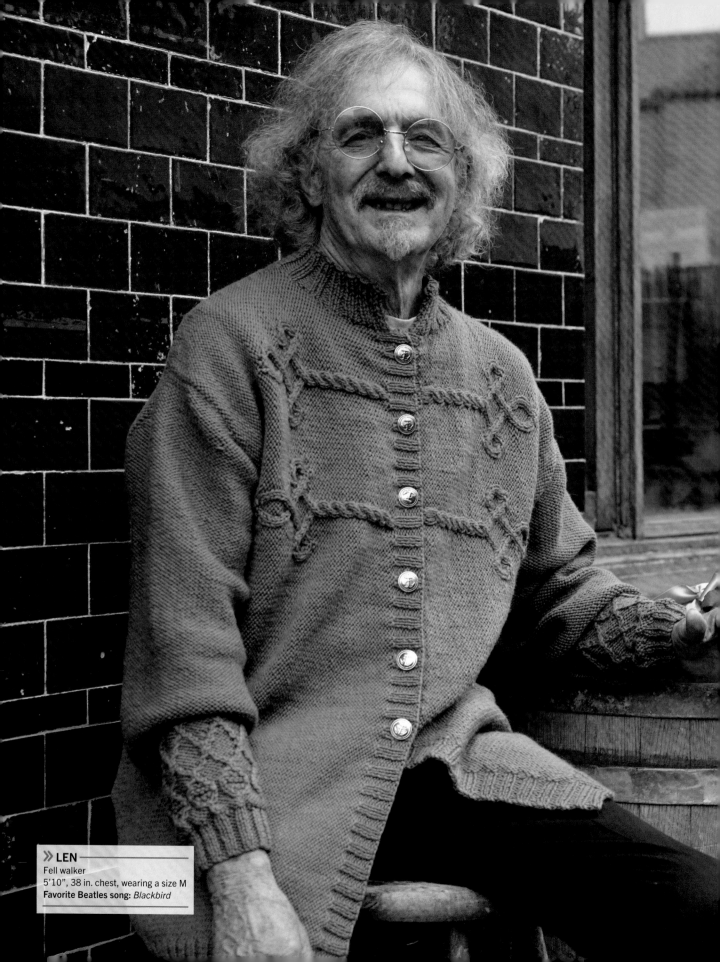

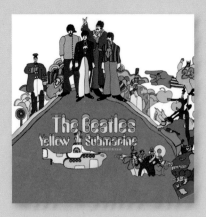

OLD FRED'S JACKET

Designed by **Sian Brown**

Skill level ●●●

In the *Yellow Submarine* movie, when Pepperland is overrun by the Blue Meanies, the Lord Mayor sends Fred to find help. Fred ends up in Liverpool, where he meets Ringo followed by the rest of The Beatles. He persuades them to return with him to Pepperland on the Yellow Submarine.

In the movie, Old Fred is seen wearing a naval-style coat, complete with brass buttons and braid-trimmed cuffs. This pattern for a knitted jacket replaces the gold braid with cables, and uses them to add a frogging-style detail to the front. Choose your favorite style of brass or silver-colored buttons to finish the jacket.

SIZES

XS:**S**:M:**L**:XL:2XL:**3XL**:4XL

FINISHED MEASUREMENTS

Chest:
37½:**42⅞**:**47¼**:51:**55½**:59⅞:**64⅛**:68⅞ in. /
95:109:**120**:130:**141**:152:**163**:175 cm
Length to back neck:
29¼:29½:**30**:30½:**30¾**:31:**31½**:32 in. /
74:75:**76**:77:**78**:79:**80**:81 cm
Sleeve length to underarm: 18 in. / 46 cm
(all sizes)

YARN

Aran weight (medium #4), shown in Cascade Yarns, 220 Superwash® Aran (100% wool; 150 yd. / 137.5 m per 3½ oz. / 100 g hank) Smoke Blue (1993), **6**:6:**7**:8:**8**:9:**10**:10 hanks

NEEDLES

US 6 / 4 mm and US 7 / 4.5 mm needles (see Pattern Notes), or size needed to obtain gauge
US 6 / 4 mm circular needle, 48 in. / 120 cm long, or size needed to obtain gauge
Cable needle

NOTIONS

Tapestry needle
Stitch markers
Stitch holders
Six ⅞ in. / 22 mm buttons

continued on the next page >>

GAUGE

20 sts and 26 rows = 4 in. / 10 cm square over rev St st using US 7 / 4.5 mm needles
Be sure to check your gauge.

ABBREVIATIONS

See page 201.

PATTERN NOTES

- If you are making a larger size and need to accommodate a lot of stitches, it may be easier to use long circular needles.
- The Back is worked sideways, from the right side seam to the left side seam.
- The Right and Left Front pieces are worked from the side seams to the center front.

SPECIAL NOTES

- When the pattern states "work 5tog," work as foll: Ytb, sl 3 sts p-wise, * pass second st on right-hand needle over first st, sl this st back onto left-hand needle, pass second st on left-hand needle over first st *, sl this st back onto right-hand needle; rep from * to * once more, p rem st.
- For the cable panel on Right and Left Front, work as foll (beg with 19 sts):

Row 1 (RS): P9, m1, kfb, m1, p9. (22 sts)
Row 2: K9, p4, k9.
Row 3: P7, Cr4R, Cr4L, p7.
Row 4: K7, p2, k4, p2, k7.

Row 5: P6, Cr3R, p4 Cr3L, p6.
Row 6: K6, p2, k6, p2, k6.
Row 7: P6, k2, p6, k2, p6.
Row 8: K6, p2, k6, p2, k6.
Row 9: P6, Cr3L, p4, Cr3R, p6.
Row 10: K7, p2, k4, p2, k7.
Row 11: P7, Cr4L, Cr4R, p7.
Row 12: K9, p4, k9.
Row 13: P9, C4B, p9.
Row 14: K9, p4, k9.
Row 15: P2, m1, kfbf, m1, p4, Cr4R, Cr4L, p4, m1, kfbf, m1, p2. (30 sts)
Row 16: K2, p2, k1, [p2, k4] 3 times, p2, k1, p2, k2.
Row 17: Cr4R, p1, Cr4L, Cr4R, p4, Cr4L, Cr4R, p1, Cr4L.
Row 18: P2, K5, p4, k8, p4, k5, p2.
Row 19: K2, p5, C4F, p8, C4F, p5, k2.
Row 20: P2, K5, p4, k8, p4, k5, p2.
Row 21: Cr4L, p1, Cr4R, Cr4L, p4, Cr4R, Cr4L, p1, Cr4R.
Row 22: K2, p2, k1, [p2, k4] 3 times, p2, k1, p2, k2.
Row 23: P2, work 5tog, p4, Cr4L, Cr4R, p4, work 5tog, p2. (22 sts)
Row 24: K9, p4, k9.
Row 25: P9, C4B, p9.
Row 26: K9, p4, k9.
Row 27: P9, k4, p9.
Row 28: K9, p4, k9.
Rep Rows 25 to 28 to end of work.

THE JACKET

BACK (SEE PATTERN NOTES)

Using US 7 / 4.5 mm needles, cast on **136**(137:**138**:139:**140**:141:**142**:143) sts.
Beg with a p row, work in rev St st for 6 rows.
Shape shoulder
Next row (RS): P to last 3 sts, m1 p-wise, p3. (**137**(138:**139**:140:**141**:142:**143**:144) sts)
Work 5 more rows in rev St st.
Rep the prev 6 rows **5**(6:**7**:8:**9**:10:**11**:12) more times. (**142**(144:**146**:148:**150**:152:**154**:156) sts)
PM at beg of last row to indicate end of shoulder shaping.
Work **44**(46:**48**:50:**52**:54:**56**:58) more rows in rev St st for back neck.
PM at beg of last row to indicate beg of shoulder shaping.
Work 6 more rows in rev St st.
Next row: P to last 4 sts, p2tog, p2. (**141**(143:**145**:147:**149**:151:**153**: 155) sts)
Work 5 more rows in rev St st.
Rep the prev 6 rows **5**(6:**7**:8:**9**:10:**11**:12) more times. (**136**(137:**138**:139:**140**:141:**142**: 143) sts)
Bind off.

RIGHT FRONT (SEE PATTERN NOTES)

Using US 7 / 4.5 mm needles, cast on **136**(137:**138**:139:**140**:141:**142**:143) sts.
Beg with a p row, work in rev St st for 6 rows.
Shape shoulder
Next row (RS): P to last 3 sts, m1 p-wise, p3. (**137**(138:**139**:140:**141**:142:**143**:144) sts)
Work 5 more rows in rev St st.
Rep the prev 6 rows **1**(2:**2**:3:**3**:4:**4**:5) more time(s). (**138**(140:**141**:143:**144**:146:**147**:149) sts)

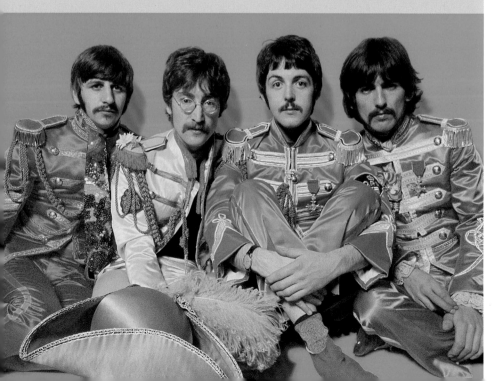

Next row: P to last 3 sts, m1 p-wise, p3. (**139**(141:**142**:144:**145**:147:**148**: 150) sts)

Work 1 more row in rev St st.

Cable Pattern (see Special Notes)

Row 1 (RS): P82(84:**86**:86:**88**:88:**90**:92), work Row 1 of Cable Panel, p6, work Row 1 of Cable Panel, p**13**(13:**12**:14:**13**:15:**14**:14).

Row 2: K13(13:**12**:14:**13**:15:**14**:14), work Row 2 of Cable Panel, p6, work Row 2 of Cable Panel, k82(84:**86**:86:**88**:88:**90**:92).

This sets position of the Cable Pattern.

Work 2 more rows in patt as set.

Next row: Work to last 3 sts, m1 p-wise, p3. (**140**(142:**143**:145:**146**:148:**149**: 151) sts)

Work 5 more rows in patt as set.

Rep the last 6 rows **2**(2:**3**:3:**4**:4:**5**:5) more times. (**142**(144:**146**:148:**150**: 152:**154**:156) sts)

PM at beg of last row to indicate end of shoulder shaping.

Shape front neck

Next row: Work in patt as set to last **5**(5:**5**:6:**6**:7:**7**:7) sts, turn, and work on these **137**(139:**141**:142:**144**:145: **147**:149) sts, leaving last **5**(5:**5**:6:**6**:7: **7**:7) sts on a holder.

Next row: K2tog, work in patt to end.

Next row: Work in patt to end.

Rep prev 2 rows 3 more times, then the first of the 2 rows once more.

Work **10**(10:**12**:12:**14**:14:**16**:16) more rows in patt as set.

Leave rem **132**(134:**136**:137:**139**: 140:**142**:144) sts on a spare needle, counting cable panel as 19 sts.

LEFT FRONT (SEE PATTERN NOTES)

Using US 7 / 4.5 mm needles, cast on **136**(137:**138**:139:**140**:141:**142**: 143) sts.

Beg with a p row, work in rev St st for 6 rows.

Shape shoulder

Next row (RS): P3, m1 p-wise, p to end. (**137**(138:**139**:140:**141**:142:**143**: 144) sts)

Work 5 more rows in rev St st.

Rep the prev 6 rows **1**(2:**2**:3:**3**:4:**4**:5) more time(s). (**138**(140:**141**:143: **144**:146:**147**:149) sts)

Next row: P3, m1 p-wise, p to end. (**139**(**141**:142:**144**:145:**147**:148:**150**) sts)

Work 1 more row in rev St st.

Now work Cable Pattern (see Special Notes) thus:

Row 1 (RS): P13(13:**12**:14:**13**:15:**14**: 14), work Row 1 of Cable Panel, p6, work Row 1 of Cable Panel, p82(84:**86**:86:**88**:88:**90**:92).

Row 2: K82(84:**86**:86:**88**:88:**90**:92), work Row 2 of Cable Panel, p6, work Row 2 of Cable Panel, k13(13:**12**:14:**13**:15: **14**:14).

These 2 rows set the position of the Cable Pattern.

Work 2 more rows in patt as set.

Next row: Work to last 3 sts in patt as set, m1 p-wise, p3. (**140**(142:**143**:145:**146**:148:**149**: 151) sts)

Work 5 more rows in patt as set.

Rep the last 6 rows **2**(2:**3**:3:**4**:4:**5**:5) more times. (**142**(144:**146**:148:**150**: 152:**154**:156) sts)

PM at beg of last row to indicate end of shoulder shaping.

Shape front neck

Next row: P5(5:**5**:6:**6**:7:**7**:7), leave these sts on a holder, work in patt to end. (**137**(139:**141**:142:**144**:145: **147**:149) sts)

Next row: Work in patt to last 2 sts, skpo. (**136**(138:**140**:141:**143**:144: **146**:148) sts)

Next row: Work in patt to end.

Rep prev 2 rows 3 more times, then the first of these 2 rows once.

Work **10**(10:**12**:12:**14**:14:**16**:16) more rows in patt as set.

Leave rem **132**(134:**136**:137:**139**: 140:**142**:144) sts on a spare needle, counting cable panel as 19 sts.

SLEEVES (MAKE 2)

Using US 6 / 4 mm needles, cast on **42**(46:**50**:58:**58**:66:**70**:74) sts.

Rib row 1: K2, *p2, k2, rep from * to end.

Rib row 2: P2, *k2, p2, rep from * to end.

Rep the prev 2 rows 5 more times, inc **0**(4:**8**:0:**8**:8:**4**:8) st(s) evenly across the last row. (**42**(50:**58**:58:**66**:74:**74**:82) sts)

Change to US 7 / 4.5 mm needles and work the border patt as foll:

Row 1 (RS): P to end.

Row 2: K to end.

Row 3: P to end.

Row 4: K1, [k3, p2, k3] **5**(6:**7**:7:**8**: 9:**9**:10) times, k1.

Row 5: P1, [p2, Cr2R, Cr2L, p2] **5**(6:**7**: 7:**8**:9:**9**:10) times, p1.

Row 6: K1, [k2, p4, k2] **5**(6:**7**:7:**8**:9: **9**:10) times, k1.

Row 7: P1, m1 p-wise, [p1, Cr2R, p2, Cr2L, p1] **5**(6:**7**:7:**8**:9:**9**:10) times, m1 p-wise, p1. (**44**(52:**60**: 60:**68**:76:**76**:84) sts)

Row 8: K2, [k1, p6, k1] **5**(6:**7**:7: **8**:9:**9**:10) times, k2.

Row 9: P2, [p1, k1, p4, k1, p1] **5**(6:**7**: 7:**8**:9:**9**:10) times, p2.

Row 10: K2, [k1, p6, k1] **5**(6:**7**: 7:**8**:9:**9**:10) times, k2.

Row 11: P2, [p1, Cr2L, p2, Cr2R p1] **5**(6:**7**:7:**8**:9:**9**:10) times, p2.

Row 12: K2, [k2, p4, k2] **5**(6:**7**:7:**8**:9: **9**:10) times, k2.

Row 13: P2, m1 p-wise, [p2, Cr2L, Cr2R, p2] **5**(6:**7**:7:**8**:9:**9**:10) times, m1 p-wise, p2. (**46**(54:**62**:62:**70**:78:**78**:86) sts)

Row 14: K3, [k3, p2, k3] **5**(6:**7**:7:**8**:9: **9**:10) times, k3.

Row 15: P3, [p3, Cr2L, p3] **5**(6:**7**:7:**8**: **9**:9:**10**) times, p3.

Row 16: K3, [k2, sl next st onto CN and hold at front of work, p1, then p1 from CN, sl next st onto CN and hold at back of work, p1, then p1 from CN, k2] **5**(6:**7**:7:**8**:9:**9**:10) times, k3.

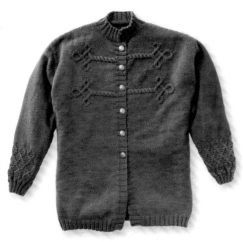

Row 17: P3, [p1, Cr2R, p2, Cr2L p1] **5**(6:**7**:7:**8**:9:**9**:10) times, p3.

Row 18: K3, [k1, p1, k4, p1, k1] **5**(6:**7**:7:**8**:9:**9**:10) times, k3.

Row 19: P3, m1 p-wise, [Cr2R, p4, Cr2L] **5**(6:**7**:7:**8**:9:**9**:10) times, m1 p-wise, p3. (**48**(56:**64**:64:**72**:80:**80**:88 sts)

Row 20: K4, p1, [k6, p2] **4**(5:**6**:6:**7**:8:**8**:9) times, k6, p1, k4.

Row 21: P4, k1, [p6, Cr2R] **4**(5:**6**:6:**7**:8:**8**:9) times, p6, k1, p4.

Row 22: K4, p1. [k6. p2] **4**(5:**6**:6:**7**:8:**8**:9) times, k6, p1, k4.

Row 23: P4, [Cr2L, p4, Cr2R] **5**(6:**7**:7:**8**:9:**9**:10) times, p4.

Row 24: K4, [k1, p1, k4, p1, k1] **5**(6:**7**:7:**8**:9:**9**:10) times, k4.

Row 25: P4, m1 p-wise, [p1, Cr2L, p2, Cr2R, p1] **5**(6:**7**:7:**8**:9:**9**:10) times, m1 p-wise, p4. (**50**(58:**66**:66:**74**:82:**82**:90 sts)

Row 26: K5, [k2, sl next st onto CN and hold at back of work, p1, then p1 from CN, sl next st onto CN and hold at front of work, p1, then p1 from CN, k2] **5**(6:**7**:7:**8**:9:**9**:10) times, k5.

Row 27: P5, [p3, Cr2L, p3] **5**(6:**7**:7:**8**:9:**9**:10) times, p5.

Row 28: K5, [k3, p2, k3] **5**(6:**7**:7:**8**:9:**9**:10) times, k5.

Row 29: P5, [p2, Cr2R, Cr2L, p2] **5**(6:**7**:7:**8**:9:**9**:10) times, p5.

Row 30: K5, [k2, p4, k2] **5**(6:**7**:7:**8**:9:**9**:10) times, k5.

Row 31: P4, m1 p-wise, p1, [p1, Cr2R, p2, Cr2L, p1] **5**(6:**7**:7:**8**:9:**9**:10) times, p1, m1 p-wise, p4. (**52**(60:**68**:68:**76**:84:**84**:92 sts)

Row 32: K6, [k1, p6, k1] **5**(6:**7**:7:**8**:9:**9**:10) times, k6.

Row 33: P6, [p1, k1, p4, k1, p1] **5**(6:**7**:7:**8**:9:**9**:10) times, p6.

Row 34: K6, [k1, p6, k1] **5**(6:**7**:7:**8**:9:**9**:10) times, k6.

Row 35: P6, [p1, Cr2L, p2, Cr2R p1] **5**(6:**7**:7:**8**:9:**9**:10) times, p6.

Row 36: K6, [k2, p4, k2] **5**(6:**7**:7:**8**:9:**9**:10) times, k6.

Row 37: P4, m1 p-wise, p2, [p2, Cr2L, Cr2R, p2] **5**(6:**7**:7:**8**:9:**9**:10) times, p2, m1 p-wise, p4. (**54**(62:**70**:70:**78**:86:**86**:94 sts)

Row 38: K7, [k3, p2, k3] **5**(6:**7**:7:**8**:9:**9**:10) times, k7.

This completes the border patt.

Beg with a p row, work in rev St st for 4 rows.

Inc row: P4, m1 p-wise, p to last 4 sts, m1 p-wise, p4. (**56**(64:**72**:72:**80**:88:**88**:96 sts)

Work 5 more rows in rev St st.

Rep the prev 6 rows 5 more times and the inc row once more. (**68**(76:**84**:84:**92**:100:**100**:108) sts)

Work straight in rev St st until Sleeve measures 18 in. / 46 cm from cast-on edge, ending with a p row.

Shape sleeve top

Next row (WS): K2, skpo, k to last 4 sts, k2tog, k2. (**66**(74:**82**:82:**90**:98:**98**:106) sts)

Next row: P to end.

Rep the prev 2 rows **3**(4:**5**:6:**7**:8:**9**:10) more times. (**60**(66:**72**:70:**76**:82:**80**:86) sts)

Next row: Bind off 2 sts, k to last 2 sts, skpo. (**57**(63:**69**:67:**73**:79:**77**:83) sts)

Next row: Bind off 2 sts, p to last 2 sts, p2tog. (**54**(60:**66**:64:**70**:76:**74**:80) sts)

Rep the prev 2 rows 7 more times. (**12**(18:**24**:22:**28**:34:**32**:38) sts)

Bind off.

BACK: LOWER EDGING

With RS facing and using US 6 / 4 mm needles, pick up and k **98**(106:**114**:126:**134**:142:**154**:162) sts evenly along row ends on straight edge of Back.

Rib row 1: P2, *k2, p2, rep from * to end.

Rib row 2: K2, *p2, k2, rep from * to end.

Rep these 2 rows 4 more times, then rep Rib row 1 once more.

Bind off rib-wise.

RIGHT FRONT: LOWER EDGING

With RS facing and using US 6 / 4 mm needles, pick up and k **51**(55:**59**:63:**67**:71:**75**:79) sts evenly along row ends of bottom edge of Right Front.

Rib row 1: P3, *k2, p2, rep from * to end.

Rib row 2: K2, *p2, k2, rep from to last 5 sts, p2, k3.

Rep these 2 rows 4 more times, then rep Rib row 1 once more.

Bind off rib-wise.

LEFT FRONT: LOWER EDGING

With RS facing and using US 6 / 4 mm needles, pick up and k **51**(55:**59**:63: **67**:71:**75**:79) sts evenly along row ends of bottom edge of Left Front.

Rib row 1: P2, *k2, p2, rep from * to last 5 sts, k2, p3.

Rib row 2: K3, *p2, k2, rep from * to end.

Rep these 2 rows 4 more times, then rep Rib row 1 once more.

Bind off rib-wise.

BUTTON BAND

Now cable panels are completed there are 22 sts in each panel. **138**(140: **142**:143:**145**:146:**148**:150) sts on front holder.

With RS facing and using US 6 / 4 mm circular needle, work across sts left on holder for Left Front.

Dec 2 sts over each cable and **3**(1:**3**:0:**3**:3:**1**:3) sts along remainder of row, p to end, then pick up and k 9 sts along row ends of edging. (**140** (144:**144**:148:**148**:148:**152**:152) sts)

Rib row 1: K1, *p2, k2, rep from * to last 3 sts, p2, k1.

Rib row 2: K3, *p2, k2, rep from * to last 5 sts, p2, k3.

Rep these 2 rows 3 more times, then rep Rib row 1 once more.

Bind off rib-wise.

BUTTONHOLE BAND

Now cable panels are completed there are 22 sts in each panel. **138**(140: **142**:143:**145**:146:**148**:150) sts on front holder.

With RS facing and using US 6 / 4 mm circular needle, work across sts left on holder for Right Front.

Pick up and k 9 sts along row ends of edging, then dec 2 sts over each cable and **3**(1:**3**:0:**3**:3:**1**:3) sts along remainder of row, p to end. (**140**(144:**144**:148:**148**:148:**152**: 152) sts)

Rib row 1: K1, *p2, k2, rep from * to last 3 sts, p2, k1.

Rib row 2: K3, *p2, k2, rep from * to last 5 sts, p2, k3.

Rep these 2 rows 2 more times.

Buttonhole row: Rib 4, skpo, yrn2, k2tog, [rib 12, skpo, yrn2, k2tog] 5 times, rib to end.

Rep Rib row 2 once more, then rep both Rib rows 2 more times.

Bind off rib-wise.

COLLAR

Weave in yarn ends on Back, Right Front, and Left Front; block all the pieces. Join both shoulder seams.

With RS facing and using US 6 / 4 mm needles, skip last 4 rows of left front band, then pick up and k 24 sts to sts on holder, k these **5**(5:**5**:6:**6**:7:**7**:7) sts, pick up and k **30**(34:**34**:36:**40**:42:**46**:46) sts across

back neck, k**5**(5:**5**:6:**6**:7:**7**:7) sts from holder, pick up and k 24 sts down left side of front neck and across first 5 rows of neckband. (**88**(92:**92**:96:**100**:104:**108**:108) sts)

Rib row 1: K1, *p2, k2, rep from * to last 3 sts, p2, k1.

Rib row 2: K3, *p2, k2, rep from * to last 5 sts, p2, k3.

Rep these 2 rows 5 more times, then rep Rib row 1 once more.

Bind off rib-wise.

FINISHING

Weave in remaining yarn ends and block the Sleeves (see page 199 for more on blocking).

Sew the sleeves in place, matching centers of sleeve tops to shoulder seams.

Join the side and sleeve seams.

Sew on buttons.

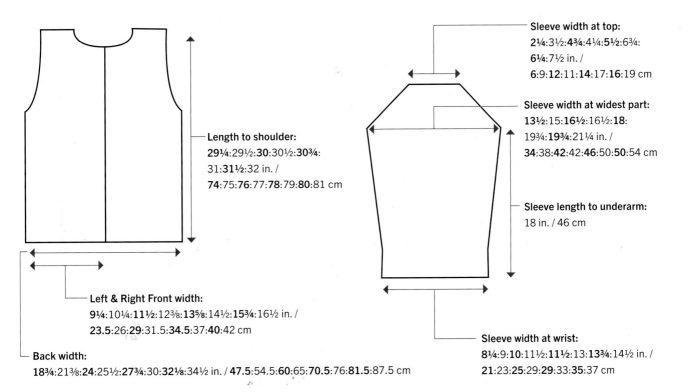

Length to shoulder:
29¼:29½:**30**:30½:**30¾**:
31:**31½**:32 in. /
74:75:**76**:77:**78**:79:**80**:81 cm

Left & Right Front width:
9¼:10¼:**11½**:12⅜:**13⅝**:14½:**15¾**:16½ in. /
23.5:26:**29**:31.5:**34.5**:37:**40**:42 cm

Back width:
18¾:21⅜:**24**:25½:**27¾**:30:**32⅛**:34½ in. / **47.5**:54.5:**60**:65:**70.5**:76:**81.5**:87.5 cm

Sleeve width at top:
2¼:3½:**4¾**:4¼:**5½**:6¾:
6¼:7½ in. /
6:9:**12**:11:**14**:17:**16**:19 cm

Sleeve width at widest part:
13½:15:**16½**:16½:**18**:
19¾:**19¾**:21¼ in. /
34:38:**42**:42:**46**:50:**50**:54 cm

Sleeve length to underarm:
18 in. / 46 cm

Sleeve width at wrist:
8¼:9:**10**:11½:**11½**:13:**13¾**:14½ in. /
21:23:**25**:29:**29**:33:**35**:37 cm

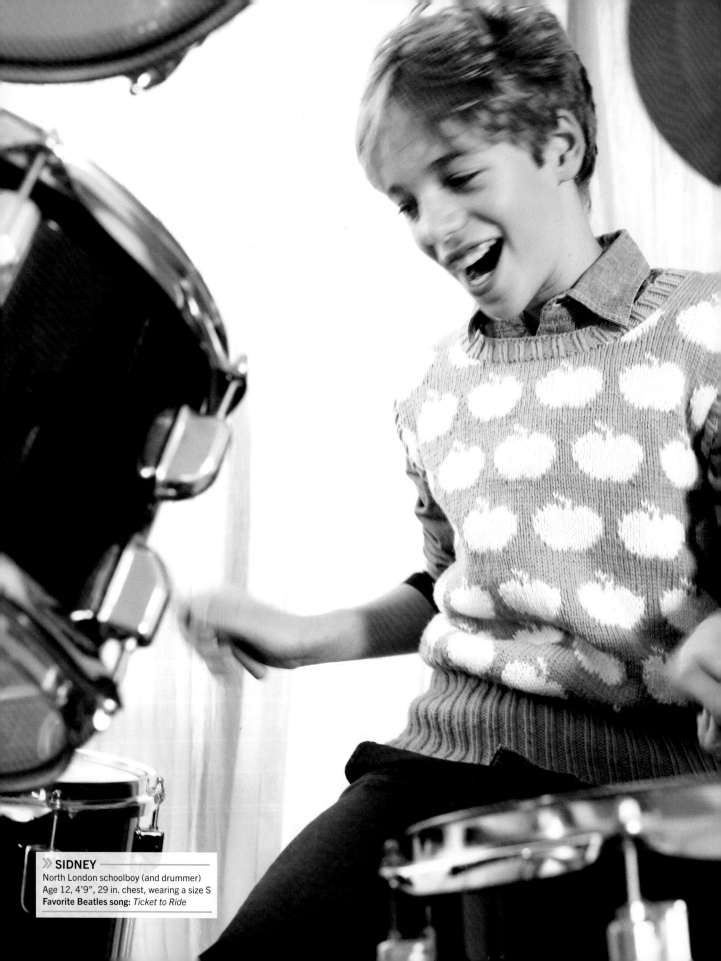

≫ SIDNEY

North London schoolboy (and drummer)
Age 12, 4'9", 29 in. chest, wearing a size S
Favorite Beatles song: *Ticket to Ride*

The Apple Corps venture was announced in New York—the Big Apple—in May 1968. The first single on the new Apple label was "Hey Jude," launched in August of the same year; the first album released—in November—was The Beatles, now known as The White Album.

APPLE
SWEATER VEST

Designed by Jane Burns
Skill level 🍎🍎

The name of the company founded by The Beatles—Apple Corps—is a pun on "apple core," and the fruit has always featured as the organization's logo. The simple graphic of an apple's outline and photograph of a bright green, juicy apple influenced the design of this garment.

This sweater vest pays homage to the company's iconic logo with a simple apple shape repeated in rows across the front. Knitted in a white double-knit yarn on a punchy apple-green background, the apple motifs are worked using the intarsia technique; the back, neckband, and armbands are worked plain in the green color.

SIZES
XS:S:M:L:**XL**:2XL:**3XL**:4XL

FINISHED MEASUREMENTS
Chest: **30**:34⅛:**38**:41⅞:**46**:50:**53⅞**:57⅞ in. /
76:86.5:**96.5**:106.5:**117**:127:**137**:147 cm
Length to shoulder:
22:22½:**23⅛**:23⅛:**23½**:24¼:**24½**:25 in. /
56:57:**58.5**:58.5:**59.5**:61:**62**:63.5 cm

YARN
DK weight (medium #4), shown in Cascade Yarns, 220 Superwash® Merino (100% wool; 220 yd. / 200 m per 3½ oz. / 100 g ball)
MC: Peridot (84), **3**:3:**4**:4:**5**:5:**5**:5 balls
CC1: White (25), 2 balls for each size

NEEDLES
US 6 / 4 mm needles, or size needed to obtain gauge
US 3 / 3.25 mm circular needle, 16 in. / 40 cm long, or size needed to obtain gauge

NOTIONS
Tapestry needle
Stitch marker

continued on the next page >>

GAUGE

22 sts and 30 rows = 4 in. / 10 cm over St st using US 6 / 4 mm needles
Be sure to check your gauge.

ABBREVIATIONS

See page 201.

PATTERN NOTES

- Use the intarsia technique to create the apple design on the Front (see page 196), following the chart on page 87. Wind separate balls of the different colors and twist them together where they join to avoid holes in the finished work.
- When decreasing, work RS rows as foll: K1, ssk at the beginning of the row and k2tog, k1 at the end of the row. On WS rows, decrease as foll: P1, p2tog at the beginning of the row and p2tog tbl, p1 at the end of the row.
- For more on reading charts, see page 196.

THE SWEATER VEST

BACK

Using US 3 / 3.25 mm needles and MC, cast on **84(94:**104**:116:**126**:138:**148**:160) sts.
Sizes XS:M:L:3XL:4XL:
Rib row 1 (RS): *K2 tbl, p2, rep from * to end.
Rib row 2: *K2, p2 tbl, rep from * to end.
Sizes S:XL:2XL:
Rib row 1 (RS): *K2 tbl, p2, rep from * to last 2 sts, k2 tbl.
Rib row 2: *P2 tbl, k2, rep from * to last 2 sts, p2 tbl.
All sizes:
Cont to work twisted rib as set until work measures 5(5⅜:**5¾**:6:4:4½:**5**:5⅛) in. / **12.5**(13.5:**14.5**:15:**10**:11.5:**12.5**:13) cm from cast-on edge, ending with a WS row.
Change to US 6 / 4 mm needles.
**Cont in St st until work measures 15 in. / 38 cm from cast-on edge, ending with a p row.
Shape armholes
Bind off **2**(3:**3**:4:**4**:5:**7**:7) sts at beg of next 2 rows. (**80**(88:**98**:108:**118**:128:**134**:146) sts)
Bind off **2**(2:**2**:3:**3**:3:**3**:4) sts at beg of next 2 rows. (**76**(84:**94**:102:**112**:122:**128**:138) sts)
Cont in St st, dec as foll:
Dec 1 st (see Pattern Notes) at each end of row **0**(0:**2**:4:**10**:14:**14**:18) time(s). (**76**(84:**90**:94:**92**:94:**100**:102) sts)
Dec 1 st at each end of every RS row **1**(2:**4**:3:**1**:0:**2**:1) time(s). (**74**(80:**82**:88:**90**:94:**96**:100) sts)
Dec 1 st at each end of every 4th row **1**(1:**0**:0:**0**:0:**0**:0) time. (**72**(78:**82**:88:**90**:94:**96**:100) sts)
Cont in St st without shaping until work measures **21¼**(21½:**22**:22½:**23⅛**:23½:**24¼**:24½) in. /

54(55:**56**:57:**58.5**:59.5:**61**:62) cm from cast-on edge, ending with a p row.
Shape right back neck
Row 1 (RS): K18(21:**23**:26:**27**:29:**30**:32), turn and work on these 18(21:**23**:26:**27**:29:**30**:32) sts only for right back neck.
Row 2: P to end.
Row 3: K to last 3 sts, k2tog, k1. (**17**(20:**22**:25:**26**:28:**29**:31) sts)
Beg with a p row, cont in St st until work measures **22**(22½:**23⅛**:23:**23½**:24¼:**24½**:25) in. / **56**(57:**58.5**:58.5:**59.5**:61:**62**:63.5) cm from cast-on edge, ending with a p row.
Shape right shoulder
Next row (RS): Bind off **4**(5:**6**:6:**7**:7:**7**:8) sts, k to end. (**13**(15:**16**:19:**19**:21:**22**:23) sts)
Next row: P to end.
Rep prev 2 rows 2 more times. (**5**(5:**4**:7:**5**:7:**8**:7) sts)
Bind off.
Shape left back neck
With RS facing, rejoin MC to rem sts.
Row 1 (RS): Bind off 36 sts, k to end. (**18**(21:**23**:26:**27**:29:**30**:32) sts)
Row 2: P to end.
Row 3: K1, ssk, k to end. (**17**(20:**22**:25:**26**:28:**29**:31) sts)
Shape left shoulder
Next row (WS): Bind off **4**(5:**6**:6:**7**:7:**7**:8) sts, p to end. (**13**(15:**16**:19:**19**:21:**22**:23) sts)
Next row: K to end.
Rep prev 2 rows 2 more times. (**5**(5:**4**:7:**5**:7:**8**:7) sts)
Bind off.

FRONT

Work as for Back from ** to **.
Working in St st and foll chart from right to left on odd-numbered rows and left to right on even-numbered rows:
XS only:
Work the 2 sts bet blue and pink lines, work 16-st rep bet pink lines five times, work the 2 sts bet pink and blue lines.

S only:

Work the 7 sts bet brown and pink lines, work 16-st rep bet pink lines five times, work the 7 sts bet pink and brown lines.

M only:

Work the 4 sts bet orange and pink lines, work the 16-st rep bet pink lines six times, work the 4 sts bet pink and orange lines.

L only:

Work the 2 sts bet blue and pink lines, work 16-st rep bet pink lines seven times, work the 2 sts bet pink and blue lines.

XL only:

Work the 7 sts bet brown and pink lines, work 16-st rep bet pink lines seven times, work the 7 sts bet pink and brown lines.

2XL only:

Work the 5 sts bet yellow and pink lines, work 16-st rep bet pink lines eight times, work the 5 sts bet pink and yellow lines.

3XL only:

Work the 2 sts bet blue and pink lines, work 16-st rep bet pink lines nine times, work the 2 sts bet pink and blue lines.

4XL only:

Work the 8 sts bet red and pink lines, work 16-st rep bet pink lines nine times, work the 8 sts bet pink and red lines.

Foll chart as set, cont in St st until work measures 15 in. / 38 cm, ending with a p row.

Shape armholes as for Back, foll chart as set, AND AT SAME TIME, shape front neck when work measures 17⅝(19½:**20**:20:20½:21⅛: **21¼**: 21½) in. / **48.5**(49.5:**51**:51:**52**:53.5: **54**:55) cm from cast-on edge, ending with a p row.

Shape left front neck

Cont to foll chart as set, work as foll:

Row 1 (RS): K29(32:**34**:37:**38**:40:**41**: 43), turn and work on these sts only for left front neck.

Row 2: Bind off 5 sts, p to end. (**24**(27:**29**:32:**33**:35:**36**:38) sts)

Row 3: K to end.

Row 4: Bind off 3 sts, p to end. (**21**(24:**26**:29:**30**:32:**33**:35) sts)

Dec 1 st at neck edge of foll 3 rows. (**18**(21:**23**:26:**27**:29:**30**:32) sts)

P 1 row.

Dec 1 st at neck edge of next row. (**17**(20:**22**:25:**26**:28:**29**:31) sts)

Beg with a p row, cont in St st until piece measures 22(22½:**23⅛**:23⅛: **23½**:24¼:**24½**:24⅝) in. / 56(57: **58.5**:58.5:**59.5**:61:**62**:63.5) cm from cast-on edge, ending on a p row.

NOTE: Complete only whole apple motifs, then cont in MC only.

Shape left shoulder

Cont to foll chart as set, work as foll:

Next row: Bind off **4**(5:**6**:6:**7**:7:**7**:8) sts, k to end. (**13**(15:**16**:19:**19**:21:**22**: 23) sts)

Next row: P to end.

Rep prev 2 rows 2 more times. (**5**(5:**4**:7: **5**:7:**8**:7) sts)

Bind off.

Shape right front neck

With RS facing, rejoin MC to rem sts.

Cont to foll chart as set, work as foll:

Row 1 (RS): Bind off 14 sts, k to end. (**29**(32:**34**:37:**38**:40:**41**:43) sts)

Row 2: P to end.

Row 3: Bind off 5 sts, k to end. (**24**(27:**29**:32:**33**:35:**36**:38) sts)

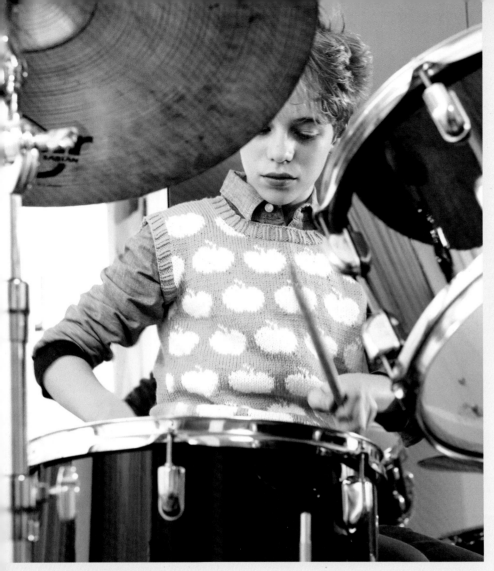

Row 4: P to end.
Row 5: Bind off 3 sts, k to end.
 (**21**(24:**26**:**29**:**30**:**32**:**33**:35) sts)
Row 6: P to end.
Dec 1 st at neck edge of foll 3 rows.
 (**18**(21:**23**:**26**:**27**:**29**:**30**:32) sts)
P 1 row.
Dec 1 st at neck edge of next row.
 (**17**(20:**22**:**25**:**26**:**28**:**29**:31) sts)
Beg with a p row, cont in St st until work
 measures 22(22½:**23⅛**:**23⅛**:**23½**:
 24¼:**24½**:24⅝) in. / **56**(57:**58.5**:
 58.5:**59.5**:61:62:63.5) cm from cast-
 on edge, ending on a k row.
Shape right shoulder
Cont to foll chart as set, work as foll:
Next row: Bind off **4**(5:**6**:**6**:**7**:7:**7**:8) sts,
 p to end. (**13**(15:**16**:**19**:**19**:**21**:**22**:
 23) sts)

Next row: K to end.
Rep prev 2 rows 2 more times.
 (**5**(5:**4**:**7**:**5**:**7**:**8**:7) sts)
Bind off.

NECKBAND
Weave in yarn ends on Back and Front
 and block both pieces.
Join the shoulder seams.
With RS facing, using US 3 / 3.25 mm
 circular needle and MC, pick up and k
 23(23:**23**:**23**:**23**:**23**:**25**:25) sts down
 left front neck, 12 sts around left
 neck shaping, 14 sts along bound-
 off edge at center of front neck, 12
 sts around right front neck shaping,
 23(23:**23**:**23**:**23**:**23**:**25**:25) sts up
 right front neck, 6 sts around right
 back neck shaping, 36 sts along

bound-off edge at center of back
 neck, 6 sts around left back neck
 shaping. (**132**(132:**132**:132:**132**:
 132:**136**:136) sts)
Join to work in the round, placing SM to
 mark the beginning of the round.
Rib round 1: *K2 tbl, p2, rep from * to
 end.
Rep this round until neckband
 measures 1 in. / 2.5 cm, slipping SM
 at the end of every round.
Bind off loosely in rib.

ARMBANDS
Join the side seams.
With RS facing and starting at an
 underarm seam, using US 3 /
 3.25 mm circular needle and MC,
 pick up and k **6**(8:**12**:14:**18**:22:**26**:
 30) sts around armhole shaping,
 38(40:**42**:42:**42**:44:**44**:46) sts up
 straight edge of armhole to shoulder,
 38(40:**42**:42:**42**:44:**44**:46) sts
 down straight edge of armhole from
 shoulder, **6**(8:**12**:14:**18**:22:**26**:
 30) sts around armhole shaping.
 (**88**(96:**108**:112:**120**:132:**140**:
 152) sts)
Join to work in the round, placing SM to
 mark the beginning of the round.
Rib round 1: *K2 tbl, p2, rep from * to
 end.
Rep this round until neckband
 measures 1 in. / 2.5 cm, slipping SM
 at the end of every round.
Bind off loosely in rib.
Rep for second armhole.

FINISHING
Block neckband and armbands lightly
 and weave in remaining yarn ends.

CHART

KEY

▨	MC
☐	CC

▬	S
▬	M
▬	L
▬	XL
▬	2XL
▬	3XL

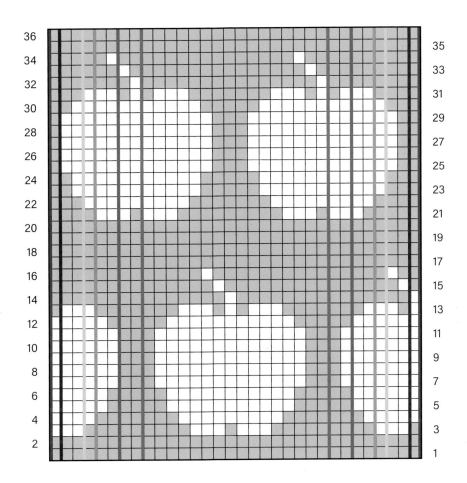

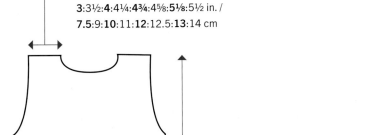

Shoulder width:
3:3½:**4**:4¼:**4¾**:4⅝:**5⅛**:5½ in. /
7.5:9:**10**:11:**12**:12.5:**13**:14 cm

Length to shoulder:
22:22½:**23⅛**:23⅛:**23½**:24¼:**24½**:25 in. /
56:57:**58.5**:58.5:**59.5**:61:**62**:63.5 cm

Front & Back width:
15:16¾:**18½**:20¾:**22½**:24⅝:**26½**:28⅝ in. /
38:42.5:**47**:52.5:**57**:62.5:**67**:72.5 cm

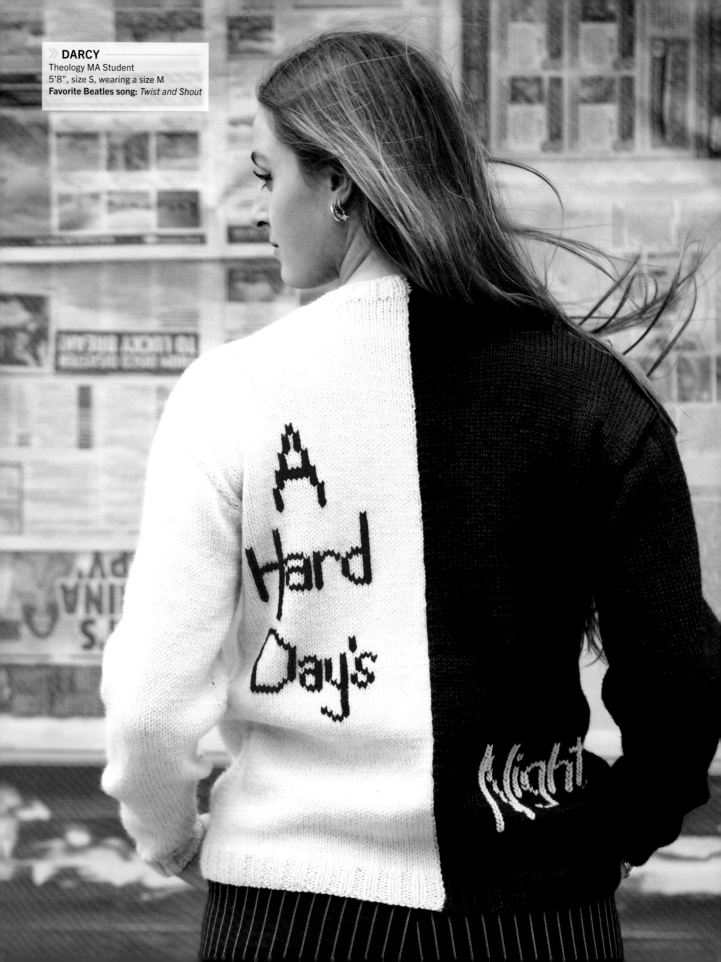

A HARD DAY'S NIGHT
CARDIGAN

Designed by Sian Brown
Skill level

The Beatles' first full-length movie was *A Hard Day's Night*. The band began filming on March 2, 1964, with the premiere taking place just a few months later, in July. It was a busy year for the band. As well as making a movie, The Beatles embarked on a series of tours around the world—their first visit to the US was in February and they returned again in August. They had a packed schedule—for example, on the UK tour in October they played fifty-four gigs in twenty-five cities over a thirty-three-day period.

If you've been having a particularly busy schedule, then hit pause and take time to relax in this cozy cardigan. Enjoy both day and night with this two-tone design, featuring a moon motif on a blue background on one side and a sun motif on a cream background on the other. The designs are worked in intarsia, but you could use duplicate stitch if preferred.

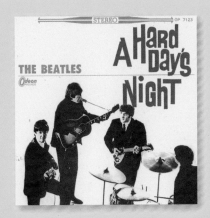

"A Hard Day's Night" was released in July 1964, to coincide with the launch of the movie of the same name. The song, along with other tracks from the movie, was released on an album that shared the name in the same year.

The band released an incredible eleven singles, two albums, and six EPs in 1964.

SIZES
Child sizes
4–6yrs:6–8yrs:**8–10yrs**:10–12yrs
Adult sizes
XS:S:**M**:L:**XL**:2XL:**3XL**:4XL

FINISHED MEASUREMENTS
Child sizes
Chest: **28½**:30:**31½**:33½ in. / **72**:76:**80**:85 cm
Length to shoulder: **14¼**:15¾:**17¼**:19 in. / **36**:40:**44**:48 cm
Sleeve length to underarm: **12**:13:**14¼**: 15¼ in. / **30**:33:**36**:39 cm
Adult sizes
Chest: **39½**:44:**48½**:52⅜:**57**:61⅜:**65¾**: 70⅜ in. / **100**:112:**123**:133:**145**:156:**167**: 179 cm
Length to shoulder: **24¼**:24½:**24¾**:25¼:**25½**:26:**26½**:26¾ in. / **61**:62:**63**:64:**65**:66:**67**:68 cm
Sleeve length to underarm: 18 in. / 46 cm (all adult sizes)

YARN
Aran weight (medium #4), shown in Cascade Yarns, Cascade 220® (100% merino wool; 220 yd. / 200 m per 3. oz. / 100 g hank)

continued on the next page >>

Child sizes
MC1: Atlantic (2404), **2**(**2**:**2**:3) hanks
MC2: Natural (8010), **2**(**2**:**2**:3) hanks
CC1: Bright Red (8414), 1 hank for each size
CC2: Gold Fusion (9669), 1 hank for each size
Adult sizes
MC1: Atlantic (2404), **3**(**3**:**4**:**4**:**4**:**5**:**5**:5) hanks
MC2: Natural (8010), **3**(**3**:**4**:**4**:**4**:**5**:**5**:5) hanks
CC1: Bright Red (8414), 1 hank for each size
CC2: Gold Fusion (9669), 1 hank for each size

NEEDLES
US 6 / 4 mm, US 7 / 4.5 mm, and US 8 / 5 mm
needles, or size needed to obtain gauge

NOTIONS
Tapestry needle
Stitch holder
¾ in. / 20 mm buttons: for child sizes—**5**:**5**:**6**:6
buttons; for all adult sizes—7 buttons

GAUGE
18 sts and 24 rows = 4 in. / 10 cm square over
St st using US 8 / 5 mm needles
Be sure to check your gauge.

ABBREVIATIONS
See page 201.

PATTERN NOTES
- If preferred, you can work the designs on the Right and Left Back and Front pieces in duplicate stitch (see page 197), rather than using the intarsia method (see page 196). Follow the charts on pages 96–98. If you use the intarsia method, wind separate balls of the different colors and twist them together where they join to avoid holes in the finished work.
- The Back is made up of two pieces that are joined together along the center back. Use ladder stitch for a neat join (see page 198).

RIGHT BACK
Using US 7 / 4.5 mm needles and MC1, cast on 34(34:38:38) sts.
****Rib row 1:** K2, *p2, k2, rep from * to end.
Rib row 2: P2, *k2, p2, rep from * to end.
Rep the prev 2 rows 3 more times, inc **0**(2:**0**:2) st(s) evenly across last row. (**34**(36:**38**:40) sts)**
Change to US 8 / 5 mm needles.
Beg with a k row, work **6**(10:**14**:18) rows in St st.
Foll Night Chart 1, work as foll:
Row 1 (RS): K**8**(10:**12**:14) in MC1, k19 sts from Row 1 of chart, k7 in MC1.
Row 2: P7 in MC1, p19 sts from Row 2 of chart, p**8**(10:**12**:14) in MC1.
These 2 rows set the position of the charted design.
Cont to work to end of chart, then cont in St st in MC1 only until work measures 9½(10¾:**12**:13) in. / **24**(27:**30**:33) cm from cast-on edge, ending with a p row.
Shape armhole
Next row: K2, skpo, k to end. (**33**(35:**37**:39) sts)
Next row: P to end.
Rep the prev 2 rows **2**(2:**3**:3) more times. (**31**(33:**34**:36) sts)
Work straight until Back measures 14¼(15¾:**17¼**:19) in. / **36**(40:**44**:48) cm from cast-on edge, ending with a p row.

Shape shoulder
Bind off **9**(10:**10**:10) sts at beg of next row and **10**(10:**10**:11) sts at beg of foll RS row. (**12**(13:**14**:15) sts)
P 1 row.
Leave sts on a holder.

LEFT BACK
Using US 7 / 4.5 mm needles and MC2, cast on **34**(34:**38**:38) sts.
Work as for Right Back from ** to **.
Change to US 8 / 5 mm needles.
Beg with a k row, work 26(30:**34**:38) rows in St st.
Foll Hard Day Chart 1, work as foll:
Row 1: K7 in MC2, k19 from Row 1 of chart, k**8**(10:**12**:14) in MC2.
Row 2: P**8**(10:**12**:14) in MC2, p19 from Row 2 of chart, p7 in MC2.
These 2 rows set the position of the charted design.
Cont to work to end of chart, then cont in St st in MC2 only. AT SAME TIME, when work measures 9½(10¾:**12**:13) in. / **24**(27:**30**:33) cm from cast-on edge and ending with a p row, cont as foll:
Shape armhole
Next row: K to last 4 sts, k2tog, k2. (**33**(35:**37**:39) sts)
Next row: P to end.
Rep the prev 2 rows **2**(2:**3**:3) more times. (**31**(33:**34**:36) sts)
Work straight until Back measures 14¼(15¾:**17¼**:19) in. / **36**(40:**44**:48) cm from cast-on edge, ending with a k row.
Shape shoulder
Bind off **9**(10:**10**:10) sts at beg of next row and **10**(10:**10**:11) sts at beg of foll WS row. (**12**(13:**14**:15) sts)
Leave sts on a holder.

LEFT FRONT
Using US 7 / 4.5 mm needles and MC2, cast on **31**(31:**35**:35) sts.
Rib row 1: K2, *p2, k2, rep from * to last 5 sts, p2, k3.
Rib row 2: P3, *k2, p2, rep from * to end.
Rep the prev 2 rows 3 more times, inc

0(2:0:2) st(s) evenly across last row.
(**31**(33:**35**:37) sts)

Change to US 8 / 5 mm needles.

Beg with a k row, work in St st until 2
 rows fewer have been worked than on
 Right Back to armhole shaping.

Foll Sun Chart 1, work as foll:

Row 1: K**12**(14:**16**:18) in MC2, k9 from
 Row 1 of chart, k10 in MC2.

Row 2: P10 in MC2, p9 from Row 2 of
 chart, then p**12**(14:**16**:18) in MC2.

These 2 rows set the position of the
 charted design.

Shape armhole

Cont to work to end of chart, then cont in
 MC2 only.

Next row: K2, skpo, k to end. (**30**(32:**34**:
 36) sts)

Next row: P to end.

Rep the prev 2 rows **2**(2:**3**:3) more times.
 (**28**(30:**31**:33) sts)

Work straight until 14 rows fewer have
 been worked than on Right Back to
 shoulder shaping.

Shape front neck

Next row: K**21**(22:**22**:23), skpo, turn and
 work on these **22**(23:**23**:24) sts only
 for first side of neck shaping, place
 rem **5**(6:**7**:8) sts on a holder.

Next row: P to end.

Next row: K to last 2 sts, skpo.
 (**21**(22:**22**:23) sts)

Rep the prev 2 rows 2 more times.
 (**19**(20:**20**:21) sts)

Work 7 more rows in St st.

Shape shoulder

Bind off **9**(10:**10**:10) sts at beg of next
 row. (**10**(10:**10**:11) sts)

P 1 row.

Bind off.

RIGHT FRONT

Using US 7 / 4.5 mm needles and MC1,
 cast on **31**(31:**35**:35) sts.

Rib row 1: K3, *p2, k2, rep from * to end.

Rib row 1: P2, *k2, p2, rep from * to last
 5 sts, k2, p3.

Rep the prev 2 rows 3 more times, inc
 0(2:**0**:2) st(s) evenly across last row.
 (**31**(33:**35**:37) sts)

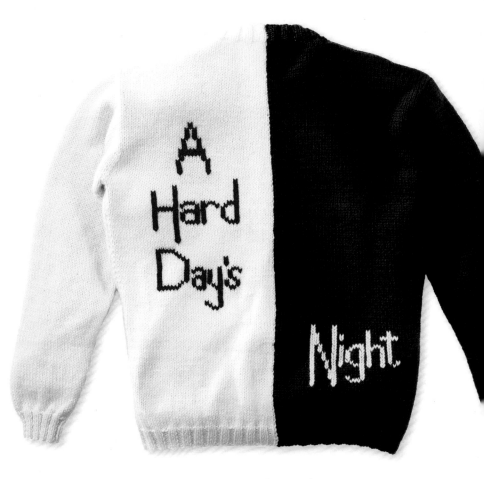

Change to US 8 / 5 mm needles.

Beg with a k row, work **6**(8:**10**:12) rows
 in St st.

Foll Moon Chart 1, work as foll:

Row 1: K**6**(7:**8**:9) in MC1, k19 from Row
 1 of chart, then k**6**(7:**8**:9) in MC1.

Row 2: P**6**(7:**8**:9) in MC1, p19 from Row
 2 of chart, then p**6**(7:**8**:9) in MC1.

These 2 rows set the position of the
 charted design.

Cont to work to end of chart, then cont
 in MC1 only until Front measures
 9½(10¾:**12**:13) in. / **24**(27:**30**:
 33) cm from cast-on edge, ending with
 a p row.

Shape armhole

Next row: K to last 4 sts, k2tog, k2.
 (**30**(32:34:36) sts)

Next row: P to end.

Rep the prev 2 rows **2**(2:**3**:3) more times.
 (**28**(30:**31**:33) sts)

Work straight until 14 rows fewer have
 been worked than on Right Back to
 shoulder shaping.

Shape front neck

Next row: K**5**(6:**7**:8) and leave on holder,
 k2tog, k to end. (**22**(23:**23**:24) sts)

Next row: P to end.

Next row: K2tog, k to end. (**21**(22:**22**:
 23) sts)

Rep the prev 2 rows 2 more times.
 (**19**(20:**20**:21) sts)

Work 8 more rows in St st.

Shape shoulder

Bind off **9**(10:**10**:10) sts at beg of next
 row. (**10**(10:**10**:11) sts)

K 1 row.

Bind off.

RIGHT SLEEVE

Using US 6 / 4 mm needles and MC1,
 cast on **30**(30:**34**:34) sts.

****Rib row 1:** K2, *p2, k2, rep from * to
 end.

Rib row 2: P2, *k2, p2, rep from * to end.

Rep the prev 2 rows 3 more times, inc
 0(2:**0**:2) st(s) evenly across last row.
 (**30**(32:**34**:36) sts)

Change to US 8 / 5 mm needles.

Beg with a k row, work 6 rows in St st.

Inc row: K4, m1, k to last 4 sts, m1, k4.
(**32**(34:**36**:38) sts)

Work 5 rows in St st.

Rep the prev 6 rows **5**(6:**7**:9) more
times and the inc row once more.
(**44**(48:**52**:58) sts)

Work straight until Sleeve measures **12**
(13:**14¼**:15¼) in. / **30**(33:**36**:39) cm
from cast-on edge, ending with p row.

Shape sleeve top

Next row: K2, skpo, k to last 4 sts,
k2tog, k2. (**42**(46:**50**:56) sts)

Next row: P to end.

Rep the prev 2 rows **2**(2:**3**:3) more
times. (**38**(42:**44**:50) sts)

Next row: Bind off 2 sts, k to last 2 sts,
skpo. (**35**(39:**41**:47) sts)

Next row: Bind off 2 sts, p to last 2 sts,
p2tog. (**32**(36:**38**:44) sts)

Rep the last 2 rows 3 more times.
(**14**(18:**20**:26) sts)

Bind off.**

LEFT SLEEVE

Using US 6 / 4 mm needles and MC2,
cast on **30**(30:**34**:34) sts.

Work as for Right Sleeve from ** to **.

RIGHT NECKBAND

Weave in yarn ends on Right Front and
Back pieces; block. Join at shoulder
seam.

With RS facing, using US 6 / 4 mm
needles and MC1, place **5**(6:**7**:8) sts
from right neck holder on a needle,
pick up and k 14 sts up right side of
front neck, k**12**(13:**14**:15) sts from
back neck holder. (**31**(33:**35**:37) sts)

Rib row 1: K0(2:**0**:2), *p2, k2, rep from *
to last 3 sts, p3.

Rib row 1: K3, *p2, k2, rep from * to last
0(2:**0**:2) st(s), p0(2:**0**:2) st(s).

Rep these 2 rows once more, then rep
Rib row 1 once more.

Bind off rib-wise.

LEFT NECKBAND

Weave in yarn ends on Left Front and
Back pieces; block. Join at shoulder
seam.

With RS facing, using US 6 / 4 mm
needles and MC2, k**12**(13:**14**:15) sts
from back neck holder, pick up and
k 14 sts down left side of front neck,
k **5**(6:**7**:8) sts from left neck holder.
(**31**(33:**35**:37) sts)

Rib row 1: P3, *k2, p2, rep from * to
last **0**(2:**0**:2) st(s), k0(2:**0**:2) st(s).

Rib row 2: P0(2:**0**:2), *k2, p2, rep from
* to last 3 sts, k3.

Rep these 2 rows once more, then rep
Rib row 1 once more.

Bind off rib-wise.

BUTTON BAND

With RS facing, using US 6 / 4 mm
needles and MC2, pick up and k
60(68:**76**:84) sts evenly down Left
Front edge.

Rib row 1: K1, *p2, k2, rep from * to
last 3 sts, p2, k1.

Rib row 2: K3, *p2, k2, rep from * to
last 5 sts, p2, k3.

Rep these 2 rows once more, then rep
Rib row 1 once more.

Bind off rib-wise.

BUTTONHOLE BAND

With RS facing, using US 6 / 4 mm
needles and MC1, pick up and k
60(68:**76**:84) sts evenly up Right
Front edge.

Rib row 1: K1, *p2, k2, rep from * to
last 3 sts, p2, k1.

Rib row 2: K3, *p2, k2, rep from * to
last 5 sts, p2, k3.

Buttonhole row: Rib **4**(4:**6**:6), [rib2tog,
yrn2, rib2tog, rib **8**(10:**8**:10)]
4(4:**5**:5) times, rib2tog, yrn2,
rib2tog, rib **4**(4:**6**:6).

Rep Rib row 2, then rep Rib row 1.

Bind off rib-wise.

FINISHING

See Adult size.

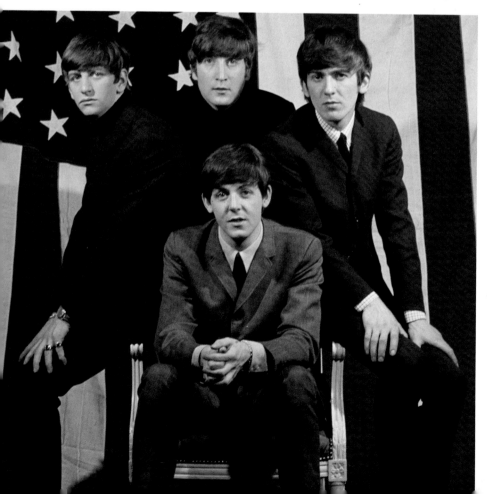

ADULT-SIZE CARDIGAN

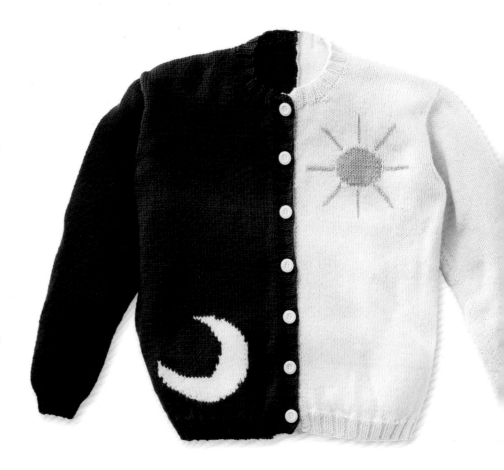

RIGHT BACK

Using US 7 / 4.5 mm needles and MC1, cast on 46(50:**54**:62:**66**:70:**74**:82) sts.

****Rib row 1:** K2, *p2, k2, rep from * to end.

Rib row 2: P2, *k2, p2, rep from * to end.

Rep the prev 2 rows 4 more times, inc 1(2:**3**:0:**1**:2:**3**:0) st(s) evenly across last row. (**47**:52:**57**:62:**67**:72:**77**:82) sts.)**

Change to US 8 / 5 mm needles.

Beg with a k row, work 16(16:**18**:18:**18**:18:**20**:20) rows in St st.

Foll Night Chart 2(2:**2**:2:**3**:3:**3**:3), work as foll:

Row 1 (RS): K12(15:**18**:21:**20**:23:**26**:29) in MC1, k25(25:**25**:25:**33**:33:**33**:33) from Row 1 of chart, k10(12:**14**:16: **14**:16:**18**:20) in MC1.

Row 2: P10(12:**14**:16:**14**:16:**18**:20) in MC1, p25(25:**25**:25:**33**:33:**33**:33) from Row 2 of chart, p12(15:**18**:21: **20**:23:**26**:29) in MC1.

These 2 rows set the position of the charted design.

Cont to work to end of chart, then cont in St st in MC1 only until work measures 16½ in. / 42 cm from cast-on edge, ending with a p row.

Shape armhole

Next row: K2, skpo, k to end. (**46**:51:**56**:61:**66**:71:**76**:81) sts)

Next row: P to end.

Rep the prev 2 rows 3(4:**5**:6:**7**:8: **9**:10) more times. (**43**(47:**51**:55: **59**:63:**67**:71) sts)

Work straight until Back measures 24¼(24½:**24¾**:25¼:**25½**:26:**26½**: 26¾) in. / 61(62:**63**:64:**65**:66:**67**: 68) cm from cast-on edge, ending with a p row.

Shape shoulder

Bind off 9(10:**11**:12:**13**:14:**15**:16) sts at beg of next and 2 foll RS rows. (**16**(17:**18**:19:**20**:21:**22**:23) sts)

P 1 row.
Leave sts on a holder.

LEFT BACK

Using US 7 / 4.5 mm needles and MC2, cast on 46(50:**54**:62:**66**:70:**74**: 82) sts.

Work as for Right Back from ** to **.

Change to US 8 / 5 mm needles.

Beg with a k row, work 44(44:**46**:46:**48**:48:**50**:50) rows in St st.

Foll Hard Day Chart 2(2:**2**:2:**3**:3:**3**:3), work as foll:

Row 1: K10(12:**14**:16:**13**:15:**17**:19) in MC2, k25(25:**25**:25:**34**:34:**34**:34) from Row 1 of chart, k12(15:**18**:21: **20**:23:**26**:29) in MC2.

Row 2: P12(15:**18**:21:**20**:23:**26**:29) in MC2, p25(25:**25**:25:**34**:34:**34**:34) from Row 2 of chart, p10(12:**14**:16: **13**:15:**17**:19) in MC2.

These 2 rows set the position of the charted design.

Cont to work to end of chart, then cont in St st in MC2 only. AT SAME TIME, when work measures 16½ in. / 42 cm from cast-on edge and ending with a p row, cont as foll:

Shape armhole

Next row: K to last 4 sts, k2tog, k2. (**46**(51:**56**:61:**66**:71:**76**:81) sts)

Next row: P to end.

Rep the prev 2 rows 3(4:**5**:6:**7**:8: **9**:10) more times. (**43**(47:**51**:55: **59**:63:**67**:71) sts)

Work straight until Back measures 24¼(24½:**24¾**:25¼:**25½**:26:**26½**: 26¾) in. / 61(62:**63**:64:**65**:66:**67**: 68) cm from cast-on edge, ending with a k row.

Shape shoulder

Bind off 9(10:**11**:12:**13**:14:**15**: 16) sts at beg of next and 2 foll WS rows. (**16**(17:**18**:19:**20**:21: **22**:23) sts)

Leave sts on a holder.

LEFT FRONT

Using US 7 / 4.5 mm needles and MC2, cast on **43**(47:**51**:59:**63**:67:**71**:79) sts.

Rib row 1: K2, *p2, k2, rep from * to last 5 sts, p2, k3.

Rib row 2: P3, *k2, p2, rep from * to end.

Rep the prev 2 rows 4 more times, inc **1**(2:**3**:0:**1**:2:**3**:0) st(s) evenly across last row. (**44**(49:**54**:59:**64**:69:**74**:79) sts)

Change to US 8 / 5 mm needles.

Beg with a k row, work in St st until 2 rows fewer have been worked than on Right Back to armhole shaping.

Foll Sun Chart **2**(2:**2**:2:**3**:3:**3**:3), work as foll:

Row 1: K**19**(22:**25**:28:**29**:32:**35**:38) in MC2, k**13**(13:**13**:13:**18**:18:**18**:18) from Row 1 of chart, k**12**(14:**16**:18:**17**:19:**21**:23) in MC2.

Row 2: P**12**(14:**16**:18:**17**:19:**21**:23) in MC2, p**13**(13:**13**:13:**18**:18:**18**:18) from Row 2 of chart, then p**19**(22:**25**: 28:**29**:32:**35**:38) in MC2.

These 2 rows set the position of the charted design.

Shape armhole

Cont to work to end of chart, then cont in MC2 only.

Next row: K2, skpo, k to end. (**43**(48:**53**:58:**63**:68:**73**:78) sts)

Next row: P to end.

Rep the prev 2 rows **3**(4:**5**:6:**7**:8:**9**:10) more times. (**40**(44:**48**:52:**56**:60:**64**:68) sts)

Work straight until **18**(18:**20**:20:**20**: 22:**22**:22) rows fewer have been worked than on Right Back up to shoulder shaping.

Shape front neck

Next row: K**33**(36:**39**:42:**45**:48:**51**:54), turn and work on these sts only for first side of neck shaping, place rem **7**(8:**9**:10:**11**:12:**13**:14) sts on a holder.

Next row: P to end.

Next row: K to last 2 sts, skpo. (**32**(35: **38**:41:**44**:47:**50**:53) sts)

Rep the prev 2 rows 5 more times. (**27**(30:**33**:36:**39**:42:**45**:48) sts)

Work **5**(5:**7**:7:**7**:9:**9**:9) more rows in St st.

Shape shoulder

Bind off **9**(10:**11**:12:**13**:14:**15**:16) sts at beg of next and foll RS row. (**9**(10:**11**:12:**13**:14:**15**:16) sts)

P 1 row.

Bind off.

RIGHT FRONT

Using US 7 / 4.5 mm needles and MC1, cast on **43**(47:**51**:59:**63**:67:**71**:79) sts.

Rib row 1: K3, *p2, k2, rep from * to end.

Rib row 2: P2, *k2, p2, rep from * to last 5 sts, k2, p3.

Rep the prev 2 rows 4 more times, inc **1** (2:**3**:0:**1**:2:**3**:0) st(s) evenly across last row. (**44**(49:**54**:59:**64**:69:**74**:79) sts)

Change to US 8 / 5 mm needles.

Beg with a k row, work 6 rows in St st.

Foll Moon Chart **2**(2:**2**:2:**3**:3:**3**:3), work as foll:

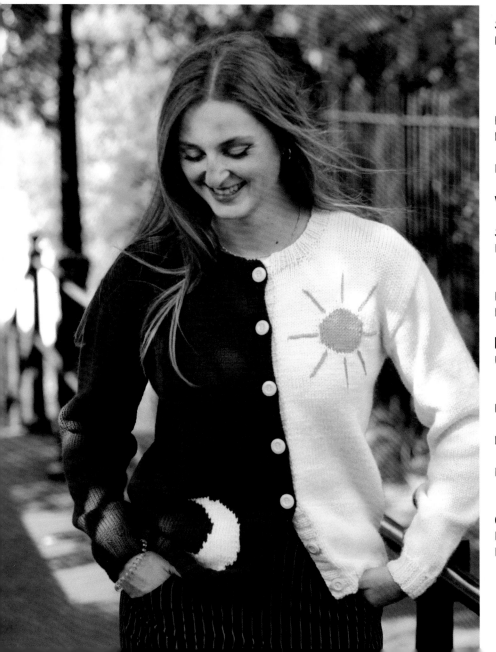

Row 1: K9(11:**13**:15:**13**:15:**17**:19) in MC1, k27(27:**27**:27:**36**:36:**36**:36) from Row 1 of chart, then k8(11:**14**:17:**15**:18:**21**:24) in MC1.

Row 2: P8(11:**14**:17:**15**:18:**21**:24) in MC1, p27(27:**27**:27:**36**:36:**36**:36) from Row 2 of chart, then p9(11:**13**:15:**13**:15:**17**:19) in MC1.

These 2 rows set the position of the charted design. Cont to work to end of chart, then cont in MC1 only until Front measures 16½ in. / 42 cm from cast-on edge, ending with a p row.

Shape armhole

Next row: K to last 4 sts, k2tog, k2. (**43**(48:**53**:58:**63**:68:**73**:78) sts)

Next row: P to end.

Rep the prev 2 rows 3(4:**5**:6:**7**:8:**9**:10) more times. (**40**(44:**48**:52:**56**:60:**64**:68) sts)

Work straight until 18(18:**20**:20:**20**:22:**22**:22) rows fewer have been worked than on Right Back to shoulder shaping.

Shape front neck

Next row: K7(8:**9**:10:**11**:12:**13**:14), leave these sts on a holder, k to end. (**33**(36:**39**:42:**45**:48:**51**:54) sts)

Next row: P to end.

Next row: K2tog, k to end. (**32**(35:**38**:41:**44**:47:**50**:53) sts)

Rep the prev 2 rows 5 more times. (**27**(30:**33**:36:**39**:42:**45**:48) sts)

Work 6(6:**8**:8:**8**:10:**10**:10) more rows in St st.

Shape shoulder

Bind off 9(10:**11**:12:**13**:14:**15**:16) sts at beg of next and foll WS row. (**9**(10:**11**:12:**13**:14:**15**:16) sts)

K 1 row.

Bind off.

RIGHT SLEEVE

Using US 6 / 4 mm needles and MC1, cast on **38**(42:**46**:54:**58**:62:**70**:74) sts.

****Rib row 1:** K2, *p2, k2, rep from * to end.

Rib row 2: P2, *k2, p2, rep from * to end.

Rep the prev 2 rows 5 more times, inc 2(4:**6**:4:**6**:8:**6**:8) sts evenly across last row. (**40**(46:**52**:58:**64**:70:**76**:82) sts)

Change to US 8 / 5 mm needles.

Beg with a k row, work 6 rows in St st.

Inc row: K4, m1, k to last 4 sts, m1, k4. (**42**(48:**54**:60:**66**:72:**78**:84) sts)

Work 5 rows in St st.

Rep the prev 6 rows 12 more times and the inc row once more. (**68**(74:**80**:86:**92**:98:**104**:110) sts)

Work straight until Sleeve measures 18 in. / 46 cm from cast-on edge, ending with a p row.

Shape sleeve top

Next row: K2, skpo, k to last 4 sts, k2tog, k2. (**66**(72:**78**:84:**90**:96:**102**:108) sts)

Next row: P to end.

Rep the prev 2 rows 3(4:**5**:6:**7**:8:**9**:10) more times. (**60**(64:**68**:72:**76**:80:**84**:88) sts)

Next row: Bind off 2 sts, k to last 2 sts, skpo. (**57**(61:**65**:69:**73**:77:**81**:85) sts)

Next row: Bind off 2 sts, p to last 2 sts, p2tog. (**54**(58:**62**:66:**70**:74:**78**:82) sts)

Rep the last 2 rows 7 more times. (**12**(16:**20**:24:**28**:32:**36**:40) sts)

Bind off.**

LEFT SLEEVE

Using US 6 / 4 mm needles and MC2, cast on **38**(42:**46**:54:**58**:62:**70**:74) sts.

Work as for Right Sleeve from ** to **.

RIGHT NECKBAND

Weave in yarn ends on Right Front and Back pieces; block. Join at shoulder seam.

With RS facing, using US 6 / 4 mm needles and MC1, place **7**(8:**9**:10:**11**:12:**13**:14) sts from right neck holder on a needle, pick up and k**16**(16:**18**:18:**18**:20:**20**:20) sts up right side of front neck, k16(17:**18**:19:**20**:21:**22**:23) sts from right back neck holder. (**39**(41:**45**:47:**49**:53:**55**:57) sts)

Rib row 1: K0(2:2:0:2:2:0:2), *p2, k2, rep from * to last 3 sts, p3.

Rib row 2: K3, *p2, k2, rep from * to last 0(2:2:0:2:2:0:2) st(s), p0(2:2:0:2:2:0:2).

Rep these 2 rows twice more, then rep Rib row 1 once more.

Bind off rib-wise.

LEFT NECKBAND

Weave in yarn ends on Left Front and Back pieces; block. Join at shoulder seam.

With RS facing, using US 6 / 4 mm needles and MC2, k**16**(17:**18**:19:**20**:21:**22**:23) sts from back neck holder, pick up and k**16**(16:**18**:18:**18**:20:**20**:20) sts down left side of front neck, k**7**(8:**9**:10:**11**:12:**13**:14) sts from left front neck holder. (**39**(41:**45**:47:**49**:53:**55**:57) sts)

Rib row 1: P3, *k2, p2, rep from * to last 0(2:2:0:2:2:0:2) st(s), k0(2:2:0:2:2:0:2).

Rib row 2: P0(2:2:0:2:2:0:2), *k2, p2, rep from * to last 3 sts, k3.

Rep these 2 rows twice more, then rep Rib row 1 once more.

Bind off rib-wise.

BUTTON BAND

With RS facing, using US 6 / 4 mm needles and MC2, pick up and k **108** (108:**112**:112:**116**:116:**120**:120) sts evenly down Left Front edge.

Rib row 1: K1, *p2, k2, rep from * to last 3 sts, p2, k1.

Rib row 2: K3, *p2, k2, rep from * to last 5 sts, p2, k3.

Rep these 2 rows twice more, then rep Rib row 1 once more.

Bind off rib-wise.

BUTTONHOLE BAND

With RS facing, using US 6 / 4 mm needles and MC1, pick up and k **108**(108:**112**:112:**116**:116:**120**: 120) sts evenly up Right Front edge.

Rib row 1: K1, *p2, k2, rep from * to last 3 sts, p2, k1.

Rib row 2: K3, *p2, k2, rep from * to last 5 sts, p2, k3.

Rep Rib row 1.

Buttonhole row: Rib **4**(4:**5**:5:**5**:5:**6**:6), [rib2tog, yrn2, rib2tog, rib **12**(12:**13**:13:**13**:13:**14**:14), rib2tog, yrn2, rib2tog, rib **12**(12:**12**:12:**13**:13:**13**:13)] 3 times, rib2tog, yrn2, rib2tog, rib **4**(4:**4**:4:**5**:5:**5**:5).

Rep Rib rows 1 and 2 once more, then rep Rib row 1 once more.

Bind off rib-wise.

FINISHING

Weave in remaining yarn ends and block the Sleeves (see page 199 for more on blocking).

Using the picture as a guide, embroider eight radiating lines of chain stitch (see page 198) in CC2 around the sun motif on the Left Front.

Join the Right and Left Back pieces.

Sew the sleeves in place, matching centers of sleeve tops to shoulder seams. Join the side and sleeve seams.

Sew on the buttons, matching their positions to the buttonholes.

CHART

KEY

☐ MC2
▨ CC2

SUN CHART 1

SUN CHART 2

SUN CHART 3

KEY

☐ MC2
■ CC1

HARD DAY CHART 3

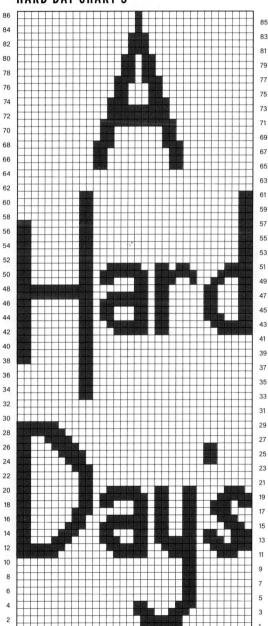

HARD DAY CHART 2

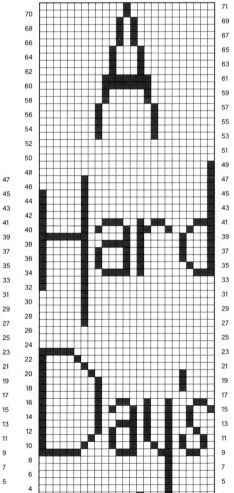

HARD DAY CHART 1

KEY

■ MC1
□ MC2

NIGHT CHART 1

NIGHT CHART 2

NIGHT CHART 3

MOON CHART 1

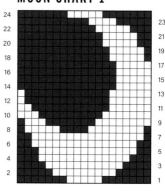

MOON CHART 2

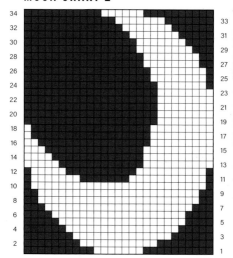

MOON CHART 3

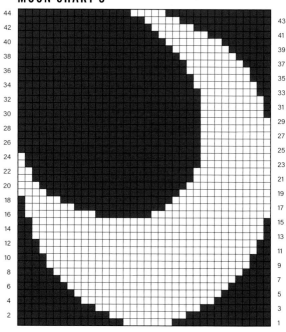

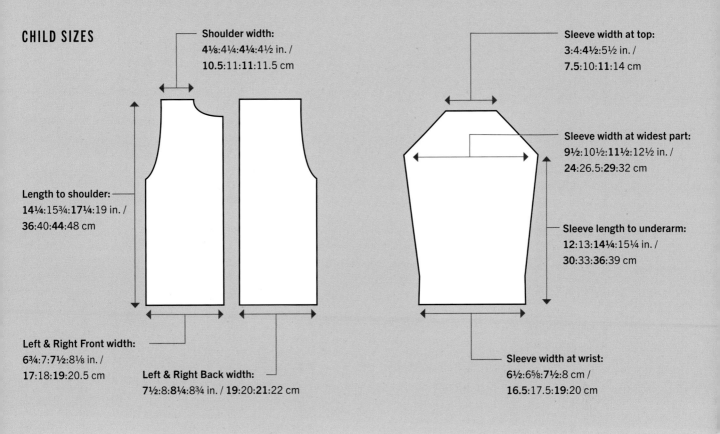

CHILD SIZES

Shoulder width:
4⅛:4¼:4¼:4½ in. /
10.5:11:11:11.5 cm

Sleeve width at top:
3:4:4½:5½ in. /
7.5:10:11:14 cm

Sleeve width at widest part:
9½:10½:11½:12½ in. /
24:26.5:29:32 cm

Length to shoulder:
14¼:15¾:17¼:19 in. /
36:40:44:48 cm

Sleeve length to underarm:
12:13:14¼:15¼ in. /
30:33:36:39 cm

Left & Right Front width:
6¾:7:7½:8⅛ in. /
17:18:19:20.5 cm

Left & Right Back width:
7½:8:8¼:8¾ in. / 19:20:21:22 cm

Sleeve width at wrist:
6½:6⅝:7½:8 cm /
16.5:17.5:19:20 cm

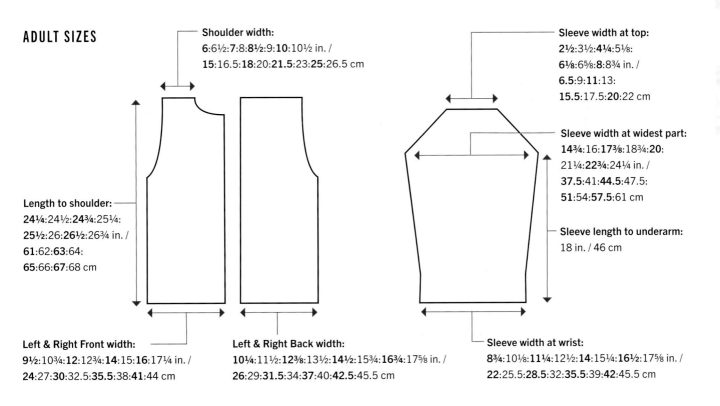

ADULT SIZES

Shoulder width:
6:6½:7:8:8½:9:10:10½ in. /
15:16.5:18:20:21.5:23:25:26.5 cm

Sleeve width at top:
2½:3½:4¼:5⅛:
6⅛:6⅝:8:8¾ in. /
6.5:9:11:13:
15.5:17.5:20:22 cm

Sleeve width at widest part:
14¾:16:17⅜:18¾:20:
21¼:22¾:24¼ in. /
37.5:41:44.5:47.5:
51:54:57.5:61 cm

Length to shoulder:
24¼:24½:24¾:25¼:
25½:26:26½:26¾ in. /
61:62:63:64:
65:66:67:68 cm

Sleeve length to underarm:
18 in. / 46 cm

Left & Right Front width:
9½:10¾:12:12¾:14:15:16:17¼ in. /
24:27:30:32.5:35.5:38:41:44 cm

Left & Right Back width:
10¼:11½:12⅜:13½:14½:15¾:16¾:17⅝ in. /
26:29:31.5:34:37:40:42.5:45.5 cm

Sleeve width at wrist:
8¾:10⅛:11¼:12½:14:15¼:16½:17⅝ in. /
22:25.5:28.5:32:35.5:39:42:45.5 cm

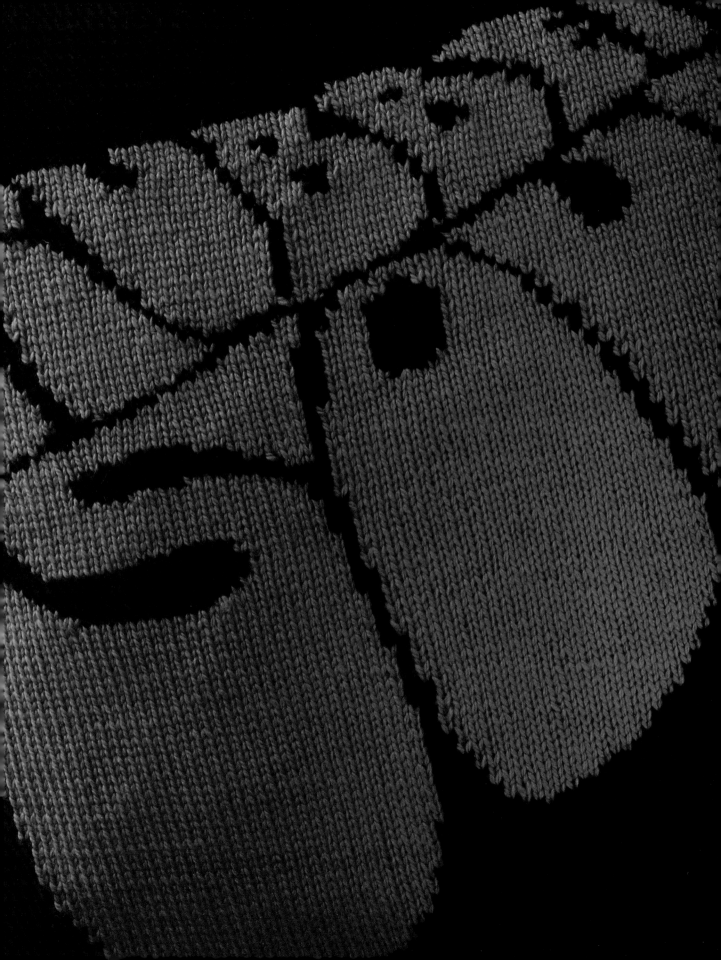

FROM ME TO YOU

Stylish accessories with timeless appeal
make the perfect gift for friends, family,
and of course, yourself.

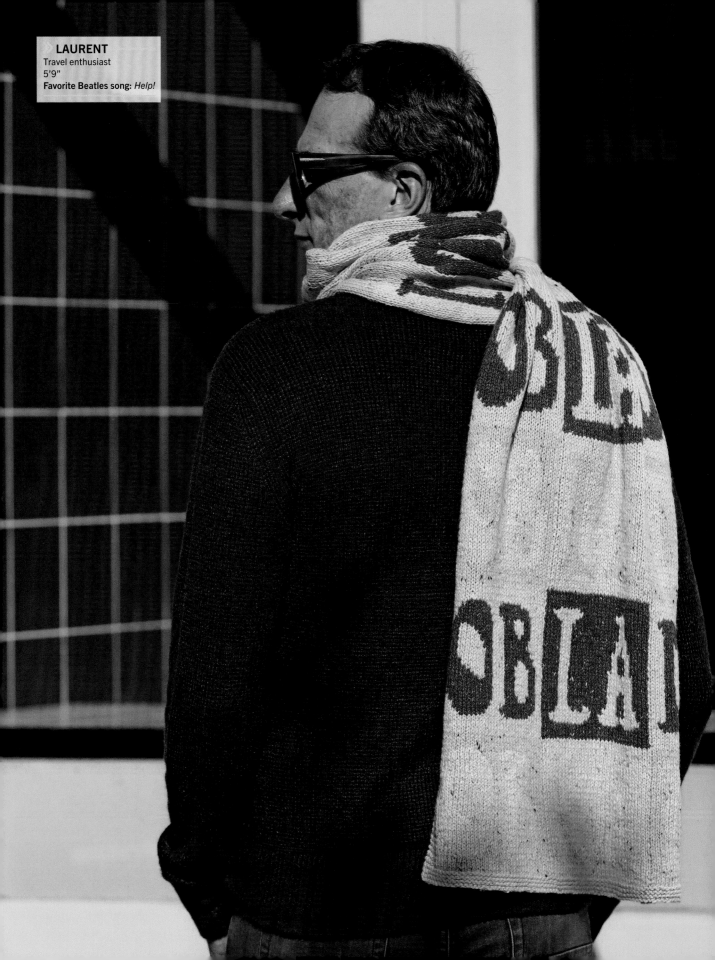

OB-LA-DI, OB-LA-DA WRAP

Designed by Sian Brown
Skill level 🍎🍎

The catchy chorus of the song "Ob-La-Di, Ob-La-Da" has inspired the design of this cozy wrap. The title has been turned into a simple repeating pattern that's worked across the whole of the fabric. The syllables of the title are set inside squares, and a simple color scheme made up of just three shades gives structure to the design and reinforces the repetitive motifs. The background and lettering alternate between the main color and the two contrasting shades. The wrap is worked in intarsia, so remember to take care to twist the yarns together when changing color to get a neat finish at the transition points.

"Ob-La-Di, Ob-La-Da" featured on The White Album, *which was released in November 1968. Although the disc is known as* The White Album, *it was officially titled* The Beatles. *It was the first album to be released on the band's Apple label.*

SIZE
One size

FINISHED MEASUREMENTS
Width: 19¾ in. / 50 cm
Length: 60 in. / 152 cm

YARN
DK weight (light #3), shown in Scheepjes Terrazzo DK (70% recycled wool, 30% recycled viscose; 191 yd. / 175 m per 2 oz. / 50 g ball)
MC: Mediterraneo (737), 4 balls
CC1: Oro (703), 2 balls
CC2: Mandarino (715), 2 balls

NEEDLES
US 6 / 4 mm needles, or size needed to obtain gauge

NOTIONS
Tapestry needle

GAUGE
22 sts and 30 rows = 4 in. / 10 cm square over intarsia patt using US 6 / 4 mm needles
Be sure to check your gauge.

continued on the next page >>

ABBREVIATIONS
See page 201.

PATTERN NOTES
- You will need to wind separate small balls of each color for the intarsia design (see page 196 for more information on working intarsia), following the charts on page 105. Wind separate balls of the different colors and twist them together where they join to avoid holes in the finished work.
- The charts have been turned on their sides; to read them correctly, turn the book so you can read across the rows. Alternatively, copy the charts (enlarging them if desired) and use them, marking off rows as you work. For more on reading charts, see page 196.

THE WRAP

Using MC, cast on 104 sts.
K 6 rows.
**Foll the relevant charts, work as foll:
Row 1 (RS): K4 in MC; k96 sts from Row 1 of Chart 1 (letters in CC1); k4 in MC.
Row 2: K4 in MC; p96 sts from Row 2 of Chart 1; k4 in MC.
These 2 rows set the position of the charted design, with garter st borders at the end of each row.
Cont until 42 more rows have been worked.

Row 45 (RS): K4 in MC; k96 sts from Row 1 of Chart 2 (letters in CC2); k4 in MC.
Row 46: K4 in MC; p96 sts from Row 2 of Chart 2; k4 in MC.
Cont as set until 42 more rows have been worked.**
Rep from ** to ** 4 more times (440 rows worked).
Using MC, k 6 rows.
Bind off.

FINISHING
Weave in yarn ends and block (see page 199 for more on blocking).

CHARTS

CHART 2

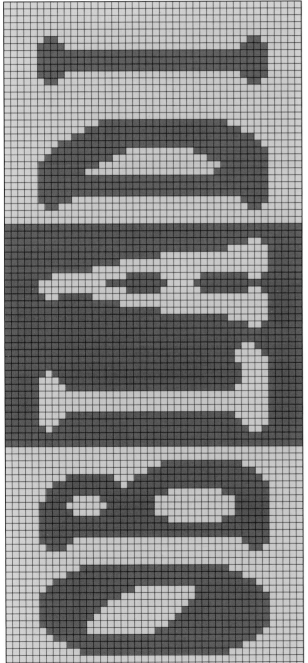

CHART 1

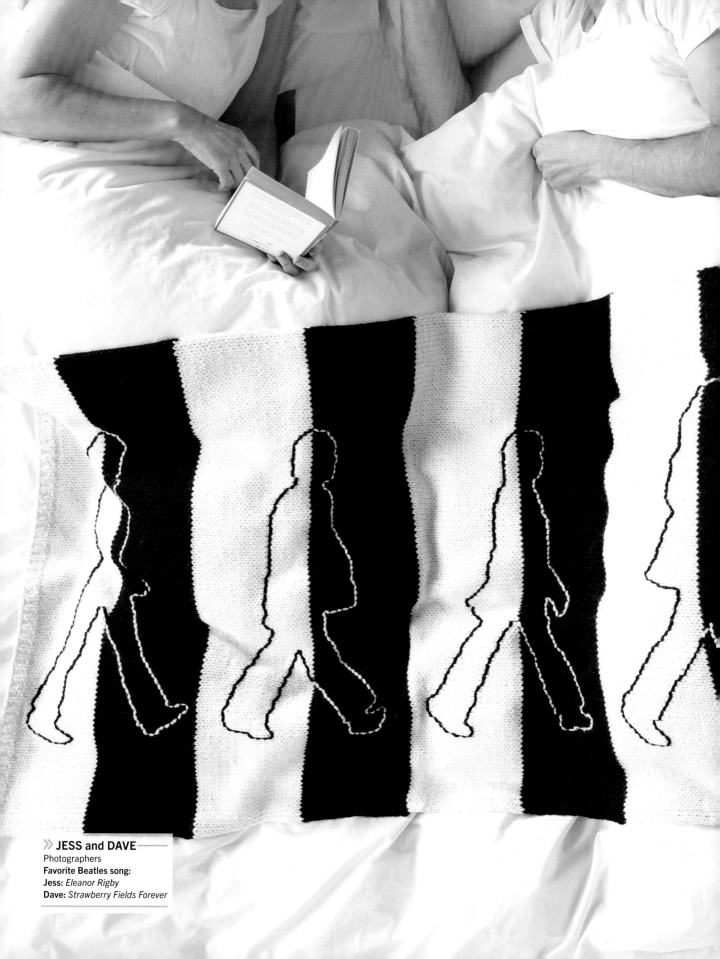

>> **JESS and DAVE**
Photographers
Favorite Beatles song:
Jess: *Eleanor Rigby*
Dave: *Strawberry Fields Forever*

THE BEATLES ABBEY ROAD

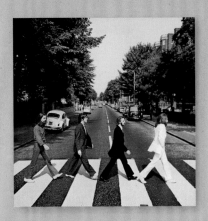

Abbey Road was released in the UK in September 1969, and in the United States in October that year. Earlier that year, the band performed their celebrated rooftop concert at Apple's headquarters in London's Savile Row.

ABBEY ROAD
THROW

Designed by **Anna Alway**
Skill level 🍎

Possibly the most iconic image of The Beatles appeared on the cover of *Abbey Road*. The group stride across a black and white crosswalk—known as a zebra crossing in the UK—on the eponymous street in St. John's Wood, north west London, that was home to their recording studios.

Inspired by the album cover, this throw features the silhouettes of George, Paul, Ringo, and John, as they were seen in that famous image, superimposed upon bold black and white stripes that echo the crossing. Worked in stockinette stitch, with ribbed borders, the throw is embroidered with backstitch to create the image. Made in a chunky weight yarn, it's ideal for snuggling up under with someone you love.

SIZE
One size

FINISHED MEASUREMENTS
Width: 32¼ in. / 82 cm
Length: 55 in. / 140 cm

YARN
Super chunky weight (super bulky #6), shown in DROPS Andes Uni Color (65% wool, 35% alpaca; 98 yd. / 90 m per 3½ oz. / 100 g ball)
MC1: White (1101), 5 balls
MC2: Black (8903), 5 balls

NEEDLES
US 11 / 8 mm circular needle, 32 in. / 80 cm long, or size needed to obtain gauge

NOTIONS
Tapestry needle
Measuring tape
Pins
Sheets of printer paper
Glue or tape
Scissors

continued on the next page >>

GAUGE

13 sts and 16 rows = 4 in. / 10 cm square over St st using US 11 / 8 mm needles
Be sure to check your gauge.

ABBREVIATIONS

See page 201.

PATTERN NOTES

- Backstitch is used to work the outlines of The Beatles (see page 198 for the technique). Templates for the figures are given on pages 110–113 to help you create neat outlines with your stitching.

THE THROW

Using MC1, cast on 107 sts.
Rib row 1: *K1, p1, rep from * to last st, k1.
Rib row 2: *P1, k1, rep from * to last st, p1.
Rep these 2 rows once more.
Row 1: [K1, p1] twice, k to last 4 sts, [p1, k1] twice.
Row 2: [K1, p1] twice, p to last 4 sts, [k1, p1] twice.
Rep Rows 1 and 2 eleven more times.
**Cut off MC1 and join on MC2.
Rep Rows 1 and 2 fourteen times.
Cut off MC2 and join on MC1.
Rep Rows 1 and 2 fourteen times.**
Rep from ** to ** twice more.
Cut off MC1 and join on MC2.
Rep Rows 1 and 2 twelve times.
Rep Rib rows 1 and 2 twice.
Bind off in rib.

FINISHING

Weave in yarn ends and block (see page 199 for more on blocking).

Embroidery

Photocopy the figure templates on pages 110–113; measuring from the top of the vertical line to the feet on each one, enlarge figure 1 (George) to 21⅛ in. / 53.5 cm, figure 2 (Paul) to 20 in. / 51 cm, figure 3 (Ringo) to 19¾ in. / 53.5 cm, and figure 4 (John) to 20 in. / 51 cm. You will have to copy them onto several sheets of paper, then glue or tape these together and cut out each figure.

Lay the finished throw out flat and place the paper cutouts on top, matching the central line on each one to the dividing line between the black and white stripes—use the photograph below as a further guide to placement. Pin each one in place.

Cut four 3¼ yd. / 3 m lengths of MC1 and of MC2. Using a tapestry needle, and starting between the legs, backstitch (see page 198) around the figures, using MC1 yarn on the MC2 stripes and MC2 yarn on the MC1 stripes.

Weave in the remaining yarn ends.

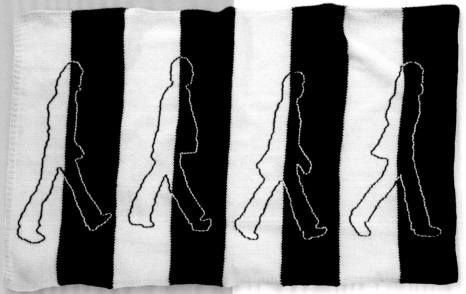

《 LEFT
Use the templates to help you embroider The Beatles onto your throw.

1

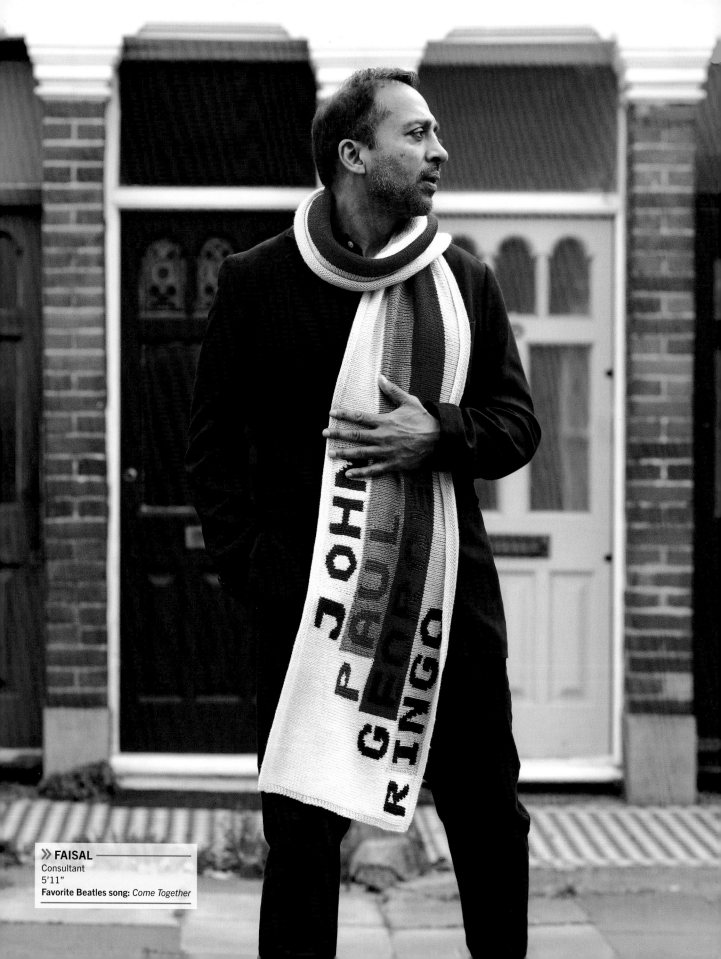

FAISAL
Consultant
5'11"
Favorite Beatles song: *Come Together*

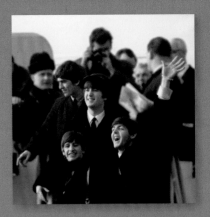

Beatlemania arrived in North America with the band's first US visit in February 1964. It became a global phenomenon when the Fab Four embarked on their first world tour in June that year with visits to countries including Denmark, the Netherlands, Australia, and New Zealand.

FAB FOUR
SCARF

Designed by Sian Brown
Skill level ●●

John, Paul, George, and Ringo first made headlines in 1962 with the success of their first hit, "Love Me Do." As the band gained in popularity, and the term *Beatlemania* was coined as a label for their fandom, the group also became known as the Fab Four.

Go the extra mile and gift someone a fantastic Fab Four accessory by making this gorgeous long scarf. Knitted lengthwise, it features colored stripes with the band members' names worked on top. You'll need a long circular needle to accommodate all the stitches as you work back and forth.

SIZE
One size

FINISHED MEASUREMENTS
Width: 13 in. / 33 cm
Length: 78¾ in. / 200 cm

YARN
DK weight (light #3), shown in Scheepjes Merino Soft (50% wool, 25% acrylic, 25% microfiber; 115 yd. / 105 m per 2 oz. / 50 g ball)
MC: Raphael (602), 2 balls
CC1: Magritte (614), 2 balls
CC2: Hockney (638), 1 ball
CC3: Picasso (621), 2 balls
CC4: Klimt (616), 1 ball
CC5: Van Gogh (641), 2 balls
CC6: Gaugin (619), 1 ball
CC7: De Goya (648), 2 balls
CC8: Millais (631), 1 ball

NEEDLES
US 6 / 4 mm circular needle, or size needed to obtain gauge

NOTIONS
Tapestry needle

continued on the next page >>

GAUGE

22 sts and 30 rows = 4 in. / 10 cm square over intarsia patt using US 6 / 4 mm needles
Be sure to check your gauge.

ABBREVIATIONS

See page 201.

PATTERN NOTES

- The scarf is worked across its length so you will need a very long circular needle to accommodate all the stitches.
- The lettering on this scarf is worked using intarsia (see page 196), following the charts on page 117. Wind separate balls of the different colors and twist them together where they join to avoid holes in the finished work.
- For more on reading charts, see page 196.

THE SCARF

Using MC, cast on 385 sts.
K 4 rows.
Foll the relevant charts, work as foll:
Row 1 (RS): K3 in MC; k309 in CC1; k70 sts from Row 1 of Chart 1; k3 in MC.
Row 2: K3 in MC; p70 sts from Row 2 of Chart 1; p in CC1 to last 3 sts; k3 in MC.
These 2 rows set the position of the charted design and the first stripe, with garter st borders at the end of each row (letters in CC2).
Work 22 rows as set.
Row 25 (RS): K3 in MC, k275 in CC3; k87 sts from Row 1 of Chart 2; k20 in MC.
Row 26: K3 in MC; p17 in MC; p87 sts from Row 2 of Chart 2; p in CC3 to last 3 sts; k3 in MC.
These 2 rows set the position of the charted design and the second stripe, with garter st borders at the end of each row (letters in CC4).
Work 22 rows as set.

Row 49 (RS): K3 in MC; k285 in CC5; k60 sts from Row 1 of Chart 3; k37 MC.
Row 50: K3 in MC, p34 in MC, p60 sts from Row 2 of Chart 3; p in CC5 to last 3 sts; k3 in MC.
These 2 rows set the position of the charted design and the third stripe, with garter st borders at the end of each row (letters in CC6).
Work 22 rows as set.
Row 73 (RS): K3 in MC, k269 in CC7; k59 sts from Row 1 of Chart 4, k54 in MC.
Row 74: K3 in MC; p51 in MC; p59 sts from Row 2 of Chart 4, p in CC7 to last 3 sts; k3 in MC.
These 2 rows set the position of the charted design and the fourth stripe, with garter st borders at the end of each row (letters in CC8).
Work 22 rows as set.
Using MC, k 4 rows.
Bind off.

FINISHING

Weave in yarn ends and block (see page 199 for more on blocking).

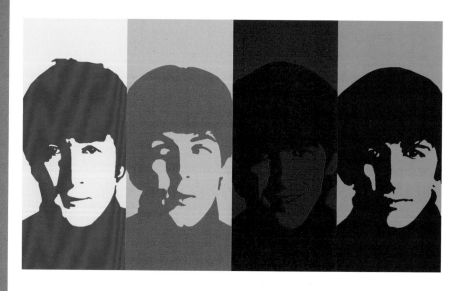

CHARTS

CHART 1

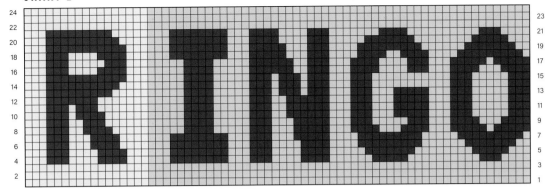

CHART 2

CHART 3

KEY

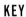

 MC

CC1

CC2

CC3

CC4

CC5

CC6

CC7

CC8

CHART 4

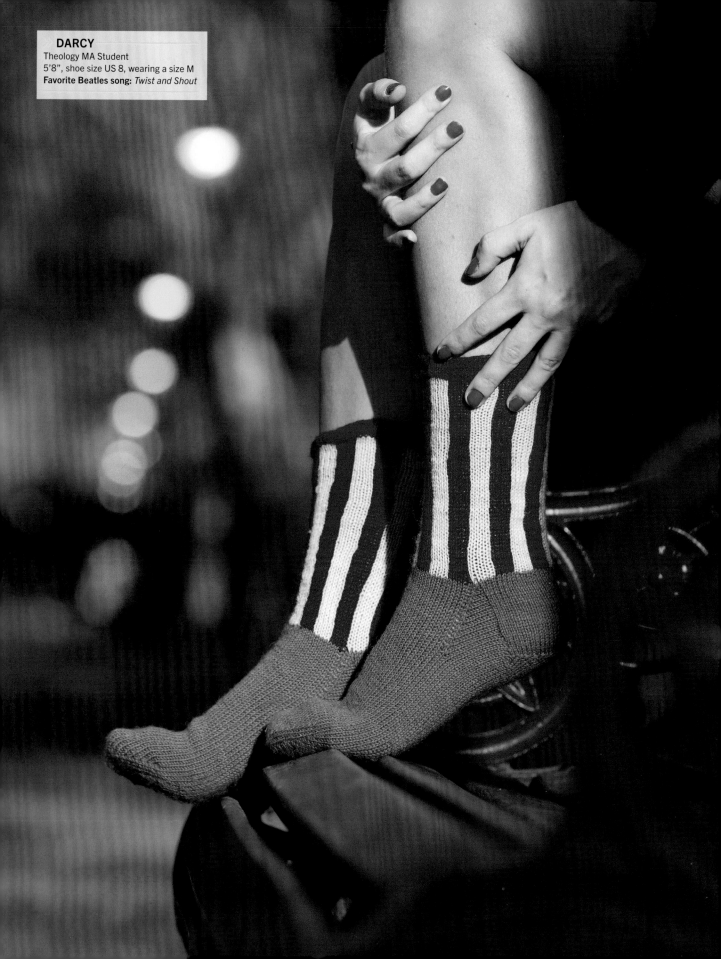

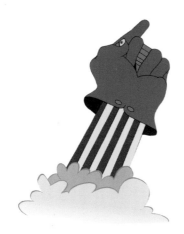

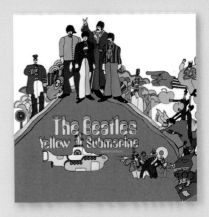

DREADFUL FLYING GLOVE
SOCKS

Designed by Caroline Smith
Skill level 🍎🍎

The Dreadful Flying Glove is used as a weapon by the Blue Meanies in the *Yellow Submarine* movie. Propelled by a streak of red and yellow stripes, he zooms around Pepperland crushing all things fun and upbeat. The Glove is defeated when John sings out the positive message of "All You Need Is Love."

With splendidly stripy legs and bold blue feet, these socks are made in a practical wool-blend yarn, so they're hard-wearing as well as fun. To create the vertical stripes, you'll need to use the Fair Isle technique to change color as you work in the round. These are top-down socks, beginning at the cuff and working to the toe, which is finished by grafting the ends together.

Pepperland is a musical utopia and home to Sgt. Pepper and his Lonely Hearts Club Band, who are trapped by the Blue Meanies as part of their plot to banish music. The Dreadful Flying Glove is a tool used by the movie's villains, the dastardly Blue Meanies, in their attempt to take over Pepperland.

SIZES
S:M:L, to fit shoe sizes US **6**—**8**:**8½**—**10**: **11**—**13** / European **37**—**39**:**40**—**43**:**44**—**47**

FINISHED MEASUREMENTS
Foot circumference: **4¼**:**8¼**:**9½** in. / **18.5**:**21**:**24** cm

YARN
4-ply weight (superfine #1), shown in Opal Uni 4-ply (75% wool, 25% polyamide; 464 yd. / 425 m per 3½ oz. / 100 g ball)
MC: Blue (5188), 1 ball
CC1: Red (5180), 1 ball
CC2: Sun Yellow (5182), 1 ball

NEEDLES
Set of four US 2 / 2.5 mm dpn, or size needed to obtain gauge
One US 3 / 3.25 mm needle, or size needed to obtain gauge (see Pattern Notes)

NOTIONS
Lockable stitch markers
Tapestry needle

GAUGE
30 sts and 42 rows = 4 in. / 10 cm square over St st using US 2 / 2.5 mm needles
Be sure to check your gauge.

continued on the next page >>

ABBREVIATIONS
See page 201.

PATTERN NOTES
- A stretchy cast on—the Norwegian cast on (see page 194)—is used; you can use another cast on if you prefer but it should have some give.
- Casting the stitches onto a needle one size up from the project needle size helps keep the top edge stretchy and makes it easier to divide the stitches between the double-pointed needles.
- After the ribbing, the legs are worked using the Fair Isle technique (see page 195).
- You will need stitch markers to keep track of the decreases when shaping the foot and toe. Ring stitch markers are impractical if you need to place a marker at the beginning of a round on double-pointed needles, so use lockable stitch markers and clip them into the stitches, moving them up with each round.
- To finish, the toes are grafted together using Kitchener stitch (see page 198).

THE SOCKS (MAKE 2)

Using CC1 and the Norwegian cast on (see page 194), cast on **56**(64:**72**) sts onto the US 3 / 3.25 mm needle; divide bet four US 2 / 2.5 mm dpn and join for working in the round, taking care not to twist the sts.

Round 1: *K4 tbl, p4; rep from * to end of round.

Rep prev round 9 times.

Next round: *K4 in CC2, k4 in CC1; rep from * to end of round.

This round forms the patt, rep until work measures desired length from cast-on edge.

Cut off CC1 and CC2, and join on MC.

Heel flap

Turn so you are working on WS; change to using two needles and working back and forth.

Row 1: Sl 1 p-wise, p**27**(31:**35**), turn.

Cont on these **28**(32:**36**) sts as foll:

Row 2: Sl 1 k-wise, k to end.

Row 3: Sl 1 p-wise, p to end.

Rep Rows 2 and 3 thirteen times.

Turning the heel

All sizes:

Row 1: Sl 1 k-wise, k**15**(17:**19**), ssk, k1, turn.

Row 2: Sl 1 p-wise, p5, p2tog, p1, turn.

Row 3: Sl 1 k-wise, k6, ssk, k1, turn.

Row 4: Sl 1 p-wise, p7, p2tog, p1, turn.

Row 5: Sl 1 k-wise, k8, ssk, k1, turn.

Row 6: Sl 1 p-wise, p9, p2tog, p1, turn.

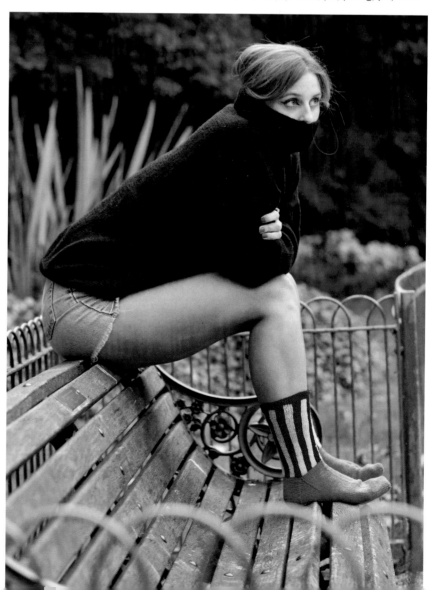

>> *RIGHT*
Darcy wearing socks with the Greatest Hits Sweater (page 40, in XL).

Row 7: Sl 1 k-wise, k10, ssk, k1, turn.
Row 8: Sl 1 p-wise, p11, p2tog, p1, turn.
Row 9: Sl 1 k-wise, k12, ssk, k1, turn.
Row 10: Sl 1 p-wise, p13, p2tog, p1, turn.

S size only:
Row 11: Sl 1 k-wise, k14, ssk, turn.
Row 12: Sl 1 p-wise, p14, p2tog, turn.
Row 13: K to end.

M size only:
Row 11: Sl 1 k-wise, k14, ssk, k1, turn.
Row 12: Sl 1 p-wise, p15, p2tog, p1, turn.
Row 13: Sl 1 k-wise, k16, ssk, turn.
Row 14: Sl 1 p-wise, p16, p2tog, turn.
Row 15: K to end.

L size only:
Row 11: Sl 1 k-wise, k14, ssk, k1, turn.
Row 12: Sl 1 p-wise, p15, p2tog, p1, turn.
Row 13: Sl 1 k-wise, k16, ssk, k1, turn.
Row 14: Sl 1 p-wise, p17, p2tog, p1, turn.
Row 15: Sl 1 k-wise, k18, ssk, turn.
Row 16: Sl 1 p-wise, p18, p2tog, turn.
Row 17: Sl 1 k-wise, k to end.
There should be **16**(18:**20**) sts left on heel flap.

Shape foot
Pick up and k 16 sts down side of heel flap; pick up and k 1 st in gap bet flap and sts on top of foot, PM; k across sts on top of foot, PM; pick up and k 1 st in gap bet top of foot and heel flap; pick up and k 16 sts up other side of heel flap; PM to indicate beg of round. (**78**(84:**90**) sts)

Arrange sts so there are **16**(18:**20**) sts on first needle (sole of foot), **23**(24:**25**) sts on second needle (side), **16**(18:**20**) sts on third needle (top), and **23**(24:**25**) sts on fourth needle (side).

Round 1: K to 2 sts before next SM, k2tog, sl SM, k to next marker, sl SM, ssk, k to end of round. (**76**(82:**88**) sts)
Round 2: K to end of round.
Rep these 2 rounds until there are **56**(64:**72**) sts.

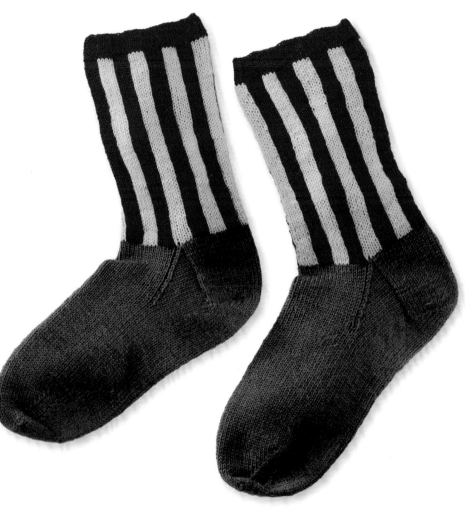

ABOVE
Vertical stripes and bright blue feet make for a fancy pair of socks!

Cont in St st, maintaining position of SM, until foot measures desired length minus about 1½ in. / 4 cm.

Toe shaping
Round 1: *K to 3 sts before next SM, ssk, k1, sl SM, k1, k2tog, rep from * once, k to end of round.
Round 2: K to end.
Rep Rounds 1 and 2 until there are **20**(24:**28**) sts.
As the number of sts dec, redistribute sts bet the other needles, maintaining the positions of the SM.

Last round: K to first marker.

Seaming the toe
Transfer each set of sts bet the SM to two needles; **10**(12:**14**) sts on each needle.
Graft the sts tog using Kitchener st (see page 198).

FINISHING
Weave in yarn ends and block (see page 199 for more on blocking).

LILA
Pie seller at Borough Market, London
Favorite Beatles song: *In My Life*

YELLOW SUBMARINE
BEANIE HAT

Designed by **Caroline Smith**
Skill level ●●

I n the film of the same name, The Beatles voyage aboard the Yellow Submarine to Pepperland, to help the inhabitants defeat the music-hating Blue Meanies. The animated submarine features four portholes, one for each Beatle, and the Fab Four can often be seen peering out as the submarine glides by on its travels.

This Yellow Submarine—inspired hat is decorated with a repeating motif made up of four porthole-like circles. It begins with a brim of twisted ribbing, and is then knitted in the round until it's time to decrease to shape the crown. Two simple rounds of red stitches border the ribbing, and the portholes are added when the knitting is complete using duplicate stitch. A pair of tassels adds a finishing touch.

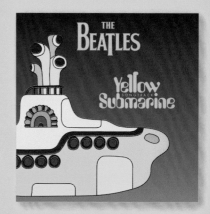

In the Yellow Submarine *film, The Beatles journey from Liverpool to Pepperland in the eponymous underwater vessel. They travel through strange seas and have many adventures before arriving in Pepperland.*

SIZE
One size

FINISHED MEASUREMENTS
Circumference (above ribbing): 20½ in. / 52 cm

YARN
4-ply weight (superfine #1), shown in DROPS Flora (65% wool, 35% alpaca; 230 yd. / 210 m per 2 oz. / 50 g ball)
MC: Yellow (17), 1 ball
CC: Red (18), 1 ball

NEEDLES
Set of five US 2½ / 3 mm dpn, or size needed to obtain gauge

NOTIONS
Stitch marker
Tapestry needle
Piece of stiff cardboard measuring 1¼ x 2 in. / 3 x 5 cm

GAUGE
27 sts and 36 rows = 4 in. / 10 cm square over St st using US 2½ / 3 mm needles
Be sure to check your gauge.

continued on the next page >>

ABBREVIATIONS

See page 201.

PATTERN NOTES

- This hat is worked in the round from the brim upward.
- You will need a cast on with some, but not too much, stretch such as a long-tail cast on (see page 194).
- The porthole decoration is added once the hat is completed using duplicate stitch (see page 197), following the chart on page 125.
- Two tassels on lengths of twisted cord have been added as decoration. You could omit these, or you could add a pom-pom instead.
- For more on reading charts, see page 196.

THE HAT

Using CC, cast on 140 sts.
Divide sts bet needles and join to work in round, taking care not to twist the sts.
Join on MC and cut off CC; PM to mark beg of round.
K 1 round.
Next round: *K1 tbl, p1, rep from * to end of round.
Rep prev round 9 more times.
Join on CC and k 1 round.
Change to MC and cut off CC; cont to k every round until hat measures 5⅜ in. / 13.5 cm from top edge of ribbing.

Shape crown
Dec round 1: *K2tog, k8, rep from * to end of round. (126 sts)
K 1 round.
Dec round 2: *K2tog, k7, rep from * to end of round. (112 sts)
K 1 round.
Dec round 3: *K2tog, k6, rep from * to end of round. (98 sts)
K 1 round.
Dec round 4: *K2tog, k5, rep from * to end of round. (84 sts)
K 1 round.
Dec round 5: *K2tog, k4, rep from * to end of round. (70 sts)
K 1 round.
Dec round 6: *K2tog, k3, rep from * to end of round. (56 sts)
K 1 round.
Dec round 7: *K2tog, k2, rep from * to end of round. (42 sts)
K 1 round.
Dec round 8: *K2tog, k1, rep from * to end of round. (28 sts)
K 1 round.
Dec round 9: *K2tog, rep from * to end of round. (14 sts)
Dec round 10: *K2tog, rep from * to end of round. (7 sts)
Cut yarn, leaving a long tail. Thread tail through rem sts and pull tight to close hole, securing yarn on WS.

FINISHING

Weave in yarn ends and block lightly (see page 199 for more on blocking).

Embroidery

Beginning 4 rows up from the row of CC above the ribbing, use a length of CC and a tapestry needle to embroider a set of portholes, working in duplicate stitch (see page 197) and following the chart.
Mark a position that is 18 stitches to the left of these embroidered portholes and 14 rows down from Dec round 1. Working from right to left, and starting at this marked position, embroider another set of portholes.

Mark a position that is halfway between the embroidered portholes, both horizontally and vertically. Count 5 rows down from this position and 13 stitches to the right; starting at this point, and working from right to left, embroider a third set of portholes.

Tassel decoration

Take a piece of stiff cardboard about 1¼ in. / 3 cm wide and 2 in. / 5 cm long and wrap CC around the width until you have the thickness you desire. Thread a tapestry needle with a length of CC and push it under the wraps of yarn; draw the yarn through and up to the top edge of the cardboard; tie in a loose knot. Unthread the needle.

Ease the wraps of yarn off the cardboard and tighten the loose knot at the top of the tassel. Wrap another length of CC tightly around the tassel, a short distance below the top; knot securely.

Use scissors to snip through the loops at the bottom of the tassel. Thread the ends of yarn used to secure the tassel onto a tapestry needle and work them into the middle of the tassel; snip off any long tails. Make another tassel the same way.

To make cords for the tassels, cut about 78¾ in. / 200 cm of CC and fold in half. Knot a loop at the point where the yarn is folded. Place this loop on a hook or get someone to hold it for you, then take the loose ends of the

≫ **RIGHT**
If desired, you can make a pair of tassels and attach them to the hat.

yarn and hold in either hand, pulling them taut. Twist the pairs of yarn in the same direction as tightly as is possible, then bring them together so they are next to each other and let go: the strands of yarn should twist together.

Run your fingers along the twisted strands to neaten the cord. *Make a knot about 3¼ in. / 8 cm from the loose ends of the cord, then make

another knot 2¾ in. / 7 cm from this one. Cut through the cord 3¼ in. / 8 cm from the second knot. Repeat from * to cut a second length of cord.

Untwist the loose ends on both lengths of cord. **Take a cord and, using a tapestry needle, sew one set of loose ends to a tassel; attach the other set of loose ends to the center top of the hat. Repeat from ** with the second cord and tassel.

CHART

KEY

■ MC

☐ No stitch

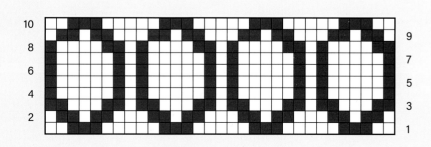

≫ MAYA
Runner
5′5″
Favorite Beatles song: *Here Comes the Sun*

HEY JUDE
SHAWL

Designed by **Caroline Smith**
Skill level ●●

The sing-along lyrics of "Hey Jude" have made it one of The Beatles' most popular hits. This wraparound shawl features the song's title, taken from one version of the single's cover—with the words worked in shades of orange on a simple cream background. Made in a warm, woolen DK yarn, it makes a great cover-up for cooler spring and fall days, and a cozy, extra thick scarf for the chillier months.

The Hey Jude design is worked using the intarsia technique, so remember to keep the transitions between colors as neat as possible. The chart for the design is a large one, so to keep track of where you are as you work, lay a sheet of paper or a ruler over each row as you progress.

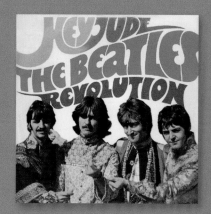

"Hey Jude" was released in August 1968 as The Beatles' first single on their new Apple label. The song "Revolution" was on the B-side.

SIZE
One size

FINISHED MEASUREMENTS
Width: 21¼ in. / 54 cm
Length: 63 in. / 162 cm

YARN
DK weight (medium #4), shown in Cascade Yarns, 220 Superwash® (100% wool; 220 yd. / 200 m per 3½ oz. / 100 g ball)
MC: Ecru (817), 4 balls
CC1: Gold Fusion (263), 1 ball
CC2: Desert Sun (253), 1 ball
CC3: Chrysanthemum (290), 1 ball

NEEDLES
US 7 / 4.5 mm circular needle, 48 in. / 120 cm long (see Pattern Notes), or size needed to obtain gauge

NOTIONS
Yarn needle

GAUGE
18.5 sts and 25.5 rows = 4 in. / 10 cm square over St st using US 7 / 4.5 mm needles
Be sure to check your gauge.

ABBREVIATIONS
See page 201.

continued on the next page >>

PATTERN NOTES

- This pattern uses the intarsia technique (see page 196), following the charts on pages 131–133. Wind separate balls of yarn before you begin and twist the yarns together tightly where they join to avoid holes in the finished work.
- You might like to copy the chart; you can then cross off rows as they are worked. For more on reading charts, see page 196.
- Using a circular needle, and working the rows back and forth, is useful when you are working on a large number of stitches. However, if you are new to the intarsia technique, you may find that the cable of the circular needle gets tangled with the separate balls of yarn, so you may prefer to work on long straight needles.

THE SHAWL

Using MC, cast on 100 sts.
Row 1: Sl 1, k to end.
Row 2: Rep Row 1.
Row 3: Sl 1, k1, p to last 2 sts, k2.
Rep Rows 2 and 3 seven more times.
Foll the chart, work as foll:
Row 1 (RS): Sl 1, k8 in MC; k81 sts from Row 1 of chart; k to end in MC.
Row 2: Sl 1, k1, p8 in MC; p81 sts from Row 2 of chart; p in MC to last 2 sts, k2 in MC.

These 2 rows set the position of the charted design, worked in St st, with garter st borders at the end of each row and sl sts at the beg of each row.
Cont until all rows of chart have been worked.
Rep Rows 2 and 3 eight times, then rep Row 3 once.
Bind off p-wise.

FINISHING

Weave in yarn ends, then block (see page 199 for more on blocking).

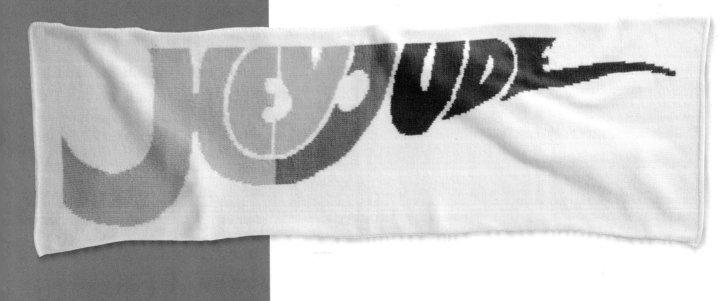

BRITISH
COMFORT
FOOD

Pies,Bangers,Mash
Fruit Crumbles,Sponge Puddings,Sweet Pies

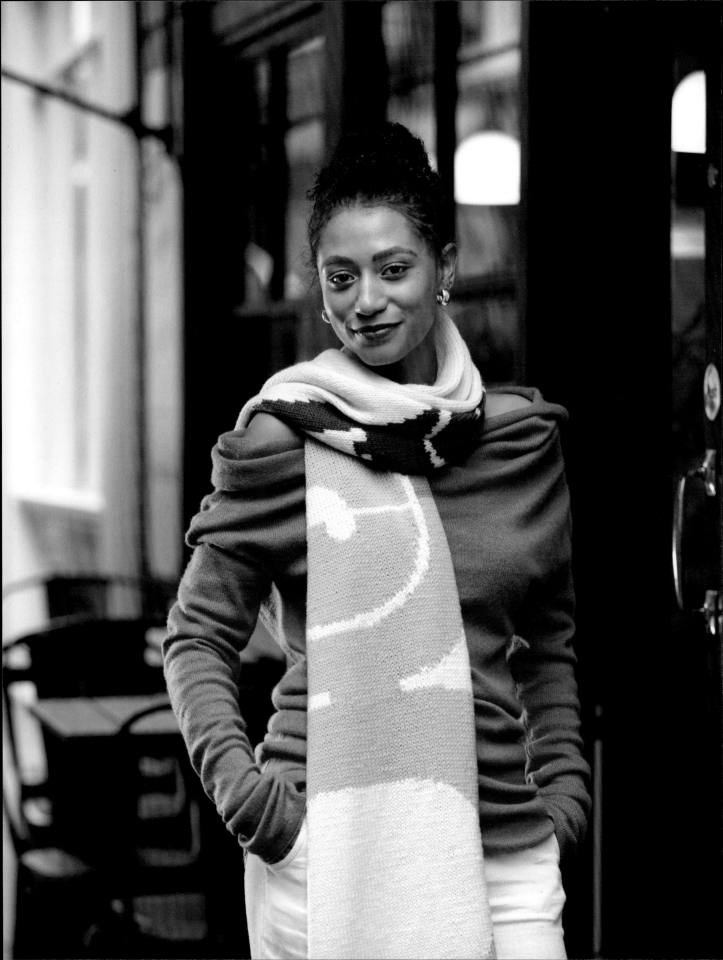

CHARTS

KEY

☐	MC
▨	CC1
▨	CC2
▨	CC3

Copy the charts on these pages (enlarging them if you wish) and join them together.

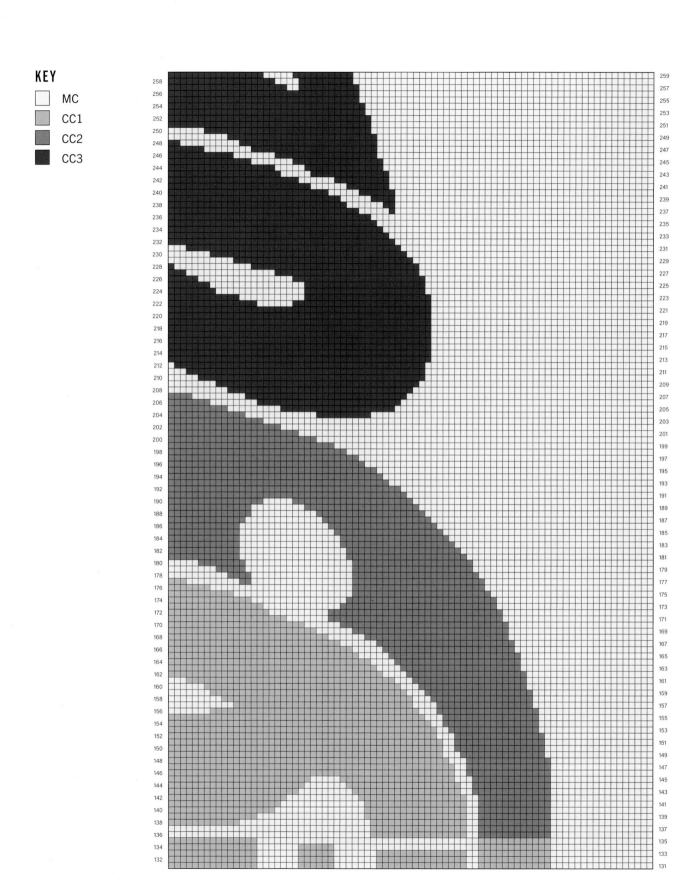

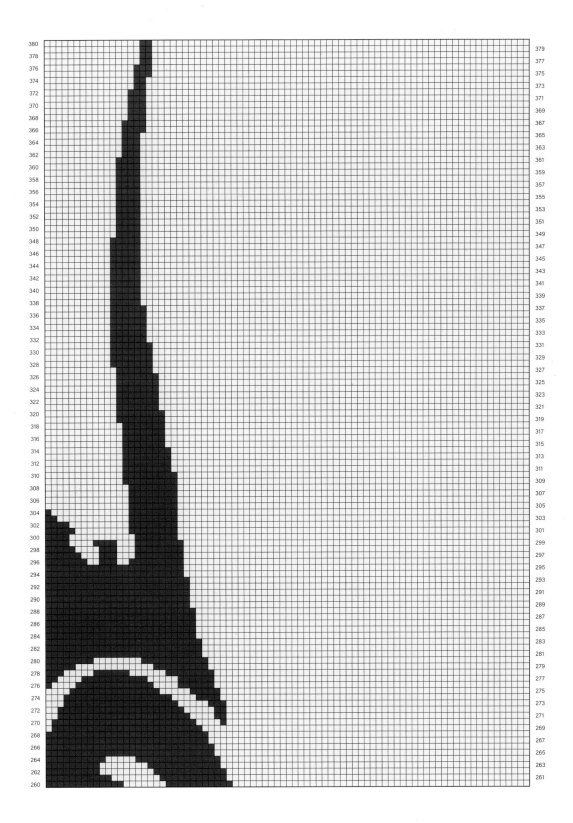

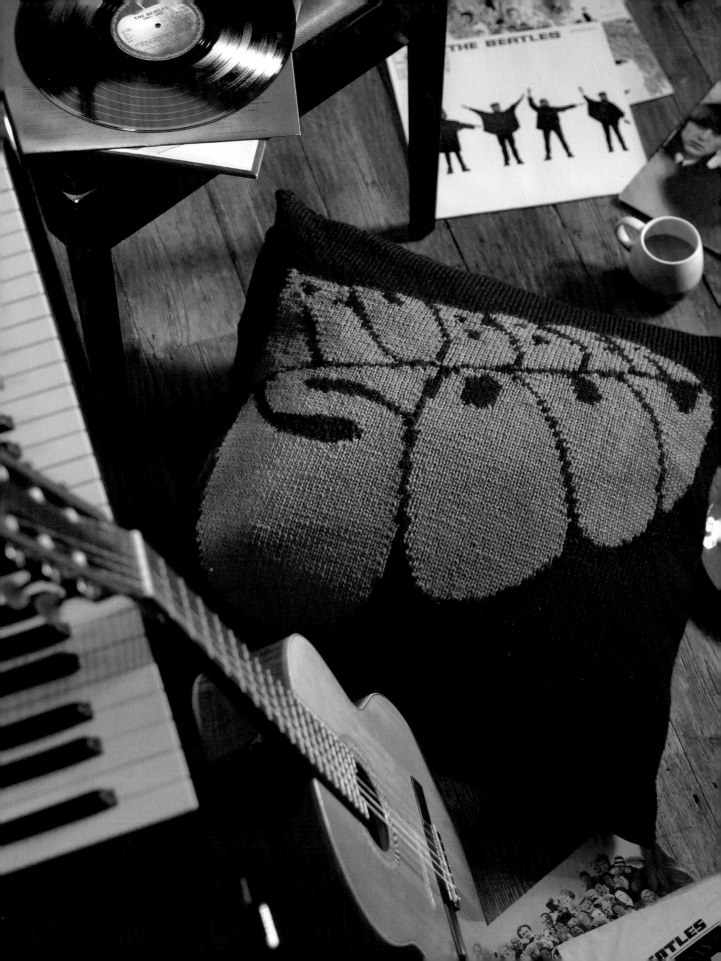

RUBBER SOUL
PILLOW

Designed by Jane Burns
Skill level

The *Rubber Soul* album featured a title logo where the two words began in the top left corner of the record sleeve and then widened and bulged outward and downward. That motif has been enlarged to form the design on the front of this pillow cover.

Created using the intarsia technique, the pillow is worked in a chunky yarn. Because it is a floor pillow, it has a fabric backing, but you could knit a piece for the back to the same size, either by repeating the pillow front or by using plain stockinette stitch. A beanbag-style pillow form is the ideal filling.

Rubber Soul was released in December 1965. Its UK release coincided with the beginning of a British tour, where the band played in eight towns over ten days, giving two performances at each venue.

SIZE
One size

FINISHED MEASUREMENTS
27½ in. / 70 cm square

YARN
Chunky weight (bulky #5), shown in Cascade Yarns, 128 Superwash® (100% merino wool; 128 yd. / 117 m per 3½ oz. / 100 g ball)
MC: Black (815), 3 balls
CC: Pumpkin (822), 2 balls

NEEDLES
US 9 / 5.5 mm needles, or size needed to obtain gauge

NOTIONS
27½ in. / 70 cm square beanbag-style pillow form
28¾ in. / 73 cm square of black cotton twill fabric (see Pattern Notes)
22 in. / 56 cm black zipper
Pins
Sewing needle and black sewing thread
Sewing machine (optional)

continued on the next page >>

GAUGE

16 sts and 22 rows = 4 in. / 10 cm square
over St st using US 9 / 5.5 mm needles
Be sure to check your gauge.

ABBREVIATIONS

See page 201.

PATTERN NOTES

- The front of the pillow is knitted using the intarsia method (see page 196), following the chart on page 138. Wind separate small balls of yarn and twist the different colors together where they join to avoid holes in the finished work.
- The back of the pillow is fabric. Use a hard-wearing material (such as cotton twill) because this side will be in contact with the floor.
- For more on reading charts, see page 196.

THE PILLOW

Using MC, cast on 112 sts.
Beg with a k row, work 24 rows in St st.
Cont in St st, foll the chart as foll:
Row 1: K12 in MC, k89 sts from Row 1 of chart, k in MC to end.
Row 2: P11 in MC, p89 sts from Row 2 of chart, p in MC to end.
These 2 rows set the position of the charted design, with St st in MC on either side. Cont until all rows on chart have been worked.
Cont in St st in MC for 24 more rows.
Bind off.

FINISHING

Weave in yarn ends and block (see page 199 for more on blocking).
Pin the zipper along one side of the square of black fabric, centered along the width of the fabric, with the right side of the zipper to the right side of the fabric and so the teeth are ⅝ in. / 1.5 cm below the raw edge of the fabric. Using a sewing machine (fitted with a zipper foot) or sewing by hand (using backstitch, see page 198), stitch the zipper tape to the fabric.
Pin the other side of the zipper tape to the left-hand edge of the pillow front, with the wrong side of the pillow front to the right side of the zipper tape. Center the pillow front along the fabric's width. Using a sewing needle and black thread, backstitch along the edge of the pillow front to join it to the zipper tape—you may find it easier to open the zipper as you work. (It is better to sew the knitting to the fabric by hand; using a sewing machine might distort the knitting.)
Bring the pillow front and the fabric right sides together and pin around the edges; make sure the zipper is open once you have done this. Hand sew around the edges, using backstitch as before, one knitted stitch or one row of knitting in from the edges. For extra strength in the seams, you can go around the edges again, whipstitching the knitting to the fabric.
Turn the pillow cover to the right side through the opening in the zipper. Gently push a finger into the corners to neaten them. Insert the pillow form and close the zipper.

» *RIGHT TOP*
*The Beatles in 1965
—the year of* Rubber
Soul's *release.*

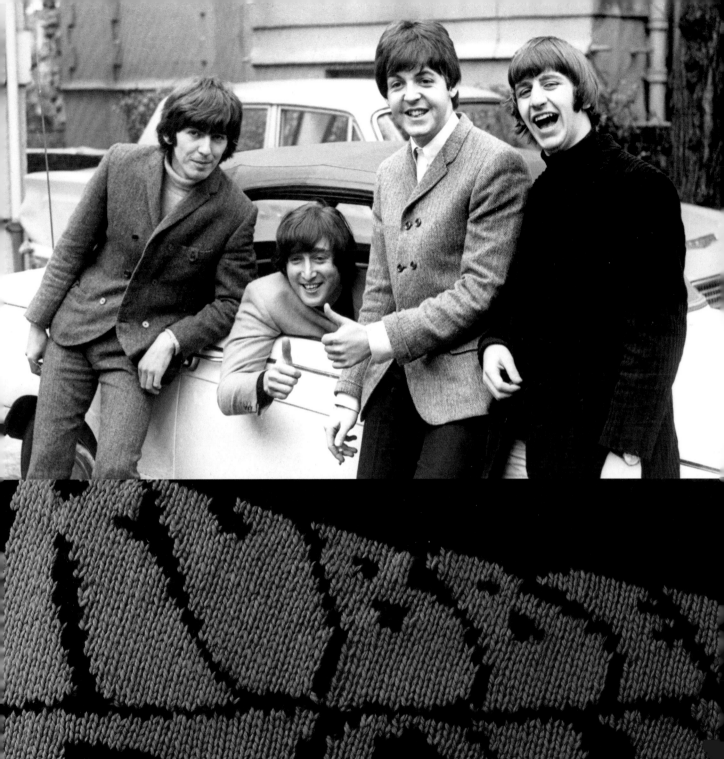

CHART

MC

CC

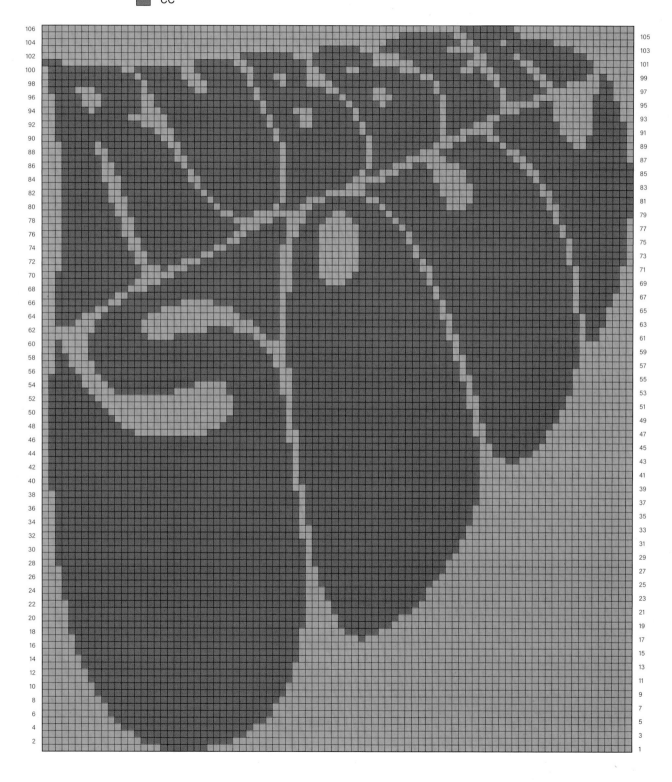

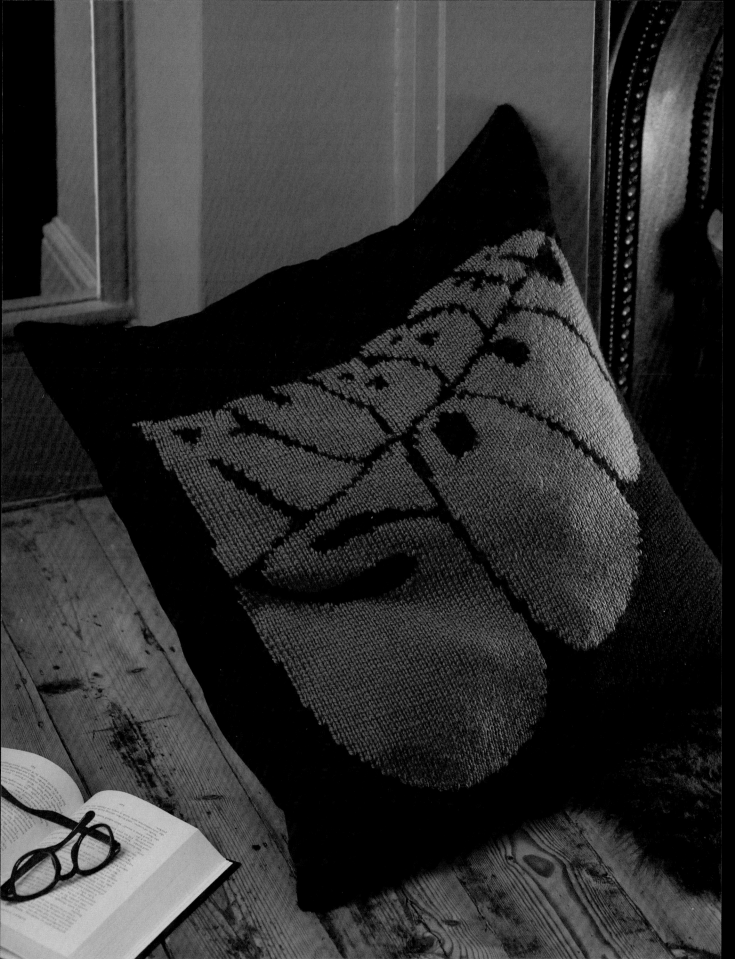

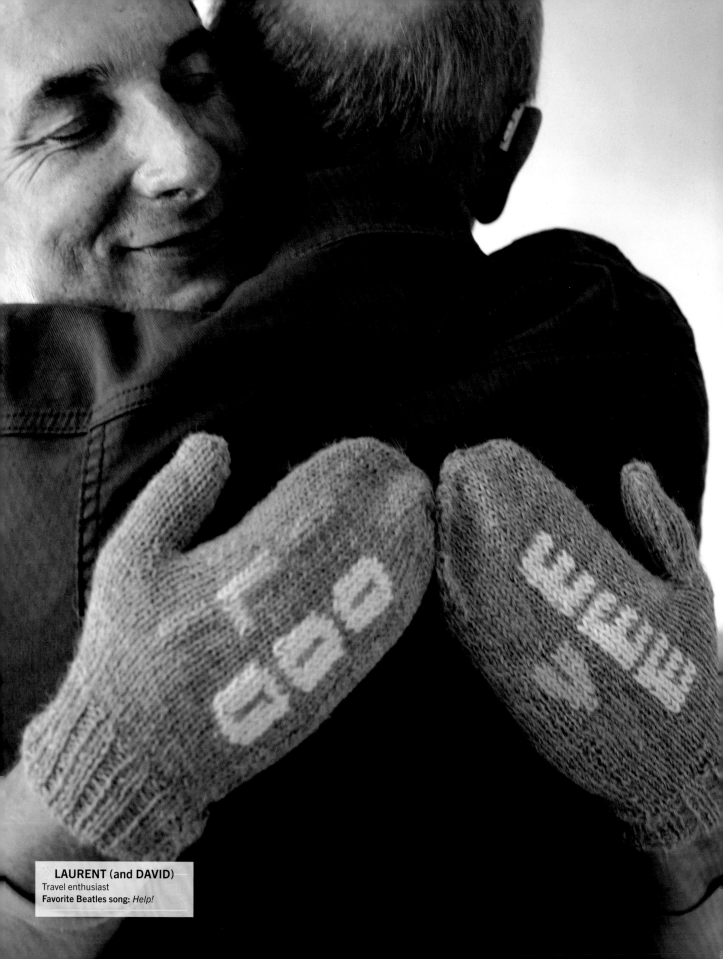

LAURENT (and DAVID)
Travel enthusiast
Favorite Beatles song: *Help!*

"All You Need Is Love" was released in July 1967, but it's not the only Beatles song to feature the word love in the title. Starting with "Love Me Do" and "P.S. I Love You" in 1962, the word has appeared in many of the band's hits.

SIZE
One size

FINISHED MEASUREMENTS
Hand circumference: 7½ in. / 19 cm
Hand length: 9½ in. / 24.5 cm

YARN
4-ply weight (fine #2), shown in DROPS Alpaca (100% alpaca; 183 yd. / 167 m per 2 oz. / 50 g ball)
MC: Light Gray (0501), 1 ball
CC1: White (101), 1 ball
CC2: Wild Rose (3720), 1 ball
CC3: Turquoise (2917), 1 ball

NEEDLES
US 2 / 2.75 mm and US 2½ / 3 mm needles, or size needed to obtain gauge

continued on the next page >>

LOVE LOVE LOVE
MITTENS

Designed by Lynne Watterson
Skill level ●●

If "All You Need Is Love," then the message is clear with these mittens—join your hands and send a little bit more love out into the world. The words "Love, Love, Love" are formed when you bring your hands together—one half of the words is worked on the left mitten; the other half is worked on the right.

Knitted flat, the mittens are joined at the sides and the words are added last by being worked in duplicate stitch using three different colors. Use the chart as a guide to the embroidery. A soft gray has been used here, with pastel shades for the contrasting yarns, but you can choose any colors you like—why not mix things up with some bright shades?

THE MITTENS

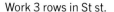

RIGHT MITTEN

Using US 2 / 2.75 mm needles and CC2, cast on 46 sts.
Cut off CC2 and join on MC.
K 1 row.
Rib row 1 (WS): P2, *k2, p2, rep from * to end.
Rib row 2: K2, *p2, k2, rep from * to end.
Rep these 2 rows 7 times more, then rep Rib row 1 once.
Change to US 2½ / 3 mm needles.
Beg with a k row, work 4 rows in St st.**
Shape for thumb
Row 1 (RS): K24, m1, k2, m1, k to end. (48 sts)
Work 3 rows in St st.
Row 5: K24, m1, k4, m1, k to end. (50 sts)
Work 3 rows in St st.
Row 9: K24, m1, k6, m1, k to end. (52 sts)

Work 3 rows in St st.
Row 13: K24, m1, k8, m1, k to end. (54 sts)
Work 3 rows in st s.
Row 17: K24, m1, k10, m1, k to end. (56 sts)
Row 18: P to end.
Row 19: K24, place next 12 sts on a stitch holder or spare yarn for thumb, turn and cast on 2 sts, turn again and k to end. (46 sts)
Row 20: P to end.
***Work on these 46 sts as foll:
Beg with a k row, work 34 rows in St st, ending with a p row.
Shape top
Dec row 1: K1, [ssk, k18, k2tog] twice, k1. (42 sts)
Dec row 2: P1, [p2tog, p16, p2tog tbl] twice, p1. (38 sts)
Dec row 3: K1, [ssk, k14, k2tog] twice, k1. (34 sts)
Dec row 4: P1, [p2tog, p12, p2tog tbl] twice, p1. (30 sts)
Cont to dec 4 sts in this way on every row until 18 sts rem.
Divide the sts bet 2 needles (9 sts on each needle), with points at the same end, and graft tog using Kitchener st (see page 198).
Thumb
With RS facing, rejoin MC to base of thumb and using US 2½ / 3 mm needles pick up and k 2 sts from cast-on sts and 12 sts from holder. (14 sts)
Next row: Pfb, p to last 2 sts, pfb, p1. (16 sts)
Beg with a k row, work 14 rows in St st.
Shape thumb top
Dec row 1: [K2tog] 8 times. (8 sts)
Dec row 2: [P2tog tbl] 4 times. (4 sts)
Cut yarn, leaving a long tail. Thread tail through rem sts and pull tight to close hole, securing yarn on WS.

LEFT MITTEN
Work as given for right mitten to **.
Shape for thumb
Row 1 (RS): K20, m1, k2, m1, k to end. (48 sts)

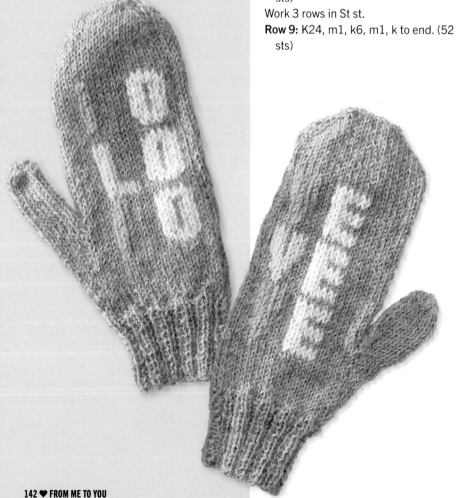

Work 3 rows in St st.

Row 5: K20, m1, k4, m1, k to end. (50 sts)

Work 3 rows in St st.

Row 9: K20, m1, k6, m1, k to end. (52 sts)

Work 3 rows in St st.

Row 13: K20, m1, k8, m1, k to end. (54 sts)

Work 3 rows in St st.

Row 17: K20, m1, k10, m1, k to end. (56 sts)

Row 18: P to end.

Row 19: K20, place next 12 sts on a holder for thumb, turn and cast on 2 sts, turn again and k to end. (46 sts)

Row 20: P to end.

Work as given for right mitten from *** to end.

FINISHING

Weave in yarn ends and block each mitten (see page 199 for more on blocking).

Embroidery

The lettering on the mittens is worked in duplicate stitch (see page 197), following the relevant chart for each mitten.

With the right side of the left mitten facing you, position the embroidery so it begins on the 13th row above the ribbing and 3 stitches in from the left edge. On the right mitten, position the embroidery on the 13th row above the ribbing, 3 stitches in from the right edge.

Join the side and thumb seams.

Weave in remaining yarn ends.

CHARTS

KEY

- CC1
- CC2
- CC3
- No stitch

RIGHT MITTEN CHART

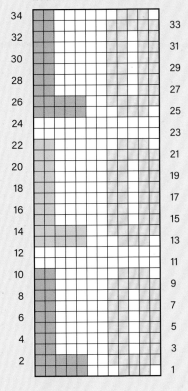

LEFT MITTEN CHART

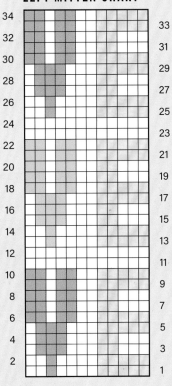

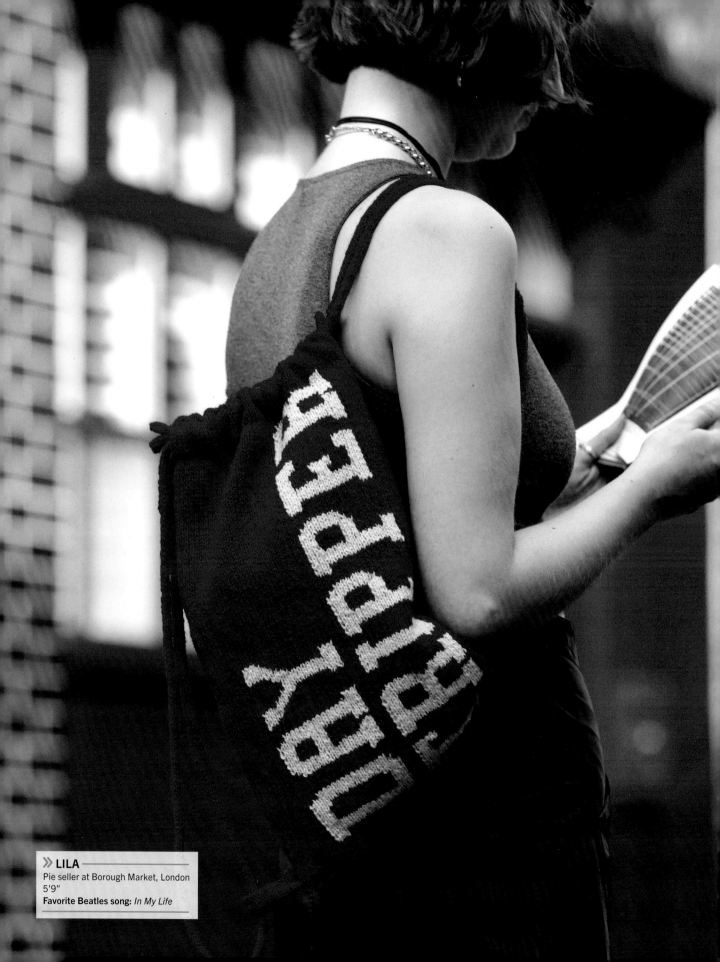

DAY TRIPPER
BAG

Designed by **Julie Brooke**
Skill level

Whether you're taking a day trip or planning a world tour—musical or otherwise—you'll need a Beatles-style bag like this one to keep all your travel essentials close at hand. Inspired by the "Day Tripper" single, this bag is made in a bright red yarn with contrasting yellow lettering. The drawstring straps are two i-cords, threaded through a casing at the top of the bag and through tabs at the sides: Pull on the straps to draw the top of the bag closed, then loop them over your shoulders to carry the bag. The "Day Tripper" lettering is worked using the intarsia technique. A fabric lining is added for a practical and neat finish. Choose a red fabric to match the knitting, or go for something in a contrasting color or pattern.

On December 3, 1965, not long after The Beatles were awarded their MBEs, the song "Day Tripper" was released as a double A-side with "We Can Work It Out."

SIZE
One size

FINISHED MEASUREMENTS
About 9½ x 15 in. / 24 x 38 cm, not including straps and tabs

YARN
4-ply weight (fine #2), shown in Jamieson & Smith 2-ply Jumper Weight (100% Shetland wool; 125 yd. / 115 m per 1 oz. / 25 g ball)
MC: Red (1403), 4 balls
CC: Bright Yellow (23), 1 ball

NEEDLES
US 3 / 3.25 mm needles, or size needed to obtain gauge
Two US 3 / 3.25 mm dpn, or size needed to obtain gauge

NOTIONS
Tapestry needle
20 x 15¾ in. / 51 x 40 cm piece of fabric (see Pattern Notes)
Sewing needle
Sewing thread to match both the fabric and the MC yarn
Bodkin or safety pin

GAUGE
26 sts and 35 rows = 4 in. / 10 cm square over St st using 3.25 mm needles
Be sure to check your gauge.

continued on the next page >>

ABBREVIATIONS
See page 201.

PATTERN NOTES

- Use the intarsia technique to work the charted design (see page 196), following the chart on page 148. Remember to read right-side rows from right to left and wrong-side rows from left to right. Wind separate balls of the different colors and twist them together where they join to avoid holes in the finished work.
- The bag's straps are two i-cords—see page 197 for instructions on how to make them.
- The backpack is lined with a piece of fabric—choose something that is lightweight but closely woven and in a color that won't show through your knitting.
- You can use a sewing machine to stitch the lining pieces together or sew by hand. If you do the latter, then use small backstitches for your seams.
- For more on reading charts, see page 196.

THE BAG

FRONT
Using US 3 / 3.25 mm needles and MC, cast on 65 sts.
Beg with a k row, work 6 rows in St st.
Foll the chart, work as foll:
Row 1 (RS): K12 in MC, k41 sts from Row 1 of chart, k12 in MC.
Row 2 (WS): P12 in MC, p41 sts from Row 2 of chart, p12 in MC.
These 2 rows set the position of the charted design.
Cont to work entire chart as set.
Beg with a p row, work 9 rows in St st, cont in MC only.
P 1 row.
Beg with a p row, work 9 rows in St st.
Bind off.

BACK
Using US 3 / 3.25 mm needles and MC, cast on 65 sts.
Beg with a k row, work 134 rows in St st.
P 1 row.
Beg with a p row, work 9 rows in St st.
Bind off.

TABS (MAKE 2)
Using US 3 / 3.25 mm needles and MC, cast on 6 sts.
Work in St st until piece measures 4⅓ in. / 11 cm from cast-on edge.
Bind off.

STRAPS (MAKE 2)
Using two US 3 / 3.25 mm dpn and MC, cast on 6 sts.
Make an i-cord (see page 197) 51 in. / 130 cm long.

FINISHING
Weave in yarn ends on the Front, Back, and Tabs and block using the spray method (see page 199). (Do not weave in the yarn ends on the Straps, or block them.)
Turn under the bound-off edge of the Front so that the purl-stitch ridge is at the top and sew in place using a tapestry needle and MC to form the casing for the straps. Repeat with the Back.
Fold each Tab in half widthwise and sew the short ends together. Lay the Back out flat and pin a Tab in the

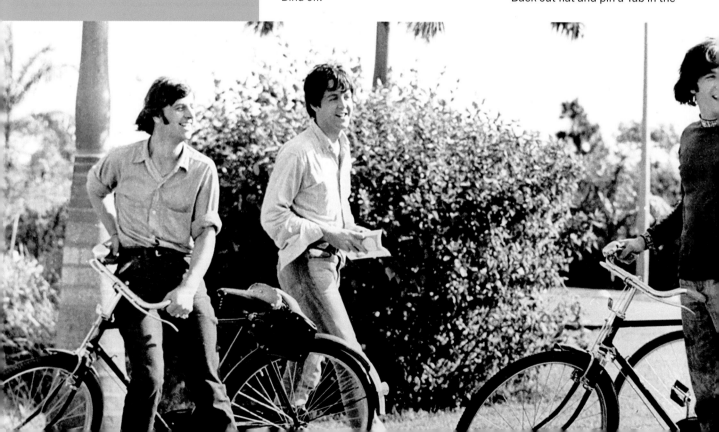

bottom right corner, positioned just above the cast-on edge and with the stitched ends lining up with the side of the bag. Sew in place. Repeat to attach the other Tab to the bottom left corner.

Pin the Front and Back with right sides together, making sure that the tabs are inside. Starting and finishing just below the casing, sew along the sides.

Turn the bag to the right side and join the bottom edge.

At one end of the casing, join the edges on the inside of the bag—leave the outer edges open so you can insert the Straps. Repeat at the other end of the casing.

To line the bag, fold your fabric in half widthwise, with right sides together, and sew along both side seams using a ⅝ in. / 1.5 cm seam allowance. Turn under the top edge to the wrong side by ¼ in. / 5 mm, and press. Insert the lining in the bag and turn under the top edge again so that fold lines up with the bottom of the casing. Pin the turning, then take

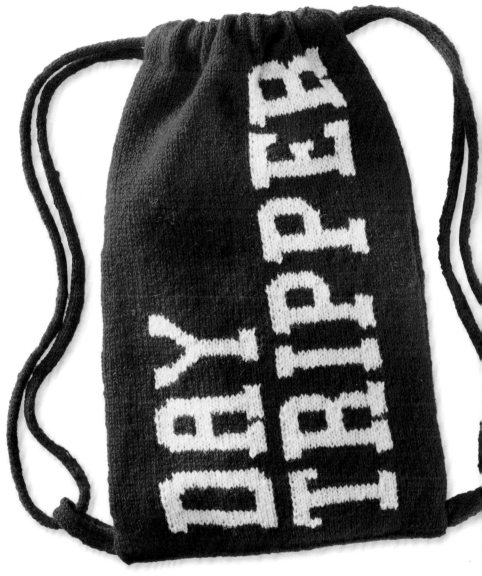

« LEFT ———
In 1965 The Beatles were back on the road again for international tours.

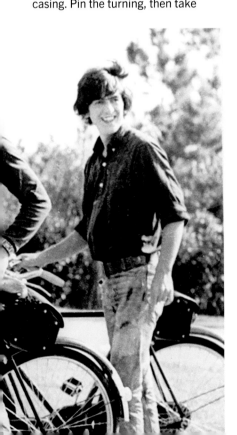

the lining out of the bag and press the turning; sew it in place. Put the lining back in the bag and, using a sewing needle and thread, stitch the hemmed edge to the casing.

Take one Strap and tie one of the yarn ends to a bodkin or safety pin. With the front of the bag facing you, thread the bodkin through the right-hand bottom tab, then pass it through the casing, from right to left; untie the yarn end from the bodkin. Tie the yarn end at the opposite end of the Strap to the bodkin. Turn the bag so the back is facing you, then thread the bodkin through the casing from left to right. Knot the strap ends together.

Repeat the process with the second Strap, reversing the directions that you pass the bodkin through the casing.

CHART

KEY

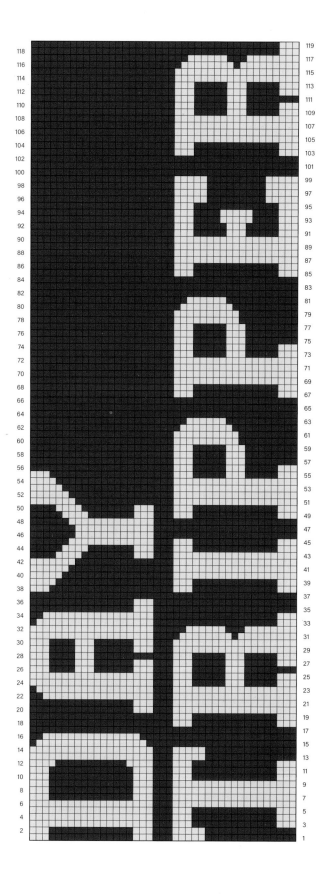

■ MC
□ CC

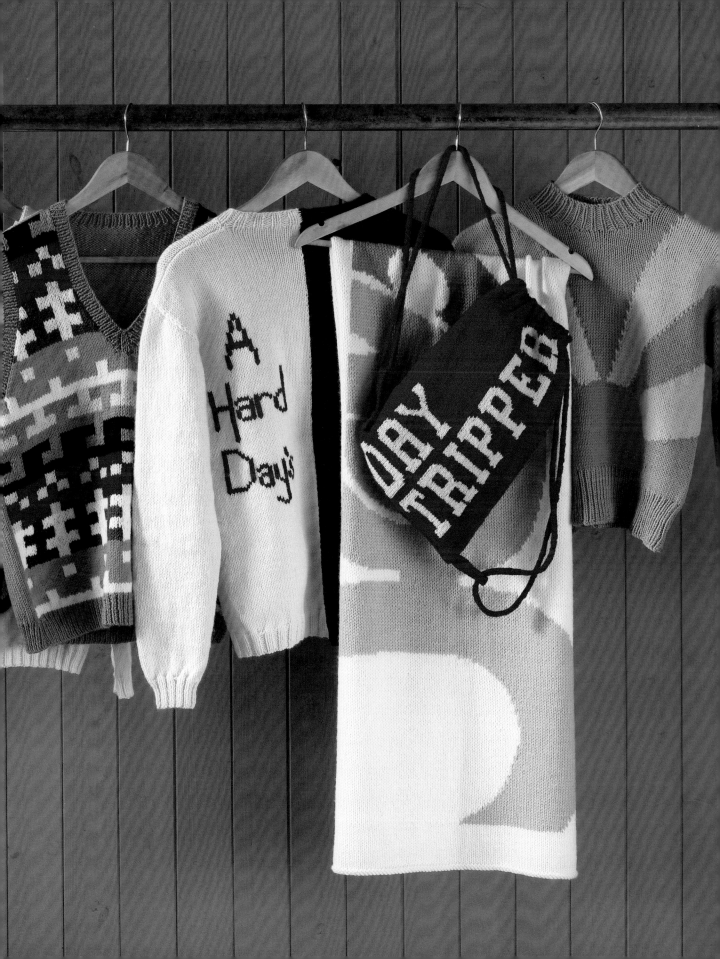

» LOIS
Copy writer
Favorite Beatles song: *I Want You
(She's So Heavy)*

MAGICAL MYSTERY TOUR
HAT AND MITTENS

Designed by **Julie Brooke** and **Caroline Smith**
Skill level ●●

The brightly colored Magical Mystery Tour bus is at the heart of the film of the same name—a story about a group of people on a bus tour who experience some strange, magical adventures. The bus from the movie was painted yellow and blue, and the name of the movie was written in a groovy rainbow-colored typeface; stars and other colorful motifs decorated the sides of the bus.

This bright yellow hat with its matching mittens is embroidered with colored stars. The hat is made in the round and seamed simply with a three-needle bind off that creates two points at the top; small tassels make the ideal finishing touch. The mittens are knitted flat and then sewn together after the embroidery has been added.

Magical Mystery Tour *was The Beatles' third movie, and it aired on British television on December 26, 1967.*

The Magical Mystery Tour *album was released in the United States the same year, but it originally came out as an EP in the UK.*

THE HAT

SIZE
One size

FINISHED MEASUREMENTS
Head circumference (above ribbing): 21⅛ in. / 53.5 cm

YARN
4-ply fingering weight (superfine #1), shown in Cascade Yarns, Cascade 220® Fingering (100% wool; 273 yd. / 250 m per 2 oz. / 50 g hank)
MC: Goldenrod (7827), 1 skein
CC1: Cerise (7802), 1 skein
CC2: Poppy Red (1021), 1 skein
CC3: Highland Green (9430), 1 skein
CC4: Blue Velvet (7818), 1 skein

NEEDLES
US 2 / 2.75 mm circular needle, 16 in. / 40 cm long (see Pattern Notes), or size needed to obtain gauge
US 2½ / 3 mm circular needle, 16 in. / 40 cm long, or size needed to obtain gauge

continued on the next page >>

NOTIONS

Stitch marker
Tapestry needle
Piece of stiff cardboard measuring 3 x 2 in. /
7.5 x 5 cm

GAUGE

28 sts and 32 rows = 4 in. / 10 cm square
over St st using US 2½ / 3 mm needles
Be sure to check your gauge.

ABBREVIATIONS

See page 201.

PATTERN NOTES

- If you prefer, you can use double-pointed needles instead of circular ones.
- The long-tail method (see page 194) has been used for the cast on; the hat is bound off using a three-needle bind off (see page 199).
- The ribbing used is 1x1: *K1, p1, rep from * to end.
- The star pattern is added to both the hat and the mittens using duplicate stitch (see page 197), following the charts on pages 154 and 155.
- For more on reading charts, see page 196.

THE HAT

Using US 2 / 2.75 mm circular needle and MC, cast on 150 sts using a long-tail method (see page 194).
Join to work in the round, taking care not to twist the sts, PM at beg of round.
Work 12 rounds of 1x1 ribbing, sl SM on each round.
Change to US 2½ / 3 mm needles and k for 70 rounds, sl SM as you go.
Bind off, using the three-needle bind off (see page 199) with the WS facing each other.

FINISHING

Weave in yarn ends and block (see page 199 for more on blocking).

Embroidery

Using the chart and CC1, CC2, CC3, and CC4, decorate the hat with stars and stardust, worked in duplicate stitch (see page 197).

Tassels

Take a piece of stiff cardboard about 3 in. / 7.5 cm wide and 2 in. / 5 cm long. For each tassel, hold MC, CC1, CC2, CC3, and CC4 together and wrap them around the length of the piece of cardboard to the desired thickness.
Cut about 8 in. / 20 cm of MC and thread it onto the yarn needle. Pass the needle under the wrapped threads and draw the thread through. Pull the thread upward and knot it tightly to draw the tassel together at the top.
Cut the threads at the other end of the piece of cardboard to form the tassel strands and remove the piece of cardboard.
Cut another length of MC and wrap it around the tassel about ⅜ in. / 1 cm from the tied end.
Trim the ends of the tassel strands to neaten them, then use the thread at the top of the tassel to sew it to one corner of the hat.
Repeat to make a second tassel and join it to the other corner.

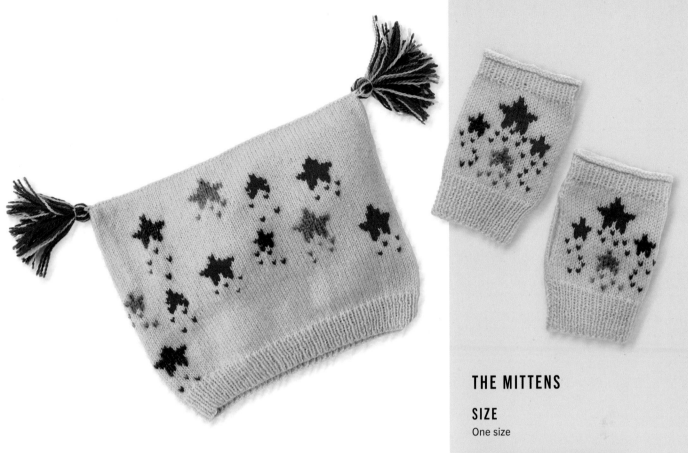

THE MITTENS (MAKE 2)

Using US 2 / 2.75 mm needles and MC, cast on 54 sts using a long-tail method (see page 194).

Work in 1x1 rib for 1½ in. / 4 cm.

Change to US 2½ / 3 mm needles.

Beg with a k (RS) row, work 32 rows of St st.

Work in 1x1 rib for ¾ in. / 2 cm, ending on a RS row.

Beg with a p row, work 3 rows of St st.

Bind off.

FINISHING

Weave in yarn ends and block both pieces (see page 199 for more on blocking).

Embroidery

On both mitten pieces, count in 27 stitches from one edge to find the center. Using one of the CC yarns and a tapestry needle, work a line of running stitches lengthwise along the center to divide each mitten piece into two sections.

Using the Left Mitten Chart as a guide to placement and colors, work the design on the right-hand side of one mitten piece in duplicate stitch (see page 197). Work the design from the Right Mitten Chart onto the left-hand side of the other mitten piece.

Making up

Decide where you want the opening for the thumb on each mitten; mark the position with pins. Fold each mitten in half, wrong sides together, so the side edges meet, and use ladder stitch (see page 198) to join the seams above and below the thumb opening.

Weave in any remaining yarn ends.

THE MITTENS

SIZE

One size

FINISHED MEASUREMENTS

Circumference: About 7½ in. / 19 cm
Length: About 6¼ in. / 16 cm

YARN

4-ply fingering weight (superfine #1), shown in Cascade Yarns, Cascade 220® Fingering (100% wool; 273 yd. / 250 m per 2 oz. / 50 g hank)

MC: Goldenrod (7827), 1 skein
CC1: Cerise (7802), 1 skein
CC2: Poppy Red (1021), 1 skein
CC3: Highland Green (9430), 1 skein
CC4: Blue Velvet (7818), 1 skein

NEEDLES

US 2 / 2.75 mm and US 2½ / 3 mm needles, or size needed to obtain gauge

NOTIONS

Tapestry needle

GAUGE

28 sts and 32 rows = 4 in. / 10 cm square over St st using US 2½ / 3 mm needles
Be sure to check your gauge.

CHARTS

KEY

- ■ CC1
- ■ CC2
- ■ CC3
- ■ CC4
- □ No Stitch

HAT CHART

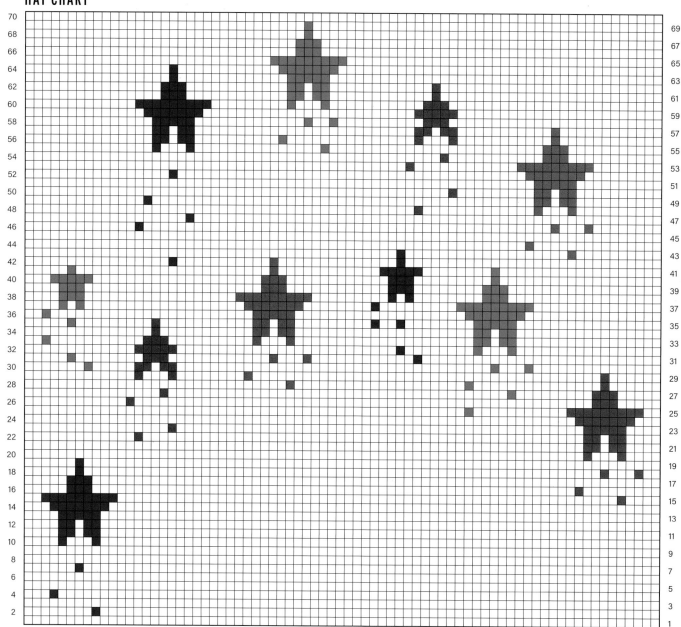

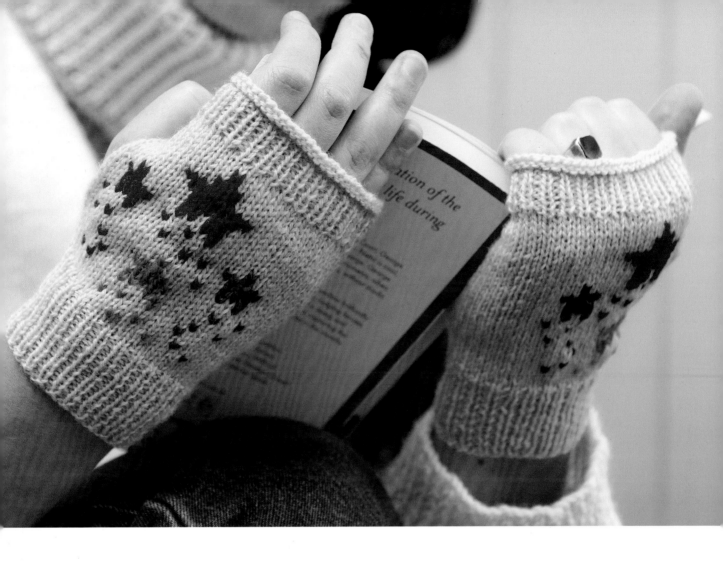

LEFT MITTEN CHART

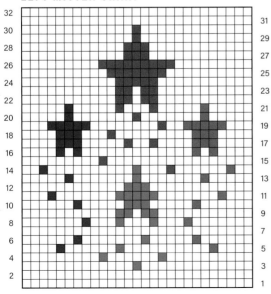

RIGHT MITTEN CHART

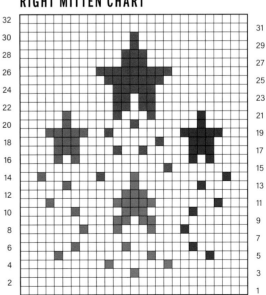

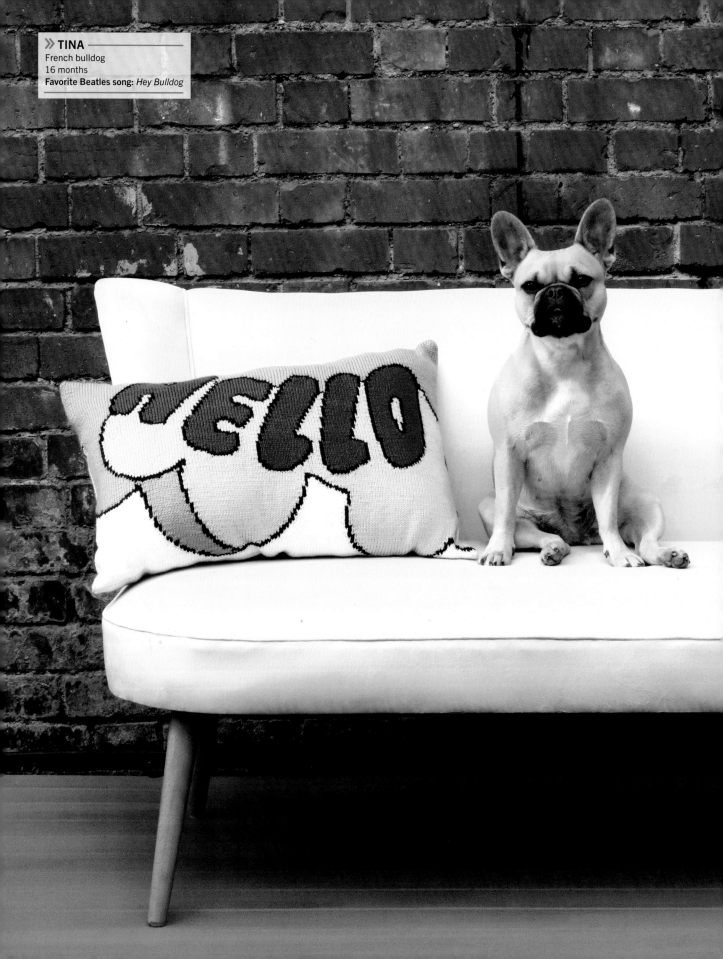

Released in November 1967, "Hello, Goodbye" featured "I Am the Walrus"—a hit from the Magical Mystery Tour movie—as the B-side.

HELLO, GOODBYE
PILLOW

Designed by Jane Burns
Skill level ●●

The song "Hello, Goodbye" is the perfect inspiration for the last pattern in this chapter. Knitted in simple primary colors, this pillow will look good in any home, and you can welcome friends and family with the "Hello" side, then drop a subtle hint when you want guests to leave by turning to the "Goodbye" side!

There are two separate charts for this project, one for each side. When you've finished knitting the front and back, you can simply join them together—with a pillow form inside—or, if you are confident in your sewing skills, you can add a zipper along one side. Alternatively, make both sides and then knit two plain backs to create two separate pillows.

SIZE
One size

FINISHED MEASUREMENTS
Width: 15¾ in. / 40 cm
Length: 24 in. / 60 cm

YARN
DK weight (medium #4), shown in Cascade Yarns, 220 Superwash® Merino (100% wool; 220 yd. / 200 m per 3½ oz. / 100 g ball)
MC: White (25), 3 balls
CC1: Black (28), 1 ball
CC2: Artisan Gold (08), 1 ball
CC3: Molten Lava (96), 1 ball
CC4: Medium Blue (32), 1 ball

NEEDLES
US 6 / 4 mm needles, or size needed to obtain gauge

NOTIONS
Tapestry needle
15¾ x 24 in. / 40 x 60 cm pillow form
15 in. / 38 cm long zipper (optional)
Sewing thread and needle (optional)
Pins (optional)

GAUGE
22 sts and 30 rows = 4 in. / 10 cm square over St st using US 6 / 4 mm needles
Be sure to check your gauge.

continued on the next page >>

ABBREVIATIONS

See page 201.

PATTERN NOTES

- This pillow is worked using the intarsia method (see page 196), following the charts on pages 160–161. Wind separate balls of the different colors and twist them together where they join to avoid holes in the finished work.
- For more on reading charts, see page 196.

❯❯ *BELOW* ─────────
The band's colorful fashion sense was on show during the filming of Magical Mystery Tour *in 1967.*

THE PILLOW

HELLO SIDE

Using MC, cast on 136 sts.
P 1 row (WS).
Cont in St st and using intarsia method, foll Hello Chart.
Bind off.

GOODBYE SIDE

Work as for Hello side, foll Goodbye Chart.

FINISHING

Weave in yarn ends and block (see page 199 for more on blocking).

Use mock grafting (see page 199) to join the Hello and Goodbye Sides together along the cast-on and bound-off edges; use ladder stitch (see page 198) to join one side edge. Insert the pillow form, then use ladder stitch to join the final edge.

Alternatively, for a pillow with a zippered closure, pin the zipper between the Hello and Goodbye side edges, centered along the edges and with the wrong side of the knitting pinned to the right side of the zipper. Sew in place using a sewing needle and thread. Join the remaining side edge and the cast-on and bound-off edges as above, then open the zipper and insert the pillow form.

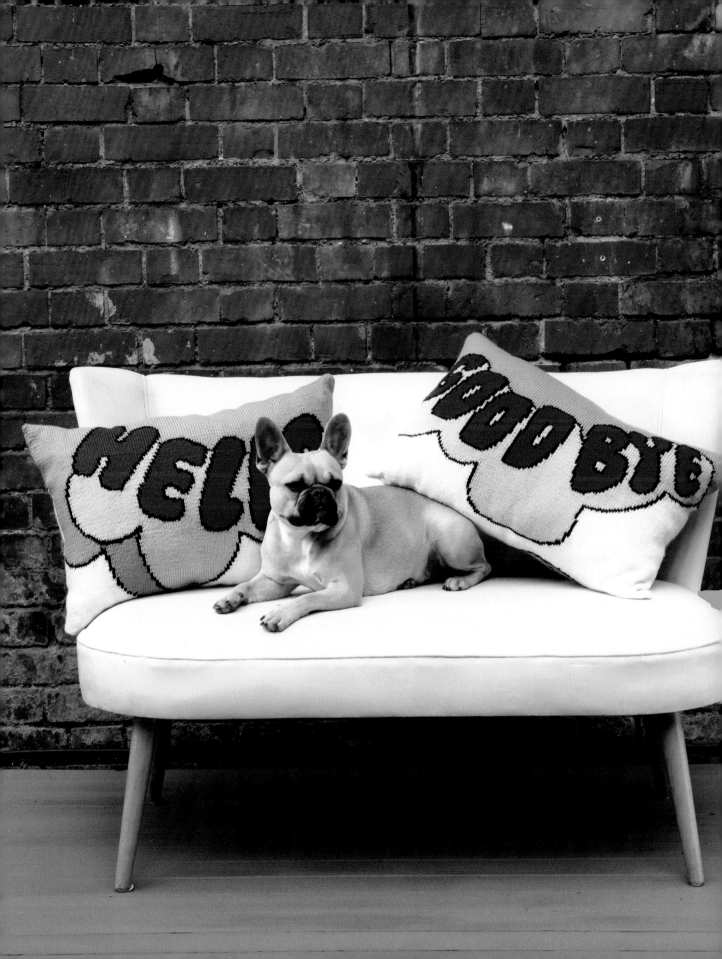

CHARTS

KEY

☐ MC ☐ CC2 ■ CC4

■ CC1 ■ CC3

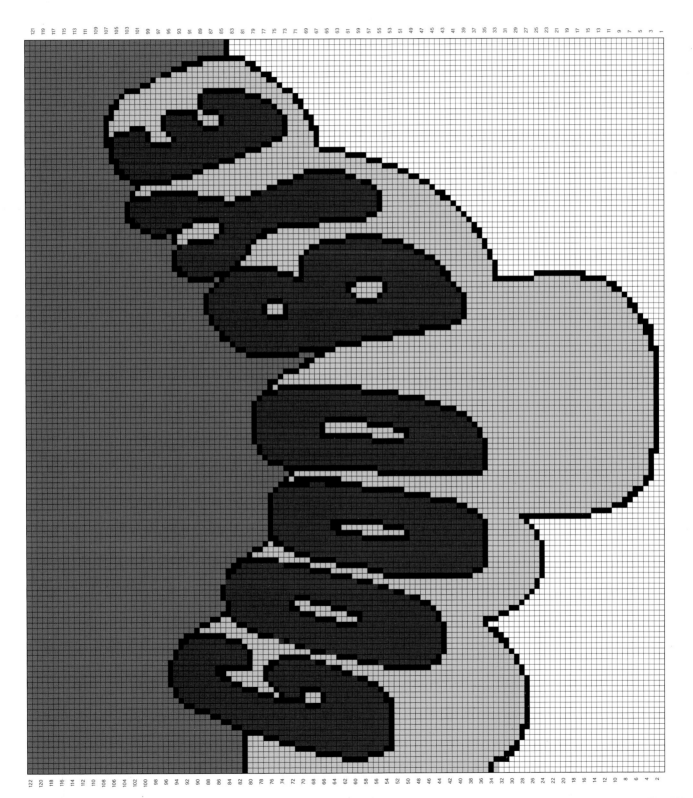

OH! DARLING

The sweetest Beatles-themed garments and accessories for babies and children.

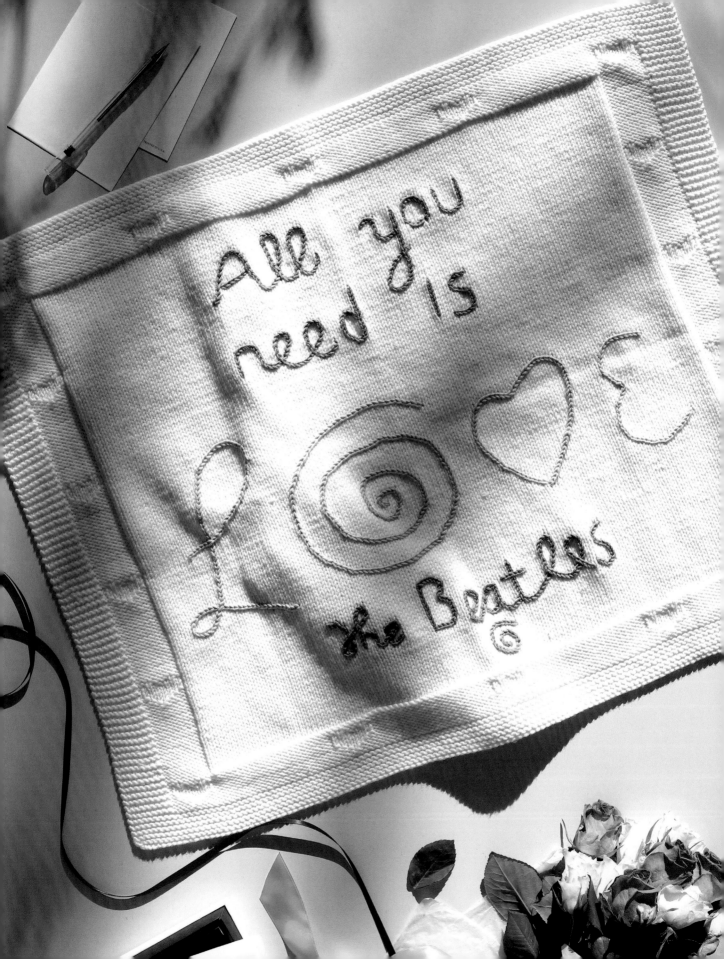

"All You Need Is Love" was released as a single in July, with *"Baby, You're a Rich Man"* on the flip side.
The BBC satellite-TV program Our World aired on June 25, 1967. It was broadcast to an audience of about 350 million people around the world.

ALL YOU NEED IS LOVE
BABY BLANKET

Designed by Anna Alway
Skill level 🍏

In 1967, The Beatles performed "All You Need Is Love" for the first time as part of a pioneering satellite TV broadcast that reached a global audience of millions of people long before the days of the internet. The song's lyrics—and its inspiring title—appeal to people everywhere. As a result, the track has remained one of the band's most enduring hits.

If the message that the song spreads is all you need is love, then what better way to welcome a new baby into the world than with this beautiful soft blanket, embroidered with the title of the song? With a textured border, featuring heart motifs—and the message of love—it's the ideal embrace for any little one.

FINISHED MEASUREMENTS
About 24½ x 30 in. / 62 x 76 cm

YARN
Aran weight (medium #4), shown in DROPS Big Merino (100% wool; 82 yd. / 75 m per 2 oz. / 50 g ball)
MC: Off-White (01), 8 balls
CC1: Forget-Me-Not (06), 1 ball
CC2: Powder Pink (22), 1 ball

NEEDLES
US 8 / 5 mm circular needle, 32 in. / 80 cm long, or size needed to obtain gauge

NOTIONS
Tapestry needle
Lockable stitch markers
Light-colored water-erasable fabric pen

GAUGE
19 sts and 27 rows = 4 in. / 10 cm square over St st using US 8 / 5 mm needles
Be sure to check your gauge.

ABBREVIATIONS
See page 201.

continued on the next page >>

PATTERN NOTES

- Lockable stitch markers are used to mark the position of the embroidered lettering because they can be clipped into the knitting.
- The lettering detail on this blanket is added using chain stitch (see page 198). Use the template on page 167 as a guide to the lettering style. If you don't feel confident drawing the letters freehand, copy the template, enlarging it to the size required, then place a piece of white tissue paper over the top and trace over the design. Tack the tissue paper onto the knitted blanket and work chain stitch over the tissue paper. When you have finished, gently tear away the tissue paper.

THE BLANKET

Using US 8 / 5 mm circular needle and MC, cast on 143 sts.

Rows 1 to 12: K to end.

Row 13 (RS): K9, p to last 9 sts, k to end.

Row 14: K13, [p1, k28] 4 times, p1, k to end.

Row 15: K9, p3, [k3, p26] 4 times, k3, p3, k to end.

Row 16: K11, p5, [k24, p5] 4 times, k to end.

Row 17: K9, p1, [k7, p22] 4 times, k7, p1, k to end.

Row 18: K10, p7, [k22, p7] 4 times, k to end.

Row 19: K9, [p1, k3, p1, k3, p21] 4 times, p1, [k3, p1] twice, k to end.

Row 20: K11, [p1, k3, p1, k24] 4 times, p1, k3, p1, k to end.

Row 21: K9, p to last 9, k to end.

Row 22: K18, p to last 18 sts, k to end.

Row 23: K9, p9, k to last 18 sts, p9, k to end.

Rep Rows 22 and 23 nine more times.

****Row 42:** K13, p1, k4, p to last 18 sts, k4, p1, k to end.

Row 43: K9, p3, k3, p3, k to last 18 sts, p3, k3, p3, k to end.

Row 44: K11, p5, k2, p to last 18 sts, k2, p5, k to end.

Row 45: K9, p1, k7, p1, k to last 18 sts, p1, k7, p1, k to end.

Row 46: K10, p7, k1, p to last 18 sts, k1, p7, k to end.

Row 47: K9, [p1, k3] twice, p1, k to last 18 sts, p1, [k3, p1] twice, k to end.

Row 48: K11, p1, k3, p1, k2, p to last 18 sts, k2, p1, k3, p1, k to end.

Row 49: K9, p9, k to last 18 sts, p9, k to end.

Row 50: K18, p to last 18 sts, k to end.

Rep Rows 49 and 50 nine more times, then rep Row 49 once more.**

Work from ** to ** 2 more times, then rep Rows 42 to 50 once more, and then rep Rows 49 and 50 nine more times.

Rep Rows 13 to 21 once more.

K 11 rows.

Bind off.

FINISHING

Weave in yarn ends and block (see page 199 for more on blocking).

Embroidery

Start by marking out the position of the "All you need is" lettering as follows: About ¾ in. / 2 cm down from the top heart border count 30 sts in from each side border and mark these positions with lockable markers. Count 44 rows down from these markers and place lockable markers at these points. Using a light-colored water-erasable fabric pen and the template as a guide, lightly write the words "All you need is," centered inside the marked points. Thread a tapestry needle with a length of CC1 and embroider over the written lettering using chain stitch (see page 198).

To mark the position of "The Beatles" lettering, about ¾ in. / 2 cm up from the bottom border, count 28 sts in from each side border and mark these positions with lockable markers. Count 28 rows up from these markers and place lockable markers at these points. Lightly write out the words "The Beatles," centering them inside the marked points; draw the spiral shape below the words. Using the tapestry needle and CC1, embroider over the lettering and spiral using chain stitch.

In the space between the embroidered letters, lightly write out the word "LOVE" as shown on the template, centering the letters between "All you need is" and "The Beatles," and between the side borders. Embroider the letters with chain stitch using CC2.

All you need is

LOVE

The Beatles ®

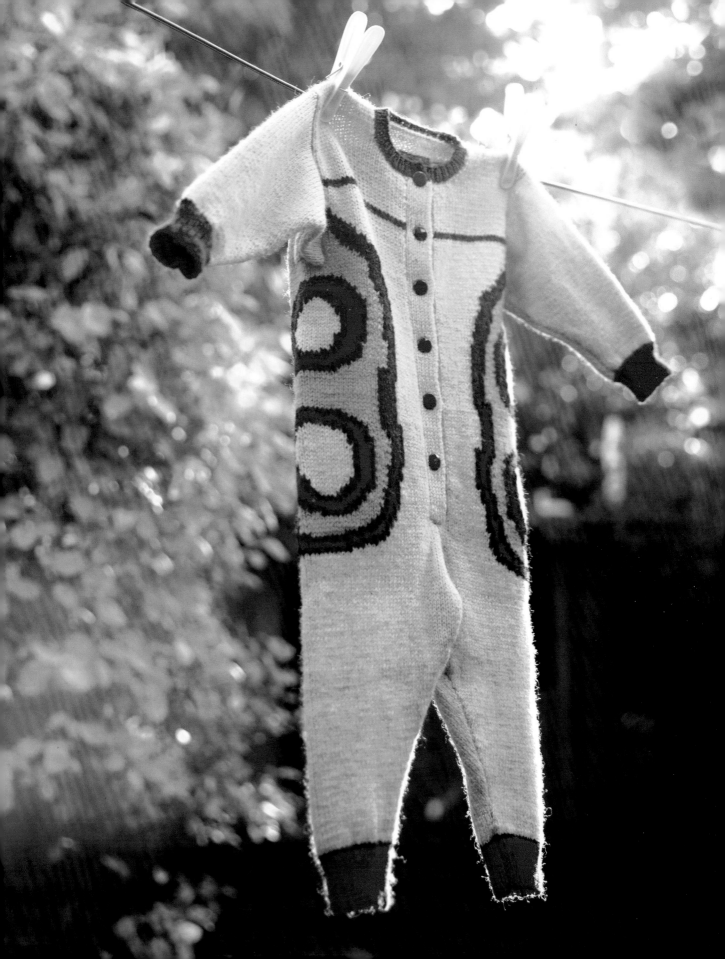

YELLOW SUBMARINE

ONESIE

Designed by **Cécile Jeffrey**
Skill level

"Yellow Submarine" is a Lennon-McCartney hit, sung by Ringo Starr, which inspired the 1968 animated movie of the same name. With its child-friendly, happy lyrics, it's the perfect song to inspire a special Beatles-themed baby outfit. This darling onesie picks up on the design motifs and color of the submarine in the film—it even features little propellers on the back!

The body and legs of the onesie are knitted together in one piece, with the legs joined with one seam and the edges brought together to create the front opening, secured with snap closures. The accompanying chart sets out the whole design of the body and legs; the sleeves are worked separately. Use the intarsia technique to work the motifs.

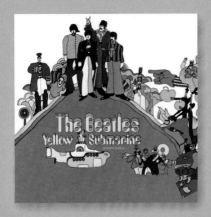

"Yellow Submarine" was released as a double A-side with "Eleanor Rigby" in August 1966. The track featured on the Revolver *album, released at the same time.*

SIZES
3mo:6mo:**12mo**:18mo:**24mo**

FINISHED MEASUREMENTS
Chest: **19⅛**:20½:**23**:25:**27¼** in. /
48.5:52:**58**:63.5:**69** cm
Length: **22**:24:**25½**:27¾:**29½** in. /
56:60:**65**:70.5:**75** cm
Sleeve length: **8½**:8⅝:**9¼**:10:**10¾** in. /
21.5:22.5:**23.5**:25:**26** cm

YARN
4-ply fingering weight (superfine #1), shown in Cascade Yarns, Cascade 220® Fingering (100% wool; 273 yd. / 250 m per 2 oz. / 50 g hank)
MC: Sunflower (1026), **1**:2:**2**:2:**2** ball(s)
CC1: Goldenrod (7827), 1 ball for each size
CC2: Beige (8021), 1 ball for each size
CC3: Poppy Red (1021), 1 ball for each size
CC4: Black (8555), 1 ball for each size,
CC5: Tutu (9477), 1 ball for each size
CC6: Blue Moon (1013), 1 ball for each size

NEEDLES
US 2/ 2.75 mm and US 3 / 3.25 mm needles, plus one spare US 3 / 3.25 mm needle, or size needed to obtain gauge

NOTIONS
Tapestry needle
Stitch holder
6:7:**7**:8:**8** snap closures

continued on the next page >>

GAUGE

28 sts and 40 rows = 4 in. / 10 cm square over St st using US 3 / 3.25 mm needles Be sure to check your gauge.

ABBREVIATIONS

See page 201.

PATTERN NOTES

- The cast on used here is the backward loop technique (see page 194).
- Use the intarsia technique (see page 196) to create the propeller and rainbow motifs, following the charts on pages 172–175. Remember to wind small balls of yarn before you begin and to twist yarns together tightly where they join.
- Use duplicate stitch (see page 197) to outline the intarsia motifs.
- For more on reading charts, see page 196.

THE ONESIE

LEFT LEG

Using US 2 / 2.75 mm needles and CC3, cast on **49**(51:**55**:61:**69**) sts.
Rib row 1 (RS): K1, *p1, k1, rep from * to end of row.
Rib row 2: P1, *k1, p1, rep from * to end of row.
Rep these 2 rows until work measures 1½ in. / 4 cm, ending with a Rib row 2.
Cut off CC3.
Change to US 3 / 3.25 mm needles and join on CC4.
K 1 row.
Cut off CC4 and join on MC.
Beg with a p row, work **8**(9:**12**:8:**14**) rows in St st.
Inc 1 st at each end of next row, then at each end of every foll 3rd and alt rows on the first three sizes, or every foll 3rd row on the largest two sizes, until **97**(105:**113**:121:**129**) sts rem.
Work **2**(4:**6**:3:**4**) rows in St st.**
Shape crotch
Bind off **12**(14:**14**:14:**14**) sts at beg of next row and **2**(3:**3**:3:**3**) sts at beg of foll row. (**83**(88:**96**:104:**112**) sts)
Dec row: K2tog, k to last 2 sts, k2tog. Cont in St st and dec 1 st at each end of every foll alt row until **71**(76:**84**:92:**100**) sts rem.
P 1 row.
AT SAME TIME, foll Left Leg Chart (Row 1 of the chart corresponds to the number of sts after the first Dec row). For first size, work area inside pink line; for second size, work area inside green line; for third size, work area inside brown line; for fourth size, work area inside blue line; for fifth size, work area inside black line.
Leave sts on a spare US 3 / 3.25 mm needle, with RS facing, as if to beg work.

RIGHT LEG

Work as for Left Leg to **.
Shape crotch
Bind off **2**(3:**3**:3:**3**) sts at beg of next row and **12**(14:**14**:14:**14**) sts at beg of foll row. (**83**(88:**96**:104:**112**) sts)
Dec row: K2tog, k to last 2 sts, k2tog. (**81**(86:**94**:102:**110**) sts)
Cont in St st and dec 1 st at each end of every foll alt row until **71**(76:**84**:92:**100**) sts rem.
P 1 row.
AT SAME TIME, foll Right Leg Chart (Row 1 of the chart corresponds to the number of sts after the first Dec row). For first size, work area inside pink line; for second size, work area inside green line; for third size, work area inside brown line; for fourth size, work area inside blue line; for fifth size, work area inside black line.
Leave sts on a spare US 3 / 3.25 mm needle, with RS facing, as if to beg work.

BODY

Join legs
Row 1: With RS of Right Leg facing, bind off 3 sts, k to last st, sl this st onto the spare needle holding Left Leg sts, then k first st of Left Leg, then k last st of Right Leg, k to end. (**139**(149:**165**:181:**197**) sts)
Row 2: Bind off 3 sts, p to end. (**136**(146:**162**:178:**194**) sts)
AT SAME TIME, foll Lower Body Chart (Row 1 above corresponds with Row 1 of the chart).
For first size, work area bet first two pink lines, then area bet second two

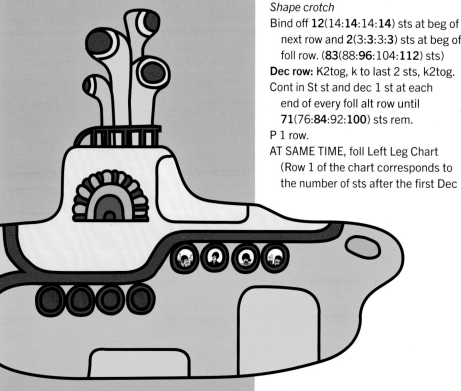

pink lines; for second size, work area bet first two green lines, then area bet second two green lines; for third size, work area bet first two brown lines, then area bet second two brown lines; for fourth size, work area bet first two blue lines, then area bet second two blue lines; for fifth size, work area bet first two black lines, then area up to next black line.

Cont to work straight in St st, foll chart as set above, working as far as pink line for first size, as far as green line for second size, as far as brown line for third size, as far as blue line for fourth size, and as far as black line for fifth size.

Foll Upper Body Chart until Row 36 has been worked. For first size, work area bet first two pink lines, then area bet second two pink lines; for second size, work area bet first two green lines, then area bet second two green lines; for third size, work area bet first two brown lines, then area bet second two brown lines; for fourth size, work area bet first two blue lines, then area bet second two blue lines; for fifth size, work area bet first two black lines, then area up to next black line.

Right front

Next row: K29(32:**34**:38:**42**), turn, leaving rem sts on a holder.

Foll Upper Body Chart to end.

Cont in St st in CC2 for **14**(14:**14**:16:**18**) more rows.

To shape neck, bind off **5**(6:**7**:7:**8**) sts at beg of next row, then dec 1 st at right-hand edge of every row until **19**(20:**20**:23:**26**) sts rem.

Cont to work straight in St st for **10**(11:**10**:9:**9**) more rows.

Bind off.

Back

Put rem sts back on a US 3 / 3.25 mm needle with RS facing, rejoin yarn and bind off **6**(6:**10**:10:**10**) sts. Foll Upper Body Chart, k66(70:**74**:82:**90**) sts, turn, leaving rem sts on holder.

Cont on these sts in St st to end of chart.

Cont in St st in CC2 and foll Rainbow Chart as foll:

Next row: K14(16:**18**:22:**26**) in CC2, k 38 sts from Row 1 of Rainbow Chart, in CC2 k to end.

Next row: P14(16:**18**:22:**26**) in CC2, p 38 sts from Row 2 of Rainbow Chart, in CC2 p to end.

These 2 rows set the position of the Rainbow motif, cont as set to end of chart.

Cont in St st in CC2 for **7**(9:**9**:11:**13**) more rows.

Bind off.

Left front

Put rem **29**(32:**34**:38:**42**) sts back on a US 3 / 3.25 mm needle with RS facing, rejoin yarn and bind off **6**(6:**10**:10:**10**) sts, k to end.

Foll Upper Body Chart to end.

Cont in St st in CC2 for **15**(15:**15**:17:**19**) more rows.

To shape neck, bind off **5**(6:**7**:7:**8**) sts at beg of next row, then dec 1 st at left-hand edge of every row until **19**(20:**20**:23:**26**) sts rem.

Cont to work straight in St st for **9**(10:**9**:8:**8**) more rows.

Bind off.

SLEEVES (MAKE 2)

Using US 2 / 2.75 mm needles and CC3, cast on **39**(43:**47**:49:**49**) sts.

Rib row 1 (RS): K1, *p1, k1, rep from * to end of row.

Rib row 2: P1, *k1, p1, rep from * to end of row.

Rep these 2 rows until work measures 1½ in. / 4 cm, ending with a Rib row 2.

Cut off CC3.

Change to US 3 / 3.25 mm needles and join on CC4.

K 1 row.

Cut off CC4 and join on CC2.

Cont in St st, inc 1 st at each end of every 3rd row until there are **81**(83:**83**:85:**89**) sts.

Cont to work straight for **7**(14:**24**:30:**28**) more rows.

Bind off.

SNAP CLOSURE BAND

Weave in yarn ends on the Legs and Body of the onesie; block. Join the inner leg seams, then the crotch seam from back to beg of front opening.

Using US 2 / 2.75 mm needles and MC, cast on 13 sts.

Rib row 1 (RS): K1, *p1, k1, rep from * to end of row.

Rib row 2: P1, *k1, p1, rep from * to end of row.

Rep these 2 rows until band fits around the front opening, ending with a Rib row 2.

Bind off rib-wise.

Sew the band around the front opening.

NECKBAND

Join shoulder seams.

With RS facing and using US 2 / 2.75 mm needles and CC4, pick up and k 24(26:**29**:29:**29**) sts across top edge of snap closure band and up Right Front neck, 27(31:**35**:37:**39**) sts across Back neck, and 24(26:**29**:29:**29**) sts down Left Front neck and the other top edge of snap closure band. (**75**(83:**93**:95:**97**) sts

Cut off CC4 and join on CC3.

Rib row 1 (RS): K1, *p1, k1, rep from * to end of row.

Rib row 2: P1, *k1, p1, rep from * to end of row.

Rep these 2 rows twice more, then rep Rib row 1 once more.

Bind off rib-wise.

FINISHING

Thread a tapestry needle with CC4
and, using the photographs as a
guide, work duplicate stitch (see
page 197) outlines around the
intarsia design motifs.

Weave in any remaining yarn ends and
block the Sleeves (see page 199 for
more on blocking).

Join bound-off edges of sleeves to
armhole row ends, then join row
ends at the top of the sleeves to
the bound-off edges at base of the
armholes, ending at the center
of the underarm bound-off edge.

Join the sleeve seams.

Mark evenly spaced positions for
6(7:7:8:**8**) snap closures along the
snap closure band and attach.

CHARTS

KEY

▢	MC
▤	CC1
▢	CC2
■	CC3
■	CC4

—	3 months
—	6 months
—	12 months
—	18 months
—	24 months

*Copy both parts of the Lower Body
chart and join the Left to the Right
along the unnumbered sides.*

LOWER BODY CHART—LEFT

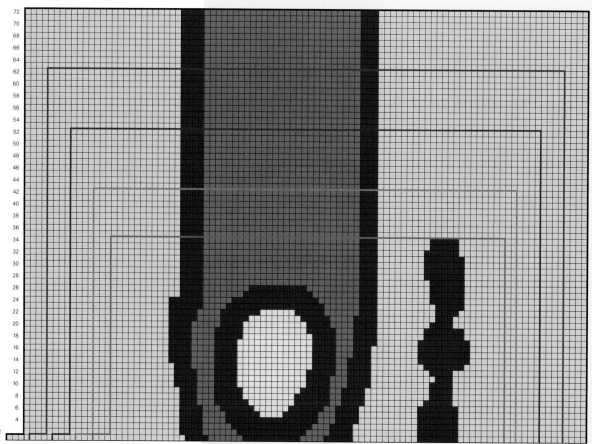

RIGHT LEG

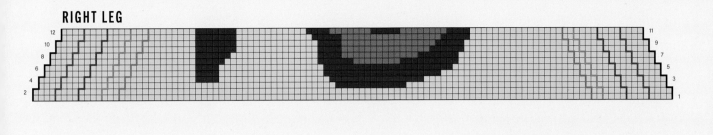

LEFT LEG

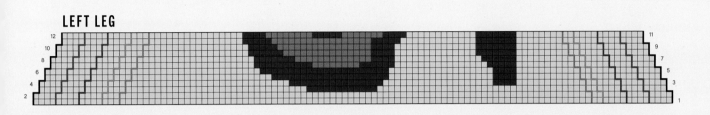

LOWER BODY CHART—RIGHT

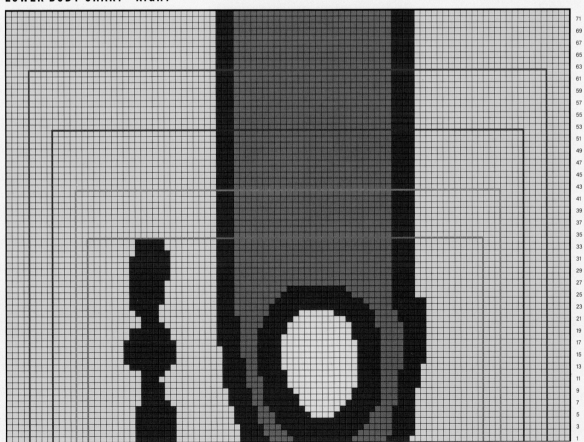

*Copy both parts of the Upper Body
chart and join the Left to the Right
along the unnumbered sides.*

UPPER BODY CHART—LEFT

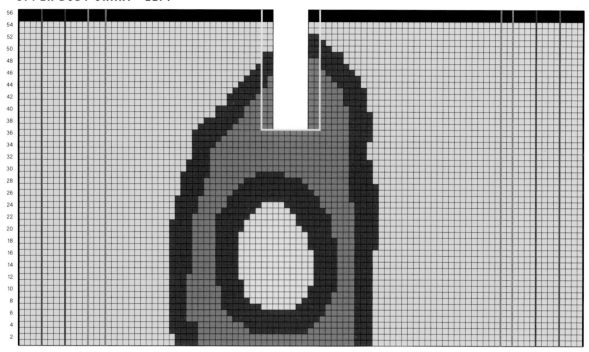

UPPER BODY CHART—RIGHT

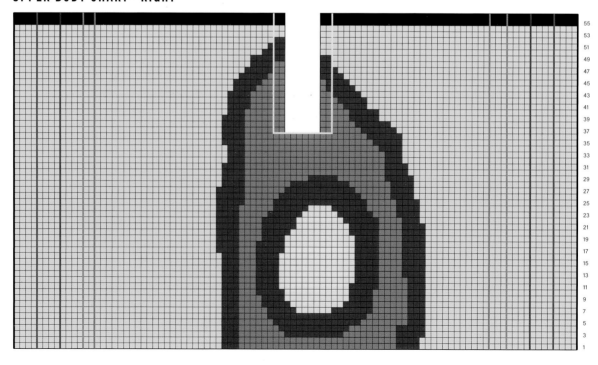

KEY

▢	MC
▢	CC1
▢	CC2
▢	CC3
▢	CC4
▢	CC5
▢	CC6

—	3 months
—	6 months
—	12 months
—	18months
—	24 months

RAINBOW CHART

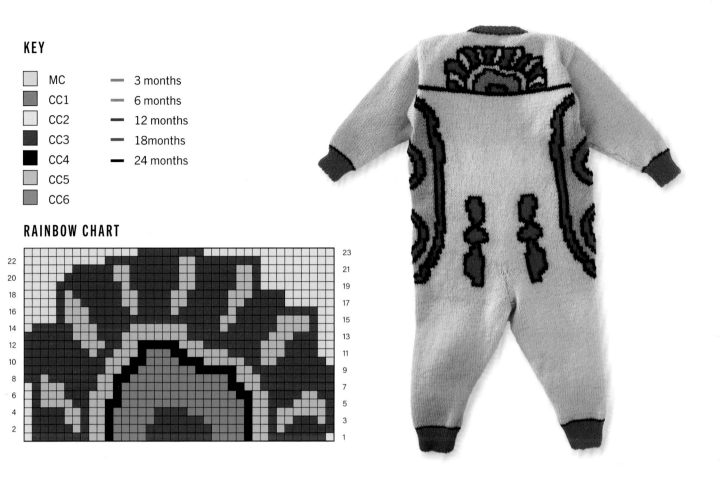

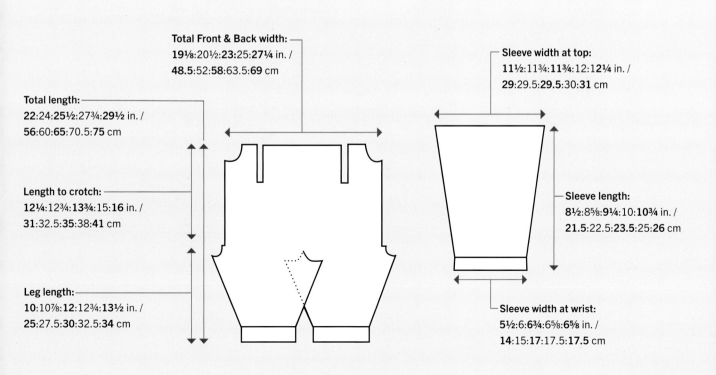

Total Front & Back width:
19⅛:20½:23:25:27¼ in. /
48.5:52:58:63.5:69 cm

Total length:
22:24:25½:27¾:29½ in. /
56:60:65:70.5:75 cm

Length to crotch:
12¼:12¾:13¾:15:16 in. /
31:32.5:35:38:41 cm

Leg length:
10:10⅞:12:12¾:13½ in. /
25:27.5:30:32.5:34 cm

Sleeve width at top:
11½:11¾:11¾:12:12¼ in. /
29:29.5:29.5:30:31 cm

Sleeve length:
8½:8⅝:9¼:10:10¾ in. /
21.5:22.5:23.5:25:26 cm

Sleeve width at wrist:
5½:6:6¾:6⅝:6⅝ in. /
14:15:17:17.5:17.5 cm

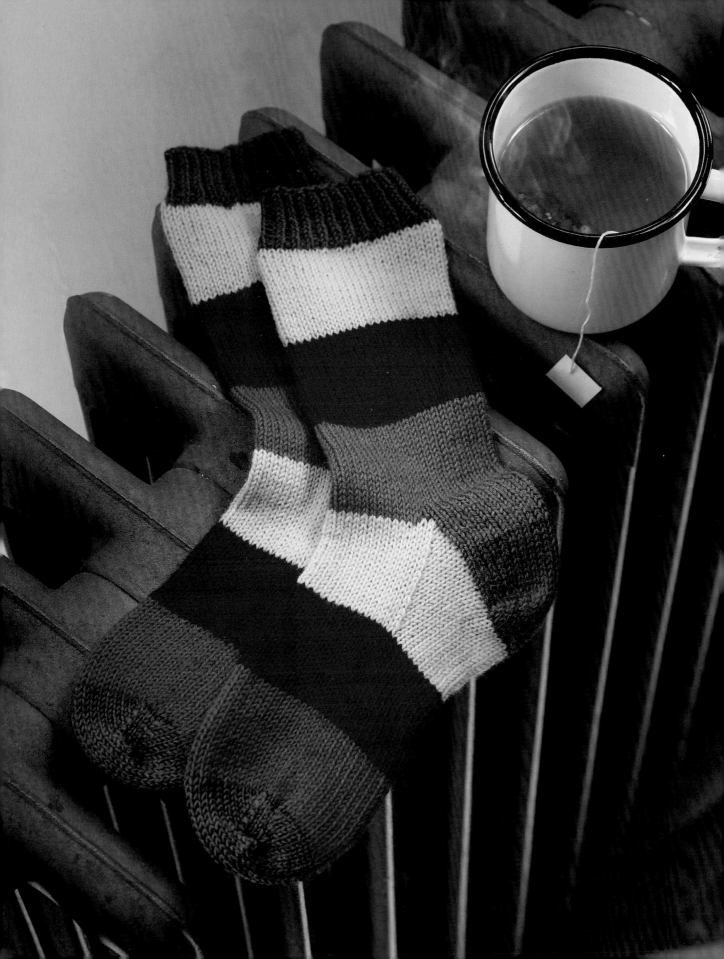

BLUE MEANIE SOCKS

Designed by **Caroline Smith**

Skill level ●●

The Blue Meanies are mostly blue, although most of them have red, yellow, and orange striped legs and wear rather incongruous Mary Jane shoes. Their leader, however, wears tall, military-style boots—one dark blue, and one pale blue. With six-fingered hands emerging from cloud-like blue bodies, and heads topped with strange ears, the Blue Meanies are both ridiculous and a bit scary. They turn the colorful Pepperland landscape to monochrome and ban music, but are finally defeated by The Beatles and their songs. As a result, they change their ways and embrace music and happiness.

You too can turn the Blue Meanies' music-hating message into something more joyful with these bright socks. Knitted with yellow, red, and orange striped legs, and with bright blue toes, heels, and ribbing, this pattern has been designed for two children's sizes.

The Blue Meanies are the baddies in the Yellow Submarine movie—they hate music and fun. They attack the musical paradise of Pepperland, trapping Sgt. Pepper's Lonely Hearts Club Band under a glass globe.

SIZES
2–**4yrs**:5–9yrs

FINISHED MEASUREMENTS
Foot circumference: 5⅜(6¼) in. / **13.5**(16) cm

YARN
4-ply weight (superfine #1), shown in Opal Uni 4-ply (75% wool, 25% polyamide; 464 yd. / 425 m per 3½ oz. / 100 g ball)
MC: Blue (5188), 1 ball
CC1: Sun Yellow (5182), 1 ball
CC2: Red (5180), 1 ball
CC3: Orange (5181), 1 ball

NEEDLES
Set of four US 2 / 2.5 mm dpn, or size needed to obtain gauge
One US 3 / 3.25 mm needle, or one size larger than gauge needles (see Pattern Notes)

NOTIONS
Lockable stitch markers
Tapestry needle

GAUGE
30 sts and 42 rows = 4 in. / 10 cm square over St st using US 2 / 2.5 mm needles
Be sure to check your gauge.

continued on the next page >>

ABBREVIATIONS

See page 201.

PATTERN NOTES

- A stretchy cast on—the Norwegian cast on (see page 194)—is used for these socks; you can use another cast on if you prefer, but it should have some elasticity.
- Casting on to a needle one size up from the project needle size helps keep the top edge stretchy and makes it easier to divide the stitches among the double-pointed needles.
- Use jogless joins between the stripes (see page 197).
- You will need stitch markers to keep track of decreases when shaping the foot and toe: ring stitch markers are impractical if you need to place a marker at the beginning of a round on double-pointed needles, so use lockable stitch markers and clip them into the stitches, moving them up with each round.
- To finish, the toes are grafted together using Kitchener stitch (see page 198).

THE SOCKS (MAKE 2)

Using MC and the Norwegian cast on (see page 194), cast on **40**(48) sts using one US 3 / 3.25 mm needle; divide the sts bet four US 2 / 2.5 mm dpn and join for working in the round, taking care not to twist the sts.

Round 1: *K1 tbl, p1; rep from * to end of round.

Rep this round 11 more times.

Cut off MC and join on CC1.

Next round: K to end of round.

Work **14**(20) rounds in CC1, **14**(20) in CC2, and **14**(20) in CC3.

Heel flap

Turn so that you are working on WS; change to using two needles and working back and forth; cut off CC3 and join on MC.

Row 1: Sl 1 p-wise, p**19**(23), turn.

Cont on these **20**(24) sts as foll:

Row 2: Sl 1 k-wise, k to end.

Row 3: Sl 1 p-wise, p to end.

Rep Rows 2 and 3 **eleven**(twelve) more times.

Turning the heel

Both sizes:

Row 1: Sl 1 k-wise, k**11**(13), ssk, k1, turn.

Row 2: Sl 1 p-wise, p5, p2tog, p1, turn.

Row 3: Sl 1 k-wise, k6, ssk, k1, turn.

Row 4: Sl 1 p-wise, p7, p2tog, p1, turn.

Row 5: Sl 1 k-wise, k8, ssk, k1, turn.

Row 6: Sl 1 p-wise, p9, p2tog, p1, turn.

1st size only:

Row 7: Sl 1 k-wise, k10, ssk, turn.

Row 8: Sl 1 p-wise, p10, p2tog, turn.

Row 9: K to end.

2nd size only:

Row 7: Sl 1 k-wise, k10, ssk, k1, turn.

Row 8: Sl 1 p-wise, p11, p2tog, p1, turn.

Row 9: Sl 1 k-wise, k12, ssk, turn.

Row 10: Sl 1 p-wise, p12, p2tog, turn.

Row 11: K to end.

There should be **12**(14) sts left on heel flap. Cut off MC.

Shape foot

Using CC1, pick up and k **12**(13) sts down side of heel flap; pick up and k 1 st in gap bet flap and sts on top of foot, PM; k across sts on top of foot, PM; pick up and k 1 st in gap bet top of foot and heel flap; pick up and k **12**(13) sts up other side of heel flap; PM to indicate beg of round. (**58**(66) sts)

Arrange sts so there are **12**(13) sts on first needle (sole of foot), **17**(20) sts on second needle (side), **12**(13) sts on third needle (top), and **17**(20) sts on fourth needle (side).

Round 1: K to 2 sts before next SM, k2tog, sl SM, k to next marker, sl SM, ssk, k to end of round. (**56**(64) sts)

Round 2: K to end of round.

1st size only:

Rep prev 2 rounds 5 more times, rep Round 1 once more. (44 sts)

Cut off CC1 and join on CC2.

Rep Round 2.

Rep Rounds 1 and 2 two more times. (40 sts)

Cont in St st, working 10 more rounds in CC2, then 14 rounds in CC3, maintaining position of SM.

2nd size only:

Rep Rounds 1 and 2 until there are 48 sts.

Cont in St st, working 1 more round in CC1, 20 rounds in CC2, and 20 rounds in CC3, maintaining position of SM.

Toe shaping

Both sizes:

Cut off CC3 and join on MC.

Round 1: *K to 3 sts before next SM, ssk, k1, sl SM, k1, k2tog, rep from * once, k to end of round.

Round 2: K to end.

Rep Rounds 1 and 2 until **16**(20) sts rem.

As the number of sts dec, redistribute sts bet the other needles, maintaining the positions of the SM.

Last round: K to first marker.
Seaming the toe
Transfer one set of sts bet SM to one needle, transfer the rem sts to another needle; **8**(10) sts on each needle.
Graft the sts tog using Kitchener st (see page 198).

FINISHING

Weave in yarn ends and block (see page 199 for more on blocking).

>> **RIGHT**
The perfect socks for kids who want to step out in stripy style!

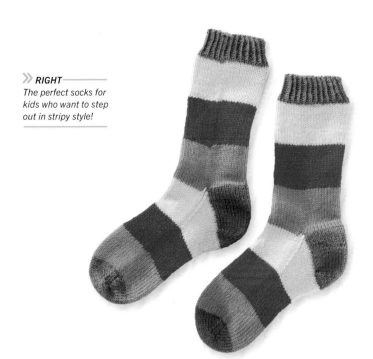

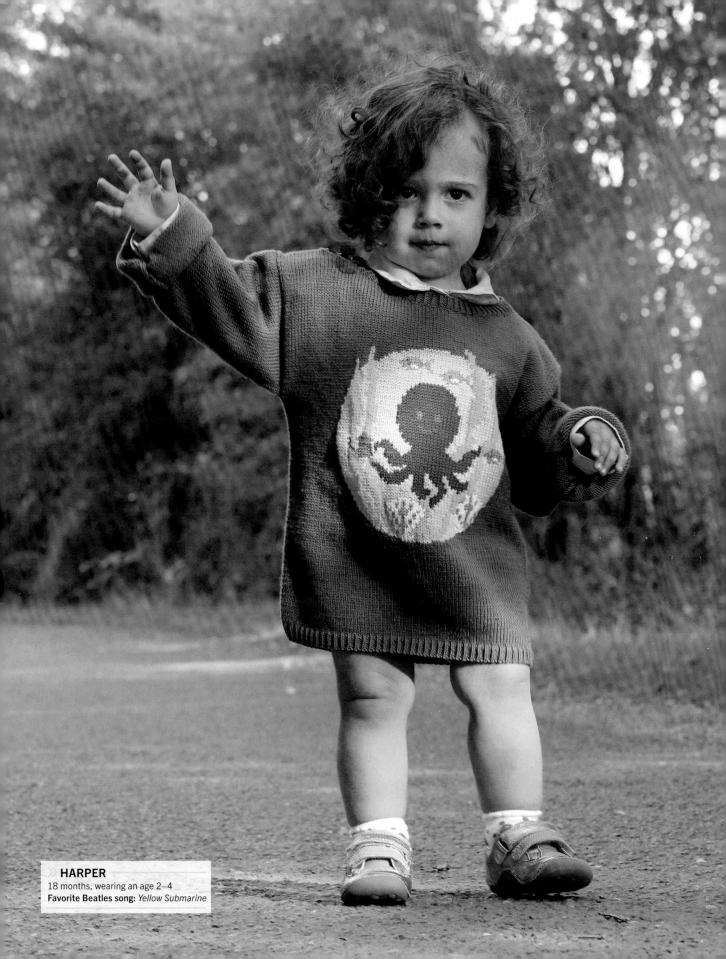

HARPER
18 months, wearing an age 2–4
Favorite Beatles song: *Yellow Submarine*

OCTOPUS'S GARDEN SWEATER

Designed by Anna Alway
Skill level 🍏🍏

Ringo's song, "Octopus's Garden," is a charming hit, popular with adults and children since it first came out. Inspired by the song's cheerful whimsy, this cute little sweater is decorated with a friendly octopus holding a watering can.

This pattern can be made in five different sizes to fit babies and toddlers from six months up to four years of age. The design on the front is worked using intarsia, while the name of the song on the back is embroidered.

The song "Octopus's Garden" appeared on the 1969 album Abbey Road. *It was written by Ringo Starr but credited under his real name, Richard Starkey.*

SIZES
6–9mo:9–12mo:**12–18mo**:18–24mo:**2–4yrs**

FINISHED MEASUREMENTS
Chest: **23**:23¼:**24½**:24¾:**26** in. /
58:59:**62**:63:**66** cm
Length to shoulder: **13¾**:14¼:**14½**:15:
15¾ in. / **35**:36:**37**:38:**40** cm
Sleeve length: **8¼**:8¾:**9**:9½:**10** in. /
21:22:**23**:24:**25** cm

YARN
Sport weight (fine #2), shown in DROPS
Baby Merino (100% wool; 191 yd. / 175 m
per 2 oz. / 50 g ball)
MC: Petrol (42), **4**(4:**4**:4:**5**) balls
CC1: White (01), 1 ball for each size
CC2: Cerise (08), 1 ball for each size
CC3: Light Turquoise (10), 1 ball for each size
CC4: Vibrant Green (31), 1 ball for each size
CC5: Orange (36), 1 ball for each size

NEEDLES
US 2½ / 3 mm needles, or size needed to
obtain gauge
US 2½ / 3 mm circular needle, 16 in. / 40 cm
long, or size needed to obtain gauge

NOTIONS
Stitch holder
Tapestry needle
Three ⅜ in. / 1 cm diameter blue buttons
Sewing needle and blue sewing thread

continued on the next page >>

GAUGE

29 sts and 40 rows = 4 in. / 10 cm square over St st using US 2½ / 3 mm needles
Be sure to check your gauge.

ABBREVIATIONS

See page 201.

PATTERN NOTES

- Because this is a sweater for babies and toddlers, take great care when sewing on the buttons to make sure they are firmly secured.
- This sweater is designed to be worn with 4½–5⅛ in. / 11–13 cm of positive ease (see sizing information on page 203).
- The instructions here use the intarsia technique (see page 196) for the octopus design on the sweater front, while the lettering on the back is worked using duplicate stitch (see page 197), following the charts on pages 184–185. If preferred, you can work the lettering in intarsia or the octopus design in duplicate stitch. If you choose to work the lettering in intarsia, remember that the white squares on that chart will stand for MC. If you work the octopus design in duplicate stitch, you won't be working the blue squares.
- When working in intarsia, wind separate balls of the different colors and twist them together where they join to avoid holes in the finished work.
- For more on reading charts, see page 196.

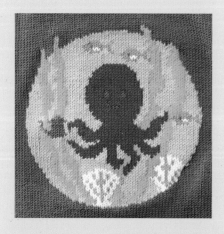

THE SWEATER

BACK

Using US 2½ / 3 mm needles and MC, cast on **84**(86:**90**:92:**96**) sts.
Rib row 1: K1, *k1tbl, p1tbl, rep from * to last st, k1.
Rib row 2: P1, *k1tbl, p1tbl, rep from * to last st, p1.
Rep these 2 rows 2 more times.**
Beg with a k row, cont in St st until work measures 13¾(14¼:**14½**:15: **15¾**) in. / **35**(36:**37**:38:**40**) cm from cast-on edge, ending with a p row.
Making the button flap
Next row: Bind off **10**(11:**12**:12:**13**) sts, k10 (including st used to bind off), turn work.
Working on these 10 sts only and beg with a p row, work 3 rows in St st.
Bind off.
Place next **44**(44:**46**:48:**50**) sts on a stitch holder, rejoin yarn to rem sts, and bind off.

FRONT

Work as for Back to **.
Beg with a k row, work **34**(36:**38**:40:**46**) rows in St st.
Foll the chart, work as foll:
Row 1 (RS): K**16**(17:**19**:20:**22**) in MC, k52 sts from Row 1 of chart, k in MC to end.
Row 2: P**16**(17:**19**:20:**22**) in MC, p52 sts from Row 2 of chart, p in MC to end.
These 2 rows set the position of the charted design.
Cont to work entire chart as set.
Cont in St st and in MC only until work measures **12¼**(12⅜:**12½**:12¾: **13½**) in. / **31**(31.5:**32**:32.5:**34**) cm from cast-on edge, ending with a p row.
Shape neck
Row 1: K**33**(34:**36**:37:**39**), k2tog, place rem sts on a stitch holder.
Turn and work on these **34**(35:**37**:38:**40**) sts for left side of neck.

Row 2: Bind off 2 sts, p to end. (**32**(33:**35**:36:**38**) sts)
Row 3: K to last 2 sts, k2tog. (**31**(32:**34**:35:**37**) sts)
Row 4: Rep Row 2. (**29**(30:**32**:33:**35**) sts)
Row 5: Rep Row 3. (**28**(29:**31**:32:**34**) sts)
Row 6: P2tog, p to end. (**27**(28:**30**:31:**33**) sts)
Rep Rows 5 and 6 three more times. (**21**(22:**24**:25:**27**) sts)
Row 13: K to last 2 sts, ssk. (**20**(21:**23**:24:**26**) sts)
Row 14: P to end.
Rep the last 2 rows **0**(0:**1**:2:**3**) more time(s). (**20**(21:**22**:22:**23**) sts)
Work **2**(4:**4**:4:**4**) more rows in St st.
Bind off.
With RS facing, place next 14 sts on a stitch holder.
Work on rem **35**(36:**38**:39:**41**) sts for right side of neck as foll:
Row 1: Bind off 2 sts, k to end. (**33**(34:**36**:37:**39**) sts)
Row 2: P to last 2 sts, p2tog tbl. (**32**(33:**35**:36:**38**) sts)
Row 3: Rep Row 1. (**30**(31:**33**:34:**36**) sts)
Row 4: Rep Row 2. (**29**(30:**32**:33:**35**) sts)
Row 5: Ssk, k to end. (**28**(29:**31**:32: **34**) sts)
Row 6: Rep Row 2. (**27**(28:**30**:31:**33**) sts)
Rep Rows 5 and 6 three more times. (**21**(22:**24**:25:**27**) sts)
Row 13: Ssk, k to end. (**20**(21:**23**:24: **26**) sts)
Row 14: P to end.
Rep the last 2 rows **0**(0:**1**:2:**3**) more time(s). (**20**(21:**22**:22:**23**) sts)
Work **0**(2:**2**:2:**2**) more row(s) in St st.
Buttonhole row: K2, yo, k2tog, k3, yo, k2tog, k to end.
Next row: P to end.
Bind off.

SLEEVES (MAKE 2)

Using US 2½ / 3 mm needles and MC, cast on **54**(54:**60**:60:**66**) sts.
Rib row 1: K1, *k1tbl, p1tbl, rep from * to last st, k1.
Rib row 2: P1, *k1tbl, p1tbl, rep from * to last st, p1.

Rep these 2 rows 2 more times.

2—4 yrs only:
Beg with a k row, work 8 rows in St st.

All sizes:
Working in St st, inc 1 st at each end of next and every foll 4th row until there are **66**(62:**78**:76:**80**) sts, then inc 1 st at each end of every foll **6th**(6th:**8th**:8th:**8th**) row until there are **84**(84:**90**:90:**94**) sts.

Work **3**(3:**5**:5:**5**) more rows in St st.
Bind off.

NECKLINE

Weave in yarn ends and block Front and Back.

Join Front and Back at shoulder seams, leaving the button flap and buttonhole section open.

With RS of back facing you, join on MC at base of button flap and, using US 2½ / 3 mm circular needle, pick up and k 4 sts, k across the **44**(44:**46**:48:**50**) sts at back of neck on the stitch holder, pick up and k **19**(20:**22**:24:**26**) st along left neck edge, k across 14 sts at front of neck on the stitch holder, pick up and k **19**(20:**22**:24:**26**) st along right neck edge. (**100**(102:**108**:114:**120**) sts)

Working back and forth in rows, cont as foll:

Rows 1 to 3: *K1tbl, p1tbl, rep from * to end.

Buttonhole row: K1tbl, p1tbl, yo, k2tog, *k1tbl, p1tbl, rep from * to end.

Rep Row 1 two more times.
Bind off.

FINISHING

Embroidery

For the lettering on the back, use duplicate stitch and follow the Back Chart as a guide to stitch placement and color choice.

Begin the design at the bottom right of the lettering—with the letter *n* from the word garden—positioning it **29**(31:**33**:35:**39**) rows up from the

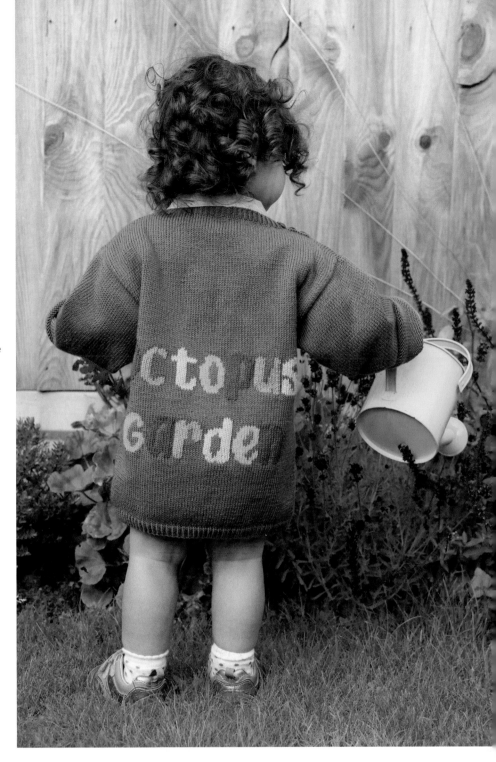

cast-on edge and **13**(14:**16**:17:**19**) sts in from the right-hand side.

Making up

Weave in yarn ends on Sleeves and block (see page 199 for more on blocking).

Sew the sleeves in place, matching centers of sleeve tops to shoulder seams. Join side and sleeve seams.

Sew buttons securely in place, matching their position to the buttonholes.

CHARTS

KEY

■ (dark)	MC
□ (white)	CC1
■ (medium-dark)	CC2
■ (light)	CC3
■ (lighter)	CC4
■ (light-medium)	CC5

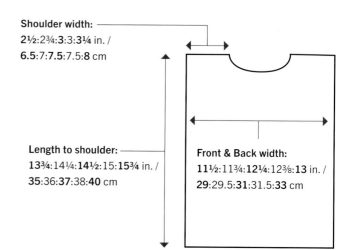

Shoulder width:
2½:2¾:3:3:3¼ in. /
6.5:7:7.5:7.5:8 cm

Length to shoulder:
13¾:14¼:14½:15:15¾ in. /
35:36:37:38:40 cm

Front & Back width:
11½:11¾:12¼:12⅜:13 in. /
29:29.5:31:31.5:33 cm

FRONT CHART

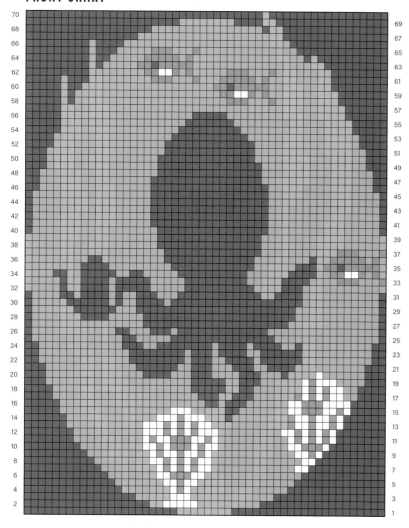

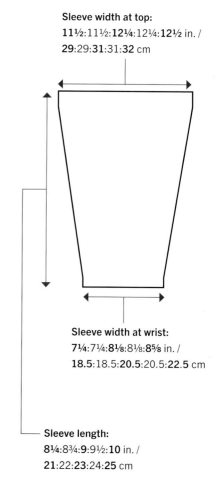

Sleeve width at top:
11½:11½:12¼:12¼:12½ in. /
29:29:31:31:32 cm

Sleeve width at wrist:
7¼:7¼:8⅛:8⅛:8⅝ in. /
18.5:18.5:20.5:20.5:22.5 cm

Sleeve length:
8¼:8¾:9:9½:10 in. /
21:22:23:24:25 cm

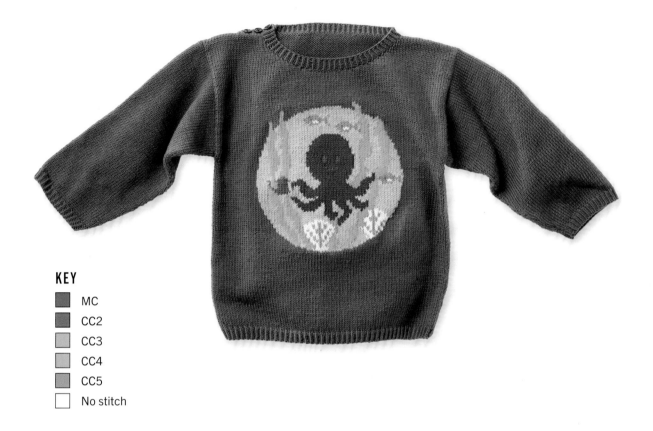

KEY

■	MC
■	CC2
■	CC3
■	CC4
■	CC5
□	No stitch

BACK CHART

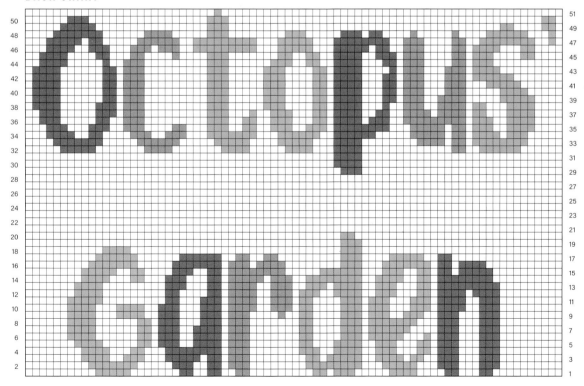

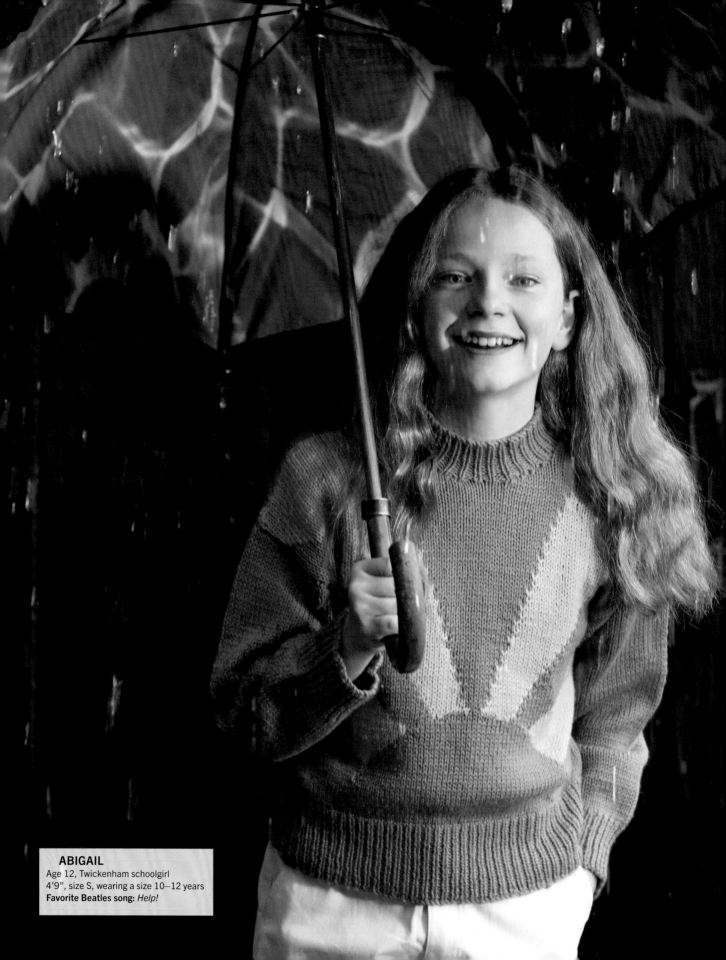

ABIGAIL
Age 12, Twickenham schoolgirl
4'9", size S, wearing a size 10–12 years
Favorite Beatles song: *Help!*

HERE COMES THE SUN SWEATER

Designed by **Susie Johns**
Skill level 🍏🍏

" Here Comes the Sun" is a joyful Beatles song written by George Harrison, and it remains one of the band's most popular hits—in recent years it has become the most streamed Beatles song on several platforms. It's a song to enjoy on summer days, as you bask in the warmth of the sun, as well as one that reminds you of better weather to come when it's cold and dark outside. A bold, bright sunburst design brings that happy message to the front of this kids' sweater.

This pattern is sized for children aged two through twelve years old. The simple motif on the front of the sweater is created using intarsia; the back is left plain. Made in a 100 percent wool in a DK weight, it's a warm and cozy sweater for any child; using a superwash yarn makes it a practical option for a kids' garment too.

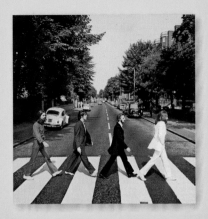

"Here Comes the Sun" appeared on the Abbey Road *album. The album was released in 1969—on September 26 in the UK and October 1 in the United States.*

SIZES
2–**4yrs**:4–6yrs:**6–8yrs**:8–10yrs:**10–12yrs**

FINISHED MEASUREMENTS
Chest: **22**:24½:**26½**:28¾:**30¾** in. / **56**:62:**67**:73:**78** cm
Length to shoulder: **14½**:15¼:**15¾**:16½:17 in. / **37**:39:**40**:42:**43** cm
Sleeve length to underarm: **9**:10¾:**11½**:12½:**13¾** in. / **23**:27:**29**:32:**35** cm

YARN
DK weight (medium #4), shown in Cascade Yarns, 220 Superwash® (100% wool; 220 yd. / 200 m per 3½ oz. / 100 g ball)
MC: Blue Horizon (896), **2**:3:**3**:3:**4** balls
CC1: Autumn Sunset (345), 1 ball for each size
CC2: Golden (877), 1 ball for each size

NEEDLES
US 4 / 3.5 mm and US 6 / 4 mm needles, or size needed to obtain gauge

NOTIONS
Stitch holders
Tapestry needle

GAUGE
22 sts and 30 rows = 4 in. / 10 cm square over St st using US 6 / 4 mm needles
Be sure to check your gauge.

continued on the next page >>

PATTERN NOTES

- The ribbing used is 1x1: *k1, p1, rep from * to end.
- The design on the sweater front is created using the intarsia technique (see page 196), following the chart on page 190. Wind separate balls of the different colors and twist them together where they join to avoid holes in the finished work.
- For more on reading charts, see page 196.

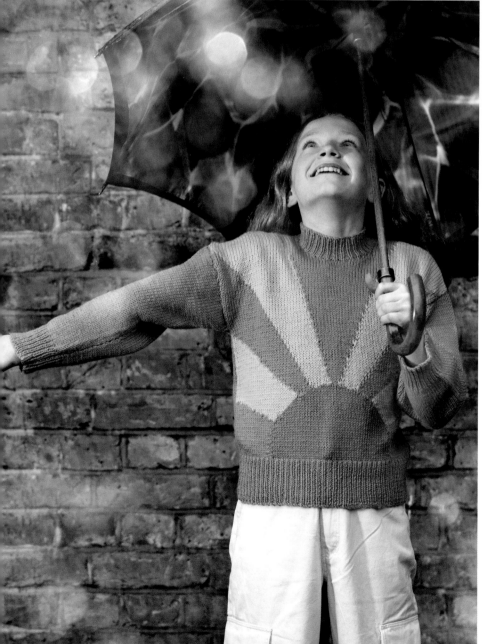

THE SWEATER

BACK

Using US 4 / 3.5 mm needles and MC, cast on **62**(68:**74**:80:**86**) sts.
Work in 1x1 rib for **2**(2¼:**2¼**:2¾: **2¾**) in. / **5**(6:**6**:7:**7**) cm.
Change to US 6 / 4 mm needles.
Beg with a **k**(p:**k**:p:**k**) row, work in St st for **92**(95:**98**:101:**104**) rows.

Shape right back neck
Next row: K**23**(26:**29**:32:**35**) sts, turn, place rem sts on a stitch holder, and cont on this set of sts only.
Dec 1 st at neck edge on next 3 rows.
Bind off rem **20**(23:**26**:29:**32**) sts.
Leave first 16 sts on the stitch holder for center back neck, transfer rem **23**(26:**29**:32:**35**) sts to needle, k to end, then work left back neck on these sts to match right, reversing shaping.

FRONT

Using US 4 / 3.5 mm needles and MC, cast on **62**(68:**74**:80:**86**) sts.
Work in 1x1 rib for **2**(2¼:**2¼**:2¾:**2¾**) in. / **5**(6:**6**:7:**7**) cm.
Change to US 6 / 4 mm needles, cont in St st, working from chart up to Row 90 as foll:
For first size, beg with a k row on Row 13, work area inside pink line; for second size, beg with a p row on Row 10, work area inside blue line; for third size, beg with a k row on Row 7, work area inside orange line; for fourth size, beg with a p row on Row 4, work area inside red line; for fifth size, beg with a k row on Row 1, work entire chart.
Cont to foll chart, shape left front neck as foll:
Next row: K**28**(31:**34**:37:**40**), turn, leaving rem sts on stitch holder.
Dec 1 st at neck edge on next 8 rows. (**20**(23:**26**:29:**32**) sts)
Work 11 more rows in St st.
Bind off.
Leave first 6 sts on the stitch holder for center front neck, transfer rem **28**(31:**34**:37:**40**) sts to needle, then shape right front neck to match left.

SLEEVES (MAKE 2)

Using US 4 / 3.5 mm needles and MC, cast on **48**(50:**52**:54:**56**) sts.
Work in 1x1 rib for **1½**(2:**2**:2¼:**2¼**) in. / **4**(5:**5**:6:**6**) cm.
Change to US 6 / 4 mm needles.

Beg with a p row, work 5 rows in St st.
Inc 1 st at each end of next and
 every foll 6th row until there are
 60(66:**72**:78:**84**) sts.
Cont in St st until work measures
 9(10¾:**11½**:12½:**13¾**) in. /
 23(27:**29**:32:**35**) cm from cast-on
 edge.
Bind off.

NECKBAND

Join right shoulder seam.
Using US 4 / 3.5 mm needles and MC,
 with RS facing, pick up and k 17
 sts down left front neck, 6 sts from
 holder, 17 sts up right front neck,
 4 sts down right back neck, 16 sts
 from holder, and 4 sts up left back
 neck. (64 sts)
Work 12 rows in 1x1 rib.
Bind off loosely in rib.

FINISHING

Block all pieces (see page 199 for more
 on blocking). Join the left shoulder
 and neckband seam. Sew the
 Sleeves in place, matching centers of
 sleeve tops to shoulder seams. Join
 the side and sleeve seams.

>> *RIGHT*
As the '60s drew to a close,
The Beatles recorded some of
their most iconic tracks.

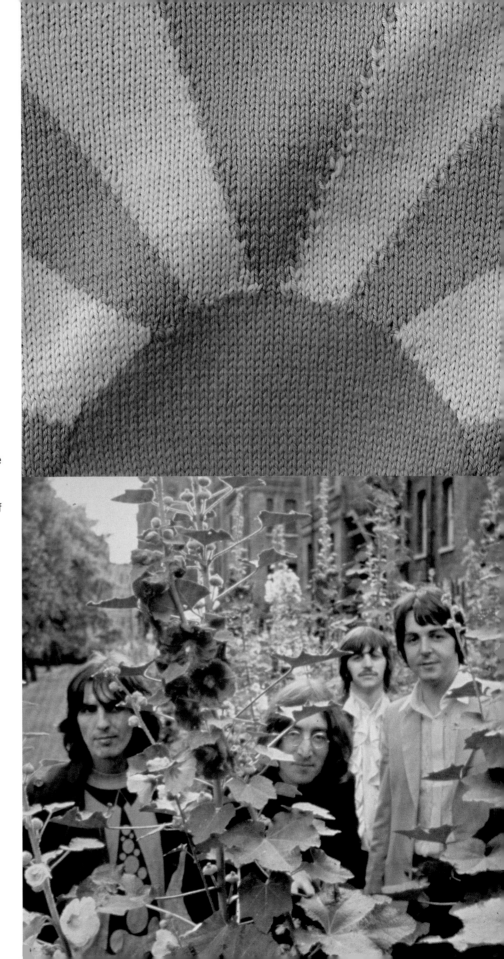

CHARTS

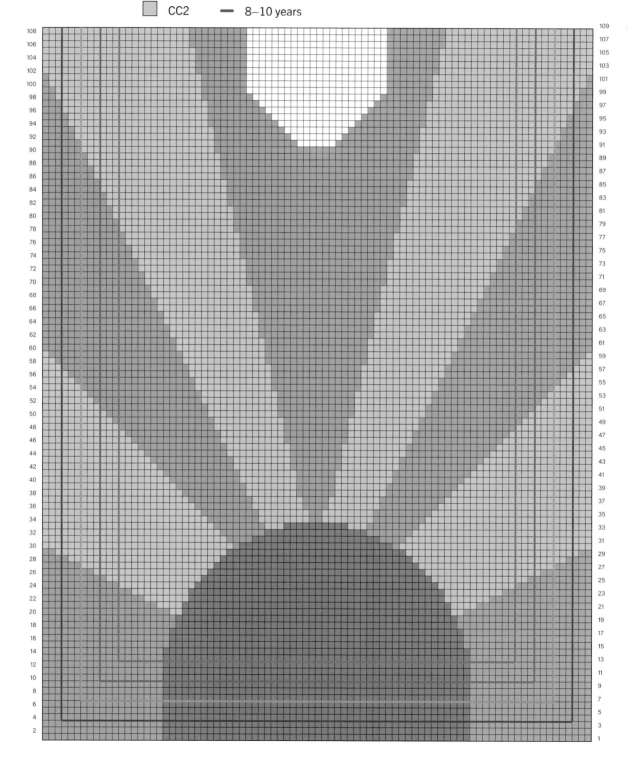

CHILD SIZES

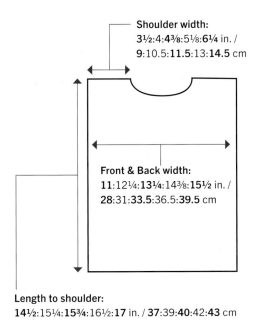

Shoulder width:
3½:4:4⅜:5⅛:6¼ in. /
9:10.5:11.5:13:14.5 cm

Front & Back width:
11:12¼:13¼:14⅜:15½ in. /
28:31:33.5:36.5:39.5 cm

Length to shoulder:
14½:15¼:15¾:16½:17 in. / 37:39:40:42:43 cm

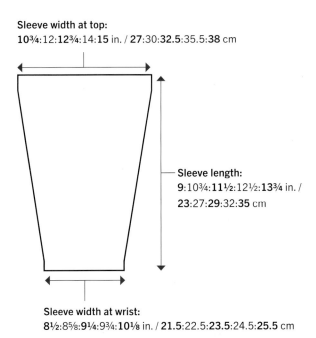

Sleeve width at top:
10¾:12:12¾:14:15 in. / 27:30:32.5:35.5:38 cm

Sleeve length:
9:10¾:11½:12½:13¾ in. /
23:27:29:32:35 cm

Sleeve width at wrist:
8½:8⅝:9¼:9¾:10⅛ in. / 21.5:22.5:23.5:24.5:25.5 cm

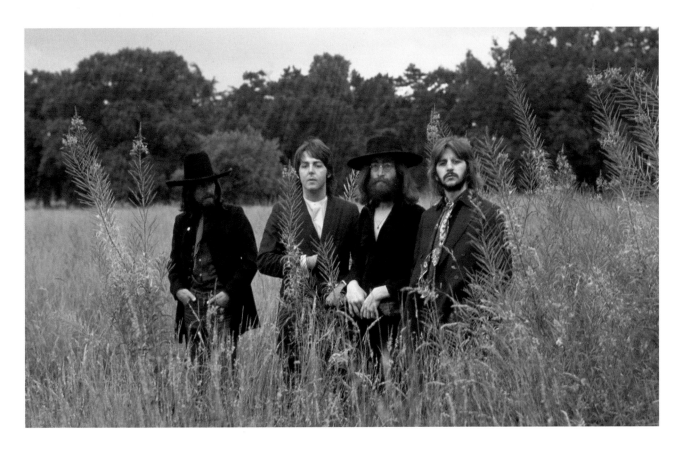

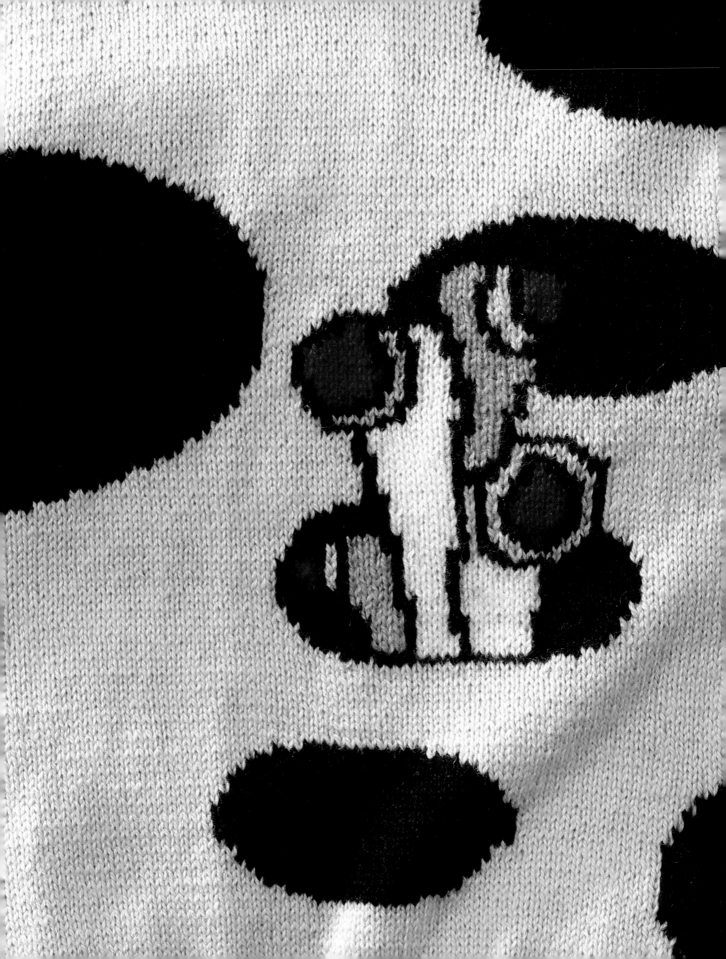

WE CAN WORK IT OUT

Tips, tricks, and useful stuff: Glossary, abbreviations, yarn information, and size guide.

GLOSSARY

CAST ONS

KNITTED CAST ON

Worked with two needles, this is one of the simplest cast
 ons: After putting a slip knot onto your needle, you simply
 knit into that and all subsequent stitches. It gives quite
 an elastic edge with a slight ridge, and is often used when
 you have to cast on stitches at the beginning of a new row,
 partway through a project.

To work it, place a slip knot on your left-hand needle to form
 the first stitch; *using the right-hand needle, knit into the
 stitch, then slip the new stitch onto the left-hand needle
 knitwise; repeat from * until the required number of
 stitches has been cast on.

CABLE CAST ON

Similar to the knitted cast on, the cable cast on will give
 a firm edge that still has some elasticity; it's ideal for
 beginning the cuffs of sleeves and the bottom edges of
 sweater fronts and backs.

To work it, place a slip knot on your left-hand needle to form
 the first stitch; using the right-hand needle, knit into the
 stitch, then transfer this new stitch to the left-hand needle;
 *knit between the two stitches on the left-hand needle,
 then slip this new stitch to the left-hand needle knitwise;
 repeat from *, knitting between the first two stitches on
 the left-hand needle each time. Repeat from * to * until the
 required number of stitches has been cast on.

BACKWARD LOOP CAST ON

The previous two cast ons are worked with two needles, but
 for this cast on you use only one. It gives a stretchy edge,
 but it isn't particularly neat. For that reason, it's often used
 to add extra stitches at the end or in the middle of a row.

To work it, make a slip knot, leaving a 5 in. / 12.5 cm tail, and
 place this on the needle. *Hold the needle in your right
 hand and the working yarn (the yarn that comes from the
 ball) in your left hand, so that it comes from the needle and
 passes inside and over the thumb. Insert the needle under
 the yarn on the outside of your thumb and draw it up into
 a loop; let this slide off your thumb and gently tighten it on
 the needle. Repeat from * to cast on the stitches required.

ALTERNATING CABLE CAST ON

Like the cable cast on, this method is useful when a
 combination of knit and purl stitches is required for a
 ribbed edging. For a knit stitch, work as for the cable cast
 on. For a purl stitch, purl between the stitches on the left-
 hand needle, then slip the new stitch onto the left-hand
 needle knitwise.

LONG-TAIL CAST ON

Like the backward loop method, this cast on uses one needle.
 It's much more elastic than a knitted or cable cast on, and
 so is good for any areas where you need a bit more stretch.

Before you begin, you will need to work out how long a yarn
 tail to leave if the pattern does not say. One method is to
 multiply the number of stitches you want to cast on by 1 in.
 / 2.5 cm. Alternatively, use a length that's three times the
 width of your project.

Work this cast on as follows: Make a slip knot in the yarn
 so that you have a tail the required length (see above)
 hanging down and place this on a needle. Holding the
 needle in your right hand, hold the yarn in your left hand
 so the long tail (that comes from the needle) goes inside
 and over your thumb, and so the working yarn (that comes
 from the ball) passes inside and over your index finger;
 use your remaining fingers to grasp the two ends of yarn
 against your left palm. (This way of holding the yarn is
 often called the "slingshot" position.) *Using the needle,
 reach under the yarn, coming down the outside of your
 thumb, then over the top of the yarn going over your index
 finger and bring that yarn through the thumb loop. Remove
 your thumb and gently tighten the stitch on the needle.
 Reposition the yarn on your thumb and repeat from * until
 you have cast on the required number of stitches.

Bear in mind that this technique will form a row of knit
 stitches, so if you are using it at the beginning of a piece of
 stockinette stitch your next row should be a purl one.

NORWEGIAN CAST ON

This is a very stretchy cast on and is similar to the long-tail
 cast on; it's also known as the twisted German cast on. Its
 elasticity makes it perfect for casting on where you need a
 fair amount of stretch, such as at the top of socks.

It is worked as follows: Set up in the "slingshot" position
 (see above), as for the long-tail cast on. *Insert the needle
 under both strands of yarn on your thumb. Bring the needle
 down over the top of these two strands (the one behind
 your thumb) and under the lower strand (the one in front
 of your thumb). Reach the needle over the strand on your
 index finger, pick up the yarn, and draw it through the loop

on your needle. Remove your thumb and gently tighten the stitch on the needle. Reposition the yarn on your thumb and repeat from * for the required number of stitches.

WORKING WITH COLOR

Several of the projects in this book use more than one color of yarn to create the knitted design. Two knitting techniques are used to do this—Fair Isle and intarsia knitting.

FAIR ISLE KNITTING

Named after the Scottish island famed for its traditional knitwear, Fair Isle knitting (also known as stranded colorwork) is a technique that allows you to work with more than one color to create different designs. In this technique, two (and occasionally more) colors are used in the same row; the yarn that is not being used is carried across the back of the work. Using two strands of yarn at the same time will mean that your finished work is, in effect, a double thickness. Fair Isle patterns are rendered in charts that show you how many stitches to work in each color on each row.

Most knitters will find that the gauge of their Fair Isle work is tighter than the gauge they usually get in plain stockinette stitch. Follow the gauge guide given in the pattern information and if your knitting is too tight, change to larger needles.

Holding the yarn

When knitting a Fair Isle design, two different yarns are being handled repeatedly as you work across a row, with the yarn not in use being carried across the back of the work. This means that you will have to hold two separate yarns at the same time. How you do this is up to you, but the key thing to remember is to hold one yarn so that it is lower than the other and to ensure that this is the same color throughout. The way you hold your yarns will affect how the different colors appear on the right side of the work, and if you are not consistent this can mean the finished pattern is uneven.

One technique is to hold a color in each hand. With this method, loop the "upper" color over the index finger of your right hand and loop the "lower" color over the index finger of your left hand. Use your right index finger to loop the yarn over the needles as you knit; hold the yarn tight over your left index finger and use the right-hand needle to pick up the yarn. This is, in effect, a combination of the two classic ways of knitting—"throwing," or English knitting, and "picking," or Continental knitting.

It is also possible to hold both yarns in one hand. If you usually hold your yarn in your right hand—in other words, if you prefer English knitting or the "throwing" method—loop one color over the index finger of your right hand and loop the second color (the lower yarn) over the middle or ring finger, then knit as normal, alternating the colors. Keep the same color over your index finger throughout. If you favor "picking" or Continental knitting—if you usually hold the yarn in your left hand—tension both strands over your index finger with the "upper" yarn to the right and the "lower" yarn to the left.

Whichever approach you take, when you change color, spread out the last eight or ten stitches on the right-hand needle to stretch them out slightly before you introduce the new shade. This will ensure that the strands aren't pulled too tight.

Carrying yarn across the back of the work

In Fair Isle knitting, the color not being used "floats" on the wrong side of the work until needed again. These floats must either be stranded or woven into your work depending on how many stitches they have to stretch across. With either of these methods, it's important that the float is not too tight, or the pattern will pucker, and not too loose, or there will be loops on the wrong side that can snag.

With stranding, the unused yarn lies across the wrong side of the work until needed. Only use this method when the yarn spans a maximum of four stitches—any more and the floats will be too long and they will catch or snag. On a knit row, keep both yarns at the back of the work. Knit the number of stitches required with the first color, then loop the second color past these stitches, without pulling it tight, and knit the required number of stitches. Alternate the yarns in this way, leaving them both loosely stranded at the back. On a purl row, keep both yarns at the front and purl the required number of stitches with the first color. Loop the second color along and purl the required stitches. Alternate the yarns, leaving them lying loosely at the front of the work.

If the second color needs to be carried across five or more stitches, it must be woven in at regular intervals on the back of the work, making sure it is not pulled too tight. When weaving in colors, try to avoid doing this at the same position in every row.

On a knit row, when the lower color is not being used and you want to weave it in, insert the right-hand needle into the next stitch knitwise and wrap the lower color over the right-hand needle from right to left. Wrap the upper color around the needle as if to knit, then unwrap the lower color and complete the stitch with the upper color. When you want

to weave in the upper color, insert the right-hand needle in the next stitch knitwise and wrap the upper color over the needle as if to knit. Wrap the lower color over the needle as if to knit, then unwrap the upper color and complete the stitch with the lower color.

On a purl row, when you want to weave in the lower color, insert the needle into the next stitch purlwise and wrap the lower color around the needle from underneath (i.e. in the opposite direction from purlwise). Wrap the upper color around the needle purlwise and unwrap the lower color before completing the stitch with the upper color. If you want to weave in the upper color, insert the needle in the next stitch purlwise and wrap the upper color around the needle purlwise. Wrap the lower color around the needle purlwise and unwrap the upper color before completing the stitch with the lower color.

INTARSIA KNITTING

Intarsia is used to create designs made up of separate blocks of color. These might be single large motifs, bold geometric patterns, pictures, or text. Unlike Fair Isle knitting, intarsia involves the use of a separate ball of yarn for each block of color in the design. In comparison to Fair Isle, the finished fabric will, therefore, be lighter and a single thickness. Generally speaking, designs are worked from a chart and in stockinette stitch. When each new color is taken up, that yarn and the previous one are twisted together on the wrong side of your knitting to prevent holes from appearing at the points where the colors join.

Before you begin knitting an intarsia pattern, you will need to wind separate smaller balls of yarn for each block of color in the design. Look at the chart to work out how many balls you will need to wind. You can either form the yarn into small balls or you can wind it around plastic bobbins (available from yarn stores).

Unlike Fair Isle, there is no particular way to hold your needles. All you need to do is ensure that you twist the colors together tightly enough on the wrong side and that you don't get the separate balls (or bobbins) of yarn tangled together. When you begin a new ball of yarn, knot it together with the previous ball of yarn to secure. At the end of your knitting, look at the right side of the work to see if there are any gaps or holes at the points where the colors change. If there are, retie any knots that are loose (but not so tightly that you distort the stitches) and use the tip of a tapestry needle to pull any loose stitches to the back. If any stitches look too tight, pull them to the front. Use a tapestry needle to weave in the yarn ends carefully, making sure there is no show-through on the right side.

READING A CHART

Both Fair Isle and intarsia patterns are shown as a chart with a squared grid. Each square has a color or symbol that corresponds to a yarn color indicated in the key. Each square represents one stitch and each row of squares indicates a row of knitting.

The design is worked from bottom to top, and so the rows are numbered starting at the bottom. Working in stockinette stitch, the first row and every following odd-numbered row is a knit (right side) row, and on the chart these rows are read from right to left; the right-side row numbers are shown on the right-hand side of the chart. The second row and each following even-numbered row is a purl (wrong side) row, and on the chart these rows are read from left to right; the wrong-side row numbers are shown on the left-hand side of the chart.

If you are following a large or complex chart, it is a good idea to keep track of where you are as you work. You can simply mark off each row with a pencil, mark your position with a sticky note, or, if you prefer not to mark the book, photocopy the chart and cross off the rows on that.

SHORT-ROW SHAPING

Short-row shaping, also known as turning or partial rows, is a way to add three-dimensional shaping to your knitting by working extra rows across just some of the stitches. In this technique, a row is partially worked and then the knitting is turned and worked back to the starting point. Working short rows will give you one edge that's longer than the other. After working short rows, the knitting continues over the complete row.

To avoid a hole forming when the work is turned in the middle of a row, some patterns "wrap" the stitch following the one at the turning point. On a knit row, work the number of stitches as instructed, and then, with the yarn at the back, slip the next stitch purlwise. Bring the yarn forward, then slip the last stitch on the right-hand needle back onto the left and take the yarn to the back again before turning your work. On a purl row, work to the point where the work is to be turned, and then, with the yarn in front, slip the next stitch purlwise. Take the yarn to the back, then slip the last stitch on the right-hand needle back onto the left. Bring the yarn to the front and turn the work.

When you want to work into a wrapped stitch on a knit row, insert the right-hand needle under the front of the wrap, then into the stitch above the wrap, and knit the two together. On a purl row, insert the right-hand needle into

the back of the wrapped loop and lift it onto the left-hand needle, then purl the loop and the following stitch together.

JOGLESS JOINS

When you knit in the round you are, effectively, knitting a spiral. This means that the end of one round is one stitch above the first stitch of that round, and this offset is known as a "jog." This is really noticeable when you knit stripes.

You can avoid this by using the following technique: When you change to a new color, work one round in this color, then begin the next round by picking up the stitch (in the old color) one row below the first stitch in the new color and placing this on the left-hand needle. Knit this stitch together with the first stitch in the new color, then continue to knit as normal.

I-CORD

An i-cord is a knitted tube that can be used as a strap, handle, or tie. To make one, you need to use two double-pointed needles or a circular knitting needle.

Cast on the number of stitches required and knit the first row, but do not turn your work. Instead, slide the stitches to the other end of the needle and knit them again, pulling the working yarn across the back of the work as you knit the first stitch. Repeat until the i-cord is the desired length, then bind off.

If you look at the back of the i-cord, you will see the yarn stretched across it—as you knit, the gap between the edges of the knitting will close up to hide the yarn and create a tube. As you work, tug gently on the i-cord from time to time to even out the stitches and encourage the gap to close.

EMBROIDERY

DUPLICATE STITCH

This is a form of embroidery especially for knitting. Also known as Swiss darning, it creates a V-shaped stitch in a new color over the top of a knitted stitch. It's a good way to add small and intricate designs to an item without having to use the Fair Isle or intarsia techniques.

Thread a tapestry needle with a length of your chosen yarn. Insert it from front to back a short distance away

from where you want to begin; pull the yarn through, leaving a tail on the front of your knitting (this will be pulled to the back and woven in at the end of stitching). Bring the needle out at the base of the first stitch you want to embroider over. Pass the needle from right to left under the base of the stitch above—in other words, under the two slanted "arms" of that stitch where they meet at the point of the V shape. Draw the yarn through and reinsert the needle where it came out. Bring the needle out again at the base of the next stitch you want to embroider over. Continue to work in the same way. Don't pull your stitches too tight or they will pucker your knitted fabric. When you've worked all your stitches, weave in the yarn end, then go back to the tail at the beginning and draw it through to the back of the stitches before weaving that in.

Designs in duplicate stitch are often displayed as charts, with one square being equal to one duplicate stitch worked over one knit stitch. See Working with Color (page 196) for how to read a chart.

BACKSTITCH

This is a simple embroidery stitch that's used to outline shapes and designs.

Thread a tapestry needle with the required yarn. Insert it from front to back a short distance away from where you want to begin; pull the yarn through, leaving a tail at the front of your knitting (to be woven in later). Bring the needle back out one stitch-length away from where you want to begin, then insert it at that starting point. Bring the needle out again, two stitch-lengths away from the start, following the line you want to make; pull the yarn through so the stitch lies flat on the surface. Don't pull too tight or the stitch will disappear between the knitted stitches. *Insert the needle again at the end of the stitch just made, then bring it out again two stitch-lengths away; pull the yarn through. Repeat from * up to one stitch from the end of your stitching line, then insert the needle at the end of the previous stitch, draw the yarn through to the back, and fasten off. Draw the tail at the beginning of the backstitches through to the back and weave it in.

CHAIN STITCH

This is a classic stitch that can be added to knitting to form lines and shapes.

Thread a tapestry needle with a length of your chosen yarn. Insert it from front to back a short distance away from where you want to begin; pull the yarn through, leaving a tail on the front (to be woven in later). Bring the needle out at the point where you want the embroidery to begin, then insert it in the same spot and *draw it through to the back, leaving a large loop on the surface of the knitting. Bring the needle out again a short distance away (the length you want the stitch) and draw it through the loop of yarn, pulling the stitch tight as you do. Reinsert the needle at the point where it came out and repeat from * to complete the second stitch. Repeat until you have worked the number of stitches required.

JOINING EDGES

LADDER STITCH

Also known as mattress stitch, this is a useful stitch when joining straight edges together; it creates a nearly invisible seam, but it does leave a slight ridge on the inside. It is worked with the right sides facing you, so it is useful for joining the edges of patterned pieces because you can match the sections of the design as you sew.

Work ladder stitch as follows: Position the two edges to be joined together with the right sides facing you. Thread a tapestry needle with a length of yarn and, starting at the top, insert the needle under two of the "bars" between the knitted stitches, one stitch in from the edge of one of the pieces of knitting; leave a long yarn tail to weave in later. Insert the needle under the two stitch bars on the opposite piece, one stitch in from the edge. Without tightening the yarn, insert the needle under the next two stitch bars on the first piece, then insert it under the next two stitch bars on the opposite piece. Continue to make stitches in the same way, tightening the yarn after every four or five stitches.

KITCHENER STITCH

Also known as grafting, this technique is used when you want to join together two sets of "live" stitches; in other words, joining two pieces of knitting without binding off. It creates a seamless finish and so is useful for finishing the toes of top-down socks. You can use it only when there are an equal number of stitches on the two pieces being joined.

To work Kitchener stitch, cut the yarn, leaving a long tail, and thread this onto a tapestry needle. Arrange the stitches to be joined so they are at the tips of two knitting needles and hold the knitting needles parallel so you have one needle at the front and one at the back. Insert the tapestry needle purlwise into the first stitch on the front needle; pull the yarn through but leave the stitch on the knitting needle. Insert the tapestry needle into the first stitch on the back needle knitwise and draw the yarn through, leaving the stitch on the knitting needle. *Insert the tapestry needle knitwise into the first stitch on the front needle; pull the yarn through and slide the stitch off the knitting needle. Insert the tapestry needle purlwise into the next stitch on the front needle; pull the yarn through but leave the stitch on the knitting needle. Insert the tapestry needle purlwise into the first stitch on the back needle; pull the yarn through and slide the stitch off the knitting needle. Insert the tapestry needle knitwise into the next stitch on the back needle, pull the yarn through but leave the stitch on the knitting needle. Repeat from * until there is one stitch on each needle. Insert the tapestry needle knitwise into the stitch on the front needle, pull the yarn through and slide the stitch off the knitting needle. Insert the tapestry needle into the last stitch purlwise and slide it off the knitting needle. You may need to go back along the grafted stitches and use the tip of the tapestry needle to tighten them slightly. Use the tapestry needle to take the yarn to the wrong side of the knitting and weave it in.

MOCK GRAFTING

This technique is used to join two bound-off edges so that they appear to have been grafted together. It's useful when you want to create a flat and apparently seamless join, such as at the shoulders of garments that have been worked in stockinette stitch and that have been bound off.

To work the technique, thread a tapestry needle with yarn and bring the two edges to be joined together, with the right sides facing you and so you have one piece at the top and one at the bottom. Secure the yarn on the wrong side, at the beginning of the seam on the bottom piece, and bring the needle to the front between the two "arms" of the first stitch. Insert the needle under the two "arms" of the first stitch on the top piece and draw the yarn through. Insert the needle back into the first stitch on the bottom piece where it emerged and draw the yarn through. *Bring the needle back to the front through the next stitch to the left on the bottom piece, then insert it under the next stitch on the top piece. Repeat from * to the end of the seam.

THREE-NEEDLE BIND OFF

This is a useful way to bind off because it also joins two pieces of knitting at the same time, creating an even seam where the stitches line up neatly. If you hold the pieces of knitting right sides together as you work the bind off, the result is a smooth seam; if you hold the pieces wrong sides together, the result is a ridged seam. The two pieces need to have an equal number of stitches for this bind off.

To work it, arrange the stitches to be bound off on two needles, near to the tips, and hold the pieces together (right side or wrong side) as directed by the pattern. Insert a third needle into the first stitch on the front needle and then into the first stitch on the back needle at the same time, and knit the two stitches together. Repeat to knit together the next stitches on both needles. Lift the first stitch on the right-hand needle over the second one as normal. Continue in this way to bind off as required.

BLOCKING

Before joining together the project pieces, it is advisable to block them first. (If your project is made in one piece, such as a hat or a pair of socks, then block the finished individual items.) Blocking ensures that corresponding pieces—the back, front, and both sleeves—are the correct size so they match up when sewn together. It also helps even out the texture of your knitting and reduces the curl that you get at the edges of stockinette stitch.

For blocking, you will need rustproof pins, a tape measure, and a suitable flat, but padded, surface. If you knit a lot of garments, then it is well worth investing in blocking boards—interlocking foam pads printed with a grid—but you can also use folded towels. If you go for the latter option, then you can also cover the towels with a piece of cotton gingham or checked fabric so the squared pattern can help you position your knitted pieces—make sure any fabric you use is colorfast. If you make socks regularly, then sock blockers—special foot-shaped forms—are useful. Blocking wires are ideal for getting edges straight on large items such as shawls and wraps.

If you plan to wet block your work (see below) you will also need a suitable detergent for your yarn fiber. Be guided by care instructions on the ball band when deciding on how to block, and if you are using strong or contrasting colors in a project, wet block your gauge swatch (see below) to check for colorfastness. If you are not sure about the advisability of wet blocking your knitting, steam block it instead (see below).

For wet blocking, begin by hand-washing your pieces in tepid water, using a suitable detergent, then rinse thoroughly in the same temperature water. Gently squeeze out any excess water—do not wring—and then roll up the pieces in a towel and press down to draw out as much moisture as possible.

Lay out your pieces on your blocking board or folded towels and ease them into the correct shape, using a tape measure to check that the size is correct (use the measurement diagrams on the pattern pages for this information). Pin in place, and then let dry.

An alternative "wet" method is to pin out the dry pieces to shape and size, then spray them lightly with water until damp, before allowing to dry.

To steam block your pieces, pin them out when dry, then position the blocking board or towels on an ironing board or on the floor. Take a piece of clean cotton or linen fabric and dampen it thoroughly. Place this over the pinned knitting, then use a hot iron to quickly iron over the cloth. Make sure that there is no moisture in the knitted pieces before unpinning them.

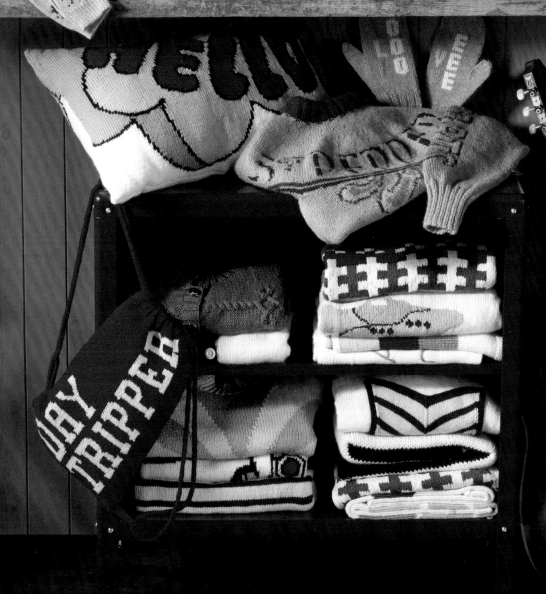

ABBREVIATIONS

alt	alternate
beg	beginning
bet	between
CC	contrast color
cm	centimeter(s)
CN	cable needle
cont	continu(e)(ing)
Cr2L	slip next st onto cable needle and hold to front of work, k1, then k1 from cable needle
Cr2R	slip next st onto cable needle and hold at back of work, k1, then k1 from cable needle
Cr3L	slip next 2 sts onto cable needle and hold to front of work, p1, then k2 from cable needle
Cr3R	slip next st onto cable needle and hold at back of work, k2, then p1 from cable needle
Cr4L	slip next 2 sts onto cable needle and hold to front of work, p2, then k2 from cable needle
Cr4R	slip next 2 sts onto cable needle and hold at back of work, k2, then p2 from cable needle
C4B	slip next 2 sts onto cable needle and hold at back of work, k2, then k2 from cable needle
C4F	slip next 2 sts onto cable needle and hold at front of work, k2, then k2 from cable needle
dec	decrease
DK	double knit
dpn	double-pointed needles
foll	follow(s)(ing)
in.	inch(es)
inc	increase
k	knit
k2tog	knit 2 stitches together (1 stitch decreased)
kfb	knit into the front and back of the same stitch (1 stitch increased)
kfbf	knit into the front, back, and then front of the same stitch (2 stitches increased)
k-wise	knitwise (as if to knit)
m	meter(s)
m1	make 1 stitch by picking up and knitting into loop lying between stitch just worked and next stitch

m1 p-wise	as for m1 but purl into the loop between stitch just worked and next stitch
MC	main color
mm	millimeter(s)
p	purl
p2tog	purl 2 stitches together (1 stitch decreased)
patt	pattern(s)
pfb	purl into the front and back of the same stitch (1 stitch increased)
PM	place marker
prev	previous
p-wise	purlwise (as if to purl)
rem	remaining
rep	repeat
rev St st	reverse stockinette stitch
RS	right side
s2kpo	slip next 2 stitches onto right-hand needle as if to knit them together, knit 1, then pass both slipped stitches over (2 stitches decreased)
skpo	slip 1 stitch knitwise, knit 1, then pass the slipped stitch over (1 stitch decreased)
sl	slip(ping)
SM	stitch marker(s)
ssk	slip, slip, knit, worked as foll: slip 2 stitches knitwise, one at a time, onto right-hand needle, insert left-hand needle into front of the 2 stitches, wrap yarn round right-hand needle knitwise and knit the 2 stitches together (1 stitch decreased)
st(s)	stitch(es)
St st	stockinette stitch
tbl	through the back loop of st(s)
tog	together
WS	wrong side
yd.	yard(s)
ytf	yarn to front
yrn2	yarn around needle twice
ytb	yarn to back

YARN INFORMATION

If you are not able to find the yarn that's been used for a particular project, it is usually possible to substitute that yarn with another one. There is a very useful website —www.yarnsub.com—that lists possible alternatives if you enter the details of the project yarn.

Alternatively, you can search for options yourself. You will need the yarn weight given in the pattern—such as Aran, DK, or 4 ply—and to know what gauge is recommended for that design. Then look for the same weight in a similar fiber composition, and make sure that the gauge recommended by the manufacturer matches that of the pattern.

To work out how much yarn you need, go back to the pattern and make a note of the yardage of the recommended yarn, then multiply that by the number of balls required. Divide this number by the yardage of your substitute yarn to work out how many balls of that you need.

When you buy the substitute yarn, be sure to knit a gauge swatch—if it doesn't match the gauge given in the pattern you will need to adjust your needle size.

Even if you are using the recommended yarn, it's advisable to knit a gauge swatch before you embark on a project—you will find this information at the beginning of the pattern. If you don't match the gauge, your finished piece won't be the size given by the designer. Plus you may run out of yarn—or have a lot left over.

Start by using the needles recommended in the pattern and cast on ten more stitches than given in the gauge information. So, for example, if the gauge is 24 stitches, cast on 34. The same goes for the number of rows worked— knit ten more than stated. You should also work in the stitch pattern given in the gauge information. For example, the gauge of a swatch in a Fair Isle pattern will be slightly different from that worked over stockinette stitch.

When you've finished your swatch, don't bind off. Instead, thread a length of spare yarn through the stitches and slip them off the needle. Lay the swatch out flat on a padded surface (such as a folded towel or blocking mat) and place a pin in it two stitches in from one side and two stitches up from the cast-on edge. Repeat to pin down the swatch close to the other three corners. Then place another pin four stitches in from one side. Measure 4 in. / 10 cm across from this point and place another pin. Count the stitches in between. Do the same vertically and count the rows between the pins. If you have a half stitch, don't round up or down; include this in your count.

If your swatch matches the gauge stated in the pattern, you can start knitting right away. But if you have more stitches than given, your knitting is too tight and you need to use larger needles. If you have fewer stitches, your knitting is too loose and you need smaller needles. You may have to make more than one gauge swatch before you can begin to knit.

YARN RESOURCES

CASCADE
www.cascadeyarns.com

ROWAN
www.knitrowan.com

DROPS
www.garnstudio.com

SCHEEPJES
www.scheepjes.com

RICO
www.rico-design.de

WOOL WAREHOUSE
www.woolwarehouse.co.uk

SIZE INFORMATION AND CHART

The sizes shown here are a guide to average measurements. When choosing which size to make, look at the sizes given in the pattern but also look at the finished measurements and the information on the measurement chart below. The difference between your actual measurement and the finished measurement is known as "ease." A garment with negative ease is one that is smaller than your actual measurements and is, therefore, meant to be tight fitting. A garment with positive ease is bigger, and so is not fitted to the body; how relaxed it is depends on the amount of ease. Compare your measurements with the pattern's finished measurements, and if you want to make a garment that has more positive ease, then simply choose to knit a larger size.

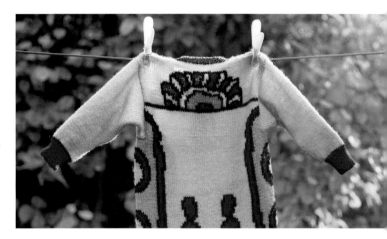

SIZE	Baby 0—3 months	Baby 3—6 months	Baby 6—12 months	Baby 12—18 months	Baby 18—24 months
MEASUREMENT	16 in. / 40.5 cm	17 in. / 43 cm	18 in. / 45.5 cm	19 in. / 48 cm	20 in. / 50.5 cm

SIZE	Child 2—4 years	Child 4—6 years	Child 6—8 years	Child 8—10 years	Child 10—12 years
MEASUREMENT	21 in. / 53 cm	23 in. / 58.5 cm	25 in. / 63.5 cm	26½ in. / 67 cm	28 in. / 71 cm

SIZE	XS	S	M	L	XL
MEASUREMENT	28—30 in. / 71—76 cm	32—34 in. / 81—86 cm	34—36 in. / 86—91 cm	38—40 in. / 96.5—101.5 cm	42—44 in. / 106.5—111.5 cm

SIZE	2XL	3XL	4XL	5XL	6XL
MEASUREMENT	46—48 in. / 116.5—122 cm	50—52 in. / 127—132 cm	54—56 in. / 137—142 cm	58—60 in. / 147.5—152 cm	62—64 in. / 157.5—162.5 cm

INDEX

Abbey Road Throw 106
abbreviations 201
accessories 100–161
albums
 Abbey Road 107, 181, 187
 Rubber Soul 135
 Sgt. Pepper's Lonely
 Hearts Club Band 33, 57, 119
 The White Album 71, 83, 103
All You Need Is Love Baby Blanket 164
Apple Sweater Vest 82
baby and child patterns
 All You Need Is Love Baby Blanket 164
 Blue Meanie Socks 176
 Greatest Hits Sweater 40
 A Hard Day's Night Cardigan 88
 Here Comes the Sun Sweater 186
 Love Me Do Sweater 22
 Octopus's Garden Sweater 180
 Paul's Fair Isle Sweater Vest 64
 Sergeant's Stripe Hoodie 56
 Yellow Submarine Onesie 168
 Yellow Submarine Sweater 12
bag
 Day Tripper Bag 144
bind off, three-needle 199
blankets and throws
 Abbey Road Throw 106
 All You Need Is Love Baby Blanket 164
blocking 199
Blue Meanie Socks 176
cast ons
 alternating cable 194
 backward loop 194
 cable 194
 knitted 194
 long-tail 194
 Norwegian 194
charts, reading 196
Day Tripper Bag 144
Dreadful Flying Glove Socks 118
duplicate stitch 197
embroidery 197

backstitch 198
 chain stitch 198
 duplicate stitch 197
Fab Four Scarf 114
fair isle knitting 195
Greatest Hits Sweater 40
glossary 194
A Hard Day's Night Cardigan 88
hats
 Magical Mystery Tour Hat 150
 Yellow Submarine Beanie Hat 122
Hello, Goodbye Pillow 156
Here Comes the Sun Sweater 186
Hey Jude Shawl 126
i-cords 197
intarsia knitting 196
jogless joins 197
joining edges 198
Kitchener stitch 198
ladder stitch 198
Love Love Love Mittens 140
Love Me Do Sweater 22
Magical Mystery Tour Hat
and Mittens 150
mittens
 Magical Mystery Tour Mittens 153
 Love Love Love Mittens 140
mock grafting 199
movies
 A Hard Day's Night 88
 Magical Mystery Tour 65, 151, 157
 Yellow Submarine 13, 47, 57, 77, 123, 169, 177
Ob-La-Di, Ob-La-Da Wrap 102
Octopus's Garden Sweater 180
Old Fred's Jacket 76
Paul's Fair Isle Sweater Vest 64
pillows
 Hello, Goodbye Pillow 156
 Rubber Soul Pillow 134
Revolution Ruana Wrap 70
Rubber Soul Pillow 134

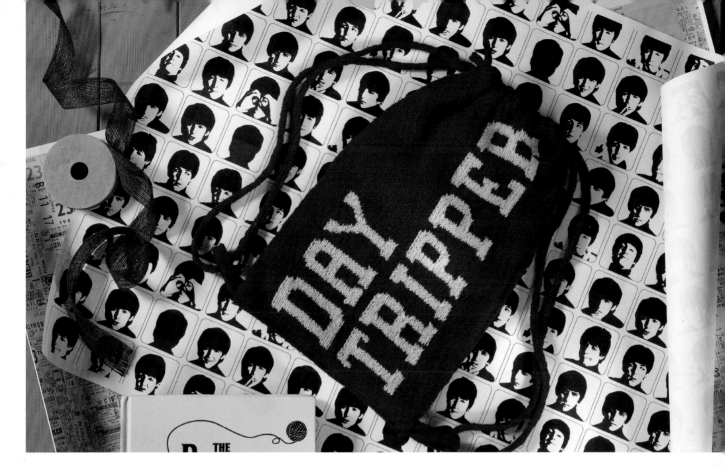

scarves and wraps			"The Long and Winding Road"	41
Fab Four Scarf	114		"Love Me Do"	23, 41, 115, 141
Hey Jude Shawl	126		"Ob-La-Di, Ob-La-Da"	103
Ob-La-Di, Ob-La-Da Wrap	102		"Octopus's Garden"	181
Revolution Ruana Wrap	70		"P.S. I Love You"	23, 141
Sea of Holes Sweater	46		"Revolution"	71, 127
Sergeant's Stripe Hoodie	56		"Paperback Writer"	41
Sgt. Pepper's Band Sweater	32		"Yellow Submarine"	169
short-row shaping	196		sweaters	
size chart	203		Greatest Hits Sweater	40
size information	203		A Hard Day's Night Cardigan	88
socks			Love Me Do Sweater	22
Blue Meanie Socks	176		Old Fred's Jacket	76
Dreadful Flying Glove Socks	118		Sea of Holes Sweater	46
songs			Sergeant's Stripe Hoodie	56
"All You Need Is Love"	119, 141, 165		Sgt. Pepper's Band Sweater	32
"Baby You're a Rich Man"	165		Yellow Submarine Sweater	12
"Day Tripper"	145		sweater vests	
"Eleanor Rigby"	169		Apple Sweater Vest	82
"A Hard Day's Night"	89		Paul's Fair Isle Sweater Vest	64
"Hello, Goodbye"	157		working with color	195
"Here Comes the Sun"	187		yarn information	202
"Hey Jude"	71, 83, 127		Yellow Submarine Beanie Hat	122
"I Am the Walrus"	157		Yellow Submarine Onesie	168
"Let It Be"	41		Yellow Submarine Sweater	12

MEET THE DESIGNERS

ANNA ALWAY
Favorite Beatles song: "Come Together"
Anna is a British-born designer who lives in Sweden with her family. She has had a passion for knitting since childhood and, after studying textile design in London, she set up her own business designing knitting patterns. She contributes to knitting magazines, planning and creating beautiful designs, as well as working with independent designers to create stunning handmade knitwear. She loves being able to make and create items that have longevity and that will be loved.

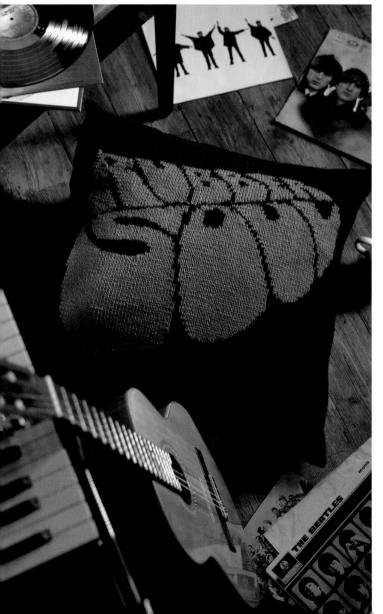

JULIE BROOKE
Favorite Beatles song: "All My Loving"
Julie was taught to knit by her grandmother before she had even started school—and she's been knitting ever since. Today she edits and acts as a consultant for knitting, crochet, and other craft books for a number of international publishers and works as a sample knitter. She lives by the sea in Sussex.

SIAN BROWN
Favorite Beatles song: "She's Leaving Home"
Sian fell in love with yarn and knitting while studying for a BA in fashion and textiles. She went on to become a knitwear designer, working for companies that supply high-end stores, starting with factory machine knits and moving on to hand knits. Sian has taught the knitwear course at the London College of Fashion, and has sold knitted swatches to US designers. She now lives in Devon and designs hand knits for several magazines and yarn companies. She has books in her own name, and has contributed to several others.

JANE BURNS
Favorite Beatles song: "Come Together"
Jane is a freelance hand-knit and crochet designer. With more than eight hundred designs in print, and as the winner of the British Knitting and Crochet Designer of the Year award in 2017, Jane is best known for her creative children's garments, many of which are regularly featured in craft publications. She believes that projects should be as much fun to make as they are to wear.

CÉCILE JEFFREY
Favorite Beatles song: "Let It Be"
Cécile has her own family-run knitwear design company based in South London. After gaining a BA in fashion knitwear design at Leicester Polytechnic, Cécile worked as a freelance designer for a few years before establishing her own label in 1984, going on to sell to stores and boutiques in the UK, United States, Japan, Australia, and Canada. In 2020, after taking an extended sabbatical, Cécile returned with an online collection of timeless garments and accessories for men and women.

SUSIE JOHNS

Favorite Beatles song: "All You Need Is Love"

London-based artist Susie Johns studied fine art at the Slade School in London. During her long career in publishing, she has transitioned from magazine editor to writer and designer, and is the author of more than fifty books, mostly on the subjects of sewing and knitting. Novelty knits are her specialty, and she has had celebrity commissions from the likes of author and broadcaster Gyles Brandreth, author Jeffrey Archer and the British new wave band Squeeze, among others.

CAROLINE SMITH

Favorite Beatles song: "I Saw Her Standing There"

Caroline was taught to knit by her grandmother when she was ten years old, and then taught herself to crochet in her teens. Having worked in publishing since graduating from university, Caroline specialized in needlecraft books and magazines, where her crafting expertise could be put to good use. She ended up contributing her own knitting and crochet projects to various books and magazines, as well as designing knitting and craft kits for licensed characters such as Harry Potter, The Beatles, and Doctor Who. She lives with her family on the beautiful Isle of Wight.

LYNNE WATTERSON

Favorite Beatles song: "Hey Jude"

Lynne has been knitting and designing for as long as she can remember—she designed her first outfit (for her Sindy doll) at the age of five. Knitting is in her blood—her grandfather was a machine knitter and her grandmother a pattern checker for a knitting publication—so it came as no surprise when, on leaving school, she started an apprenticeship on a knitting publication as a sub-editor. A career in publishing followed, with more knitting pattern writing and designing, and Lynne is now one of the UK's most experienced craft editors.

ABOVE
Go to pages 126 to 133 for the pattern for this fab shawl.

AUTHOR ACKNOWLEDGMENTS

This book wouldn't have happened without Stella Bradley at Insight who approached me with the initial concept. Special thanks go to Anna, Sian, Julie, Jane, Cécile, Efia, Susie, and Lynne—the talented team of designers who created the fabulous projects. And thanks too for the skills of the sample knitters—Brenda Bostock, Cynthia Brent, Pat Cooper, Ann Cornish, Jacqui Dunt, Lou Hodgson, Helen Jones, Carol Reeve, Sue Williams, and Karen Williamson. I'm also grateful for the talents of our wonderful technical editor, Julie Brooke, as well as those of Penny Hill and Marilyn Wilson.

A special mention too for Charlotte Hancock and the team at Wool Warehouse for helping with yarn supplies. And finally, I'd never have been a knitter if it weren't for my beloved grandmother teaching me, so thank you, Manka, for all the years of woolly fun!

INSIGHT EDITIONS

PO Box 3088—San Rafael, CA 94912
www.insighteditions.com

Find us on Facebook: www.facebook.com/InsightEditions
Follow us on Instagram: @insighteditions

ISBN: 979-8-88663-507-2

Our thanks to Euan Ferguson at Mother Mash, Covent Garden, London,
for providing the shoot location shown in the Hey Jude Shawl photography.

	Which is your favourite Beatles' song?
Publisher: Raoul Goff	*Yesterday*
VP, Co-Publisher: Vanessa Lopez	*Across the Universe*
Creative Director: Stella Bradley	*Here, There and Everywhere*
Product Designer: Paul Montague	*A Day in the Life*
Sourcing Director: Tracey Hinchliffe	*Let It Be*
Subsidiary Rights: Lina s Palma-Temena	*Blackbird*
VP, Manufacturing: Alix Nicholaeff	*Help!*
Production Editor: Katie Killebrew	*Across the Universe*
Copy Editor: Karen Levy	*Let It Be*
Proofreader: Carla Kipen	*Yesterday*
Author: Caroline Smith	*I Saw Her Standing There*
Technical Editor: Julie Brooke	*All My Loving*
Layout Designer: Marie Zedig	*Here Comes the Sun*
Technical illustrator: Paul Southcombe	*Maxwell's Silver Hammer*
Photographers: Jess Esposito and	*Eleanor Rigby / Strawberry Fields Forever*
David Burton at Studio 68b	

Manufactured in China by Insight Editions
10 9 8 7 6 5 4 3 2 1